HISPANIOLA

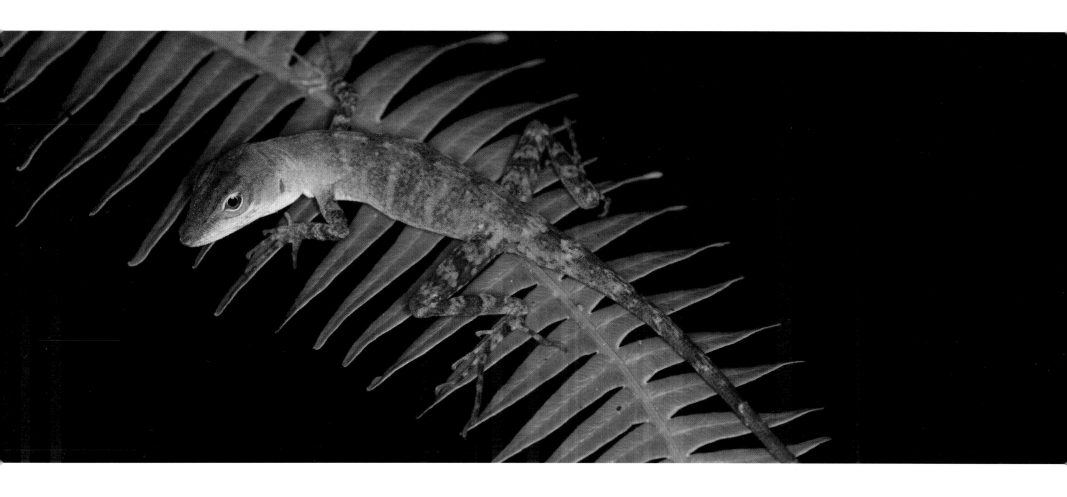

PRÓLOGO DE EDWARD O. WILSON
FOREWORD BY EDWARD O. WILSON

Eladio Fernández

HISPANIOLA

A PHOTOGRAPHIC JOURNEY THROUGH ISLAND BIODIVERSITY

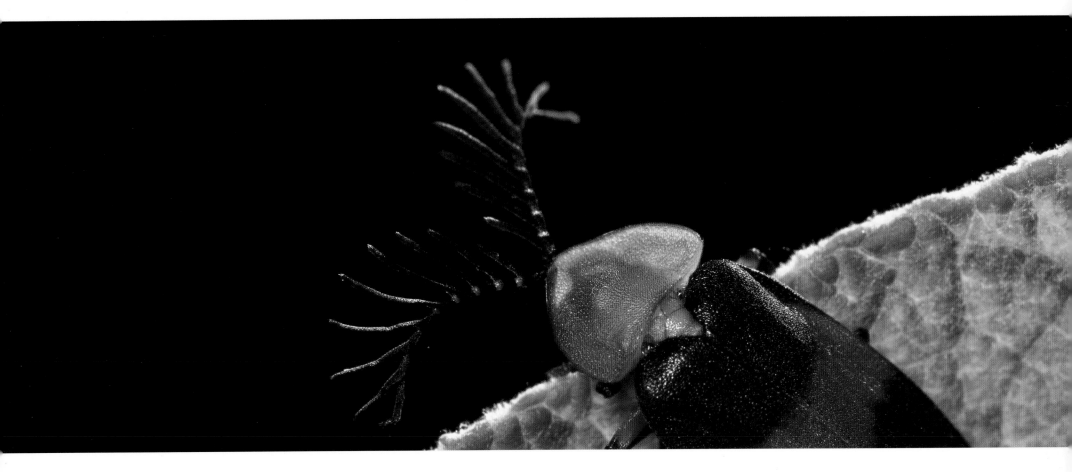

THE BELKNAP PRESS OF
HARVARD UNIVERSITY PRESS
CAMBRIDGE, MASSACHUSETTS
LONDON, ENGLAND
2007

Printed in Italy by Graphicom.

Made possible in part through the generous support
of Grupo SID, Santo Domingo, Dominican Republic.

Design and composition: Eric Mulder
from an original design by Irina Miolán,
Irina Miolán Design.

Cataloging-in-Publication Data available from the
Library of Congress
ISBN-13: 978-0-674-02628-5 (alk. paper)
ISBN-10: 0-674-02628-4 (alk. paper)

031308-08

"El proceso ahora en marcha, que tomará millones de años corregir, es la pérdida de la diversidad genética y de especies debida a la destrucción de los ambientes naturales. Esta será la insensatez que nuestros descendientes probablemente no nos perdonen."

"The one process now going on that will take millions of years to correct is the loss of genetic and species diversity by the destruction of natural habitats. This is the folly our descendants are least likely to forgive us."

— EDWARD O. WILSON

v

CONTENIDO | CONTENTS

vi

FOTOGRAFÍAS | PHOTOGRAPHS

vii

PRÓLOGO

EDWARD O. WILSON

EN ESTE BELLO TRABAJO DE ARTE FOTOGRÁFICO, Eladio Fernández nos guía por el singular mundo de la naturaleza de La Española. Viajaremos lejos a través de terrenos escabrosos, desde los vestigios de los empinados bosques de la Hotte de Haití hasta los variados hábitats de las reservas nacionales de la República Dominicana. Con un ojo de fotógrafo y la destreza de un naturalista, Fernández ha recopilado en una sola colección algunas de las joyas más finas de la historia natural de La Española.

A través de estas imágenes visitamos lo que queda de las áreas silvestres de La Española, de localidad a localidad, de ecosistema a ecosistema, de especies representativas a especies. Hay orquídeas y palmas, iguanas y culebras constrictoras, brillantes colecciones de aves, moluscos y artrópodos de gran diversidad. El autor nos proporciona una visión completa del solenodonte, un mamífero primitivo y uno de los más raros y más elusivos animales del mundo.

Lo que sólo puede ser apreciado en su totalidad por biogeógrafos y naturalistas serios es el carácter insular de la fauna y flora de La Española. Hace veinte millones de años la isla era parte de un archipiélago que descansaba cerca de la tierra firme de Centro América. Sus animales y plantas, evidenciados en los fósiles (incluyendo los de insectos y otras pequeñas criaturas atrapadas en ámbar), eran muy similares a los de tierra firme. A medida que La Española y los restos de las Antillas fueron llevados por las corrientes hacia el este durante los milenios siguientes, muchos de los animales y plantas originales se extinguieron, sin nunca ser remplazados por nuevos emigrantes.

Varias especies ancestrales no sólo sobrevivieron en La

IN THIS BEAUTIFUL WORK OF PHOTOGRAPHIC ART, Eladio Fernández guides us through the unique natural world of Hispaniola. We travel far across an often rugged terrain, from the steep remnant forest of Haiti's La Hotte to the many varied habitats of the Dominican Republic's reserves. With the eye of a skilled naturalist and photographer, Fernández has gathered some of the finest gems of Hispaniola's natural history into a single collection.

Through these images we visit the remaining wild parts of Hispaniola, locality by locality, ecosystem by ecosystem, representative species by species. There are orchids and palms, iguanas and constrictor snakes, a brilliant array of birds, and mollusks and arthropods of great diversity. We are given a full look at the solenodon, a primitive mammal and one of the rarest and most elusive animals in the world.

What may be appreciated in full only by biogeographers and serious naturalists is the insular character of the Hispaniolan fauna and flora. Twenty million years ago the island was part of an archipelago lying close to the mainland of Central America. Its animals and plants, as evidenced by fossils (including those of insects and other small creatures trapped in amber), were very similar to those of the mainland. As Hispaniola and the remainder of the West Indies drifted eastward over the ensuing millennia, many of the original stock of animals and plants became extinct, never to be replaced by fresh immigrants.

Some of the old species not only survived on Hispaniola. Together with a handful of new ones that were able to reach the island, they split repeatedly, multiplying to create

Española. Junto con las pocas especies nuevas que pudieron alcanzar la isla, se dividieron repetidamente, multiplicándose para crear grupos de nuevas especies. A medida que estos descendientes evolucionaron, se dispersaron a diferentes nichos por el proceso llamado radiación adaptativa. El resultado es una colección floreciente de especies cercanamente relacionadas pero diferentes en apariencia y en la forma en que se especializan para cada nicho en particular. Así encontramos una variedad extraordinaria de estos habitantes, como son las lagartijas *Anoles*, las mariposas *Calisto* y las hormigas de color brillante *Temnothorax*.

Otra característica de la vida de la isla es, desafortunadamente, su vulnerabilidad. Un gran número de las especies de La Española, incluyendo los vertebrados como el solenodonte y las iguanas terrestres, están en peligro. Las ranas especialmente se encuentran en condiciones críticas. En Haití, donde sólo un uno por ciento de los bosques permanece en pie y casi todos los ríos de agua dulce y arroyos están contaminados, 47 de las 51 especies de ranas (casi todas del género *Eleutherodactylus*) están amenazadas. De éstas, 31, o dos tercios del total, están clasificadas en peligro crítico, consideradas así en extinción en un futuro cercano. Las Indias Occidentales en general, y las islas de Cuba y La Española en particular, están en la lista que mantienen los expertos en conservación como polos de atracción del mundo—lugares con una gran proporción de especies bajo un alto riesgo de extinción.

La belleza y la novedad de los ambientes de La Española son bienes del mundo entero. Muchos de estos ecosistemas y especies, tan bien desplegados en la colección de Eladio Fernández, tristemente están también en peligro. Como investigador y admirador de este mundo viviente, espero que más acciones sean tomadas para salvar lo más posible para las futuras generaciones.

clusters of new species. As these descendants evolved, they dispersed into different niches, the process called adaptive radiation. The result is an array of efflorescences of species closely kin to one another yet different in appearance and the way each has specialized for particular niches. Thus we encounter an extraordinary variety of such inhabitants as *Anolis* lizards, *Calisto* butterflies, and brightly colored *Temnothorax* ants.

Another characteristic of island life is, unfortunately, its vulnerability. Large numbers of the Hispaniolan species, including vertebrates such as the solenodon and ground iguanas, are endangered. Especially critical is the condition of the frogs. On Haiti, where only one percent of the forests remain and almost all of the freshwater rivers and streams are polluted, 47 of the 51 known frog species (almost all from the genus *Eleutherodactylus*) are threatened by destruction. Of these, 31, or two-thirds of the total, are classified as critically endangered, thus considered subject to extinction in the near future. The West Indies in general, and the largest islands of Cuba and Hispaniola in particular, are high on the list kept by conservation experts of the world's terrestrial "hot spots"—places with a large proportion of species at high risk of extinction.

The beauty and novelty of Hispaniola's living environment are assets to be treasured by the whole world. Many of its ecosystems and species, so well displayed in Eladio Fernández's collection, are sadly also at risk. As a researcher and admirer of this special living world, I hope that more action will be taken to save as much as possible of it for future generations.

INTRODUCCIÓN

PHILIPPE BAYARD
Président du Conseil d'Administration de la SAH

TEL UN JOYAU ENCHÂSSÉ DANS UN ÉCRIN DE VERDURE, se présente notre petite île d'Hispaniola, dans l'ouvrage si richement illustré du spécialiste Eladio Fernandez.

Le grand mérite de l'auteur est, en effet, d'en dévoiler les richesses naturelles, mais de manière si artistique que parcourir ce livre demeure un régal pour la vue. Et pour l'esprit aussi, puisque le lecteur y glane des connaissances importantes sur l'étonnante variété de ces richesses qui ne peuvent que susciter ou renforcer chez lui le souci de les conserver au bénéfice des générations actuelles et futures. Présenter pour conscientiser: voilà donc la tâche ardue à laquelle Eladio Fernandez, ce passionné de la nature et de la photographie, cet homme de terrain infatigable qui a parcouru les coins les plus pittoresques et les plus reculés de notre île, s'est attelé, et son livre prouve bien qu'il a su la mener de main de maître.

Ses pérégrinations l'ont naturellement conduit vers les parcs nationaux de l'île entière, et il s'y est attardé pour mieux mettre en relief tantôt leur charme incomparable, tantôt leur regrettable niveau de dégradation. Aussi, il n'est pas exagéré de considérer cet album comme un document majeur à vocation multiple, puisqu'il constitue un formidable outil d'éducation et de sensibilisation, un document de référence à consulter avant toute démarche visant l'avenir de ces espaces spéciaux. Et les lecteurs haïtiens apprécient que les aires protégées de la République d'Haïti (Parc National Macaya, le Parc National La Visite et la Forêt des Pins et le Parc Historique Citadelle, Sans Souci, Les Ramiers), véritables réservoirs de la biodiversité nationale

A JEWEL SET AGAINST A BACKGROUND OF GREENERY is an apt description of our small island of Hispaniola, as Eladio Fernández has so richly illustrated in his book.

The author's greatest merit is to have unveiled the natural riches of Hispaniola, but he has done so with such art that this book is a feast for the eyes. The spirit also gains, since the reader gleans immense knowledge on the stunning variety of living organisms here that can only arouse or reinforce in him or her a concern for their safe keeping for the benefit of current and future generations. Taking on the challenge of raising awareness, Eladio Fernández has tackled this difficult task with his passion for nature and photography. A tireless fieldworker, he took the time to explore the most picturesque and remote areas of our island and gave the project his best, as evidenced by this book.

His wanderings naturally led him to the many national parks throughout the island. His photographs capture in turn their incomparable charm and their regrettable level of degradation. Thus, it would not be an exaggeration to consider this album a document of import with multiple purposes: as an incomparable educational record, an awareness-raising tool, and a reference to be consulted before any endeavor is undertaken to guarantee a future for these special spaces. Thus, the Haitian reader truly appreciates the fact that his country's protected areas (the national parks of Pic Macaya and La Visite, Forêt des Pins, the historic park of La Citadelle, Sans-Souci, Les Ramiers)—true reservoirs of the nation's mountain biodiversity—are so well represented by the author in his work.

de montagne, aient été si bien prises en compte par l'auteur dans son ouvrage.

Ils l'en remercient d'autant plus que, Haïti se trouve face à une situation environnementale critique due à des causes multiples : destruction des habitats naturels et, corollairement, réduction de la biodiversité, dégradation accélérée des ressources naturelles (des terres en particulier), des ressources marines et côtières, pollution et inquiétante explosion démographique. A ce carrefour, des mesures opportunes et éclairées doivent être prises pour juguler le mal. C'est chose quasiment faite si l'on considère, à titre d'exemples et au niveau de l'Etat haïtien, le Décret cadre de janvier 2006 sur la gestion de l'environnement, excellent instrument de pilotage qui prévoit un certain nombre de structures de gestion, le renforcement des capacités institutionnelles par la formation de cadres et la création d'un corps de surveillance environnementale.

Et, parallèlement à ces dispositions inédites du Ministère de l'Environnement, on ne saurait omettre une implication de plus en plus marquée du secteur privé et des ONG, considérée judicieusement comme un motif d'espérance, annonciateur de lendemains meilleurs.

De toute façon, s'il est vrai que ses ressources environnementales sont très fortement entamées, Haïti n'en reste pas moins l'un des pays à plus forte diversité biologique de la Caraïbe insulaire avec un taux d'endémicité particulièrement élevé, tant en botanique qu'en zoologie (oiseaux, amphibiens, poissons, mollusques, etc.) ainsi que l'ont révélé les récentes études réalisées dans la plupart de nos aires protégées.

Et c'est pour préserver ces inestimables acquis, qu'à l'instar d'autres organisations, la Société Audubon Haïti

This gratitude is enhanced by the fact that Haiti is facing an environmental crisis caused by several factors: the destruction of natural habitats and, consequently, the reduction of biodiversity; the accelerated degradation of natural resources (especially lands and including marine and coastal assets); pollution; and a worrisome demographic explosion. At this junction, timely and enlightened measures must be taken to put a stop to this state of affairs. An important step has been made in this direction by the Framework Decree of January 2006 published by the Haitian government on environmental management, an excellent steering instrument that foresees a number of management structures, the reinforcement of institutional capacities by training officers, and the creation of an environmental surveillance corps. In addition to these innovative measures taken by the Ministry of the Environment, a markedly increased involvement of the private sector and nongovernmental organizations (NGOs) is aptly considered a reason for hope, boding well for a better tomorrow.

Though it is indeed true that its environmental resources have been seriously damaged, Haiti nonetheless remains one of the countries with the highest levels of biological diversity in the Caribbean isles. It has an especially high rate of endemic species, both botanical and zoological (birds, amphibians, fish, mollusks, etc.), as demonstrated by recent studies conducted in most of our protected areas.

To preserve these invaluable resources, Société Audubon Haïti (SAH)—like other organizations—is increasingly making its mark as an institution resolutely committed to safeguarding Haiti's environmental heritage with the beneficial impact of its activities. The research it has conducted in the protected areas in partnership with overseas

(SAH) s'impose de plus en plus comme une institution résolument engagée dans la sauvegarde du patrimoine environnemental national haïtien, avec à son actif, des activités aux retombées fort positives. Les travaux de recherche menés par elle dans les aires protégées, en partenariat avec des institutions d'outre-mer, fournissent des informations actualisées particulièrement intéressantes pour le monde scientifique et seront certainement à l'origine de décisions opportunes. La mise en place de Réseaux Locaux d'Intervention en Environnement (RELIEs), cellules de la SAH réparties au niveau national, permettra une plus grande implication des communautés en vue d'une prise en charge locale de la protection et de la conservation de l'environnement. Les projets communautaires, conçues par la SAH comme alternatives aux problèmes socio-économiques, auront le double mérite de créer des richesses et d'éliminer, du même coup, la destruction des ressources naturelles par les populations démunies en vue d'assurer leur survie. La SAH espère ainsi raffermir leur volonté de lutter contre la dégradation de l'environnement haïtien, voire de réhabiliter ce qui peut encore l'être. Point n'est besoin de s'étendre sur le volet Education, particulièrement retenu par la SAH, sans lequel la conscientisation et ce

institutions provides updated information of special interest to the scientific world and will certainly give rise to timely decisions. The implementation of Local Intervention Networks on the Environment (Réseaux Locaux d'Intervention en Environnement, or RELIEs), cells of SAH scattered throughout the country, will bring about greater community involvement in the local management of environmental protection and preservation. The community projects designed by SAH to redress socioeconomic problems will have the dual merit of creating wealth and eliminating the destruction of natural resources by local populations for subsistence. In doing so, SAH hopes to strengthen the will of the Haitian people to fight against the environmental degradation of the country, and even to rehabilitate what can still be saved. Needless to say, the organization will also emphasize education, without which its goal of responsible individual and collective environmental behavior will never be attained.

For all these reasons, Société Audubon Haïti knows that it can draw immense benefit from this remarkable book, without the hint of a doubt among one of the best efforts ever made to defend Hispaniola's environment. By offering these amazing specimens of the island to Dominican and

comportement individuel et collectif responsable vis-à-vis de l'environnement auxquels elle aspire ne sauraient, selon elle, être atteints.

Pour toutes ces raisons, la Société Audubon Haïti sait pouvoir tirer un immense profit du remarquable ouvrage de Eladio Fernandez, qu'elle n'hésite pas à verser dans le champ des meilleurs efforts jamais consentis pour défendre l'environnement d'Hispaniola. En exhibant aux yeux ébahis des Dominicains et des Haïtiens de si beaux coins et spécimens de l'île, l'auteur leur adresse une exhortation à mieux connaître, mieux apprécier et mieux protéger les paysages de chez eux et à sauvegarder les trésors qu'ils abritent. La SAH, pour sa part, souscrit à cet impératif, tout en félicitant son talentueux et proche collaborateur, d'avoir, pour atteindre son objectif, utilisé, avec tant de maestria, l'ART dans l'une de ses formes les plus pures: la photographie.

Haitian eyes, Eladio Fernández exhorts us all to understand, appreciate, and protect our land and preserve the treasures it holds. As for SAH, it acknowledges this imperative need while congratulating its talented and close collaborator for attaining his objective by so masterfully using art in one of its purest forms: photography.

NOTAS DEL FOTÓGRAFO

ELADIO FERNÁNDEZ

CON FRECUENCIA ME PREGUNTAN COMO ME INTERESÉ en la fotografía de naturaleza. El apreciar la naturaleza es definitivamente un requisito para la búsqueda de esta aventura. A pesar de que cuando era más joven disfruté de una serie de actividades al aire libre, no adquirí un interés serio por la naturaleza hasta que cumplí los veinte años. Es aquí cuando comienzo a acampar, visitando algunos de los parque nacionales y subsecuentemente convirtiéndome en un ávido observador de aves. A pesar de que la observación de aves en la República Dominicana esta lejos de ser tan popular como lo es en Norte América o Europa, a veces un pequeño grupo de entusiastas se reunían, los cuales luego se convirtieron en los miembros fundadores de la Sociedad Ornitológica Hispaniola. Considerando que las aves viven una vida tan interesante, fue sólo cuestión de tiempo sentir el impulso de fotografiarlas y documentar su comportamiento. Después de un sinnúmero de horas en el campo y cientos de rollos de películas más tarde, comencé a producir imágenes aceptables, suficiente para presentar mi primera exhibición en una galería local. La reacción positiva y el hecho de que la mayoría de las personas no estaban familiarizadas con nuestras aves (y la naturaleza en general) fueron suficientes incentivos para dedicarme seriamente a la fotografía de naturaleza.

La idea de un libro sobre la biodiversidad de la isla de La Española—en inglés, Hispaniola—llegó unos años más tarde, después de darme cuenta de la limitada información que existía sobre este tema y el poco material fotográfico disponible. Una de las consecuencias más claras de

PEOPLE OFTEN ASK HOW I GOT STARTED IN NATURE photography. Having an appreciation for nature is a definite requirement for pursuing such a venture. Although I enjoyed a series of outdoor activities in my younger years, I did not acquire a serious interest in nature until my early twenties. It was then when I started camping, visiting some national parks, and subsequently becoming an avid birdwatcher. Although birdwatching in the Dominican Republic is hardly as popular as it is in North America or Europe, in time a small group of enthusiasts assembled, which later became the founding members of Sociedad Ornitológica Hispaniola. Considering that birds live such interesting lives, it was only a matter of time before I felt the urge to photograph them and record their behavior. After countless hours in the field and hundreds of rolls of film later, I started producing acceptable images, enough to present my first show in a local art gallery. The positive reaction to the show and the fact that most people were not familiar with our birds (and nature in general) was enough incentive to pursue nature photography in a more serious manner.

The idea for a book on biodiversity on the island of Hispaniola—in Spanish, La Española—came a few years later, after I realized that limited information on the subject and almost no photographic material were available. One of the clearest consequences of this problem is that our children today are more familiar with images of panda bears and lions than with our very own iguanas and solenodons—something that disturbs me. I also felt that a book on Hispaniolan biodiversity needed to include

este problema es que hoy nuestros niños están mas familiarizados con las imágenes de los osos pandas y de leones que con las de nuestras iguanas o solenodontes—lo cual me perturba. También sentí que en el libro sobre la biodiversidad de La Española necesitaba incluir a Haití. Llegar a ciertas áreas de Haití representó un inmenso desafío, mayormente por cuestiones de seguridad y la dificultad en la organización de la logística. Estas dificultades se solucionaron con la ayuda de la Sociedad de Audubon de Haití, una organización no-gubernamental haitiana dedicada a la conservación de aves. Tan pronto el problema del acceso se resolvió, estuvo claro que tenía una oportunidad enorme de obtener fotografías en ambos países en temas nunca antes retratados. Al presentar estas fotografías en un libro, espero despertar la conciencia y producir una chispa de interés en preservar la herencia natural de nuestra isla. Aunque este plan puede sonar relativamente fácil y sencillo, se convirtió en una empresa muy ambiciosa.

Un libro sobre biodiversidad necesita mostrar un lado de la isla raramente visto por el público. El hecho de que la isla de La Española tiene el mayor número de tipos de hábitats en el caribe, es ignorado por la mayoría. La gran variedad de hábitats existe debido a los amplios rangos latitudinales a lo largo de la isla. Mientras que el Pico Duarte se eleva a 3,087 metros, el Lago Enriquillo se encuentra 40 metros por debajo del nivel del mar—La Española es verdaderamente una tierra de contrastes. Todos estos hábitats han producido uno de los niveles mas altos de diversidad en el Caribe. Hasta ahora el conteo de especies estima unos 15,000 insectos, 6,382 hongos, 6,000 plantas vasculares, más de 300 especies de aves reportadas, 153 reptiles, 64

Haiti. Accessing certain areas in Haiti represented a huge challenge, mainly because of safety issues and difficulty in organizing logistics. These difficulties were resolved with the help of Société Audubon Haiti, a Haitian nongovernmental organization involved in avian conservation. Once the problem of access was solved, it became clear that I had an enormous opportunity to obtain photographs in both countries of subjects never portrayed before. Presenting these photographs in a book, I hoped, would raise awareness and spark an interest in preserving our island's natural heritage. Although this plan may sound relatively easy and straightforward, it turned out to be a very ambitious undertaking.

A book on biodiversity needed to show a side of the island seldom seen by the public. The fact that the island of Hispaniola has the greatest number of habitat types in the Caribbean is ignored by most people. The great variety of habitats exists because of the wide altitudinal ranges throughout the island. While Pico Duarte stands at 3,087 meters, Lago Enriquillo lies 40 meters below sea level—Hispaniola is truly a land of contrasts. All these habitats have produced one of the highest levels of diversity in the Caribbean. So far the estimated species count includes 15,000 insects, 6,382 mushrooms, 6,000 vascular plants, over 300 bird species reported, 153 reptiles, 64 amphibians, and 20 mammals (mostly bats). These numbers are bound to increase, given that so little research has been done on some of these groups when compared with the amount of work done in Puerto Rico, Cuba, and Jamaica.

Portraying habitats, plants, and animals from some of the more extreme sites became a priority. Over the years, few

anfibios y 20 mamíferos (mayormente murciélagos). Estos números están sujetos a aumentar dado que se ha realizado muy poca investigación en algunos de estos grupos comparado con la cantidad de trabajo hechos en Puerto Rico, Cuba y Jamaica.

El fotografiar los hábitats, plantas y animales, de los lugares más remotos, se convirtió en prioridad. A través de los años, pocas personas han explorados lugares como el Hoyo de Pelempito y Pic Macaya. Bellos estéticos paisajes fueron esenciales para el libro, pero en algunos instantes encontrar la composición artística ideal fue difícil. En ocasiones opté meramente por documentar estos ambientes tan especiales. A pesar de querer incluir la mayor cantidad de material que pudiera, la limitación física de la publicación en sí limitó el número de lugares, animales y plantas que podían ser incluidas. La decisión de dejar a un lado un tema fue, algunas veces, tomada por no tener fotos adecuadas del lugar en particular. Por otro lado, solamente porque cierto grupo de plantas y animales fueron incluidos en un capítulo no significa que otras especies no puedan ser encontradas en el mismo lugar. En algunos casos, la cantidad de material que obtuve fue abrumadora y los mejores representantes del grupo fueron seleccionados.

El énfasis en insectos, reptiles, anfibios y moluscos a través del libro es aparente. Esto se debe a que ellos son componentes importantes de nuestra biodiversidad. Por lo mismo, el libro cubre más áreas de la República Dominicana que de Haití. La razón primordial es que el grado de deforestación de Haití es mayor que el de la República Dominicana. Pese a esto, algunas de las áreas que todavía quedan sin deforestar en la parte occidental de la isla merecen ser preservadas, especialmente el área de Pic Macaya en

people have explored places such as Hoyo de Pelempito and Pic Macaya. Beautiful aesthetic landscapes were essential for the book, but in some instances finding ideal artistic compositions was difficult. On occasion I opted for merely documenting these very special environments. Despite wanting to include as much material as I could, the physical constraints of the publication itself limited the number of sites, animals, and plants that could be covered. The decision to leave out a subject was sometimes made because there were not adequate photos from a particular site. On the other hand, just because certain groups of plants and animals were included in a particular chapter does not mean that other species are not found there as well. In some cases, the amount of material I obtained was overwhelming and the best representatives of a group had to be selected.

If an emphasis on insects, reptiles, amphibians, and mollusks throughout the book seems apparent, it's because they are an important component of our biodiversity. By the same token, the book covers more areas from the Dominican Republic than Haiti. The primary reason for this is the greater degree of deforestation in Haiti than in the Dominican Republic. Regardless, some of the areas that are still left on the western part of the island are worth preserving, especially the area around Pic Macaya in Massif de la Hotte. This is a definite hotspot for biodiversity in the Caribbean, and our expeditions over the past three years have uncovered many new threatened species that are restricted to the area.

The proper photographic technique to capture my subjects also required quite a bit of sorting out. Ideally, I photographed subjects in their natural surroundings. Some studio portraits with black simplified backgrounds could not

el Macizo de la Hotte. Este es definitivamente un polo de atracción para la biodiversidad del Caribe y nuestras expediciones en los últimos tres años han descubiertos muchas nuevas especies en peligro, restringidas al área.

La técnica fotográfica apropiada para capturar mi tema también requirió un poco de experimentación. Idealmente fotografié los sujetos en su ambiente natural. No se pudo evitar hacer algunos de los retratos en el estudio, utilizando un fondo negro sencillo, dadas las dificultades de fotografiar en la noche, bajo malas condiciones de tiempo y en lugares donde la carga de equipos que se podía llevar tenía que ser limitada. Al final se tomó la decisión de incluir imágenes manipuladas digitalmente, a pesar de que esto ha sido controversial en los recientes años. Yo no me opongo a la manipulación digital especialmente cuando hay limitaciones en plasmar ciertas situaciones y luz. Siento que el realce es una solución, siempre y cuando no sea muy notable.

La mayoría de la gente tiene la impresión de que la fotografía de naturaleza es una actividad agradable y de tiempo libre. De hecho, las condiciones normales de trabajo incluyen diez y seis horas de trabajo por día, cargar equipos hacia arriba y abajo de las montañas, combatiendo calor, hambre y sed. Cuando se ha alcanzado el lugar elegido, el reto pasa a ser el encontrar tus sujetos. En este momento las extensas investigaciones hechas de antemano son de ayuda. Animales como el solenodonte y las hutías pueden ser fotografiados solamente después de haber tenido tres o cuatros meses de búsqueda detrás de un rastreador con experiencia.

La organización y el trazado del libro en forma lógica requirieron la toma de decisiones difíciles. Finalmente decidí usar los lugares como capítulos en vez de usar categorías políticas, taxonómicas o geológicas para el trazado

be avoided, however, given the difficulties of photographing at night, under bad weather conditions, and in places where only limited loads of equipment could be carried. A final decision was also made to include digitally adjusted images, despite the fact that this has been a controversial subject in recent years. I do not oppose digital manipulation, especially when there are limitations in recording certain situations and light. In these cases, I feel that digital enhancement is a resourceful solution as long as it is duly noted.

Most people have the impression that nature photography is an enjoyable and leisurely activity. In fact, normal working conditions include sixteen hours of work per day, carrying equipment up and down mountains, battling heat, hunger, and thirst. Once you have reached a targeted site, the challenge then becomes finding your subjects. At this point, previous extensive research comes in handy. Animals such as solenodons and hutias may be photographed only after three or four months of trailing behind a full-time tracker.

Organizing and laying out the book in a logical way also required difficult decisions. We finally chose to use sites as chapters instead of political, taxonomic, or geological categories for the layout. A "photographic journey" traveling clockwise around the island was the simplest way of illustrating our story. A more scientific approach, organized by taxonomic groups, is reflected in the essays that precede the photographs.

In the end, I hope this book provides us all with a better understanding and appreciation of our island's natural heritage. Both Haitians and Dominicans would benefit by incorporating an appreciation for the environment into our daily lives. If you catch yourself watching birds or if you

del libro. Un recorrido fotográfico viajando alrededor de la isla fue la forma más simple de ilustrar nuestra historia. Un enfoque más científico, organizados por grupos taxonómicos, se refleja en los ensayos que preceden las fotografías.

Finalmente espero que este libro nos proporcione a todos un mejor entendimiento y apreciación de la herencia natural de nuestra isla. Tanto haitianos como dominicanos nos beneficiaríamos si se incorporara la apreciación por el ambiente en nuestras vidas diarias. Si te encuentras observando aves o si sientes la inspiración de visitar algunos de los lugares destacados en este libro, entonces mi meta fue alcanzada. Aunque es fácil encontrar belleza en la naturaleza, nunca debemos olvidar que vivimos en una isla con recursos limitados. La Española esta dividida en dos países completamente diferentes, con diferentes culturas, diferentes idiomas y diferentes necesidades. Históricamente, la carencia de agua y combustible, las condiciones climáticas extremas y el uso inapropiado de la tierra (todos problemas relacionados con el medio ambiente) han alimentado los conflictos entre la gente y las naciones. Con un poco de visión y mucho esfuerzo podemos manejar nuestros recursos naturales de mejor forma de como lo hacemos hoy día. Si queremos evitar problemas futuros, debemos tener en cuenta que el tiempo se está terminando y que conservar nuestros recursos naturales debe de ser la prioridad de todos los que compartimos esta isla.

feel inspired to visit some of the places highlighted in this book, then my goal has been accomplished. Although it is easy to find the beauty in nature, we must never forget that we live on an island with limited resources. Hispaniola is divided into two entirely different countries, with different cultures, different languages, and different needs. Historically, a lack of water and fuel, extreme weather conditions, and improper land use (all environment-related problems) have fueled conflict between people and nations. With a little vision and a lot of effort, we can manage our natural resources better than we do today. If we are to avoid future problems, we must keep in mind that time is running out and that preserving our natural resources should be a priority for all who share this island.

ENSAYOS | ESSAYS

BIODIVERSIDAD DE LAS AVES DE LA ESPAÑOLA

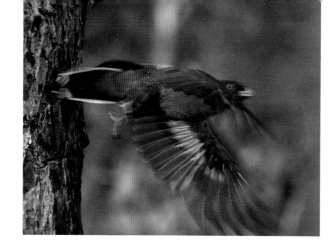

STEVEN C. LATTA and
CHRISTOPHER C. RIMMER

LA ESPAÑOLA TIENE UNA NOTABLE Y DIVERSA avifauna, con más de 300 especies de aves reportadas en la isla. Además de las 31 especies endémicas, La Española alberga un impresionante ensamblaje de especies que son residentes permanentes, de especies migratorias que pasan su ciclo no reproductivo en la isla y otras que son estrictamente transeúntes que paran en su ruta al sur para invernar o al norte a las áreas de crianza, para descansar y alimentarse. El gran nivel de endemismo de La Española y su contribución a la biodiversidad global ha hecho que la isla gane el nivel más alto en importancia biológica en una evaluación mundial realizada para dar prioridad a la protección de aves.

La diversidad de especies de aves de La Española es en parte el resultado de su compleja historia geológica. Se piensa que La Española se formó por la fusión de al menos tres bloques de tierra hace unos diez millones de años atrás. Pero cambios que continuaron ocurriendo con los ciclos glaciales y los periodos interglaciares, la subida y bajada en los niveles del mar y la alternación de ambientes secos y húmedos, resultaron en cambios ambientales drásticos y al aislamiento repetido de los sitios de alta elevación por cambios en el nivel del mar. Estos ciclos climáticos seguramente contribuyeron a la evolución de nuevas especies de aves y a la extinción de otras.

Al alterar la vegetación de la isla, los ciclos climáticos a través de las eras geológicas han tenido un efecto dramático en la biodiversidad de aves. Tipos de vegetación como coníferas, ahora limitadas a altas elevaciones, ocurrieron a

HISPANIOLA SUPPORTS A REMARKABLY DIVERSE avifauna, with more than 300 species of birds having been recorded on the island. In addition to 31 endemic species that are found nowhere else in the world, Hispaniola hosts an impressive assemblage of permanent resident species, migratory species that spend their nonbreeding season on the island, and other strictly transient species that stop to rest and refuel en route to southern wintering or northern breeding areas. Hispaniola's high level of endemism and its contribution to global biodiversity have earned the island the highest ranking of biological importance in a worldwide assessment of bird protection priorities.

Hispaniola's diversity of bird species is, in part, a result of its complex geologic history. Hispaniola is thought to have formed by the merging of at least three land blocks about nine million years ago. But change continued to take place with cycles of glacial and interglacial periods, the rising and lowering of sea levels, and the alternation of dry and moist environments, resulting in drastic environmental changes and the repeated isolation of higher-elevation sites by changes in sea level. These cyclic climatic changes likely contributed to the evolution of new bird species and the extinction of others.

Cyclic climatic changes through geologic time had a dramatic impact on avian biodiversity by altering the island's vegetation. Vegetation types such as conifers, now confined to higher elevations, occurred much lower during the cooler, drier periods. Lower sea levels also allowed the appearance of a broad expanse of savanna and thorn scrub

menores elevaciones durante periodos más fríos y secos. Niveles más bajos del mar permitieron también la aparición de amplias expansiones de sabanas y bosques espinosos en las tierras bajas de La Española. Durante estos periodos de frío y sequía, la geografía del Macizo de la Hotte, en relación a los vientos y frentes climáticos, lo predispuso a recibir altos niveles de lluvia y subsecuentemente sirvió como refugio a plantas y animales adaptados a ambientes más húmedos. Esta cadena montañosa todavía mantiene muchas de estas especies y continúa siendo albergue de un extraordinario nivel de biodiversidad.

Ahora dividida por cadenas montañosas y ríos y salpicada de lagos y lagunas, La Española contiene una rica diversidad de ambientes, cada uno con su propia y única comunidad de aves. La mayoría de las áreas montañosas tiene bosques nublados, bosque de pinos y bosques latifoliados mientras que en las bajas elevaciones predominan los bosques secos y espinosos. Extensas áreas de suelos calizos cársicos caracterizan la Península de Tiburón, Península de Barahona, Sierra de Bahoruco y Sierra de Neiba. Además, gran parte de la región este de la isla tiene un sustrato de piedra caliza cársica. A lo largo de la costa norte, suelos calizos cársicos forman promontorios en el Parque Nacional de los Haitises, Península de Samaná y a lo largo de la Cordillera Septentrional. También se encuentran dunas de arenas en más de 20 localidades costeras y las cercanas a Baní son las más grandes del Caribe.

Las aves endémicas de La Española incluyen a la Cigua Palmera (*Dulus dominicus*), el ave nacional de la República Dominicana y único miembro de su familia, lo que lo hace único desde un punto de vista evolutivo y taxonómico. La Ciguas Palmera son conspicuas aves de manadas, a menudo

habitat in the Hispaniolan lowlands. During these cold and arid periods, the geography of Massif de la Hotte, with respect to winds and weather fronts, predisposed it to receive naturally high levels of rainfall and subsequently to serve as a refuge for plants and animals adapted to wetter environments. The mountain range retains many of these species today and still harbors an extraordinary level of biodiversity.

Now divided by mountain ranges and rivers and dotted with lakes and lagoons, Hispaniola contains a rich diversity of habitats, each with its own unique bird community. Most of the mountainous areas support cloud forests, pine forests, and moist broadleaf forests, while lower elevations are dominated by dry forest and thorn scrub habitats. Extensive areas of limestone karst characterize the Tiburon Peninsula, Barahona Peninsula, Sierra de Bahoruco, and Sierra de Neiba. In addition, much of the island's eastern region is underlain by limestone karst. Along the northern coast, limestone karst forms tower formations in Los Haitises National Park, Samaná Peninsula, and along the Cordillera Septentrional. Sand dunes are found in more than 20 coastal locations, and those near Baní are the largest in the Caribbean.

Endemic birds on Hispaniola include the Palm Chat (*Dulus dominicus*), which is the national bird of the Dominican Republic and is the sole member of its family, making it unique from an evolutionary and taxonomic standpoint. Palm Chats are conspicuous, flocking birds, most often seen flying to and from treetops in semi-open country. The species is also noisy and gregarious, building large, communal nests in palm trees. A single tree may be used by many pairs of birds, with each nest chamber having a separate entrance.

3

son vistas volando del tope de un árbol a otro en campos semiabiertos. La especie es también ruidosa y gregaria, y construye grandes nidos comunales en las palmas. Un solo árbol puede ser usado por muchos parejas de aves, donde cada cámara del nido tiene una entrada independiente.

Los Todies son la única otra familia endémica de aves en las Indias Occidentales y dos especies, el Barrancolí (*Todus subulatus*) y el Chi-cuí (*Todus angustirostris*), son encontradas en La Española. Estas son aves pequeñas de color esmeralda que con frecuencia se posan calladamente en el bosque con su cola apuntando hacia abajo y su ancho pico apuntando hacia arriba, sólo volteando la cabeza para buscar insectos. Capturan a los insectos con un rápido vuelo de ida y vuelta, con un zumbido de las alas y un audible chasquido del pico. En vez de construir el típico nido en forma de taza construido con vegetación, los todies excavan largos túneles, en los bancos de los arroyos u otras pendientes verticales, donde al final de los mismos construyen una cámara.

Muchas de las aves más distintivas de La Española están restringidas a las altas elevaciones de los menguados bosques nublados, donde la densa vegetación esta cubierta de musgos epífitos, de hepáticas, orquídeas, musgo español (*Tillandsia usneoides*), helechos y bambú trepador. Estas aves incluyen la recluida Perdiz Coquito Blanco (*Geotrygon leucometopius*); el espectacular Papagayo de La Española (*Priotelus roseigaster*); el llamativo pero visto fugazmente Zorzal de La Selle (*Turdus swalesi*); la diminuta Cigüita Aliblanca (*Xenoligea montana*), las cuales se mueven en energéticas manadas a través de las copas de los árboles; y el melodioso pero furtivo Chirrí de los Bahorucos (*Calyptophilus tertius*) y en la parte este el Chirrí de la Cordillera Central (*Calyptophilus frugivorus*), que acecha en las oscuras sombras del sotobosque.

The todies are the only other bird family endemic to the West Indies, and two species, the Broad-billed Tody (*Todus subulatus*) and Narrow-billed Tody (*Todus angustirostris*), are found on Hispaniola. Todies are small, emerald, avian jewels that often perch quietly in the forest with tail pointing down and broad bill pointing up, only turning their head to watch for insects. They capture bugs in a quick sallying flight on whirring wings with an audible snap of the bill. Rather than building typical cup-shaped nests of vegetation, todies instead construct a nest chamber at the end of a long tunnel excavated into the bank of a stream or other vertical slope.

Many of Hispaniola's most distinctive birds are confined to the dwindling high-elevation cloud forests, where dense vegetation is carpeted with epiphytic mosses, leafy liverworts, orchids, Spanish moss, ferns, and climbing bamboo. These birds include the reclusive White-fronted Quail-Dove (*Geotrygon leucometopius*); the spectacular Hispaniolan Trogon (*Priotelus roseigaster*); the striking but rarely glimpsed La Selle Thrush (*Turdus swalesi*); the diminutive Hispaniolan Highland-Tanager (*Xenoligea montana*), which moves in energetic flocks through the forest canopy; and the melodious but furtive Western Chat-Tanager (*Calyptophilus tertius*) and Eastern Chat-Tanager (*Calyptophilus frugivorus*), which lurk in the dark shadows of the forest understory.

Pine forests also support a unique assemblage of birds that contribute importantly to Hispaniola's biodiversity. Endemics include the conspicuous Hispaniolan Pewee (*Contopus hispaniolensis*), sallying from pine boughs to snatch aerial insects, as well as the Antillean Siskin (*Carduelis dominicensis*) and the Hispaniolan Palm Crow (*Corvus palmarum*). By far the most specialized among this group is

4

Los bosques de coníferas también sostienen un ensamblaje singular de aves que contribuyen de forma importante a la biodiversidad de La Española. Las aves endémicas incluyen el destacado Maroíta (*Contopus hispaniolensis*), volando de allá para acá en los pinos arrebatando insectos voladores, así como el Canario (*Carduelis dominicensis*) y el Cao (*Corvus palmarum*). En gran medida, el más especializado pájaro dentro de este grupo es el Pico Cruzado (*Loxia megaplaga*). Aislado por mucho tiempo de sus parientes más cercanos de las montañas de Norte América, el Pico Cruzado depende de grandes expansiones de pinares y de sus semillas, las que pueden extraer con su pico cruzado especializado. El parloteo mecánico de una pequeña manada de esta rara especie, acompañada del chasquido de los conos soltando sus semillas, son sonidos distintivos de los bosques de coníferas de La Española.

Los ambientes que sostienen la diversa avifauna de La Española están amenazados por intensas presiones que se originan de diversas fuentes. La pérdida y degradación de los bosques es especialmente severa, con una cobertura natural de bosques restantes de un uno por ciento o menos en Haití y de menos de un diez por ciento en la República Dominicana. Un estudio reciente de alta prioridad realizado por el Plan de Conservación de Aves concluyo que los bosques nublados, húmedos y latifoliados son los ambientes más amenazados en el país, pero la mayoría de los ambientes nativos han sido afectados negativamente por el hombre. La mayoria de los bosques restantes de Haití se encuentran sólo en dos secciones a alta elevación, el Macizo de la Hotte y el Macizo de la Selle. Estas dos áreas, a pesar de estar formalmente protegidas como parques nacionales, enfrentan constantes e inexorables presiones avivadas por las crónicas penalidades socioeconómicas y la inestabilidad política. A

the Hispaniolan Crossbill (*Loxia megaplaga*). Long isolated from its closest relatives in the North American mountains, the Hispaniolan Crossbill is dependent on large expanses of mature native pine trees and their seeds, which it is able to extract with its unique crossed bill. The mechanical chatter of a small flock of this rare species, accompanied by the quiet snapping of pine cones yielding their seeds, are unforgettable signature sounds of Hispaniolan pine forests.

The habitats that support Hispaniola's diverse avifauna are threatened by intense pressures from a variety of human sources. Loss and degradation of forest habitats is especially severe, with remaining natural forest cover estimated at one percent or less in Haiti and less than ten percent in the Dominican Republic. A recent assessment of bird conservation priorities in the Dominican Republic concluded that cloud forest and moist, broadleaf forests were the most threatened habitats in the country, but every major native habitat has been adversely affected by human influences. Most of Haiti's remnant forests occur in only two high-elevation blocks, the Massif de la Hotte and the Massif de la Selle. Both areas, despite being formally protected as national parks, face unrelenting pressures from steadily encroaching deforestation fueled by chronic socioeconomic hardships and political instability. Throughout Hispaniola, population growth has been highest in coastal and lowland areas, resulting in heavy and continuing damage to lowland

5

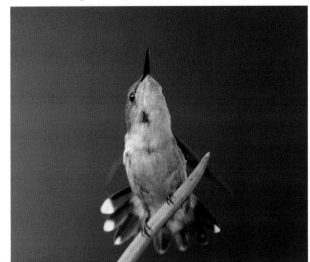

lo largo de La Española, el crecimiento de la población ha sido mayormente en las costas y en tierras bajas, resultando en un continuo y pesado daño a los bosques de tierras bajas, playas, ciénegas, lagunas y manglares.

En La Española, 38 especies de aves están consideradas en peligro de extinción o amenazadas. Algunas de las que están en condiciones de peligro critico incluyen el Gavilán (*Buteo ridgwayi*), que hoy cuenta con unos 200 individuos o menos, prácticamente restringidos al Parque Nacional de los Haitises, y el elusivo Cua (*Hyetornis rufigularis*) que ocupa una estrecha franja de bosque en transición de mediana elevación donde la alteración es menos severa. El Cuervo (*Corvus leucognaphalus*) y la Golondrina Verde (*Tachycineta euchrysea*) han sido eliminadas de las islas vecinas y ahora están confinadas a La Española; por consiguiente, los dominicanos y haitianos tienen la gran responsabilidad de proteger las poblaciones restantes. El cuervo sufre por la caza ilegal, mientras que la golondrina carece de lugares seguros para anidar como son cavidades de árboles viejos en el interior de la isla. La caza también ha contribuido en la declinación de otras especies amenazadas, como la Yaguaza (*Dendrocygna arborea*) y un conjunto de palomas, que incluyen la Paloma Turca (*Patagioenas squamosa*), la Paloma Coronita (*Patagioenas leucocephala*), Paloma Ceniza (*Patagioenas inornata*), la Perdiz (*Geotrygon chrysia*) y la Perdiz Colorada (*Geotrygon montana*).

Finalmente, las manos del hombre también amenazan dos de las especies de aves más carismáticas y queridas en La Española: el Perico (*Aratinga chloroptera*) y la Cotorra (*Amazona ventralis*), que son sumamente populares como aves de jaulas entre los isleños. Los cazadores que roban los nidos para tomar los pichones a menudo destruyen las

forests, beaches, coastal swamps and lagoons, and mangrove habitats.

On Hispaniola, 38 bird species are considered threatened or endangered with extinction. Some of the most critically imperiled include the majestic Ridgway's Hawk (*Buteo ridgwayi*), now numbering 200 individuals or less and virtually restricted to Los Haitises National Park, and the elusive Bay-breasted Cuckoo (*Hyetornis rufigularis*), which occupies a narrow band of transitional, mid-elevation forest where human disturbance is less severe. The White-necked Crow (*Corvus leucognaphalus*) and Golden Swallow (*Tachycineta euchrysea*) have already been extirpated from neighboring islands and are now confined to Hispaniola; consequently, Dominicans and Haitians have an added responsibility to protect the remaining populations. The crow suffers from illegal hunting, while the swallow may lack safe nesting sites in cavities of old trees in the island's interior. Hunting also has contributed to declines in other threatened species, such as the West Indian Whistling-Duck (*Dendrocygna arborea*) and a suite of doves, including the Scaly-naped Pigeon (*Patagioenas squamosa*), White-crowned Pigeon (*Patagioenas leucocephala*), Plain Pigeon (*Patagioenas inornata*), Key West Quail-Dove (*Geotrygon chrysia*), and Ruddy Quail-Dove (*Geotrygon montana*).

Finally, the hand of man also threatens two of the most charismatic and beloved bird species on Hispaniola. The Hispaniolan Parakeet (*Aratinga chloroptera*) and Hispaniolan Parrot (*Amazona ventralis*) are hugely popular cage birds among islanders. Poachers who rob nests for chicks, however, often destroy the old tree cavity nest sites. They jeopardize the continued existence of both species, as do the city dwellers who buy birds from roadside hawkers.

viejas cavidades de los árboles donde anidan. El peligro es contínuo para la existencia de ambas especies, como es la compra de estas aves por los moradores de la ciudad a los vendedores ambulantes en las carreteras. Una campaña coordinada para educar al público sobre la importancia de éstas y otras aves, en combinación de medidas severas para la conservación de los ambientes en todas partes de la isla, será esencial para asegurar la supervivencia a largo plazo de la frágil y preciosa biodiversidad de La Española, que incluye sus preciadas aves.

A concerted campaign to educate the public of the importance of these and other birds, in combination with strong measures to conserve habitats in all parts of the island, will be essential to ensure the long-term persistence of Hispaniola's fragile and precious biodiversity, including its avian jewels.

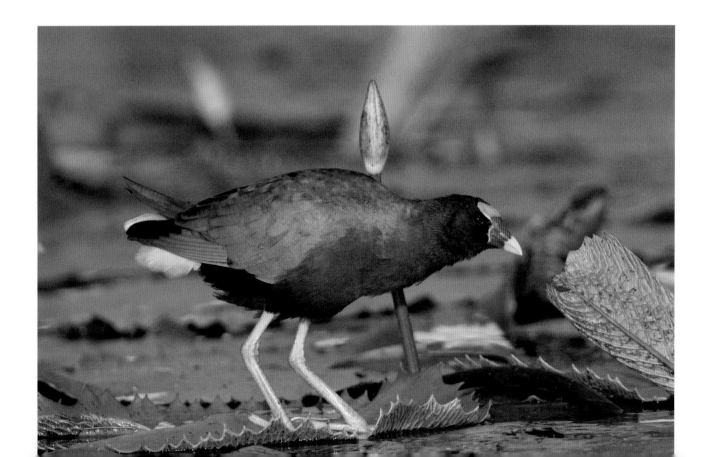

LOS MAMÍFEROS DE LA ESPAÑOLA

PALEOBIOLOGÍA, BIODIVERSIDAD, Y CONSERVACIÓN

CHARLES A. WOODS and
JOSÉ A. OTTENWALDER

HOY EN DÍA SOBREVIVEN SÓLO DOS MAMÍFEROS terrestres nativos de La Española, de los cuales ambos son endémicos y raros. Estos son la Hutía (*Plagiodontia aedium*) y el Solenodonte (*Solenodon paradoxus*). Sin embargo, antes de que los humanos llegaran a la isla, ésta era el hogar de un diverso e impresionante ensamblaje de mamíferos terrestres. La mayoría de las formas se derivaron de ancestros sudamericanos. La actual hipótesis sobre sus orígenes, que esta recibiendo seria consideración, es la teoría GAARlandia, que propone que alrededor de 35 millones de años atrás proto-Cuba, La Española y Puerto Rico (las Antillas Mayores), estaban conectadas al noroeste de la tierra firme de Sur América por la ahora sumergida Cresta de Aves. Esta cordillera de islas emergentes habría estado sobre el nivel del mar por unos dos millones de años (entre 35 y 33 millones de años antes del presente). Perezosos, monos y roedores podrían haber llegado a la parte central de las Antillas Mayores en ese entonces. Más tarde, los animales podrían haberse dispersados a las demás islas sobre el agua o por vicarianza (la separación de grupos por barreras físicas) a medida que las placas del Caribe se fragmentaron y pedazos de las islas se movieron, incluyendo partes de Cuba y La Española, hacia su posición actual. Los Soricomorfos, como el solenodonte y las especies de *Nesophontes* de la isla, probablemente se originaron en Norte América y pudieron dispersarse a las Antillas Mayores por vicarianza cuando pedazos de las proto-Antillas pasaron cerca del punto sur del Continente Norte Americano.

Las hutías y solenodontes sobrevivientes son remanentes de la rica fauna de mamíferos que caracterizaba a La

TODAY ONLY TWO NATIVE LAND MAMMALS SURVIVE on the island of Hispaniola, both of which are endemic and rare. They are the "jutía" (*Plagiodontia aedium*) and the "solenodón" (*Solenodon paradoxus*)—in English, the hutia and the solenodon. Before humans arrived on the island, however, the island was home to a diverse and impressive assemblage of land mammals. Most forms were derived from South American ancestors. A current hypothesis of their origin that is receiving serious consideration is the GAARlandia theory, which proposes that about 35 million years ago proto-Cuba, Hispaniola, and Puerto Rico (the Greater Antilles) were connected to northwestern mainland South America via the now submerged *Aves Ridge*. This bridge of emergent islands would have been above sea level for about 2 million years (between 35 and 33 million years before the present). Sloths, monkeys, and rodents could have made their way to the central Greater Antilles at that time. Later, animals may have dispersed to other islands over water or by vicariance (the separation of groups by physical barriers) as the Caribbean Plate fragmented and moved pieces of islands, including parts of Cuba and Hispaniola, toward their current location. Soricomorphs, such as *Solenodon* and island shrews (*Nesophontes*), likely originated in North America and were

Española hace 15,000 años, antes de que los humanos llegaran a la isla. Los mamíferos que habitaban La Española en ese tiempo, al igual que en tiempos recientes, incluían una variedad de órdenes. Seis especies diferentes de perezosos (Orden Pilosa) se conocen por los depósitos en cuevas y en simas de hundimiento. Varían de tamaño desde el de un perro grande hasta un gato casero. Además, había por lo menos un mono (Orden Primates), una radiación de al menos diez diferentes tipos de roedores (Orden Rodentia) en un rango entre 200 gramos y 15 kilogramos, y una radiación de formas dentro del Orden Soricomorpha que incluía varios solenodontes de tamaño mediano y al menos tres especies isleñas de *Nesophontes* más pequeñas. En total se conocen 23 mamíferos terrestres que han ocurrido en La Española, de los cuales todos excepto dos se extinguieron (87 por ciento).

Rodentia. El roedor mejor conocido es la hutía (en la República Dominicana) o zagouti (en Haití). Esta especie (*Plagiodontia aedium*) tiene dos subespecies existentes, una mayormente restringida al sur de La Española (*P. a. aedium*) y la otra al norte de la isla (*P. a. hylaeum*). La radiación del género ocurrió en una variedad de formas cercanamente relacionadas que diferían unas de otras por su masa, gracia y hábitos alimenticios. La Hutía de Dientes Anchos (*Plagiodontia araeum*) era el plagiodonte de cuerpo más pesado y el más terrestre. Tenía el cachete muy ancho y una mandíbula masiva. La Hutía de Samaná (*Plagiodontia ipnaeum*) era también Pesada pero tenía las extremidades más largas y los dientes del cachete con la corona más alta. Es muy probable que viviera en campos mas abiertos. La Hutía de Lemke (*Rhizoplagiodontia lemkei*) estaba cercanamente relacionada pero era más pequeña y con los dientes del cachete parecidos a los de la Rata Espinosa (= ¿primitivo?).

able to disperse to the Greater Antilles via vicariance events as pieces of the proto-Antilles passed close to the southern tip of the North American continent.

The surviving hutia and solenodon are remnants of the rich mammalian fauna that characterized Hispaniola 15,000 years ago, before humans arrived on the island. The mammals that inhabited Hispaniola at that time, and well into recent times, included a variety of orders. Six different species of sloths (Order Pilosa) are known from cave and sinkhole deposits. They ranged in size from that of a very large dog to smaller than a house cat. In addition were at least one monkey (Order Primates), a radiation of at least ten different rodents (Order Rodentia) ranging from 200 g to over 15 kg, and a radiation of shrewlike forms (Order Soricomorpha) that included several mid-sized solenodons and at least three much smaller "island shrews." In total 23 terrestrial mammals are known to have occurred on Hispaniola, all but two of which are now extinct (87 percent).

Rodentia. Best known among the rodents is the "jutía" (Dominican Republic) or "zagouti" (Haiti). This species (*Plagiodontia aedium*) has two extant subspecies, one mainly restricted to southern Hispaniola (*P. a. aedium*) and the other to northern Hispaniola (*P. a. hylaeum*). The genus radiated into a variety of closely related forms that differed from each other in mass, gracility, and feeding habits. The Wide-toothed Hutia (*Plagiodontia araeum*) was the heaviest-bodied and most terrestrial of the plagiodontines. It had very broad cheek teeth and massive jaws. The Samaná Hutia (*Plagiodontia ipnaeum*) was also large in mass, but with longer limbs and higher-crowned cheek teeth. It likely lived in more open country. Closely related to these but smaller in size and with more spiny ratlike cheek teeth

Esta forma estaba restringida a la parte mas occidental de la península sureña de Haití, donde era muy abundante, y es parte del grupo de plantas y animales endémicos que caracterizan el polo de atracción del Macizo de la Hotte. Estas cuatro especies están agrupadas en la Subfamilia Plagiodontinae.

Las hutías de la subfamilia Isolobodontinae, las cuales están cercanamente relacionadas a la de plagiodontines, incluyen dos formas en La Española, la Hutía de Puerto Rico (*Isolobodon portoricensis*) y la Hutía de Montaña (*Isolobodon montanus*). Estas hutías tienen en los incisivos aros o bandas de esmaltado distintivas rodeando cada diente. Eran comunes a través de la isla. *Isolobodon portoricensis* estaba semi-domesticado por los indígenas de la isla y sus huesos son comunes en restos de cocinas indígenas. Tal parece que fueron transportadas a Puerto Rico por los humanos, de allí su nombre. Además de estas formas típicas de La Española, otra hutía tuvo una distribución muy amplia en la isla cuyos patrones dentales son más cercanos a las hutías de Cuba. Esta forma, en la subfamilia Hexolobodontinae, era la Hutía Impostora.

Además de estas hutías típicas, hubo un roedor bastante grande[I think this qualification is fair since it weighed 15kg, less than a big dog] de cuerpo pesado y dientes anchos en La Española. En la Familia Heptaxodontidae, estaba relacionado a las hutías gigantes como *Amblyrhiza inundata* (de unos 200 kilogramos) de Anguila y St. Martin al este del Caribe. Sin embargo, la especie de La Española, la Hutía Gigante de Dientes Torcidos (*Quemisia gravis*), pesaba solamente unos 15 kilogramos.

La Española también comparte con Cuba y Puerto Rico una radiación de pequeños roedores parecidos a las ratas. Eran mas pequeños en peso que las hutías y tenían los incisivos

(=primitive?) was Lemke's Hutia (*Rhizoplagiodontia lemkei*). This form was restricted to the far west of the southern peninsula of Haiti, where it was very abundant, and is part of the cluster of endemic plants and animals that characterize the Massif de la Hotte hotspot. These four species are grouped together in the Subfamily Plagiodontinae.

The hutias of the Subfamily Isolobodontinae, which are closely related to the plagiodontines, include two Hispaniolan forms, the Puerto Rican Hutia (*Isolobodon portoricensis*) and the Mountain Hutia (*Isolobodon montanus*). These hutias had cheek teeth with distinctive rings or bands of enamel surrounding each tooth. They were common throughout the island. *Isolobodon portoricensis* was semi-domesticated by Amerindians, and its remains are common in their kitchen middens. It appears to have been transported to Puerto Rico by humans, hence its name. In addition to these typical Hispaniolan forms, another hutia was widespread on the island whose dental pattern is more similar to that of Cuban hutias. This form, in the Subfamily Hexolobodontinae, was the Imposter Hutia.

In addition to these typical hutias, a large, heavy-bodied, and wide-toothed rodent was present in Hispaniola. In the Family Heptaxodontidae, it is related to giant hutias such as *Amblyrhiza inundata* (about 200 kg in mass) from Anguilla and St. Martin in the eastern Caribbean. The Hispaniolan species, the Twisted-toothed Giant Hutia (*Quemisia gravis*), was only about 15 kg in size, however.

Hispaniola also shared with Cuba and Puerto Rico a radiation of small, ratlike rodents. They were smaller than hutias in mass and had cheek teeth similar in morphology to those of South American spiny rats. The two forms present on Hispaniola were the Haitian Edible Rat

10

similares en morfología a las ratas espinosas de Sur América. Las dos formas presentes en La Española son la Rata Comestible de Haití (*Brotomys contractus*) y la Rata Comestible de La Española (*Brotomys voratus*). Los huesos de estas formas son comunes en depósitos encontrados en simas de hundimiento, cuevas, y restos de las cocinas indígenas. Probablemente se extinguieron debido a la competencia con ratas introducidas (*Rattus*) y la depredación por perros, gatos y posiblemente hurón introducidos.

Folivora. Los perezosos muestran otra radiación dramática de los mamíferos terrestres en La Española. Cuatro géneros y seis especies son conocidas de la isla. Los dos perezosos muy grandes (megafaunales) están relacionados muy cercanamente con el perezoso terrestre gigantesco de Cuba (*Megalocnus rodens*), que se estima pesaba 270 kilogramos. Las dos especies de La Española eran igualmente grandes y terrestres. El perezoso más grande de La Española fue el Megalocnus (*Megalocnus zile*). El segundo mas grande (*Parocnus serus*) tenía una amplia distribución en La Española y sus islas costeras Tortue y La Gonâve.

Otra rama de la radiación de los perezosos de La Española fue la subfamilia Choloepodinae, tribu Acratocnini. Estos taxa están cercanamente relacionados con los perezosos de dos dedos, *Choloepus*, de Centro y Sur América. Este perezoso de La Española era más pequeño que los perezosos terrestres mucho más grandes de la isla que se conoce como el Acratocnus de Ayer (*Acratocnus ye*). Tenía un cráneo extremadamente cupulado, y este perezoso arbóreo posiblemente fue suspensorio (es decir, que se suspendía de las ramas de árboles, como hace el perezoso de dos dedos). La Española también tenía tres especies de perezosos más pequeños de la Tribu Cubanocnini. La especie más grande fue la Neocnus de La Española

(*Brotomys contractus*) and the Hispaniolan Edible Rat (*Brotomys voratus*). Remains of these forms are common in sinkholes, cave deposits, and Amerindian kitchen middens. They were likely driven to extinction by competition from introduced rats (*Rattus*) and predation by introduced dogs, cats, and possibly even mongooses.

Folivora. Sloths are another dramatic radiation of land mammals on Hispaniola. Four genera and six species are known from Hispaniola. The two very large (megafaunal) sloths on Hispaniola are closely related to the giant megalonychid ground sloth from Cuba (*Megalocnus rodens*) estimated to have weighed 270 kg. Both Hispaniolan species were likely large, ground-dwelling forms. The largest Hispaniolan ground sloth was the Hispaniolan Megalocnus (*Megalocnus zile*). A second large ground sloth (*Parocnus serus*) was widespread on Hispaniola and its offshore islands of Tortue and Gonâve.

Another branch of the sloth radiation on Hispaniola was in the Subfamily Choloepodinae, Tribe Acratocnini. These taxa are closely related to the two-toed sloth *Choloepus* from Central and South America. This Hispaniolan sloth is smaller in size than the much larger "ground sloths" of the island and is known as Yesterday's Acratocnus (*Acratocnus ye*). It had an extremely domed cranium, and it is likely that this tree sloth was suspensory (hung from branches, as two-toed sloths do). Hispaniola also had three species of a smaller sloth group of the Tribe Cubanocnini. The larger species was the Hispaniolan Neocnus (*Neocnus comes*). Also present was the Slow Neocnus (*Neocnus*

11

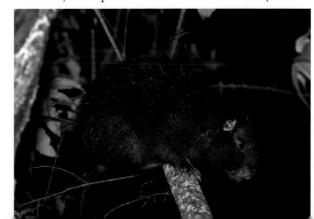

(*Neocnus comes*). También estuvo presente el Neocnus Lento (*Neocnus dousman*), que tenía una cabeza achatada con una cresta sagital bien desarrollada. El perezoso más pequeño de La Española (y uno de los perezosos más pequeños que se han conocido) es el Neocnus Menor (*Neocnus toupiti*). Estas tres formas eran perezosos arborícolas y excelentes trepadores que se movían fácilmente en el tope de los árboles pero que no se suspendían de las ramas.

Por qué y cuando terminó la radiación de los perezosos, a pesar de su amplio rango de tamaño, hábitos alimenticios y de locomoción entre las especies, son preguntas que ahora no se pueden responder. Restos bien preservados de perezosos son comunes en simas de hundimiento a lo largo de las mesetas cubiertas de carso de la península sureña de Haití. Estas mesetas tenían una buena cubierta de bosques y probablemente representaron los últimos refugios de los perezosos en la isla. Estos probablemente se extinguieron en los últimos 2,000 años como resultado de actividades antrópicas.

Monos. La más sorprendente revelación en la paleobiología de los mamíferos de La Española es la documentación de una especie endémica de monos platirrinos (*Antillothrix bernensis*). Fósiles de monos endémicos extintos también se conocen de Cuba (*Paraloutta varonai*) y Jamaica (*Xenothrix mcgregori*). La evidencia de fósiles de monos en las Antillas Mayores se extiende tan atrás como el Mioceno temprano, y es probable que formas adicionales sean descritas cuando se colecten más fósiles en La Española y otros lugares. En morfología, el mono de La Española es bastante parecido al actual mono ardilla (género *Saimiri*); fue descrito originalmente como *Saimiri bernensis*. Ahora se le considera un género endémico más cercanamente relacionado con el mono cubano. Existe material adicional de primates de La Española, pero como la mayoría

dousman), which had a flattened head with a well-developed sagittal crest. The smallest sloth known from Hispaniola (and one of the smallest sloths known) is the Least Neocnus (*Neocnus toupiti*). All three forms were tree sloths that were excellent climbers and moved easily in the treetops but did not hang under branches.

Why and when the extensive radiation of sloths came to an end, in spite of the wide range of size, food habits, and locomotory habits among the species, are questions that are not yet resolved. Well-preserved remains of sloths are common in sinkholes along the karst-covered plateaus of the southern peninsula of Haiti. These plateaus were well forested and probably represented the last haunts of sloths on the island. It is likely that they became extinct within the last 2,000 years as a result of human activity.

Monkeys. The most surprising mammalian revelation of Hispaniolan paleobiology is the documentation of an endemic platyrrhine monkey (*Antillothrix bernensis*). Extinct fossil endemic monkeys are also known from Cuba (*Paraloutta varonai*) and Jamaica (*Xenothrix mcgregori*). Fossil evidence of monkeys in the Greater Antilles extends as far back as the early Miocene, and it is likely that as further fossils are collected in Hispaniola and elsewhere additional forms will be described. In morphology, the Hispaniolan monkey is quite similar to a living squirrel monkey (genus *Saimiri*); it was originally described as *Saimiri bernensis*. It is now considered to be an endemic genus most closely related to the Cuban monkey. Additional primate material from Hispaniola is known, but since most of it consists of fragmentary limb bones no new taxa have yet been named. It would not be surprising if someday a more extensive adaptive radiation of Hispaniolan primates will be revealed

consiste de fragmentos de huesos de las extremidades, hasta ahora no se han descrito taxa nuevas. No sería sorprendente si algún día se revelara una radiación adaptativa más extensa de los monos de La Española que refleje la diversidad de roedores y perezosos ya discutida. La extinción de monos en La Española probablemente se debió a la caza excesiva y la deforestación causada por los indígenas de la isla.

Especies parecidas a las musarañas [N.T. "Musaraña" fue el término más apropiado que conseguimos para "shrew"]. Los soricomorfos de La Española son un grupo primitivo de extraña apariencia. Son "fósiles vivientes" de una más temprana y ya extinta radiación Proveniente de Norte América. Supuestamente los solenontidos se dispersaron a la proto-Española desde Norte América vía Cuba tarde en el Eoceno o temprano en el Oligoceno. Se pudieron haber dispersado a lo que es ahora el norte de La Española cuando Cuba y la "Isla del Norte" de La Española estaban conectadas durante el Oligoceno. La dispersión de *Solenodon* y *Nesophontes* al sur de Haití y la adyacente República Dominica sureña no pudiera haber ocurrido hasta tarde en el Mioceno o temprano en el Plioceno, cuando la aislada "Isla Sur" se unió a la verdadera Española. Esta colisión de masas de tierra creó una larga zona de falla que corre a todo lo largo de la península sureña de Haití y hacia el este a la República Dominicana; a la largo de esta zona se encuentran una cadena de grandes lagos y las tierras bajas de Plaine du Cul-de-Sac.

Hay dos solenodontes conocidos en La Española. El más pequeño y ahora probablemente extinto *Solenodon marcanoi* aparentemente estaba restringido al sur de Haití (el Macizo de la Hotte) y a la Sierra de Neiba de la República Dominicana, justo al norte de el Cul-de-Sac. Nunca ha sido colectado vivo,

that will reflect the diversity of rodents and sloths discussed above. The extinction of monkeys on Hispaniola was probably the result of overhunting and deforestation by Amerindians.

Shrew-like species. The soricomorphs of Hispaniola are an odd-looking primitive group. They are "living fossils" from an earlier and long extinct North American radiation. Presumably solenodontids dispersed to proto-Hispaniola from North America via Cuba in the late Eocene or early Oligocene. They could have dispersed to what is now northern Hispaniola when eastern Cuba and the "North Island" of Hispaniola were connected during the Oligocene. The dispersal of *Solenodon* and *Nesophontes* to southern Haiti and the adjacent southern Dominican Republic could not have occurred until the late Miocene or early Pliocene, when the isolated "South Island" crunched into true Hispaniola. This collision of landmasses created a long fault zone running the entire length of the southern peninsula of Haiti eastward into the Dominican Republic; running along this zone are a chain of great lakes and the lowland Plaine du Cul-de-Sac.

There are two known solenodons on Hispaniola. The smaller and now probably extinct *Solenodon marcanoi* was apparently restricted to southern Haiti (the Massif de la Hotte) and the Sierra de Neiba of the Dominican Republic, just north of the Cul-de-Sac. It has never been collected alive, but fossil remains in the Massif de la Hotte appear to be quite recent. *Solenodon paradoxus* has a very limited distribution in Haiti, having been collected only in the far southwest, near Pic Macaya. There is also a reliable report of this animal being found in southwestern Haiti near Étang Saumâtre in the Cul-de-Sac area adjacent to

pero los restos fósiles en el Macizo de la Hotte parecen ser bastante recientes. *Solenodon paradoxus* tiene una distribución muy limitada en Haití, habiendo sido colectado solamente en el extremo más suroeste, cerca de Pic Macaya. Hay también un reporte confiable de este animal en el suroeste haitiano cerca de Étang Saumâtre en el área de Cul-de-Sac al borde con la República Dominicana. Se desconoce como fósil o espécimen reciente en el norte de Haití. Tiene una distribución amplia en las montañas y las zonas bajas cársicas apropiadas de la República Dominicana, incluyendo zonas al norte muy cerca a la frontera con Haití. El por que nunca se ha encontrado en el norte de Haití es, como su nombre lo sugiere, una paradoja.

La otra radiación de soricomorfos a La Española consiste de tres especies isleñas endémicas del género *Nesophontes*. Que tan relacionados están los Solenoidontidos y los Nesofontidos todavía esta por resolverse, y la respuesta influye en el número de eventos de radiación que se requieren para explicar sus distribuciones. En la actualidad, la mejor hipótesis es que están cercanamente relacionados entre sí y también a los tenrecs. Los restos de los tres *Nesophontes* de La Española abundan en depósitos de algunas cuevas y simas de hundimiento bajo sitios de descanso de algunos búhos. Algunos huesos individuales lucen recientes, ocasionalmente encontrados con restos de tejidos secos. Hay reportes de la Sierra de Neiba de la República Dominicana en los años 1960s de campesinos que vieron animales pequeños parecidos a ratas con muchos dientes que encontraban cuando limpiaban sus conucos. La extinción de estas criaturas fue probablemente causada por la competencia y depredación de las ratas negras y los hurones. Las tres especies isleñas endémicas de La Española son el Nesophontes de St. Michel (*N. paramicrus*), el

the border with the Dominican Republic. It is unknown as a fossil or recent specimen in northern Haiti. It has a widespread distribution in the mountains and appropriate lowland karst zones of the Dominican Republic, including northern areas quite near the frontier with Haiti. Why it has never been found in northern Haiti is, as the species name suggests, a paradox.

The other soricomorph radiation on Hispaniola consists of three species of endemic island shrews of the genus *Nesophontes*. How closely related solenodontids and nesophontids are to each other is unresolved, and the answer influences how many dispersal events are required to explain their distributions. The best current hypothesis is that they are closely related to each other and also to tenrecs. The remains of all three Hispaniolan *Nesophontes* are abundant in some cave and sinkhole deposits under barn owl roosting sites. Some individual bones look recent, occasionally having bits of dried tissue attached. There are reports from the Sierra de Neiba area of the Dominican Republic of farmers in the 1960s seeing small, ratlike animals with many teeth when they cleared areas for their gardens. The extinction of these creatures was likely caused by competition and predation from black rats and mongooses. The three species of endemic Hispaniolan island shrews are the St. Michel Nesophontes (*N. paramicrus*), the largest form, the mid-sized Atalaya Nesophontes (*N. hypomicrus*), and the Haitian Nesophontes (*N. zamicrus*), which is the smallest.

Another mid-sized *Nesophontes* was reported as occurring in northern Hispaniola, the Western Cuban Nesophontes (*N. micrus*), although confirmation of this species on Hispaniola needs further work.

más grande, el Nesophontes Atalaya (*N. hypomicrus*), de tamaño mediano, y el Nesophontes de Haití (*N. zamicrus*), el más pequeño.

Otro Nesophontes mediano fue reportado del norte de La Española, el Nesophontes del Oeste de Cuba (*N. micrus*), aunque su presencia en La Española necesita más trabajo para ser confirmada.

Murciélagos. Se conocen 22 especies de murciélagos de La Española, tres de las cuales o se han extinguido (una especie grande no descrita de *Pteronotus*) o han sido eliminadas de la isla (*Mormoops megalophylla* y *Lasiurus intermedius*). Sólo una de las 19 especies de murciélagos que sobreviven en La Española se consideran endémica de la isla.

Los murciélagos de La Española tienen una mezcla ecléctica de hábitos alimenticios que se reflejan en las conductas de refugio y de alimentación de cada especie. Estas diferencias se conjugan a las condiciones ecológicas y topográficas extremas de la isla. Nueve especies se alimentan exclusivamente de insectos; algunas vuelan alto (*Tadarida brasiliensis*, *Nyctinomops macrotus*) y otras cazan cambiando de vuelo alto a bajo dependiendo de la abundancia de insectos (*Molossus molossus*). Otros murciélagos insectívoros se alimentan lentamente de insectos capturados en las alas (*Eptisicus fuscus*) o capturan insectos tanto en el aire como en la vegetación (*Lasiurus borealis*). Las dos especies de murciélagos, Oreja de Embudo, *Natalus micropus* y *N. major*, cazan con las alas mientras aletean como una polilla. *Mormoops blainvilli* caza insectos mientras vuela rápido cerca del suelo. Los dos Murciélagos Bigotudos (*Pteronotus parnellii* y *P. quadridens*) cazan a grandes distancias lejos de sus cuevas de descanso, buscando polillas y coleópteros. El bello murciélago Oreja Grande *Macrotus waterhousii* emerge de sus

Bats. Twenty-two species of bats are known from Hispaniola, three of which have become extinct (a large, unnamed *Pteronotus*) or extirpated from the island (*Mormoops megalophylla* and *Lasiurus intermedius*). Only one of the 19 surviving Hispaniolan bats is currently recognized as endemic to the island.

Hispaniolan bats have an eclectic mixture of food habits that are reflected in the roosting and feeding behaviors of each species. These differences are compounded by the extreme ecological and topographical conditions of the island. Nine species feed exclusively on insects, some flying high in the air (*Tadarida brasiliensis*, *Nyctinomops macrotus*) and some shifting from high flying to hunting close to the ground, depending on insect abundance (*Molossus molossus*). Other insectivorous bats feed slowly on the wing (*Eptisicus fuscus*) or take insects both in the air and on vegetation (*Lasiurus borealis*). The two species of Funnel-eared Bats (*Natalus micropus*, *N. major*) hunt on the wing while fluttering like moths. *Mormoops blainvilli* hunts for insects while flying very fast close to the ground. The two Mustached Bats (*Pteronotus parnellii*, *P. quadridens*) hunt great distances from their roost caves and search for moths and beetles. The beautiful Big-eared Bat (*Macrotus waterhousii*) emerges from its roost caves two hours after dark and hunts for large insects on the wing. It also may feed on some fruits.

Other bats are generalists in their food habits, allowing them to feed in a wider variety of habitats. The Fishing Bat (*Noctilio leporinus*) feeds on small fish swimming near the

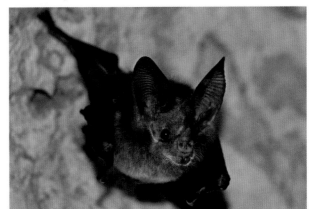

cuevas de descanso dos horas después de la puesta del sol y caza insectos grandes en las alas. Tal vez coma algo de frutas.

Otros murciélagos son generalistas en su dieta, lo que les permite comer en ambientes más diversos. El Murciélago Pescador (*Noctilio leporinus*) se alimenta de pequeños peces que nadan cerca de la superficie de charcas y lagunas, pero durante la estación de lluvia, cuando los insectos son especialmente abundantes, se nutre de polillas, coleópteros y otros insectos voladores. Algunos murciélagos más pequeños con la trompa larga (*Erophylla bombifrons*, *Monophyllus redmani*, *Phyllonycteris poeyi*) son también generalistas, y comen frutas blandas, polen, néctar e insectos, dependiendo de su disponibilidad. Capaces de comer en muchos ambientes, estas especies se pueden encontrar en las cuestas altas de montañas donde las fuentes de comida son temporalmente variables. Dos especies son especialistas en frutas grandes con piel gruesa y tienen el rostro plano y las mandíbulas masivas (*Artibeus jamaicensis* y *Phyllops falcatus*).

Mamíferos marinos. Trece especies de ballenas y delfines han sido reportadas en las aguas de La Española. Las mejores conocidas son la Ballena Jorobada (*Megaptera novaeangliae*) y el Delfín Mular (*Tursiops truncatus*). Otros mamíferos marinos incluye el Manatí (*Trichechus manatus*) y la ahora extinta Foca del Caribe (*Monachus tropicalis*), que probablemente desapareció poco después de 1952.

Tendencias en la conservación. El *Plagiodontia* y el *Solenodon* todavía sobreviven escasamente en porciones de ambientes apropiados que están muy distanciadas en La Española. Sus probabilidades de supervivencia son mejores en regiones donde el carso expuesto crea cuevas pequeñas y grietas y donde el terreno accidentado no es apropiado para la agricultura. En estas áreas, ambas especies se refugian de

surface of ponds and lagoons, but during the rainy season when insects are especially abundant it feeds on moths, beetles, and flying insects. Some smaller bats with long snouts (*Erophylla bombifrons*, *Monophyllus redmani*, *Phyllonycteris poeyi*) are also generalists, feeding on soft fruit, pollen, nectar, and insects, depending on what is available. Able to forage over a wide variety of habitats, these species may be found high on mountain slopes where food resources are seasonally variable. Two species are specialists of large fruits with thick skins and have flat faces and massive jaws (*Artibeus jamaicensis*, *Phyllops falcatus*).

Marine mammals. Thirteen species of whales and dolphins have been recorded from Hispaniolan waters. Most well known are the Humpback Whale (*Megaptera novaeangliae*) and the Bottlenose Dolphin (*Tursiops truncatus*). Other marine mammals include the manatee (*Trichechus manatus*) and the now extinct Caribbean Monk Seal (*Monachus tropicalis*), which likely became extinct soon after 1952.

Conservation Trends. *Plagiodontia* and *Solenodon* are still hanging on in widely separated pockets of suitable habitat on Hispaniola. Their chances of survival are better in regions where exposed karst creates small caves and crevices and where very rough terrain makes the landscape less suitable for agriculture. In these areas both species can find refuge from dogs and cats, as well as from local farmers with a machete in hand. Where gardens are cleared in karst areas both species are vulnerable, especially *Solenodon*. In Haiti both species occur together at middle elevations in the southwest, where forest cover, karst habitat, and low human population combine to create a zone of high biodiversity near the Massif de la Hotte hotspot. *Plagiodontia* (but not *Solenodon*) was once common along the high karst

16

perros y gatos, así como de campesinos armados de machetes. Donde se hacen conucos en areas cársicas, ambas especies peligran, especialmente *Solenodon*. En Haití ambas especies se encuentran juntas en elevaciones medias en el suroeste, donde la cubierta del bosque, ambientes de carso y bajas densidades de poblaciones humanas se combinan para crear una zona de alta diversidad cerca del polo de atracción del Macizo de la Hotte. *Plagiodontia* (pero no *Solenodon*) fue una vez común a lo largo del alta meseta cársica de la región de Morne la Visite–Pic de la Selle en la región del sureste Haitíano, junto con colonias de nidos del Diablotín (*Pterodroma hasitata*), pero el número de nidos así como las hutias han disminuido recientemente.

El *Plagiodontia* es ahora un animal extremadamente raro en el norte de Haití, y el *Solenodon* nunca ha sido reportado en esta parte de la isla. En la República Dominicana ambos animales todavía se encuentran en las lomas de carso expuesto de la región de Los Haitíses, así como en la Cordillera Central, la Cordillera Septentrional, y la Sierra del Seibo. En zonas bajas ricas en carso, como en la Península de Samaná y Boca de Yuma, todavía se encuentran ambas especies.

La única estrategia de conservación que en el futuro aumentará la posibilidad de supervivencia del *Plagiodontia* y el *Solenodon* es la protección de la cubierta de bosques en parques nacionales y zonas bajo diversos regímenes de conservación. Una parte importante de la creación de estas "reservas de biosfera" va a ser el limitar la expansión de poblados, conucos y especialmente la de perros y gatos cimarrones en las zonas protegidas.

plateau of the Morne la Visite–Pic de la Selle region of southeastern Haiti, along with nesting colonies of Black-capped Petrels, but numbers of nesting petrels as well as hutias are much reduced in recent years. *Plagiodontia* is now extremely rare in northern Haiti, and *Solenodon* has never been reported from this region of the island. In the Dominican Republic they are both still present in the karst-exposed hills of the Los Haitises region, as well as in the Cordillera Central, Cordillera Septentrional, and the Sierra del Seibo. In lowland karst-rich areas, such as the Samaná Peninsula and Boca de Yuma, both species also still occur.

The only conservation strategy that will increase the odds that *Plagiodontia* and *Solenodon* will survive into the future is to protect forest cover in national parks and conservation zones. An important part of creating these "biosphere reserves" will be to limit the expansion of human settlements, gardens, and especially dogs and feral cats into the managed zones.

LOS ANFIBIOS Y REPTILES DE LA ESPAÑOLA Y SU CONSERVACIÓN

S. BLAIR HEDGES

DE TODOS LOS GRUPOS DE VERTEBRADOS DE La Española, los anfibios y reptiles poseen el número más alto de especies endémicas. En la actualidad hay unas 217 especies reconocidas en la isla y 209 de ellas (62 de 64 especies de anfibios y 147 de las 153 de reptiles) no se encuentran en ninguna otra parte del mundo. Unas 10 a 20 nuevas especies endémicas adicionales han sido descubiertas en La Española y están en proceso de ser descritas por científicos, indicando que el número actual de especies en la isla es ciertamente mayor. Este alto grado de endemismo en los anfibios y reptiles (96 por ciento) contrasta agudamente con el de las aves de La Española (10 por ciento) y esto sin duda está relacionado a los diferentes mecanismos de dispersión. Casi todos los anfibios y reptiles están "encarcelados" en tierra, por decirlo así, porque no toleran el agua salada.

Esto nos lleva a preguntar ¿cómo y cuándo los ancestros de estas especies endémicas llegaron aquí? Los fósiles son escasos, pero hay ranas, lagartijas y culebras embebidas en el ámbar de la República Dominicana que data de 15–20 millones de años, apoyando una larga historia en la isla. Varias teorías han sido propuestas para explicar como animales que no vuelan y no nadan llegaron a La Española y a las Antillas en general. Por los estudios geológicos sabemos que éstas estaban más hacia el oeste, unos 70 millones de años atrás, cuando se conectaban al Norte y Sur de América tanto como Centro América conecta al continente hoy día.

La teoría de la vicarianza propone que los ancestros de la actual fauna de las Antillas ocupaban las "proto-Antillas" quedándose en las islas a medida que se movieron

OF ALL THE GROUPS OF VERTEBRATES IN HISPANIOLA, the amphibians and reptiles have the largest number of endemic species. There are 217 species currently recognized from the island, and 209 of them (62 of the 64 species of amphibians and 147 of the 153 species of reptiles) are found nowhere else in the world. An additional 10–20 new endemic species have been discovered in Hispaniola and are in the process of being described by scientists, indicating that the actual number of species on the island is certainly much larger. This high rate of endemism in amphibians and reptiles (96 percent) contrasts sharply with that of Hispaniolan birds (10 percent) and is undoubtedly linked to their different mechanisms of dispersal. Nearly all of the amphibians and reptiles are landlocked, so to speak, because of their intolerance of salt water.

But this raises the question: how and when did the ancestors of these endemic species get there? Fossils are scarce, but there are frogs, lizards, and a snake embedded in amber from the Dominican Republic dating from 15–20 million years ago, supporting a long history on the island. Several theories have been proposed to explain how non-flying and nonswimming animals reached Hispaniola and the Antilles in general. From geology we know that the islands were much further west about 70 million years ago, when they connected North and South America much as Central America connects the continents today. The vicariance

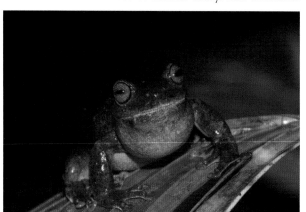

hacia el este, separándose así de tierra firme. Al contrario, la teoría de la dispersión sugiere que los animales llegaron a las islas flotando en balsas de vegetación.

Varias piezas claves de evidencia apoyan la teoría de dispersión como la mejor explicación. Primero, los anfibios y reptiles de las Antillas tienen una peculiar composición taxonómica—no representan una sección transversal de la fauna de la tierra firme del continente. Por ejemplo, no hay salamandras nativas, cecilios o serpientes coral y la mayoría de grupos de ranas, lagartijas y tortugas de tierra firme no están presentes en Las Antillas. Además, ningun grupo de éstos está presente en los fósiles, lo que contradice la noción de una conexión de tierra que hubiera permitido a muchos grupos invadir a las Antillas. Segundo, los grupos hoy presentes, como las lagartijas anolis, salamanquejas enanas y ranas del género *Eleutherodactylus*, tienen una enorme radiación de especies, como si llenaran los nichos ecológicos de grupos que no están presentes. Tercero, los parientes mas cercanos de la mayoría de los grupos antillanos están en Sur América, donde las corrientes oceánicas, que llevan las balsas a las Antillas, se originan. Y finalmente, análisis de secuencias de ADN muestran que los grupos de las Antillas divergen de sus parientes mas cercanos en épocas diferentes durante los últimos 60 millones de años, en vez de todos a la vez como podría ser predicho por los modelos que postulan las tierras conectadas. Por lo tanto, es muy probable que la mayoría o todos los ancestros de los anfibios y reptiles endémicos antillanos llegaron flotando en balsas vegetativas desde Sur América, Centro América o África, como es el caso de de algunas salamanquejas.

Después de que los anfibios y reptiles llegaron a las Antillas, de la forma que fuese, la compleja historia geoló-

theory proposes that the ancestors of the current Antillean fauna occupied the "proto-Antilles" and stayed on the islands as they moved eastward and became separated from the mainland. Another theory proposes that these animals walked across a land bridge from South America. The dispersal theory, in contrast, suggests that animals reached the islands by floating on rafts of vegetation (flotsam).

Several key pieces of evidence support the dispersal theory as the best explanation. First, Antillean amphibians and reptiles have a peculiar taxonomic composition—they do not represent a cross section of the mainland fauna. For example, there are no native salamanders, caecilians, or coral snakes, and most mainland groups of frogs, lizards, and turtles are missing. None of those missing groups are present in the fossil record either, which contradicts the notion of a land connection that would have allowed many groups to invade the Antilles. Second, the groups present today, such as anole lizards, dwarf geckos, and *Eleutherodactylus* frogs, have huge radiations of species, as if they filled the ecological niches of groups that were missing. Third, the closest relatives of most Antillean groups are in South America, where ocean currents that carry flotsam to the Antilles originate. And, finally, analyses of DNA sequences show that the Antillean groups diverged from their closest relatives at different times during the last 60 million years, rather than all at once as would be predicted by models that posit a land connection. Therefore it is likely that most or all of the ancestors of the endemic Antillean amphibians and reptiles arrived by floating on flotsam from South America, Central America, or—in the case of some geckos—Africa.

After the amphibians and reptiles arrived in the Antilles, by whatever means, the complex geologic history of the

gica del Caribe influyó en su subsecuente evolución. El sur de La Española, al sur de valles profundos o el canal llamado el Cul-de-Sac en Haití y el Valle de Neiba en la República Dominicana, fue una isla independiente por millones de años antes de su colisión con la "Isla Norte" de La Española unos diez millones de años atrás. Ambas áreas fueron colonizadas por anfibios y reptiles antes de la colisión, y grandes radiaciones de especies evolucionaron en cada región, especialmente en las montañas. Después de la fusión, algunas especies se dispersaron hacia el norte y otras al sur, pero la distinción evolutiva de estas dos paleo-islas persiste hoy en la fauna.

La fauna de los anfibios de La Española esta dominada por ranas del género *Eleutherodactylus*, que pone los huevos en la tierra—como los reptiles—que al eclosionar salen ranitas. De esta manera, sobrepasan la fase larval de renacuajo típica de las ranas acuáticas. Esto hace posible que estas ranas invadan y ocupen casi cualquier ambiente terrestre, incluyendo cuevas, bromelias, troncos de árboles, desperdicios de las hojas de los bosques, y hasta las partes

Caribbean had an influence on their subsequent evolution. Southern Hispaniola, south of the deep valley or trough called the Cul-de-Sac in Haiti and Valle de Neiba in the Dominican Republic, was a separate island for millions of years prior to its collision with the "North Island" of Hispaniola roughly ten million years ago. Both areas were colonized by amphibians and reptiles prior to the collision, and large radiations of species evolved in each region, especially in the mountains. After the merger, some species dispersed northward and others southward, but the evolutionary distinction of these two paleoislands persists today in the fauna.

The amphibian fauna of Hispaniola is dominated by frogs of the genus *Eleutherodactylus*, which lay eggs on land—like a reptile—that hatch into froglets. Thus they bypass the tadpole larval stage typical of aquatic frogs. This makes it possible for these frogs to invade and occupy almost any terrestrial habitat, including caves, bromeliads, tree trunks, forest leaf litter, and even the drier parts of the

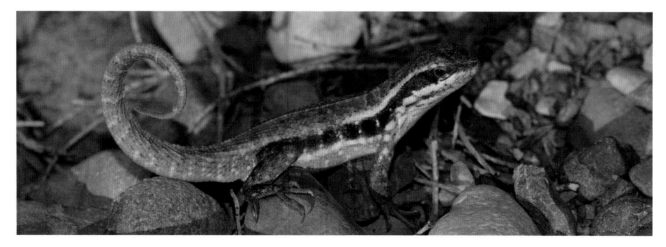

más secas de la isla. Cincuenta y cuatro especies de estas ranas son conocidas en La Española y todas son endémicas. Con excepción de unas pocas de estas especies de amplio rango, la mayoría ocurre solamente en áreas restringidas, generalmente en bosques en altas elevaciones (500–2000 metros) que crecen en una sola cadena montañosa. Por ejemplo, 28 especies ocurren en el Macizo de la Hotte de Haití y 15 especies ocurren en la Cordillera Central de la República Dominicana, pero sólo seis especies comparten las dos cadenas montañosas. Las de La Hotte son mayormente descendientes de los colonizadores de la isla sur y se caracterizan por su hábito de excavar en la tierra y la ausencia del saco vocal externo. Las de la Cordillera Central son en su mayoría descendientes de los colonizadores de la isla norte y están clasificadas en un subgénero diferente, *Eleutherodactylus*, y se caracterizan por su hábito de trepar árboles y un saco vocal externo. Aparte de tener su origen en el norte o sur de las paleo-islas, rangos de tamaño pequeño también significa que la mayoría de las especies estén restringidas a Haití o a la República Dominicana.

El anfibio más pequeño de La Española, *Eleutherodactylus thorectes*, es de 10–15 mm de largo y vive en los picos más altos del Macizo de la Hotte. Es tan pequeño que los herpetólogos primero asumieron que eran sólo juveniles de una especie de mayor tamaño; su estatus fue reconocido solo cuando un especimen fue "descubierto" en un frasco de un museo 50 años más tarde. Al otro lado del espectro del tamaño, hay un grupo de especies que incluyen *E. inoptatus* (88 mm) y *E. ruthae* (58 mm). Estas últimas especies son un complejo de razas (subespecies), las cuales todas hacen madrigueras en la tierra. Los machos construyen una cavidad en forma de domo usando sus cuatros extremidades y el

island. Fifty-four species of these frogs are known from Hispaniola and all are endemic. Except for a few of those species with wide ranges, most occur only in a restricted area, usually in upland forests (500–2,000 meters) within a single mountain range. For example, 28 species occur in the Massif de la Hotte of Haiti and 15 species occur in the Cordillera Central of the Dominican Republic, but only six species are shared between the two mountain ranges. Those in La Hotte are mostly descendants of the South Island colonists and are characterized by ground-dwelling habits and absence of an external vocal sac. Those in the Cordillera Central are mostly descendants of the North Island colonists, are classified in a different subgenus of *Eleutherodactylus*, and are characterized by tree-climbing habits and an external vocal sac. Besides having an origin in either the northern or southern paleoislands, small range size also means that most species are restricted to either Haiti or the Dominican Republic.

The smallest amphibian on Hispaniola, *Eleutherodactylus thorectes*, is only 10–15 mm long and lives on the highest peaks in the Massif de la Hotte. It is so small that herpetologists first assumed it was the hatchling of a larger species; its status was recognized only when a specimen was "discovered" in a museum jar 50 years later. At the other end of the size spectrum is a group of species that includes *E. inoptatus* (88 mm) and *E. ruthae* (58 mm). The latter species is a complex of races (subspecies), all of which burrow in the ground. Males construct a dome-shaped cavity using all four limbs and the front of the head. From this cavity, a few centimeters below the forest floor, they make a loud and complex call—unique to each subspecies—during the night. A female eventually comes to the calling male and

frente de la cabeza. Desde esta cavidad, a pocos centímetros por debajo del suelo del bosque, producen un canto alto y complejo—único a cada subespecie—durante la noche. Eventualmente, una hembra viene al llamado del macho y se aparean. La hembra pone los huevos en la cavidad y estos son probablemente cuidados por uno de los padres hasta que eclosionan y las ranitas emergen de su hogar debajo de la tierra.

Aparte de *Eleutherodactylus* y una especie *Leptodactylus*, varias especies de ranas arborícolas (*Hyla* y *Osteopilus*, cuatro especies) y sapos (*Bufo*, cuatro especies) también existen en La Española. Una de las ranas arborícola, *Osteopilus vasta* (que mide hasta 142 mm de largo), está entre las más grandes del mundo. Todas están asociadas al agua dulce, donde ponen sus huevos que eclosionan en renacuajos. Los sapos también necesitan el agua para su fase de renacuajo, pero están adaptados a regiones más secas y bajas, y aparentemente pueden sobrevivir largos periodos de tiempo sin lluvia. La densidad mas alta de especies de ranas de cualquier lugar de las Antillas está en el Macizo de la Hotte, donde 28 especies conocidas ocurren en la pequeña villa de Castillón, al sur de Jérémie.

Dos géneros de lagartijas, los anolis (*Anolis*, 44 especies) y las salamanquejas (*Sphaerodactylus*, 35 especies), constituyen más de la mitad de la fauna de reptiles de La Española. En términos de distribución ellos, como las ranas, abarcan rangos pequeños, aunque más especies ocurren en baja elevaciones y áreas más secas. Los anolis son los más visibles de los reptiles en la isla, por sus patrones de actividad diurna, movimiento de la cabeza y su exhibición de la colorida piel de la papada debajo de la cabeza de los machos. El lagarto mas pequeño del mundo es el salamanqueja enana de La Española, *S. ariasae* (14–18 mm) y la

they mate. The female lays eggs in the cavity and these are probably guarded by one of the parents until they hatch and the froglets emerge from their underground home.

Besides *Eleutherodactylus* and one species of ditch frog (*Leptodactylus*), several species of treefrogs (*Hyla* and *Osteopilus*, four species) and toads (*Bufo*, four species) also occur on Hispaniola. One of the treefrogs, *Osteopilus vasta* (measuring up to 142 mm in length), ranks as one of the largest in the world. All are associated with fresh water, where they lay eggs that hatch into tadpoles. The toads also rely on water for their tadpole larvae, but they are adapted to drier, lowland regions and apparently can survive for long periods of time without rain. The highest density of frog species anywhere in the Antilles is in the Massif de la Hotte, where 28 species are known to occur near the small Haitian village of Castillon, south of Jérémie.

Two genera of lizards, the anoles (*Anolis*, 44 species) and the dwarf geckos or sphaeros (*Sphaerodactylus*, 35 species), constitute more than half of the reptile fauna of Hispaniola. In terms of distribution they are like the frogs in having small ranges, although more species occur in the lower elevations and drier areas. The anoles are the most visible of all reptiles on the island, because of their daytime activity pattern, head bobbing, and frequent displays of the colored flap of skin (dewlap) below the head of males. The smallest lizard in the world is a dwarf gecko from Hispaniola, *S. ariasae* (14–18 mm), and most species of dwarf geckos are so small that they are hardly noticed by people. On close inspection, however, these lizards are seen to have a highly sculptured appearance, with relatively large scales, and many have bright colors. Other lizard groups include the curlytails (*Leiocephalus*, 12 species), rock iguanas (*Cyclura*, three species), galliwasps (*Celestus*, 11 species), ameivas (*Ameiva*,

mayoría de ellos son tan pequeños que pasan desapercibidos por la gente. Sin embargo, vistas de cerca, se nota que estas lagartijas tienen una apariencia altamente escultural, con escamas relativamente grandes y muchos tienen colores brillantes. Otros grupos de lagartijas incluyen doce especies de género *Leiocephalus*, iguanas de rocas (*Cyclura*, tres especies), once especies del género *Celestus*, ameivas (*Ameiva*, tres especies), varios géneros de salamanquejas grandes (*Aristelliger*, *Gonatodes* y *Hemidactylus*; siete especies) y una especie del género *Mabuya*. También hay un grupo de reptiles excavadores, sin patas, las anfisbenas (*Amphisbaena*, cinco especies).

Las culebras de La Española incluyen 30 especies colocadas en 6–10 géneros, dependiendo de la clasificación usada. Ninguna se considera peligrosa para el hombre y no existen especies de víboras o corales en la isla. Doce especies son corredoras (*Alsophis* y *Uromacer*) que poco se ven por ser tan delgadas y rápidas. Hay también dos tipos de culebras excavadoras, las culebras ciegas (de los géneros *Typhlops*, nueve especies y *Leptotyphlops*, cuatro especies), que parecen lombrices de tierra brillantes y casi nunca son vistas, con la excepción de los agricultores que ocasionalmente las desentierran por accidente. Las culebras restantes, mayormente nocturnas, incluyen pequeñas boas terrestres (*Tropidophis*,

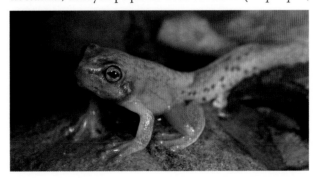

three species), several genera of larger geckos (*Aristelliger*, *Gonatodes*, and *Hemidactylus*; seven species), and a skink (*Mabuya*). There is also a group of legless, burrowing reptiles, the amphisbaenians (*Amphisbaena*, five species).

The snakes of Hispaniola include 30 species placed in 6–10 genera, depending on the classification scheme used. None are considered to be dangerous to humans and there are no species of vipers or coral snakes on the island. Twelve species are racers (*Alsophis* and *Uromacer*) that are slender and fast-moving snakes and rarely seen. Two types of burrowing snakes, the blind snakes (*Typhlops*, nine species) and thread snakes (*Leptotyphlops*, four species), resemble shiny earthworms and are almost never seen, except by farmers who occasionally dig them up by accident. The remaining snakes, mostly nocturnal, include small ground boas or tropes (*Tropidophis*, two species) and larger boas (*Epicrates*, three species). The largest snake is the Hispaniolan Boa, *E. striatus*, measuring up to 2.3 meters long.

The conservation of Hispaniola's amphibian and reptile fauna has come to the forefront now that nearly all of Haiti's original forest has been destroyed and much is gone from the Dominican Republic as well. Also, the International Union for the Conservation of Nature (IUCN) recently concluded that 52 of the 62 endemic species (84 percent) of amphibians on Hispaniola are threatened with extinction (categories Threatened, Endangered, and Critically Endangered). The IUCN is currently conducting a reptile assessment and it is expected that a large fraction of Hispaniola's reptile fauna will be found to be threatened with extinction as well.

In most cases, the primary threat is from deforestation, because nearly all species require forests to survive. Trees are cut primarily by peasant farmers to grow crops

23

dos especies) y boas grandes (*Epicrates*, tres especies). La culebra más grande de La Española es la Boa de La Española, *Epicrates striatus*, que puede llegar a medir 2.3 metros de largo.

La conservación de la fauna de anfibios y reptiles de La Española ha llegado a un primer plano ahora que ya casi todo el bosque original de Haití ha sido destruido así como gran parte del de la República Dominicana. También La Unión Mundial para la Naturaleza (IUCN) recientemente concluyó que 52 de las 62 especies endémicas (84 por ciento) de los anfibios de La Española están en peligro de extinción (en las categorías amenazadas, en peligro vulnerable y en peligro crítico). La IUCN esta actualmente evaluando el status de los reptiles y se espera que una fracción muy grande de este grupo en La Española también será identificado como en peligro de extinción.

En muchos de los casos la principal amenaza viene de la deforestación, ya que casi todas las especies necesitan de los bosques para sobrevivir. Los árboles son talados principalmente por los campesinos para el cultivo y la producción de carbón. El carbón es usado por los campesinos para cocinar o es vendido y enviado a otras partes del país. La producción de carbón es una gran industria tanto en Haití como en la República Dominicana, y es común ver en muchas áreas rurales el humo producido cuando se hace el carbón. Esta tala de árboles tiene un efecto de cascada en otros aspectos del ambiente. Por ejemplo, las cuencas de agua son dañadas significativamente, causando un incremento en las inundaciones (cuando llueve) y sequías (cuando no llueve). Tal vez esto explica porque varias de las especies de ranas que viven en los arroyos de las Antillas, incluyendo uno en La Española (*Eleutherodactylus semipalmatus*) están ahora extintas. Además, los arroyos

and to make charcoal. The charcoal is used by the farmers to cook food or is sold and shipped elsewhere in the country. Charcoaling is a major industry in both Haiti and the Dominican Republic, and the smoke of charcoal makers is a common sight in many rural areas. This removal of trees has a cascade effect on other aspects of the environment. For example, watersheds are significantly damaged, causing an increase in flooding (when it rains) and drought (when it doesn't rain). This may explain why several stream-dwelling species of frogs in the Antilles, including one on Hispaniola (*Eleutherodactylus semipalmatus*), are now extinct. Additionally, the streams carry more silt from the deforested mountains into the ocean, which contaminates or kills the coral reefs. National parks in the Dominican Republic are more effective at protecting the environment than are those in Haiti, but the cutting of trees continues to occur in both countries—and in national parks—and remains a threat to the survival of the island's unique wildlife.

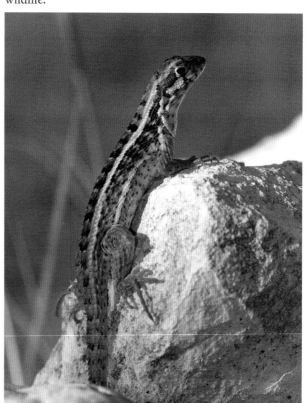

llevan más sedimentos desde las montañas desforestadas al océano, contaminando o matando los corales. Los parques nacionales de la República Dominicana son mas efectivos que los de Haití en proteger el medio ambiente, pero la tala de árboles continua en ambos países—y en los parque nacionales—siendo esto una amenaza a la supervivencia de la singular vida silvestre de la isla.

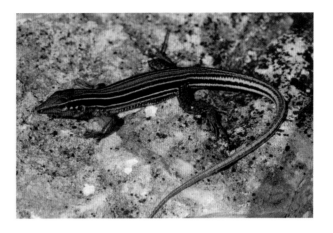

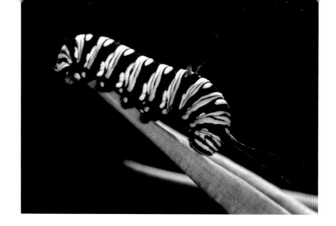

LOS INSECTOS DE LA ESPAÑOLA

BRIAN FARRELL

LOS INSECTOS SON LA MAYORÍA DE LAS ESPECIES
de animales tanto en el mundo entero como en La Española.
De cuerpos pequeños, los insectos desempeñan servicios
ecológicos vitales tales como la polinización, el reciclaje de
materia orgánica, y parasitan y depredan a otros insectos que
se alimentan de plantas. Ellos son los mayores consumidores
de plantas en la tierra y del 1,000,000 de especies conocidas,
hay alrededor de 15,000 especies en La Española.

A pesar de que La Española ha sido un lugar conocido
por la ciencia por más tiempo que ningún otro en las Amé-
ricas, la fauna de insectos sigue siendo poco conocida, con
muchos descubrimientos a ser realizados por futuras genera-
ciones de estudiantes. La mayoría de los insectos que ocurren
en La Española no han sido descritos pero muchos han sido
descubiertos en recientes expediciones de científicos domi-
nicanos y norteamericanos, y por medio de los estudios de
las colecciones históricas, como son las de la UASD (Uni-
versidad Autónoma de Santo Domingo), la Universidad de
Harvard, el Museo Carnegie, la colección de artrópodos del
Estado de la Florida y la del Instituto Smithsoniano. En este
momento, se conocen más de 5,600 especies de plantas, así
como casi todas de las aproximadamente 100 especies de
aves, 24 especies de mamíferos y 90 especies de peces de agua
dulce. Además, unas 217 especies de reptiles y anfibios han
sido descritas pero las curvas de descubrimiento para este
grupo están aumentando vertiginosamente, lo que sugiere
que hay muchas especies que están en espera de ser descu-
biertas. Sin embargo, todavía estamos lejos de tener un esti-
mado preciso de la diversidad de insectos. Sabemos por otros

THE INSECTS ARE THE MAJORITY OF ANIMAL SPECIES
on Earth and on Hispaniola. Small in body size, insects
perform the vital ecological services of pollinating plants,
recycling organic materials, and parasitizing and preying
on plant feeders. They are the major consumers of plants
on earth, and of the 1,000,000 species of insects known on
Earth, there are about 15,000 species on Hispaniola.

Although Hispaniola has been known to science
longer than anyplace else in the Americas, the insect fauna
is still little known, with many discoveries yet to be made
by the new generation of students. The majority of insects
that occur on Hispaniola have not been described, but
many have been discovered in recent expeditions of
Dominican and American scientists and through the study
of historical collections, such as those of the UASD (Uni-
versidad Autónoma de Santo Domingo) and at Harvard
University, the Carnegie Museum, the Florida State Col-
lection of Arthropods, and the Smithsonian Institution. At
this point, more than 6,000 species of plants are largely
known, as are nearly all of the approximately 100 species of
native birds, 24 species of mammals, and 90 species of
freshwater fish. In addition, 217 species of reptiles and
amphibians have been described, but the discovery curves
for these groups are steeply rising, which suggests that there
are many species waiting to be discovered. We are still very
far from having accurate estimates of the diversity of
insects, however. From other places on Earth we know that
there are 2–3 insect species for every plant species, yet only
about 6,000 kinds of insects from Hispaniola have been

lugares del planeta que existe una proporción de 2–3 especies de insectos por cada especie de planta, pero hasta ahora sólo han sido descritos formalmente alrededor de 6,000 tipos de insectos de La Española; estos representan probablemente un tercio del total existente.

Los insectos evolucionaron hace más de 400 millones de años y La Española ha estado sobre el agua quizás 40 millones de años. Durante estos 40 millones de años, muchos insectos que son fuertes voladores, así como algunos débiles voladores y aún los de formas sin alas habían llegado mayormente de Centro y Sur América pero también desde África, Norte América y de lugares más lejanos todavía. Los fuertes voladores han continuado entrando y saliendo de La Española y de otras islas del Caribe, pero algunos colonizadores son conocidos solamente por sus restos preservados en ámbar y aparentemente ya están extintos. Algunas veces, de las especies menos móviles han evolucionado grupos endémicos de especies no encontradas en ninguna otra parte del planeta. Consideremos, por ejemplo, los grupos más prominente de insectos, Lepidoptera (mariposas y polillas), Orthoptera (saltamontes, grillos, y chicharras) y Odonata (caballitos del diablo y libélulas).

De las 201 especies de lepidópteros diurnos en La Española, unas 75 especies son endémicas, mayormente de grupos en los cuales las especies son voladores débiles. Por ejemplo, hay de 25 a 30 especies de mariposas de la familia Satyridae en el género *Calisto*, endémico de La Española. Todas se alimentan de gramíneas y vuelan débilmente a baja altura sobre el suelo. Así han evolucionado muchas especies que están localmente distribuidas en la isla. Por otra parte, las Polillas Halcón, de la familia Sphingidae, son fuertes voladoras y sólo siete de las 47 especies que se encuentran

formally described; these probably represent one-third of the total that exist.

Insects evolved over 400 million years ago, and Hispaniola has been above water perhaps 40 million years. Over these 40 million years, many strong-flying insects and some weak flyers and even wingless forms have arrived, mostly from Central and South America but also from Africa, North America, and even farther away. The strong flyers have continued to arrive and depart from Hispaniola and other islands in the Caribbean, but some colonists are known only from amber and have apparently gone extinct. The less mobile species have sometimes evolved into groups of endemic species found nowhere else on Earth. Consider, for example, the most prominent groups of insects, the Lepidoptera (butterflies and moths), Orthoptera (grasshoppers, crickets, and katydids), and Odonata (the dragonflies and damselflies).

Of the 201 species of diurnal Lepidoptera on Hispaniola, some 75 species are endemic, largely in groups in which the species are weak-flying. For example, there are 25–30 species of satyrid butterflies in the genus *Calisto* endemic to Hispaniola. All feed on grasses and fly weakly, low over the ground, and so have produced many locally distributed species on this island. On the other hand, the hawkmoths, family Sphingidae, are very strong flyers, and only seven of the 47 species of hawkmoths that occur on Hispaniola are endemic to the island. Similarly, only seven of the 66 species of Odonata on Hispaniola are endemic species—most are the weaker-flying damselflies. One such damselfly species, *Phylolestes ethelae*, is not only endemic but is the only member of the family Synlestidae (mainly found in Africa and Asia) in the western hemisphere.

en La Española son endémicas a la isla. De igual forma, solo siete de las 66 especies de Odonata de La Española son especies endémicas—casi todos los caballitos del diablo son débiles voladores. Una de estas especies de Caballito del Diablo, *Phylolestes ethelae*, no es sólo endémica sino que es también el único miembro de la familia Synlestidae (que se encuentra mayormente en África y Asia) en el hemisferio occidental.

Cerca del 70 por ciento de las aproximadamente 110 especies de Orthoptera son endémicas y gran parte de ellas son voladoras débiles o no vuelan. Por ejemplo, todas de las 10–12 especies de chicharras no voladoras, en la tribu Polyancistrini, todas son endémicas y también únicas en que los machos y las hembras cantan al unísono, probablemente a consecuencia de su inhabilidad para volar en busca de pareja.

Las hormigas en la familia Formicidae comprenden unas 200 especies en La Española, de las cuales 50 son endémicas. Quizás por su habilidad en establecer colonias, las hormigas también son especialmente exitosas como invasoras y 30 especies exóticas se han establecido en la isla. Otro grupo de colonizadores excelentes son los escarabajos de corteza de los árboles, conocidos como Escarabajos Ambrosia por su habilidad de cultivar hongos Ambrosia en la profundidad de las galerías que excavan en los árboles. Aproximadamente 100 especies de escarabajos de corteza son conocidas de La Española y varias especies invasoras se han establecido. Los escarabajos de corteza y las hormigas son también los insectos mejor representados en el ámbar dominicano, probablemente a consecuencia de su asociación con los árboles. Verdaderamente, el ámbar dominicano es una cápsula de tiempo extraordinaria que muestra la diversidad de insectos que existieron en La Española unos 20 millones de años atrás.

Nearly 70 percent of the approximately 110 species of Orthoptera are endemic, and most are weak-flying or flightless. For example, all of the 10–12 species of flightless katydids in the Polyancistrini tribe are endemic, and also unique in that females join the males in singing duets, a probable consequence of their inability to fly in search of mates.

Ants in the family Formicidae comprise some 200 species on Hispaniola, of which 50 are endemic. Perhaps because of their abilities to establish colonies, ants are also unusually successful invaders, and 30 exotic species are established. Another group of excellent colonizers are the bark beetles known as ambrosia beetles for their habit of cultivating ambrosia fungi deep within the galleries they carve in trees. Approximately 100 species of bark beetles are known from Hispaniola, and several invasive species have established here. Bark beetles and ants are also the best-represented insects in Dominican amber, a probable consequence of their association with trees. Indeed, Dominican amber is a remarkable time capsule of insect biodiversity extant on Hispaniola some 20 million years ago.

Overall, the proportion of endemic versus wide-ranging species seems related to the dispersal abilities of the different insect lineages represented on Hispaniola, as has been suggested for the difference in endemism between birds and flightless vertebrates. Habitats that are extreme, such as the "sky islands" found on mountains above 2,000 meters and in the low, dry deserts of the south-central portion of the island, also have higher proportions of endemic species than occur in more mesic, widespread habitats.

The islands of the Caribbean, and Hispaniola in particular, have a much longer geological history and richer

En general, la proporción de especies endémicas versus las especies que tienen amplio rango de distribución parece estar relacionada a la habilidad de dispersión de los diferentes linajes de insectos representados en La Española, tal como ha sido sugerido para la diferencia de endemismo entre aves y vertebrados no voladores. Hábitats extremos, como los ambientes aislados ("sky islands") encontrados en montañas que se elevan sobre los 2,000 metros de altura o a bajas alturas como los desiertos secos de la porción sur-central de la isla, tienen una alta proporción de especies endémicas en contraste con las que ocurren en hábitats más mésicos y de mayor distribución.

Las islas del Caribe, y en particular La Española, tienen una historia geológica más antigua y una biota más rica que los sistemas de islas oceánicas que son más jóvenes como son las Islas Galápagos, las islas de Hawai y las Islas Canarias. No obstante, estas últimas han recibido más atención de biólogos que estudian la evolución. La Española y sus islas vecinas tienen un mayor potencial para revelar las obras a largo plazo de los procesos evolutivos que son los responsables de la sorprendente riqueza y frecuente exquisita belleza y diversa fauna de insectos aquí presentes.

biota than younger oceanic island systems that have nevertheless received more attention from evolutionary biologists, such as the Galápagos Islands, Hawaiian Islands, and Canary Islands. Hispaniola and its neighbors thus have a much greater potential to reveal the workings of longer-term evolutionary processes that have produced the surprisingly rich, and often exquisitely beautiful, diversity of insects here.

LA FLORA Y VEGETACIÓN DE LA ESPAÑOLA

MILCÍADES MEJÍA
and **RICARDO GARCÍA**

LA ISLA DE LA ESPAÑOLA TIENE UNA EXTENSIÓN de 77,914 Km² distribuidos entre la República Dominicana con 48,442 Km² y la República de Haití con 29,472 Km². Las notables variaciones topográficas que conforman el relieve de la isla, la orientación y posición casi paralela de sus cordilleras y la influencia que sobre el clima ejercen los vientos alisios han dado origen a la existencia de una gran variedad de ecosistemas con características muy peculiares; estos van desde el bosque seco tropical con fisonomía y elementos de semidesierto, hasta los bosques nublados, localizados a mediana y alta elevación. Esta alta diversidad de ambientes, ha contribuido al origen y desarrollo de una flora rica en géneros y especies endémicas de la Isla.

Los primeros estudios botánicos realizados con rigor científico en la Isla de La Española fueron iniciados por Charles Plumier en los años de 1689 al 1695. Posteriormente, notables botánicos europeos y norteamericanos continuaron realizando trabajos de exploración y estudio de la flora de la Isla. Entre los más notables se encuentran: Erick L. Ekman, el Padre Miguel Fuertes, Richard A. Howard, Rafael Ma. Moscoso y José de Jesús Jiménez, Alain Liogier. El Dr. Thomas Zanoni y los autores de este trabajo, en los últimos veinte años han explorado la Isla y recolectado alrededor de cincuenta mil ejemplares de herbario, la mayoría de los cuales están depositados en el Herbario Nacional de Santo Domingo.

La mayor parte de los ejemplares de las plantas colectadas en La Española están depositados en herbarios extranjeros como: los de los museos de Estocolmo, de

THE ISLAND OF HISPANIOLA HAS A SURFACE AREA of 77,914 square kilometers divided between the Dominican Republic (48,442 km²) and the Republic of Haiti (29,472 km²). Prominent topographic variations characterize the island. The orientation and almost parallel position of its mountain ranges and the influence that the trade winds exert over the climate have given rise to a wide variety of ecosystems with very peculiar characteristics; these vary from the tropical dry forest, with its semi-desert physiognomy and elements, to cloud forests located at medium to high altitudes. This high diversity of environments has contributed to the origin and development of an island flora particularly rich in endemic genera and species.

Charles Plumier conducted the first rigorous botanical studies done in Hispaniola between 1689 and 1695. Later, European and American botanists continued exploring and studying the flora of the island. Among the most notable are: Erick L. Ekman, Father Miguel Fuertes, Richard A. Howard, Rafael Ma. Moscoso, José de Jesús Jiménez, and Alain Liogier. In the last twenty years Dr. Thomas Zanoni and the authors of this article have explored the island and collected approximately fifty thousand specimens, most of which are now in the Santo Domingo National Herbarium. Specimens collected in earlier periods are mainly found in foreign herbariums: museums in Stockholm and Paris, the

París, el Instituto Smithsoniano y los jardines botánicos de Nueva York, Missouri y Kew, entre otros.

Varias obras sobre la flora de la Isla han sido publicadas desde principios del siglo pasado, entre las más conocidas e importantes están: *Symbolae Florae Antillanae* Vol. 8 (1920-1921), *Catalogus Florae Domingensis* (1947), *Diccionario Botánico de Nombres Vulgares de La Española* (1974), y *La Flora de La Española* volúmenes I-X. Actualmente el Dr. Liogier está terminando un nuevo suplemento de *La Flora Dominicana*, con el cual completa las Dicotiledóneas de La Española. Numerosos artículos de plantas de la Isla han sido publicados en la revista *Moscosoa* del Jardín Botánico Nacional, así como en revistas científicas de Europa y de los Estados Unidos de Norteamérica. Faltan por publicar los helechos y las monocotiledóneas.

Los inventarios florísticos realizados hasta la fecha en la Isla de La Española, reportan ciento ochenta y una (181) familias, mil doscientos ochenta y tres (1,283) géneros, con aproximadamente 6,000 especies de plantas vasculares, incluyendo las Pteridophytas y plantas asociadas, de éstas, aproximadamente dos mil (2,000) son endémicas de la Isla. En el Caribe, La Española es la segunda isla en endemismo de plantas, después de Cuba; sin embargo, la densidad de especies es mayor que la de Cuba.

Las familias botánicas con mayor número de especies en la isla son: Urticaceae (118), Myrtaceae (144), Melastomataceae (173), Cyperaceae (174), Euphorbiaceae (204), Fabaceae (210), Rubiaceae (274), Asteraceae (335), Orchidaceae (350) y Poaceae (351). Hay nueve familias con más de cincuenta especies, entre las cuales están las Boraginaceae, Lamiaceae, Loranthaceae, Malvaceae, Piperaceae, Rutaceae, Solanaceae, Malpighiaceae y

Smithsonian Institution, and the Botanical Gardens of New York, Missouri, and Kew, among others.

Various studies regarding the flora of the island have been published since the beginning of the last century. Among the most well known and important we can mention are: *Symbolae Florae Antillanae*, vol. 8 (1920–1921), *Catalogus Florae Domingensis* (1947), *Diccionario Botánico de Nombres Vulgares de la Española* (1974), and *La Flora de la Española*, vols. I–X. Presently, Dr. Liogier is finishing a new supplement of *Flora Dominicana*, which will complete the description of the dicotyledons of Hispaniola. Numerous articles about the plants of the island have been published in the journal of the Jardín Botánico Nacional, *Moscosoa*, as well as in scientific bulletins in Europe and the United States of America. Still to be published are works on the ferns and the monocotyledons.

To date, the floristic inventories done in Hispaniola report 181 families, 1,283 genera, and approximately 6,000 vascular plant species, including the pteridophytes and associated plants. Of these, approximately 2,000 are endemic to the island. In terms of endemism in the Caribbean, Hispaniola's endemic plant species make up 45 percent of its total flora; nevertheless, the density of species on the island in Hispaniola is greater than in Cuba.

The botanical families with the greatest number of species in the island are: Poaceae 351; Asteraceae 335; Orchidaceae 350; Rubiaceae 274; Fabaceae 210; Euphorbiaceae 204; Cyperaceae 174; Myrtaceae 144; Melastomataceae 173; Urticaceae 118. There are nine families with more than fifty species: Piperaceae , Rutaceae, Verbenaceae, Loranthaceae, Malvaceae, Boraginaceae, Lamiaceae, Solanaceae, and Malpighiaceae. Some families are represented by only one or two species.

Verbenaceae; algunas familias están representadas con una o dos especies.

La flora de La Española tiene varios géneros endémicos, entre los que se destacan: *Arcoa* (Caesalpiniaceae), *Coeloneurum* (Goetzeaceae), *Fuertesia* (Urticaceae), *Haitia* (Lythraceae), *Hottea* (Myrtaceae), *Leptogonum* (Polygonaceae), *Manekia* (Piperaceae), *Narvalia* (Asteraceae), *Neoabbottia* (Cactaceae), *Neobuchia* (Bombacaceae), *Salcedoa* (Asteraceae), *Stevensia* & *Samuelssonia* (Rubiaceae), *Theophrasta* (Theophrastaceae), *Vegaza* (Myrsinaceae), y *Zombia* (Arecaceae), entre otros.

Algunos de los géneros endémicos están representados por una especie, son monoespecíficos, y su distribución muchas veces está restringida a zonas con condiciones ecológicas muy especiales, por ejemplo: *Vegaea*, con su especie *V. Pungens*, se encuentra en Valle Nuevo, La Nevera y Pico del Yaque en la Cordillera Central.

Un alto número de nuestras especies endémicas tienen al igual que los géneros, distribución restringida. Muchas de ellas, solo han sido colectadas en una localidad, en las que muchas veces ocupan áreas pequeñas, debido probablemente a que tienen exigencias ecológicas muy particulares. Varias de estas especies están amenazadas de extinción, como la Rosa de Bayahibe (*Pereskia quisqueyana*), el Cotoperí (*Melicoccus jimenezii*), en la playa y el poblado de Bayahibe; *Salvia montecristiana*, en el Morro de Monte Cristi; *Acacia cucuyo*, en la Sierra Martín García; *Goetzea Ekmanii*, en la orilla del río Cumayasa; *Reinhardtia paiwonskiana*, en la Sierra de Bahoruco; *Pseudophoenix ekmanii*, en Oviedo; *Eugenia chacueyana*, en la orilla del río Chacuey de Dajabón; *Pimenta haitiensis*, entre Oviedo y Pedernales y *Caesalpinia barahonensis*, en la Sierra Martín García y Barahona.

The flora of Hispaniola has various endemic genera, among which the following stand out: *Zombia* (Arecaceae); *Leptogonum* (Polygonaceae), *Arcoa* (Caesalpiniaceae), *Neobuchia* (Bombacaceae), *Fuertesia* (Urticaceae), *Salcedoa* and *Narvalia* (Asteraceae), *Vegaea* (Myrsinaceae), *Coeloneurum* (Goetzeaceae), *Theophrasta* (Theophrastaceae), *Neoabbottia* (Cactaceae), *Haitia* (Lythraceae), *Stevensia* and *Samuelssonia* (Rubiaceae); *Hottea* (Myrtaceae), and *Manekia* (Piperaceae).

Some of the endemic genera are represented by only one species. They are monotypical in their distribution and many times restricted to areas with very special ecological conditions. For example, *Vegaea*, and its species *V. pungens*, is found in Valle Nuevo, La Nevera, and Pico del Yaque in the Cordillera Central.

As is true of the genera, a high number of our endemic species have a limited distribution. Many species have been collected from only one place, where they often occupy a very small area, probably because they have very particular ecological requirements. Some of these species are threatened with extinction, like the Rosa de Bayahibe (*Pereskia quisqueyana*) and the Cotoperí (*Melicoccus jimenezii*) in the beach and town of Bayahibe; *Salvia montecristiana* in the Morro of Monte Cristi; *Acacia cucuyo* in Sierra Martín García; *Goetzea ekmanii* in the banks of the Cumayasa river; *Reinhardtia paiwonskiana* in Sierra de Bahoruco; *Pseudophoenix ekmanii* in Oviedo; *Eugenia chacueyana* in the banks of the Chacuey River in Dajabón; *Pimenta haitiensis* between Oviedo and Pedernales; and *Caesalpinia barahonensis* in Sierra Martín García and Barahona.

Generally, the species with small, restricted distributions are the ones that are most threatened with extinction. Their habitats may be affected by any anthropogenic or

Generalmente las especies que tienen distribución restringida son las que se encuentran más amenazadas de extinción, debido a que sus poblaciones son pequeñas y están localizadas en un solo lugar. Estos hábitats pueden ser afectados por cualquier fenómeno antrópico o natural y poner en inminente peligro la supervivencia de las especies.

A diferencia de las especies antes mencionadas, cuya distribución esta limitada a unas pocas localidades, existen otras que aún siendo endémicas, tienen una amplia distribución en La Española: en este grupo podemos mencionar la palma Real (*Roystonea hispaniolana*), el Aceituno (*Tabebuia berterii*), la Palma Cana (*Sabal domingensis*), el candelón (*Acacia skleroyla*) y el Pino Criollo (*Pinus occidentalis*), entre otras.

La mayor parte de la vegetación original de la Isla de La Española ha sido destruida como consecuencia de las intensas actividades humanas desarrolladas desde los tiempos de la colonia, estimándose en un 18% la cobertura de bosque primario de la República Dominicana y un 27.5 de cubierta boscosa en general. Aquellos que fueron exuberantes bosques, son hoy extensos potreros, predios agrícolas o ciudades y vías de comunicación, lo que ha provocado la perdida de nuestra riqueza florística y el acervo fitogenético exclusivo de La Española.

natural phenomena, so their survival may easily be placed under imminent danger.

As opposed to the afore-mentioned species, whose distributions are limited to a few localities, there are other species that, although endemic, have a wide distribution in Hispaniola. In this group we can mention the Royal Palm (*Roystonea hispaniolana*); the Aceituno (*Tabebuia berterii*); the Sabal Palm (*Sabal domingensis*); the Candelón (*Acacia skleroyla*); and the Hispaniolan Pine (*Pinus occidentalis*), among others.

Most of the original vegetation of Hispaniola has been destroyed as a consequence of intense human activities since colonial times. Primary forest cover in the Dominican Republic is estimated at 18 percent and the general forest cover at 27.5 percent. What were once exuberant forests today are extensive grazing fields for horses, agricultural lands, cities, or highways and roads. The destruction of forested land has caused the loss of our floristic richness and the phytogenetic heritage exclusive to Hispaniola.

LOS MACRO-HONGOS DE LA ESPAÑOLA

ESQUIVOS, BELLOS, Y A LA ESPERA DE SER DESCUBIERTOS

TIMOTHY J. BARONI
and SHARON A. CANTRELL

CUANDO LOS MICÓLOGOS CONSIDERAN A LA ISLA de La Española, su atención se dirige a los ricos y diversos hábitats para plantas. Estos hábitats empiezan en los bosques secos tropicales, luego siguen los bosques húmedos hasta llegar a bosques montanos nublados tropicales que alcanzan más de 3000 metros de altura, un rasgo único para las islas del Caribe. Aun cuando un alto porcentaje de estos ambientes han sido degradados—y menos del 20% del bosque primario permanece en pie—es fácil para un micólogo prever que hay una rica diversidad de hongos. Los tipos de hábitats de La Española son conocidos por alojar tal diversidad. Sin embargo, cuando se buscan micotas publicadas: inventarios, monografías técnicas, libros generales sobre taxonomía, o guías de campo, sólo se consigue un trabajo general sobre los hongos comestibles de la República Dominicana, publicado por Omar Paíno Perdomo, D. J. Lodge, y T. Baroni (*Hongos Comestibles de la República Dominicana: Guía de Campo*, Santo Domingo, 2005).

En un trabajo netamente bibliográfico escrito por D. W. Minter, M. Rodríguez-Hernández, y J. Mena-Portales (*Fungi of the Caribbean: An Annotated Checklist*, London: PDMS Publishing, 2001), se listan 6,381 nombres de hongos (tanto macro como micro-hongos) de la República Dominicana y aproximadamente 250 de Haití (ver también www.cybertruffle.org.uk/dorefung). Estos números son claramente muy bajos, comparados al número de especies reportadas en Cuba (44,852) y Puerto Rico (16,082), que tienen hábitats menos diversos pero considerablemente más micólogos activos.

¿Cuantos hongos se espera que existan en La Española? Investigaciones recientes sugieren que hay una relación

WHEN MYCOLOGISTS CONSIDER THE ISLAND OF Hispaniola, their attention is drawn to its rich and diverse plant habitats. These habitats range from tropical dry through tropical wet to mountain cloud forests that reach over 3,000 m elevation, a unique feature for Caribbean Islands. Even though a large portion of these habitats have been degraded from their original states to less than 30 percent forest cover—and less than 20 percent is primary forest habitat—it is easy for a mycologist to anticipate the promise of a rich fungal biodiversity. The kinds of habitats found on Hispaniola are known to support a diversity of fungi. When one looks for published mycotas, inventories, technical monographs, general taxonomic handbooks, or field guides, however, one finds only a general work on the edible fungi of the Dominican Republic, published by Omar Paíno Perdomo, D. J. Lodge, and T. Baroni (*Hongos Comestibles de la República Dominicana: Guía de Campo*, Santo Domingo, 2005).

In a purely bibliographic work by D. W. Minter, M. Rodríguez-Hernández, and J. Mena-Portales (*Fungi of the Caribbean: An Annotated Checklist*, London: PDMS Publishing, 2001), 6,381 entries of fungal names (both macro- and microfungi) for the Dominican Republic and approximately 250 for Haiti are listed (see also www.cybertruffle.org.uk/dorefung). This number is clearly too small, given the number found in registries for Cuba (44,852) and Puerto Rico (16,082), which have less diverse habitats but considerably

THE MACROFUNGI OF HISPANIOLA

ELUSIVE, BEAUTIFUL, AND AWAITING DISCOVERY

mínima de 5–6 taxa de hongos por cada especie de planta en un hábitat, ya que los hongos utilizan cada planta en diferentes niveles tróficos: como saprótrofos (que obtienen nutrientes de la materia orgánica en descomposición), simbiones (que viven en una cercana asociación con otro organismo) y patógenos (o biótrofos, que pueden sobrevivir sólo dentro de un organismo viviente). Los investigadores que trabajan en bosques primarios han mostrado que este cociente puede ser mucho más alto (en Costa Rica, 200:1; R. E. Halling y G. M. Mueller, páginas 1–10 en *Tropical Mycology*, editado por R. Watling et al., Wallingford, UK: CABI Publishing, 2002). Sabiendo que la flora de La Española incluye 6,000 especies de plantas, podemos hipotetizar que el número de especies de hongos de la isla pueda superar las 30,0000, y que una buena porción de ellas sean nuevas para la ciencia. ¿Por qué hasta ahora no se ha explorado esta riqueza potencial? Las razones obvias son que hay pocos micólogos que en realidad hayan hecho trabajo de campo en La Española y, lo más importante, que no se publican monografías taxonómicas amplias que incluyan hongos.

Hawksworth y otros han documentado evidencia que sugiere que hoy en día se han descrito sólo 5–10% de la micota del mundo (ver *Mycological Research*, 95 [1991]: 641–655 y 105 (2001): 1422–1432; *Biodiversity and Conservation*, 8 [1999]: 977–1004). Ese número ahora alcanza más de 70,000 especies, de manera que el número total en realidad podría alcanzar un millón quinientas mil especies. Por eso es que se dificulta la identificación de colecciones, aun cuando uno se toma el tiempo y el esfuerzo para obtener buenos especimenes científicos. Faltan las monografías básicas. Es dolorosamente obvio para los que trabajamos en el campo de sistemática de hongos que una cantidad intimidante de taxonomía básica está todavía por hacer.

more working mycologists. Clearly, Hispaniola has been woefully understudied by taxonomic mycologists.

How many fungi might one expect to exist on Hispaniola? Current research suggests a minimum ratio of 5–6 fungal taxa for every plant species in a habitat, since the fungi utilize each plant species at many different trophic levels: as saprotrophs (which obtain nutrients from decaying organic matter), symbionts (which live in close association with another organism), and pathogens (or biotrophs, which can survive only within a living organism). Researchers working in old growth forest habitats have shown that this ratio can be much higher (in Costa Rica, 200:1; R. E. Halling and G. M. Mueller, pp. 1–10 in *Tropical Mycology*, edited by R. Watling et al., Wallingford, UK: CABI Publishing, 2002). Knowing that the Hispaniola flora comprises 6,000 plant species, we might then hypothesize that the number of fungal species on the island could be over 30,000, and a good portion of those will most likely be new to science. Why has this potential treasure not yet been explored? The obvious reasons are that too few mycologists have actually done fieldwork in Hispaniola and, more importantly, that no broad-based taxonomic monographs that might include fungal taxa are being published.

Hawksworth and others have documented evidence that suggests we currently have described only 5–10 percent of the world's mycota (see *Mycological Research*, 95 (1991): 641–655 and 105 (2001): 1422–1432; *Biodiversity and Conservation*, 8 (1999): 977–1004). That number now is over 70,000 species, so the actual total could easily reach 1.5 million. Therefore it becomes difficult to identify collections, even when one takes the time and makes the effort to obtain valuable scientific specimens. The basic monographs are lacking. It is painfully obvious to those of us who work

Biólogos de campo que están iniciando sus carreras deberían ver este trabajo como algo positivo—un gran número de especies que esperan ser descubiertas y descritas. Así, los taxónomos y biólogos sistemáticos pueden estar seguros que encontrarán muchas nuevas especies para dar a conocer al mundo. Hoy en día hay un solo micólogo taxónomo entrenado formalmente en la República Dominicana, nuestro colega Omar Paíno Perdomo. Otros dos dominicanos han contribuido con publicaciones recientes sobre micro-hongos, María Quírico y A. Rodríguez-Gallart. Por ejemplo, una tesis reciente de Quírico (Universidad Autónoma de Santo Domingo, 2004) sobre los hongos de la Reserva de El Ébano Verde documentó 108 especies de esa pequeña área, incluyendo 18 nuevos reportes para La Española y dos especies nuevas para la ciencia.

Pero ninguno de estos individuos ha estado contratado como micólogo a tiempo completo. Esperamos que la información que aquí presentamos convencerá a los lectores de la urgente necesidad de tener más micólogos taxónomos en la República Dominicana y en Haití.

PERSPECTIVA HISTÓRICA

Los primeros reportes de los hongos de La Española fueron publicados por J. H. Léveillé en 1845. Léveillé trabajó en Paris identificando especimenes que recibió del botánico francés Pierre Antoine Poiteau, quien trabajó en Haití por un corto tiempo. En 1852 el famoso micólogo inglés M. J. Berkeley describió 20 especies nuevas en su Enumeración de algunos hongos de Santo Domingo (*Enumeration of some Fungi from St. Domingo*), que se basó en 67 especies que le fueron proporcionadas por el colector M. Augustus Sallé. El próximo grupo de publicaciones significativas sobre hongos de La Española se produjo temprano en el siglo veinte. Carlos E.

in the field of fungal systematics that a daunting amount of basic taxonomy needs to be completed.

Field biologists just starting their careers should see the work to be done as a positive—a large number of species are waiting to be discovered and described. Thus the taxonomists/systematists who make a career of studying fungi can be confident they will find lots of new species to tell the world about. Presently there is only one fully trained taxonomic mycologist working in the Dominican Republic, our colleague Omar Paíno Perdomo. Two other Dominicans have contributed recent publications on macrofungi, Maria Quírico and A. Rodríguez-Gallart. For example, a recent thesis by Quírico (Universidad Autónoma de Santo Domingo, 2004) on the fungi of the Ébano Verde Reserve documented 108 species from that small area, with 18 as new reports for Hispaniola and two species new to science.

But none of these individuals is employed as a full-time mycologist. We hope the information presented here will convince readers of the urgent need for more working taxonomic mycologists in the Dominican Republic and Haiti.

HISTORICAL PERSPECTIVE

The first reports on fungi from Hispaniola were published by J. H. Léveillé in 1845. Léveillé worked in Paris identifying specimens given to him by the French botanist Pierre Antoine Poiteau, who worked in Haiti for a short period. In 1852 the famous English mycologist M. J. Berkeley described 20 new species in his *Enumeration of some Fungi from St. Domingo*, which was based on 67 species provided to him by the collector M. Augustus Sallé. The next significant group of publications on fungi from Hispaniola was produced early in the twentieth century. Carlos E. Chardón, a mycologist from Puerto Rico,

Chardón, un micólogo de Puerto Rico, publicó cuatro trabajos importantes (1927–1946), principalmente sobre patógenos de plantas pero incluyendo también algunos hongos saprotróficos (hongos que descomponen plantas). El más extenso juego de publicaciones de ese período fue del italiano Raffaelle Ciferri, quien vivió y trabajó en La Española desde 1925 hasta 1932. Publicó al menos 19 artículos (1925–1960) principalmente sobre hongos patógenos de plantas pero también—especialmente cuando publicó con R. González Fragoso como coautor—sobre saprótrofos. Un resumen conciso de reportes sobre hongos de la República Dominica hasta 1927 fue presentado por Rafael Toro en la revista *Mycologia* (1927), donde lista todos los taxa conocidos hasta esa fecha y describe cuatro especies nuevas de patógenos de plantas.

Estos primeros reportes sobre los hongos de La Española abarcaron un amplio rango de macro y micro-hongos, pero generalmente el énfasis fue sobre hongos patógenos de plantas. El artículo de Berkeley cubrió, además de patógenos de plantas, especies de macro-hongos tales como los champiñones, políporos, estrellas de tierra y hongos de copa. El Catálogo Bibliográfico de Minter y colegas claramente muestra una preponderancia de patógenos de plantas, con una falta obvia de los más efímeros, pero no menos importantes Basidiomycota (los champiñones, los carbones y las royas) y la Ascomycota (las levaduras, colmenillas, y trufas). Aún los hongos liquenizados (los que forman líquenes), de larga vida, que no son patógenos de

published four major works (1927–1946) mainly on plant pathogens but also including some saprotrophic fungi (plant-decomposing fungi) as well. The more extensive set of publications from that period came from the Italian Raffaelle Ciferri, who lived and worked in Hispaniola from 1925 to 1932. He published at least 19 articles (1925–1960) on mainly plant-pathogenic fungi but also—especially when he published with the co-author R. González Fragoso—on saprotrophs. A succinct summary of reports on fungi from the Dominican Republic up through 1927 is presented by Rafael Toro in the journal *Mycologia* (1927), where he lists all taxa known to date and describes four new species of plant pathogens.

These first reports on fungi from Hispaniola covered a wide range of macro- and microfungi, but the focus was usually on the plant-pathogenic fungi. Berkeley's paper covered species of macrofungi such as the mushrooms, polypores, puffballs, and cup fungi in addition to plant pathogens. The bibliographic checklist by Minter and colleagues clearly shows a preponderance of plant pathogens, with an obvious lack of the more ephemeral, but no less important, Basidiomycota (the mushrooms, smuts, and rusts) and Ascomycota (the yeasts, morels, and truffles). Even the long-lived lichen-forming fungi, which are not plant pathogens, are only sparingly documented in Minter's work, but a reasonable guess of the number of these species to be found would be 1,500–2,000 (personal communication from Richard Harris, New York Botanical Garden).

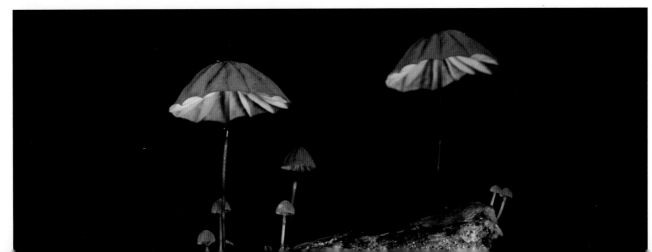

plantas, sólo se les documenta escasamente en el trabajo de Minter, pero se puede suponer que el número de especies a encontrarse podría ser de 1,500 a 2,000 (comunicación personal de Richard Harris, Jardín Botánico de Nueva York).

INVESTIGACIONES DE ACTUALIDAD

Un resurgimiento en la investigación básica de campo de los macro-hongos de la República Dominicana ha ocurrido recientemente, debido en gran parte al programa de Sondeos Bióticos e Inventarios de La Fundación Nacional de la Ciencias de los Estados Unidos. Una subvención otorgada a D. J. Lodge y T. J. Baroni proporcionó fondos para realizar un sondeo de los macro-basidiomicetos de las Antillas Mayores (excluyendo a Cuba) que empezó en 1996. Una segunda subvención otorgada a Lodge y Baroni continuó este trabajo hasta el 2005 e incluyó estudios adicionales comparativos hechos en Belice, Centro América. Por otra parte, una expedición de investigación completamente diferente para estudiar los macro-ascomicetos de la República Dominicana fue dirigida por S. A. Cantrell en el año 2002. Estas tres subvenciones apoyaron a un equipo de 15–20 micólogos investigadores de Centro América, la República Dominicana, Europa, México, Venezuela y de los Estados Unidos. Su tarea fue continuar el trabajo de campo necesario para producir un sondeo de los macro-hongos de la República Dominicana (y de otros países). Una buena porción de ese trabajo ya ha sido publicada, pero mucha de la información se está preparando para ser publicada o todavía está siendo analizada.

¿Cual ha sido el resultado de estas investigaciones recientes? Lo que sigue es un breve sumario, que se divide en dos secciones, una sobre los macro-hongos Discomicetos

CURRENT RESEARCH

A resurgence in basic field research on macrofungi in the Dominican Republic has recently occurred, in large part due to funding from the National Science Foundation's Biotic Surveys and Inventories Program. A grant to D. J. Lodge and T. J. Baroni provided funds for a survey of macro basidiomycetes of the Greater Antilles (excluding Cuba) starting in 1996. A second grant to Baroni and Lodge continued that work through 2005 and included additional comparative studies in Belize, Central America. A completely different research expedition to study just the macro ascomycetes was led by S. A. Cantrell in 2002 in the Dominican Republic. These three grants supported a team of 15–20 research mycologists from Central America, the Dominican Republic, Europe, Mexico, Venezuela, and the United States. Their task was to continue the fieldwork necessary for producing a survey of the macrofungi of the Dominican Republic (and other countries). A good portion of that work has been published, but a great deal more is being readied for publication or is still being analyzed.

What has resulted from this recent research? A brief summary follows, which is divided into sections on the macrofungal Discomycetes (Ascomycota) and the macrofungal Basidiomycota.

(Ascomycota) y otra sobre los Basidiomicetos (Basidio-mycota).

DISCOMICETOS (ASCOMYCOTA)

S. A. Cantrell, T. Iturriaga, y D. H. Pfister publicaron en 2004 sus hallazgos sobre los Discomicetos (hongos de copa) de la República Dominicana (*Caribbean Journal of Science*, 40: 139–143). Describieron 79 especies, de las cuales 64 eran nuevos reportes para la isla y ocho fueron nuevas para la ciencia. Las colmenillas fueron documentadas por primera vez en la República Dominicana. Antes de este trabajo, sólo se conocían siete especies de Discomicetos de la República Dominicana. Esta sola expedición, que cubrió sólo unos pocos ecosistemas, nos indica que existe un gran potencial para descubrir un gran número significativo de Discomicetos, y de Ascomycota en general, si se hace un trabajo de campo adicional. Claramente podemos esperar que en futuro se encuentren muchas especies nuevas de hongos de copa en La Española.

BASIDIOMICETOS (BASIDIOMYCOTA)

Casi 2,600 colecciones fueron documentadas completamente en el período de nueve años que duró el proyecto de Lodge y Baroni que describimos anteriormente. Al menos, hemos identificado hasta el momento 75 especies y dos géneros nuevos. Las colecciones cubren una amplia variedad de grupos principales de hongos: boletales, mízcalos, políporos, hongos tipo coral, hongos dentados, hongos gelatinosos, yescas (hongos del género *Stereum*), hongos de corteza, estrellas de tierra y velos de novia. Aquí vamos a presentar información de sólo unos pocos de estos hongos que hasta el momento han sido mejor estudiados.

Políporos (Aphyllophorales). De estos grupos, el mejor conocido es el de los políporos ya que han sido estudiados

DISCOMYCETES (ASCOMYCOTA)

S. A. Cantrell, T. Iturriaga, and D. H. Pfister published their findings on Discomycetes (cup fungi) of the Dominican Republic in 2004 (*Caribbean Journal of Science*, 40: 139–143). They describe 79 species, of which 64 were new reports for the island and eight species were described as new. Morels were documented from the Dominican Republic for the first time. Before this work, only seven species of Discomycetes were known for the Dominican Republic. This single expedition, which covered only a few ecosystems, indicates the potential to discover a significantly larger number of discomycetes, and Ascomycota in general, with additional fieldwork. Clearly, we can expect many new species of cup fungi, as well as many more known species, to be found in Hispaniola in the future.

BASIDIOMYCETES (BASIDIOMYCOTA)

Nearly 2,600 collections were fully documented over the nine-year period of the Lodge and Baroni project previously described. We have identified at least 75 new species and at least two new genera so far. The collections cover a wide variety of major fungal groups: mushrooms, boletes, chanterelles, polypores, corals, tooth fungi, jelly fungi, stereoids (fungi of the genus Stereum), crust fungi, puffballs, and stinkhorns. We will present information for only a few of the groups that have been more thoroughly worked up so far.

Polypores (Aphyllophorales). The best known of these groups, because they have been studied worldwide for the longest period of time, are the polypores. The fruiting structures are long-lived, usually not ephemeral in nature; since the fruit bodies do not decay readily, they do not require immediate field documentation. As a result, they have

por mucho tiempo en todo el mundo. Los cuerpos fructíferos no se descomponen fácilmente, por lo que no requieren una documentación completa en el campo. Es por eso que han recibido más atención que otros grupos de hongos por los micólogos y botánicos que trabajan en los países del trópico. Ciferri listó en 1929 sólo 19 especies de hongos poroides de la República Dominicana. En estos momentos hemos documentado 105 especies de políporos de la República Dominicana, de los cuales la mayoría tienen amplia distribución en el neotrópico o en Norte América. Nuestro equipo hasta ahora ha descrito una nueva especie, de color anaranjado brillante y de poros anchos, *Antrodia aurantia*. Esta atractiva especie se encuentra en troncos muertos de *Pinus occidentalis* (ver S. A. Cantrell, D. J. Lodge, and T. J. Baroni, *The Mycologist*, 15 (2001): 107–112, o, en el Internet http://www.fpl.fs.fed.us/documnts/pdf2001/cantr01b.pdf). La mayoría de los políporos que viven en pinos en la República Dominicana son casi idénticos a los de la taxa de Norte América, aunque tal vez queden especies nuevas por descubrir.

Boletales (Boletales). Entre los basidiomicetos documentados en un sondeo reciente de los macro-hongos se encuentran los boletales, simbiontes de plantas leñosas, una opción obvia debido al tamaño de sus cuerpos fructíferos y a sus atractivos colores. Boletales conforman simbiosis principalmente con Pinaceae y Fagaceae, y en la República Dominicana su principal compañero es *Pinus occidentialis*. Antes de nuestro trabajo, se habían reportado nueve especies de boletales para La Española. Beatriz Ortiz Santana, en un estudio comparativo de los boletales de la República Dominicana y de Belice para su tesis de doctorado (Universidad de Puerto Rico—Río Piedras, 2006), ha descrito provisionalmente cuatro especies nuevas de boletales de La Española y documentado un nuevo reporte para las Antillas Mayores.

received the lion's share of attention by mycologists and botantists working in tropical countries. As of 1929 Ciferri listed only 19 species of poroid fungi from the Dominican Republic. We currently have documented 105 species of polypores from the Dominican Republic, of which most are widespread in the neotropics or North America. One new species has been described by our team so far, the bright orange, wide-pored *Antrodia aurantia*. This attractive species is found on dead *Pinus occidentalis* logs (see S. A. Cantrell, D. J. Lodge, and T. J. Baroni, *The Mycologist*, 15 (2001): 107–112, or online at http://www.fpl.fs.fed.us/documnts/pdf2001/cantr01b.pdf). The majority of pine-inhabiting polypores in the Dominican Republic are nearly identical to the taxa in North America, but there still may be new species waiting to be discovered.

Boletes (Boletales). Among the basidiomycetes documented in the recent survey of macrofungi—an obvious choice because of the size of the fruiting bodies and their attractive colors—are the woody plant symbionts, the boletes. Boletes mainly form symbioses with Pinaceae and Fagaceae, and in the Dominican Republic the main partner is *Pinus occidentialis*. Before our work, nine species of boletes had been reported for Hispaniola. Beatriz Ortiz Santana, in a comparative study of the boletes of the Dominican Republic and Belize for her Ph.D. dissertation (Universidad de Puerto Rico—Río Piedras, 2006), has provisionally described four new species of boletes from Hispaniola and documented one new report for the Caribbean islands of the Greater Antilles.

One of the recently identified species, *Boletellus domingensis*, has a somber, dark brown cap with delicate pink showing through the cracks. The pale yellow flesh of the cap rapidly turns a deep blue when cut open. The longitudinally

Una de las especies recién descritas, *Boletellus domingensis*, tiene un píleo sombrío, marrón oscuro, con un rosado delicado que se ve en las grietas. La pulpa amarilla del píleo se vuelve azul obscura cuando se corta. Las esporas estriadas longitudinalmente, que son moderadamente grandes (para un boletal), coloca la especie en el género *Boletellus* (Boletaceae). Esta especie, aunque difiere en muchos caracteres morfológicos, parece estar relacionada a especies del este de Norte América (*Boletellus chrysenteroides* y *Boletellus pictiformis* var. *fallax*).

Champiñones (Agaricales). En gran medida, la mayoría de las nuevas especies descubiertas, al menos 50 de las identificadas hasta el momento en nuestro material, así como dos géneros nuevos, son champiñones. Además de la abundancia de especies nuevas, hay 2–3 veces más reportes nuevos de agáricos para la República Dominicana que los que eventualmente serán publicados. La suavidad, corta vida y la putrescencia de los cuerpos fructíferos de estos hongos han contribuido a la escasez de sus reportes. Aquí proveemos sólo algunos de los ejemplos más notables de las especies recién descubiertas para ilustrar este trabajo.

Dos nuevos géneros y especies de la familia Lyophyllaceae están siendo descritos del material colectado en la República Dominicana (Baroni et al., *Mycological Research*, en prensa). Un género (*Arthromyces*) también había sido colectado en Puerto Rico (citado erróneamente como *Arthrosporella* en http://www.fpl.fs.fed.us/documnts/pdf2001/cantro1b.pdf) y el otro género (*Blastosporella*) también se conoce de Colombia. Una segunda especie de *Arthromyces* fue descubierta en un bosque nublado en Belice en el 2004. Estos hongos crípticos parecen grandes clavos pegados a la tierra; tienen esporas asexuales polvorientas, de color marrón oscuro, cubriendo el píleo y el

striate spores, which are moderately large (for a bolete), place the species in *Boletellus* (Boletaceae). This species, although differing by several morphological characters, appears to be related to species from eastern North America (*Boletellus chrysenteroides* and *Boletellus pictiformis* var. *fallax*).

Mushrooms (Agaricales). By far the majority of new species discovered, at least 50 identified from our materials to date, as well as two new genera, are members of the mushroom groups. Besides the abundance of new species, there are 2–3 times as many new reports of agarics for the Dominican Republic that will eventually be published. The soft, putrescent and short-lived nature of the fruiting bodies has contributed to the scarcity of reports of these fungi. We provide here only a few of the more striking examples of the newly discovered species to illustrate our present work.

Two new genera and species in the family Lyophyllaceae are being described from the Dominican Republic (Baroni et al., *Mycological Research*, in press). One genus (*Arthromyces*) had also been collected in Puerto Rico (incorrectly cited as *Arthrosporella* at http://www.fpl.fs.fed.us/documnts/pdf2001/cantro1b.pdf), while the other genus (*Blastosporella*) is known to occur also in Colombia. A second species of *Arthromyces* was discovered in the cloud forests of Belize in 2004. These obscure mushrooms look like large nails stuck in the ground with powdery, asexual, dark brown spores covering their caps and stalks. The presence of asexual spore masses on the fruiting bodies is very unusual for mushrooms and makes them immediately distinguishable in the field.

Mycena baoensis (Tricholomataceae), a small, pure white, and very fragile mushroom growing on decaying logs, has been described from the Valle del Bao of the José

41

estípite. La presencia de masas de esporas asexuales en los cuerpos fructíferos es poco usual en estos hongos, los que los hace inmediatamente distinguibles en el campo.

Mycena baoensis (Tricholomataceae) es un champiñon blanco, diminuto y frágil que crece sobre troncos en descomposición. Este se describió basado en material colectado en Valle del Bao, en el Parque Nacional José del Carmen Ramírez. En estos momentos otra especie nueva descubierta en las altas montañas centrales de la República Dominicana, especialmente en el Valle del Tetero, está a punto de ser publicada.

En el Centro de Convenciones de Los Montones, cerca de San José de Las Matas, se encontró una especie diminuta, verde brillante de *Hygrocybe* (Hygrophoraceae), creciendo sobre las riveras cubiertas de musgos. En El Mogote de Jarabacoa, cerca del poblado de Jarabacoa, se descubrió otra nueva especie que es sólo la segunda conocida en el género *Callistodermatium* (Tricholomataceae; http://ww.fpl.fs.fed.us/cumnts/pdf2001/cantro1b.pdf). Este atractivo hongo es anaranjado brillante y produce un pigmento color azul-violeta brillante cuando las esporas y tejido se montan en una solución alcalina para su examen bajo el microscopio. También en El Mogote, en un área de filtración cerca de la cima, se descubrieron cinco pequeñas y delicadas especies de *Pouzarella* (Entolomataceae). Una es de color rojo ladrillo brillante con mezclas de tonos amarillo limón que se vuelven negras cuando se manipulan (http://www.cortland.edu/nsf/ga.html). Esta bella especie esta siendo descrita como *Pouzarella ferrerii* en honor a Andres Ferrer, el ex-President de la Fundación Moscoso Puello y el actual Director del *Nature Conservancy* de la República Dominicana, por el interés que mostró en nuestras investigaciones y por el apoyo logístico que él y su familia proporcionaron durante nuestros estudios.

del Carmen Ramírez National Park. At this time other new species discovered in the high central mountain areas of the Dominican Republic, especially from Valle del Tetero, are being prepared for publication.

At Los Montones Convention Center near San José de Las Matas, an undescribed diminutive species of bright green *Hygrocybe* (Hygrophoraceae) was found growing on the moss-covered banks. On El Mogote de Jarabacoa, near the village of Jarabacoa, a new and only the second known species of *Callistodermatium* (Tricholomataceae; www.fpl.fed.us/documnts/pdf2001/cantro1b.pdf) was discovered. This eye-catching mushroom is bright orange and produces a bright blue-violet pigment when the spores and tissue are mounted in alkali solutions for examination under the microscope. Also on El Mogote, in a seepage area near the top, five tiny and delicate new species of hairy-fruit-bodied *Pouzarella* (Entolomataceae) were discovered. One of these species is bright brick red with mixtures of lemon yellow hues and turns black when handled (http://www.cortland.edu/nsf/ga.html). This beautiful species is being described as *Pouzarella ferrerii* to honor Andres Ferrer, the former President of the Fundación Moscoso Puello and the current director of the Nature Conservancy in the Dominican Republic, for the intense interest he took in our research and the logistical support he and his family provided during our studies.

Amanita cruzii (Amanitaceae), a new species named after José Cruz, who kindly opened his property for us to explore, is a large, robust, powdery species with orange-peach and grayish hues (http://www.fpl.fs.fed.us/documnts/pdf2001/cantro1b.pdf). This frequently massive mushroom is found associated with pines in Los Dajaos and has also turned up much further to the north, in the replanted pine

Amanita cruzii (Amanitaceae), una especie nueva dedicada a José Cruz, quien gentilmente nos permitió explorar su propiedad, es una especie grande, robusta y polvorienta con tonos de color anaranjado-melocotón y grisáceos (http://www.fpl.fs.fed.us/documnts/pdf2001/cantro1b.pdf). Este champiñón, con frecuencia de gran tamaño, se encuentra asociado con pinos en Los Dajaos y también ha aparecido mucho más al norte, en los bosques de pinos re-plantados del área de La Celestina. Otra especie nueva, *Amanita circinata*, se puede conseguir bajo los pinos en la Reserva Científica Ébano Verde, en La Placeta cerca de San José de Las Matas, y en Manabao.

Se conocen en la República Dominicana al menos cinco especies no descritas de *Inocephalus* (Entolomataceae). Una de ellas es en su totalidad azul brillante pero que se vuelve verde obscuro cuando envejece o cuando se le manipula. Tiene también un sabor amargo que poco a poco se torna picante, como el de un jalapeño (llamado tentativamente *Inocephalus virescens* var. *calescerus*). Otra especie tiene la fragancia de un chicle de frutas y tiene un color amarillento con manchas delicadas y rayas de color vino en el píleo y un sabor ligeramente amargo (tentativamente llamado *Inocephalus fructodorus*). Una tercera especie tiene un píleo peludo, obscuro, del color del chocolate, que contrasta con el color amarillo o dorado de las láminas y el estípite. Como tiene un parecido extraordinario con una especie del

forests of the La Celastina area. Another new species, *Amanita circinata*, can be found under pines at the Reserva Científica Ébano Verde, at La Placeta near San José de Las Matas, and in Manabao.

At least five undescribed species of *Inocephalus* (Entolomataceae) are now known from the Dominican Republic. One of these species is bright blue overall but turns deep grass green with age or handling. It also has a bitter taste that slowly takes on the heat of a jalapeño pepper (tentatively *Inocephalus virescens* var. *calescerus*). Another has the fragrance of a fruity chewing gum and is buff-colored with delicate wine stains and streaks on the cap and a slightly bitter flavor (tentatively *Inocephalus fructodorus*). A third species has a dark, chocolate-colored hairy cap and contrasting yellow or golden gills and stipe (stalk). Because it has an uncanny resemblance to an eastern North American species, *Inocephalus luteus*, we have tentatively called this new species *Inocephalus pseudoluteus*.

Chanterelles (Aphyllophorales), corals (Aphyllophorales), tooth fungi (Aphyllophorales), stinkhorns (Phallales), jelly fungi (Heterobasidiomycetes). These groups do not appear to be as rich in species number as the others just discussed, and when collections are found they seem to be the same species as or closely related to mainly North American species; examples include the chanterelles *Canthrellus cibarius, Cantharellus xanthopus, Can-*

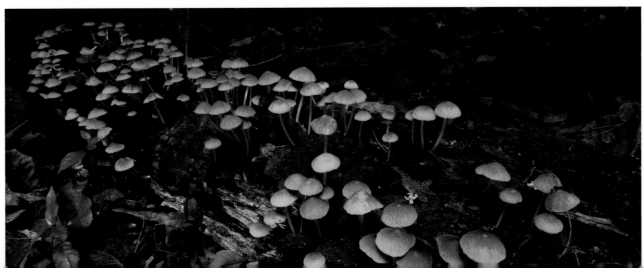

este de Norte América, *Inocephalus luteus*, lo hemos llamado tentativamente *Inocephalus pseudoluteus*.

Mízcalos (Aphyllophorales), hongos tipo coral (Aphyllophorales), hongos dentados (Aphyllophorales), velos de novia (Phallales), hongos gelatinosos (Heterobasidiomycetes). Estos grupos no parecen ser tan ricos en especies como los otros que acabamos de discutir, y cuando se consiguen colecciones parecen ser las mismas o especies relacionadas a las de Norte América; ejemplos incluyen los mízcalos *Canthrellus cibarius, Cantharellus xanthopus, Cantharellus cinnabarinus*, los hongos tipo coral *Clavulinopsis fusiformis, Clavaria vermicularis, Clavariadelphus truncata, Artomyces (Clavicorona) pyxidata* y el raro pero llamativo *Hydnodon thelephorum*, un hongo dentado gelatinoso con la parte de arriba blanca y la de abajo color melocotón o rosado. También tenemos los siguientes velos de novia: *Mutinus* cf. *caninus, Dictyophora duplicata, Clathrus columnatus*, y *Clathrus crispus*.

Varios hongos gelatinosos se encuentran comúnmente en la República Dominicana. *Auricularia polytricha, Auricularia delicata, Auricularia fuscosuccinea, Heterochaete delicata, Tremella fuciformis, Tremella mesenterica* y *Tremellostereum dichroum*, de aspecto poco usual (que se asemeja a las estructuras de crecimiento laminar de las especies de hongo del género *Stereum*).

De cada grupo aquí discutido, todavía quedan muchas colecciones por ser analizadas. Se necesita todavía realizar más trabajo para describir otros grupos, como estrellas de tierra, hongos de corteza y yescas que aquí no se han tratado. No hay duda que una vez que un análisis cuidadoso de estos datos se haya completado, muchas especies esperan a ser descritas en las colecciones cuidadosamente documentadas que se adquirieron entre 1996 y el 2005.

tharellus cinnabarinus, the corals *Clavulinopsis fusiformis, Clavaria vermicularis, Clavariadelphus truncata, Artomyces (Clavicorona) pyxidata*, and the rare but striking *Hydnodon thelephorum*, a white-topped, jelly-like tooth fungus with a peach or pinkish bottom. Also, we have such stinkhorns as *Mutinus* cf. *caninus, Dictyophora duplicata, Clathrus columnatus*, and *Clathrus crispus*.

Several jelly fungi are fairly commonly found in the Dominican Republic: *Auricularia polytricha, Auricularia delicata, Auricularia fuscosuccinea, Heterochaete delicata, Tremella fuciformis, Tremella mesenterica*, and the unusuallooking *Tremellostereum dichroum* (which resembles the platelike growths of *Stereum* species of fungi).

For each group discussed here, there are many collections yet to be analyzed. Even more work is needed to describe other groups, such as the puffballs, crust fungi, and stereoid fungi not considered here. There is no doubt that once careful analysis of these data can be undertaken, many new species await description in the carefully documented collections we acquired from 1996 to 2005.

Hispaniola, but especially the Dominican Republic, is a mycological gold mine. It will be many years before a good census of even the macrofungi will be completed. Clearly, knowledge at this level of detail will not be obtained until mycologists are living and working in the country. Fungi are beautiful but ephemeral organisms that stay hidden most of the time and fruit only when conditions are just right. If their treasures are to be uncovered and shown to the rest of the world, a commitment to their study and observation will be required.

La Española, especialmente la República Domini-
cana, es una mina de oro micológica. Pasarán muchos años
antes de que un buen censo se haya completado aun de los
macro-hongos. Obviamente, el conocimiento a este nivel de
detalle no se obtendrá hasta que micólogos vivan y trabajen
en el país. Los hongos son organismos bellos pero efímeros,
que permanecen escondidos la mayoría del tiempo y que
fructifican sólo cuando las condiciones son ideales. Para
que sus tesoros sean descubiertos y mostrados al mundo, se
requiere un compromiso estudio y observación.

HISPANIOLA

LOCALIZADA ENTRE CUBA Y PUERTO RICO, LA ISLA de la Hispaniola (Española) tiene un área total de 76,470 km² y está dividida políticamente al oeste por la República de Haití y al este por la República Dominicana. Hace millones de años la isla estuvo geológicamente dividida en dos por una antiguo canal marino que conectaba la Bahía de Neiba con la Bahía de Port-Au-Prince. Las islas se conocen como la Paleo Isla Norte y la Paleo Isla Sur, ambas contienen un alto número de plantas y animales con limitadas oportunidades de dispersión.

Otras barreras geológicas dentro del territorio de la isla consisten en varios macizos montañosos alineados paralelamente de oeste a este. Algunas de estas son El Massif Du Nord/Cordillera Central, Massif La Selle/ Sierra de Bahoruco, y la Cordillera Septentrional entre otros. Estas cadenas de montañas cuentan con un alto número de ecosistemas que van desde los bosques tropicales hasta los bosques de pinos en la zonas de clima mas templado. Estos ecosistemas están definidos por condiciones climáticas determinadas por la altura y se encuentran esparcidos por la isla.

Este mapa identifica una serie de localidades donde se realizó el trabajo fotográfico para este libro.

CAYOS SIETE HERMANOS

LABADEE

PARQUE NACIONAL MONTECRISTI

LAGUNA SALINA

CAP HAITIENNE

PUILBORO

LOS BORBOLLONES

LOS RIOS

CASTILLON

PARQUE NACIONAL LAGO ENRIQUILLO

PARC NATIONAL PIC MACAYA

PARC NATIONAL LA VISITE

FOND DES NEGRES

PARQUE NACIONAL SIERRA DE BAHORUCO

PUERTO ESCONDIDO

FORMOND

LOS ARROYOS

MENCÍA

PUEBLO VIEJO

ACEITILLAR

PARQUE NACIONAL JARAGUA

BAHÍA DE LAS AGUILAS

MAR CARIBE

FONDO PARADI

LAGUNA DE OVIEDO

ÁREAS PROTEGIDAS | PROTECTED AREAS

PUNTOS DEL RECORRIDO FOTOGRÁFICO
LOCATIONS OF THE PHOTOGRAPHIC JOURNEY

ISLA ALTO VELO

HISPANIOLA

N
W · E
S

OCÉANO ATLÁNTICO

PARQUE NACIONAL ARMANDO BERMÚDEZ
PARQUE NACIONAL JOSÉ DEL CARMEN RAMÍREZ

SABANA DE LA MAR

RESERVA CIENTÍFICA
ÉBANO VERDE

PARQUE NACIONAL
LOS HAITISES

PARQUE NACIONAL
JUAN B. PÉREZ RANCIER

MONUMENTO NATURAL
BAHÍA DE LAS CALDERAS
DUNAS DE BANÍ

PARQUE NACIONAL
DEL ESTE

RESERVA BIOLÓGICA
BAHORUCO ORIENTAL

CACHOTE

LOCATED BETWEEN CUBA AND PUERTO RICO, THE ISLAND of Hispaniola (Española) has a total surface area of 76,470 km² and is politically divided into the Republic of Haiti to the west and the Dominican Republic to the east. Millions of years ago the island was also divided geologically in two by an old marine channel, which connected the Bay of Neiba with the Bay of Port-Au-Prince. These islands, referred to as the North Paleoisland and the South Paleoisland, both have a high number of plants and animals with limited dispersal opportunities.

Other geological barriers within the island are characterized by a parallel alignment of a series of mountain ranges laid in the same direction, west to east. Among these is Massif Du Nord/ Cordillera Central, Massif La Selle/Sierra de Bahoruco and the Cordillera Septentrional. The mountain chains have a high number of ecosystems, which range from tropical forests to the pine forests. These ecosystems are defined by climatic conditions that in turn are determined by altitude.

This map identifies a series of localities where most of the photography work was executed.

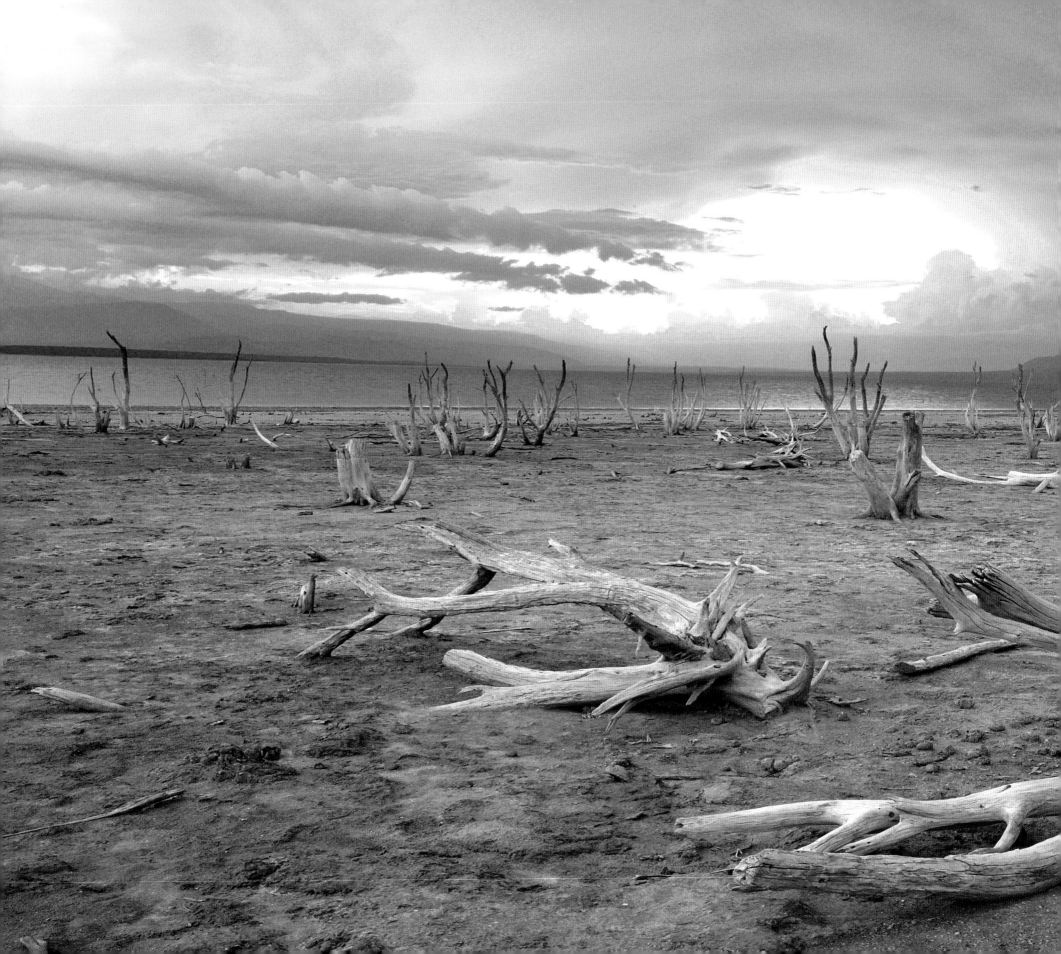

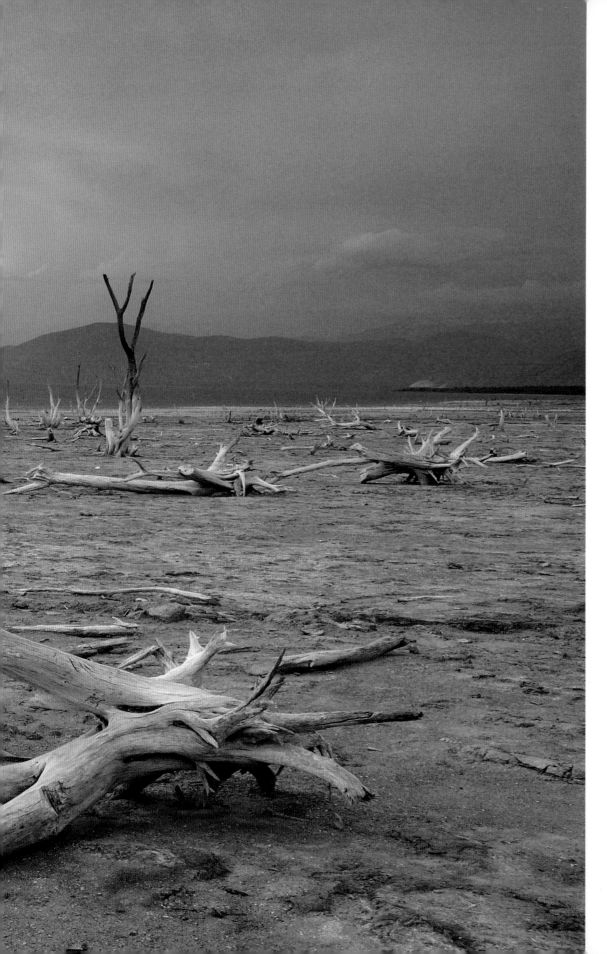

PARQUE NACIONAL LAGO ENRIQUILLO

CONSIDERADO UNO DE LOS PAISAJES MÁS DRAMÁTICOS DEL Caribe, El Lago Enriquillo, a 40 metros por debajo del nivel del mar, se encuentra entre las cadenas montañosas de Sierra de Bahoruco y Sierra de Neiba. Este lago se categoriza como hipersalino. Su contenido de sal, tres veces mayorque que el del mar, se debe al alto grado de evaporación y el poco flujo de agua dulce.[change is to cut down 3 times alto] El Lago Enriquillo tiene una superficie variable de 160 kilómetros cuadrados, la que aumenta o disminuye dependiendo de la frecuencia de los periodos de lluvia o sequía. Dentro del lago hay tres islas: Isla Barbarita, Islita y Cabritos, siendo la última la más grande de las tres y uno de los pocos lugares donde se encuentra la Iguana de Ricord (*Cyclura ricordi*), una especie en peligro de extinción, y la Iguana Rinocerontes (*Cyclura cornuta*).

Estas islas y las áreas a su alrededor están dominadas por bosques secos espinosos, con excepción de algunas áreas donde manantiales naturales de aguas sulfurosas emanan de la tierra y fluyen al lago. Estos manantiales son un refugio natural para aves, el Cocodrilo Americano (*Cocodrilus acutus*), insectos y peces. Entre los peces se encuentran varias especies que son endémicas y que están restringidas a unos pocos manantiales de agua dulce que fluyen al lago. La especie mejor conocida de estos peces tan especializados es *Limia sulphurophila*.

CONSIDERED ONE OF THE MOST DRAMATIC LANDSCAPES IN the Caribbean, Lago Enriquillo, 40 meters below sea level, lies between the Sierra de Bahoruco and Sierra de Neiba mountain ranges. This lake is categorized as hypersaline. Its high salt content, three times greater than the sea's, is caused by a high rate of evaporation and the slow influx of fresh water. Lago Enriquillo has a variable surface area of 160 square kilometers, which can decrease or increase depending on the frequency of rain and drought periods. There are three islands within the lake: Isla Barbarita, Islita, and Cabritos. The latter is the largest of the three and is one of the few places where the critically endangered Ricord's Iguana (*Cyclura ricordi*) and the Rhinoceros Iguana (*Cyclura cornuta*) can be found.

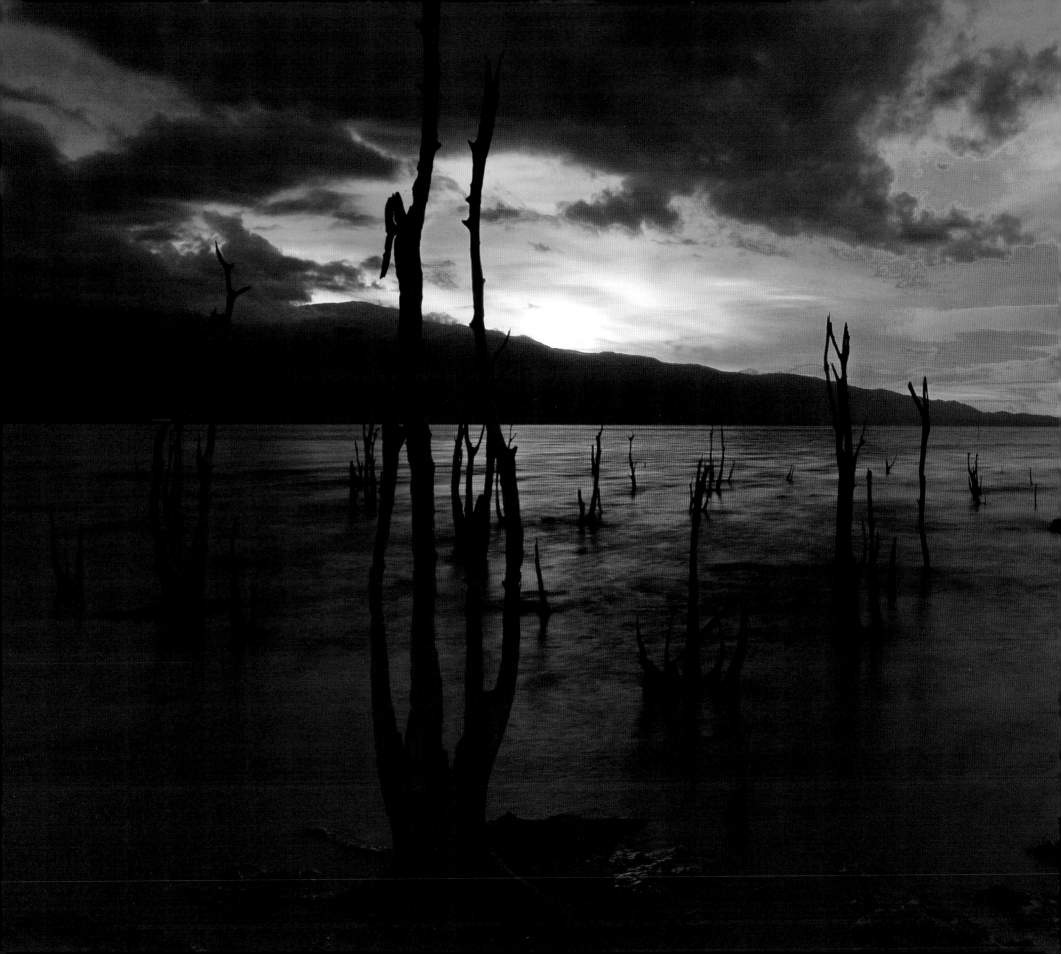

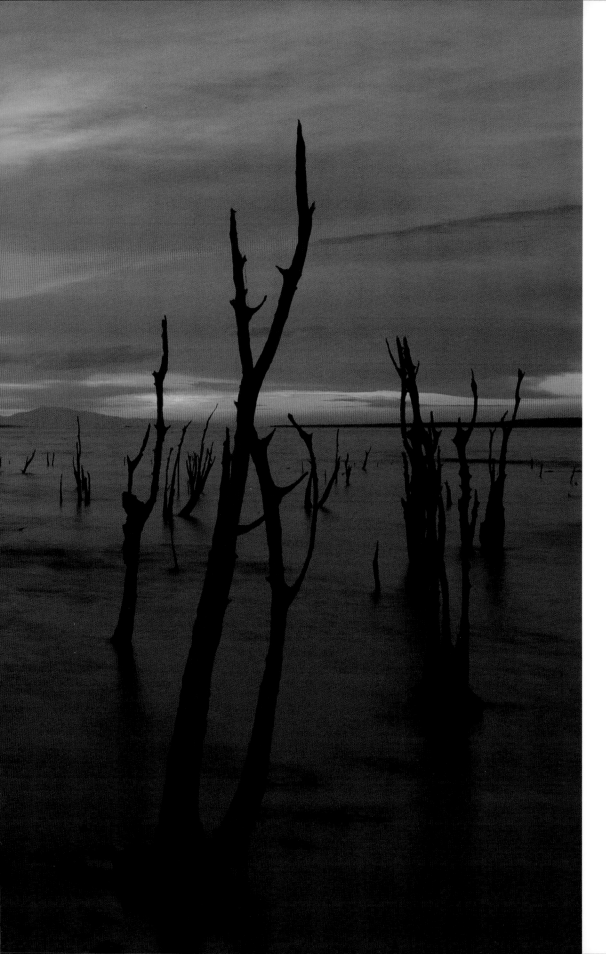

These islands and the lake's surrounding areas are dominated by dry thorn scrub, except in some areas where natural sulfurous springs emanate from the ground and flow to the lake. These springs are a natural refuge for birds, American Crocodiles (*Crocodilus acutus*), insects, and fish. Among the fish are several species that are endemic and restricted to a few freshwater springs that pour into the lake. The best-known of these highly specialized fish is *Limia sulphurophila*.

53

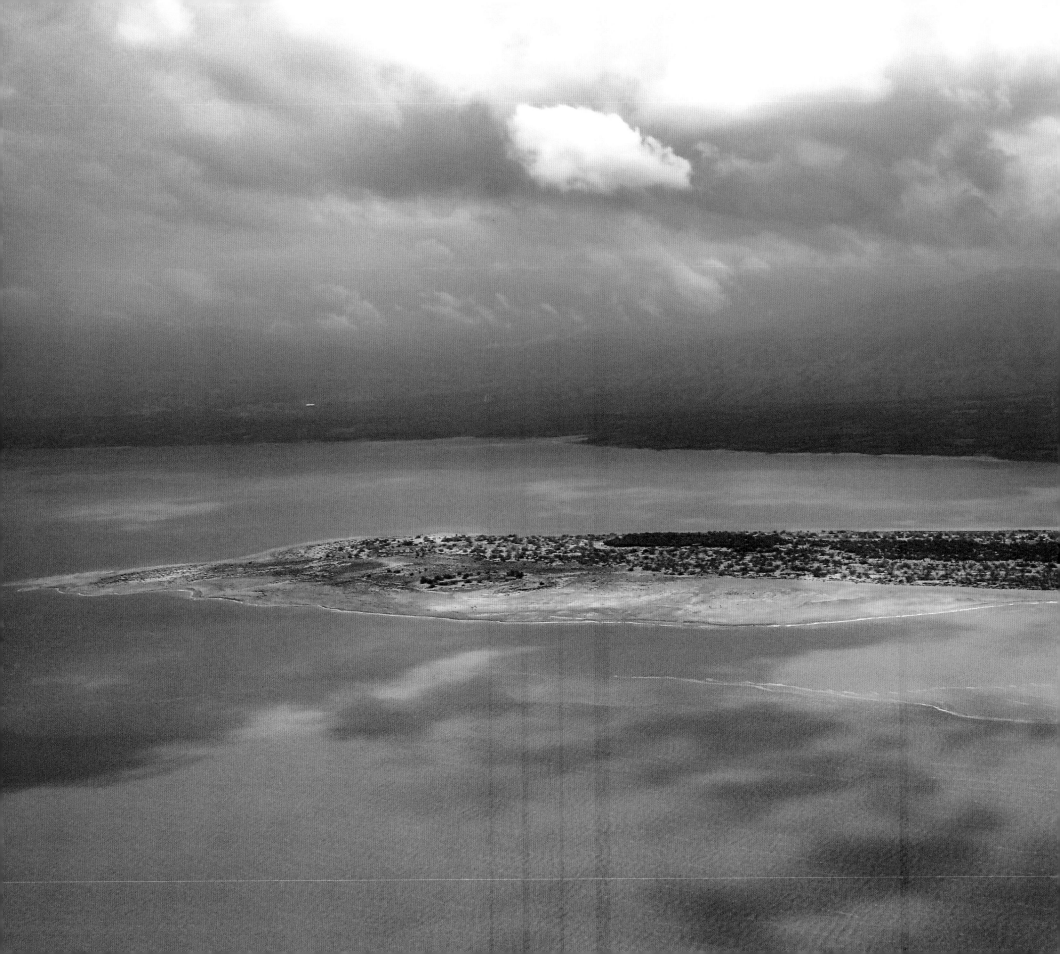

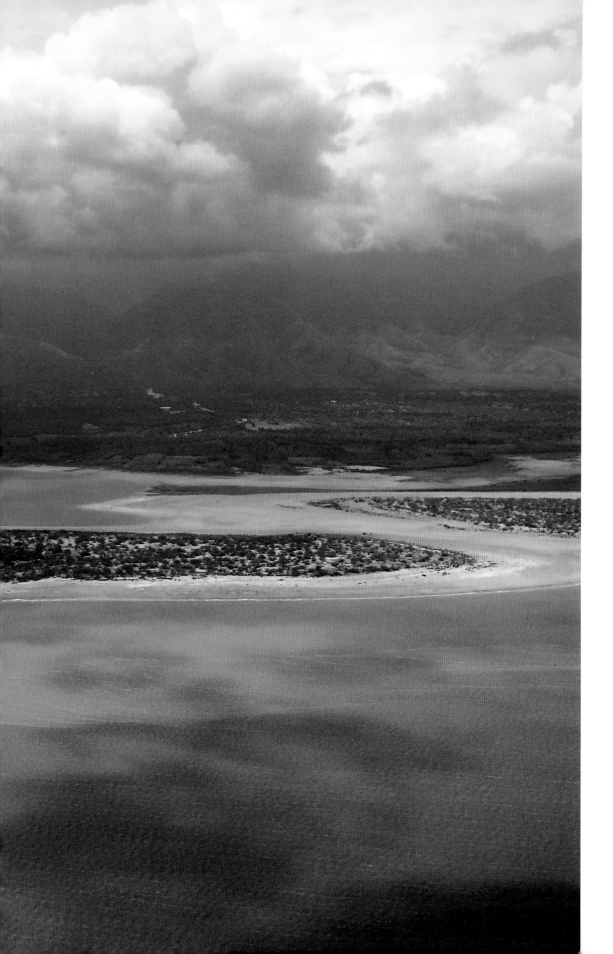

55

VISTA AÉREA DE LA ISLA BARBARITA · AERIAL VIEW OF ISLA BARBARITA

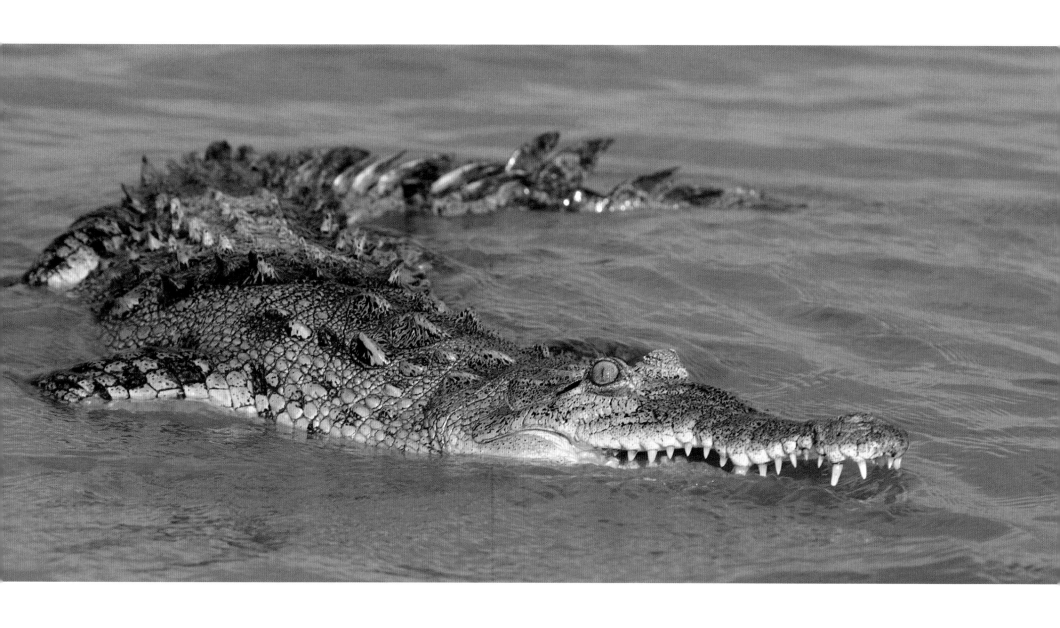

COCODRILO · CROCODILE · [*Crocodylus acutus*] · LOS BORBOLLONES

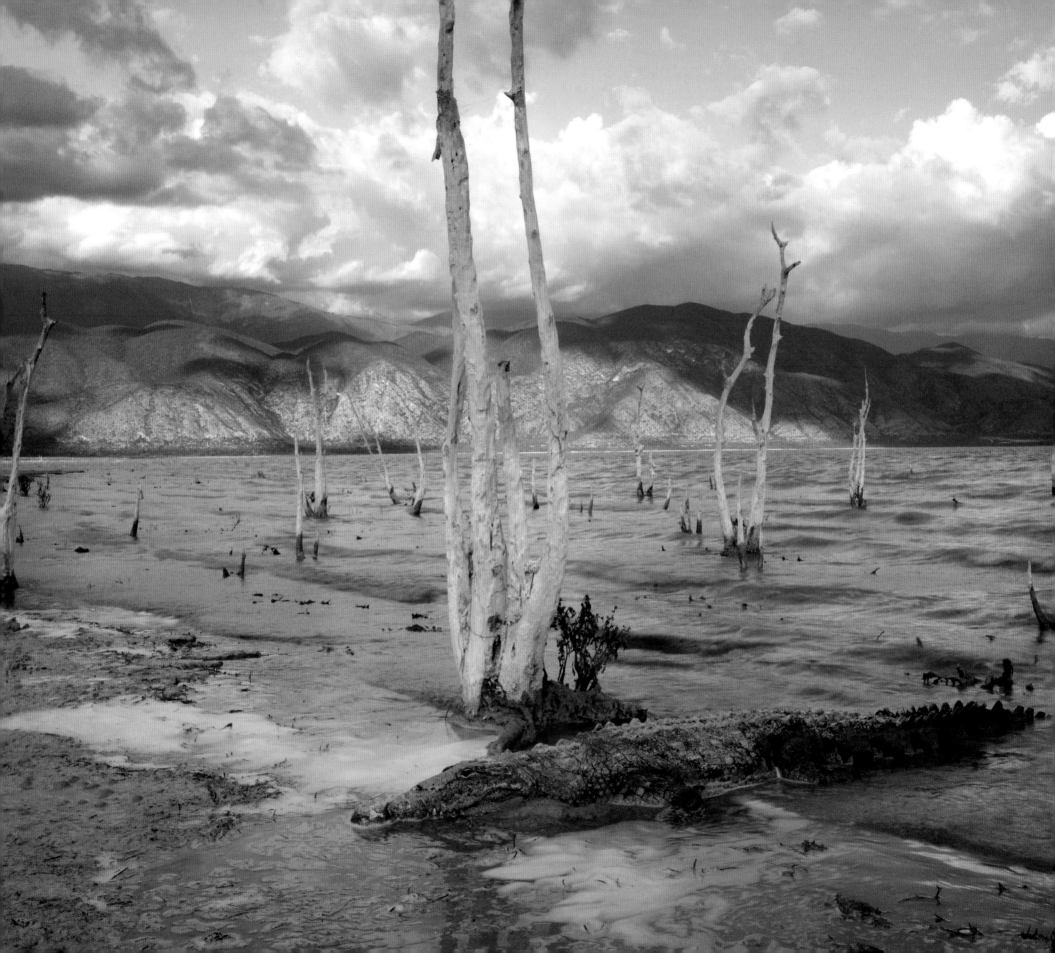

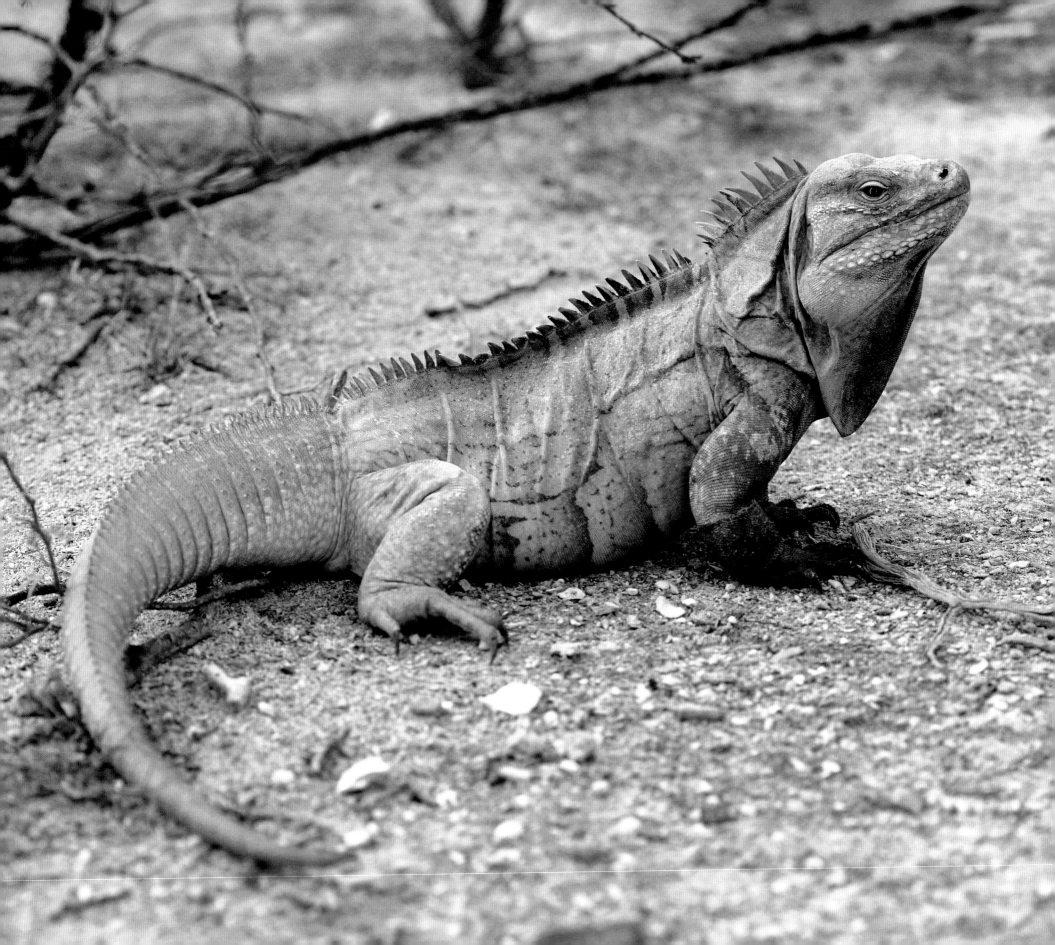

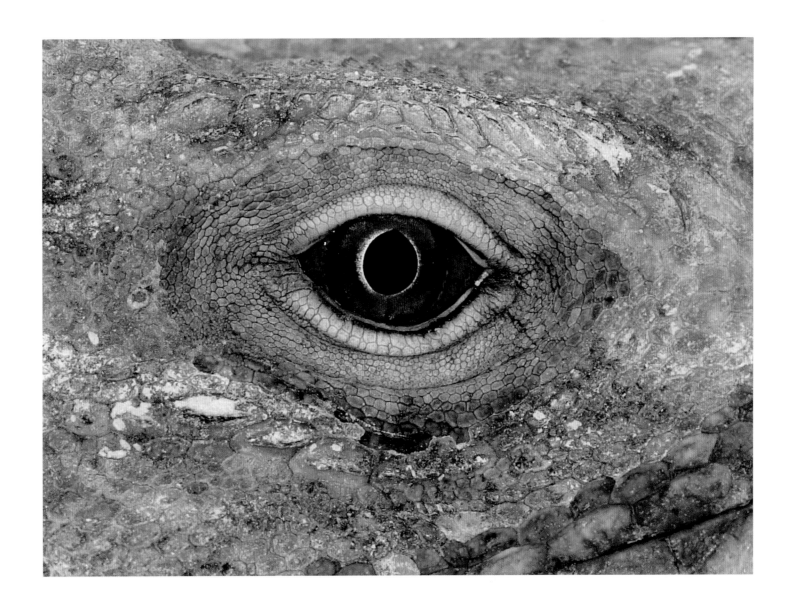

59

IGUANA RICORDI • RICORD'S IGUANA • [*Cyclura ricordi*] • ISLA CABRITOS

ESPECIE EN ALTO RIESGO DE EXTINCIÓN │ CRITICALLY ENDANGERED SPECIES

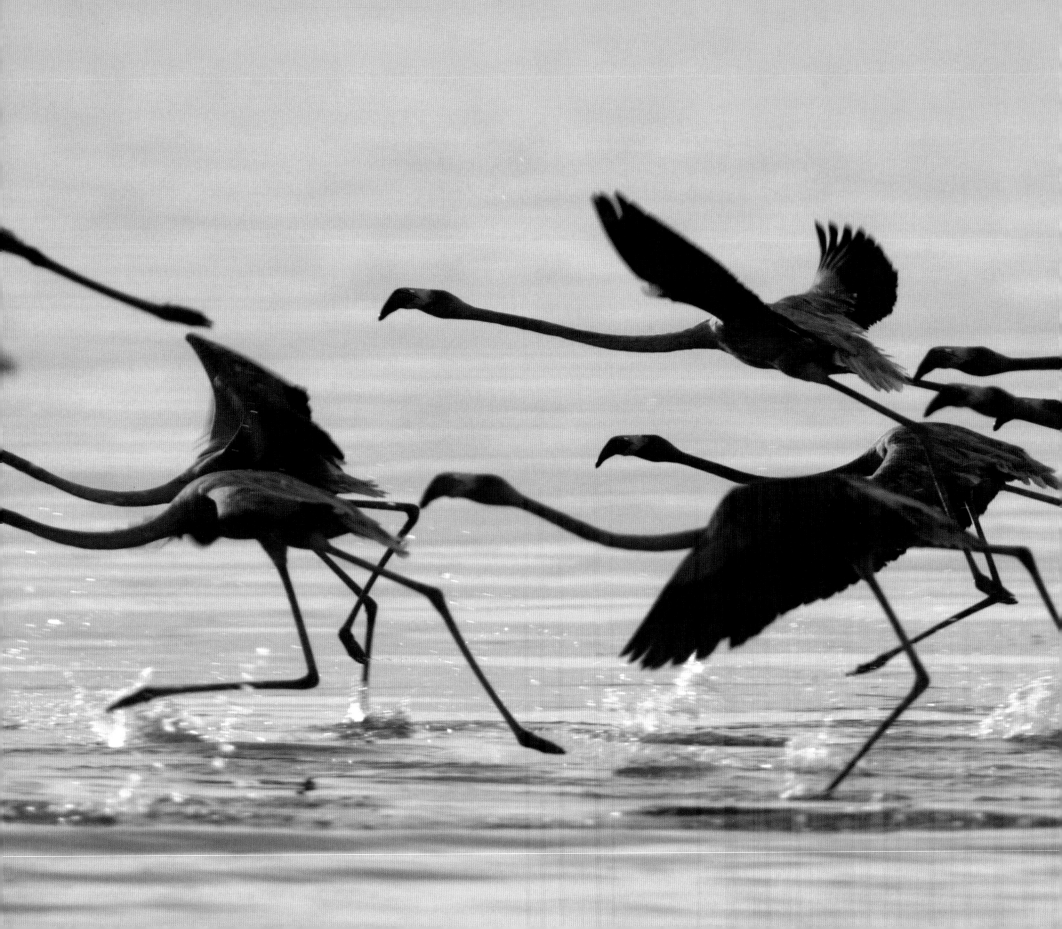

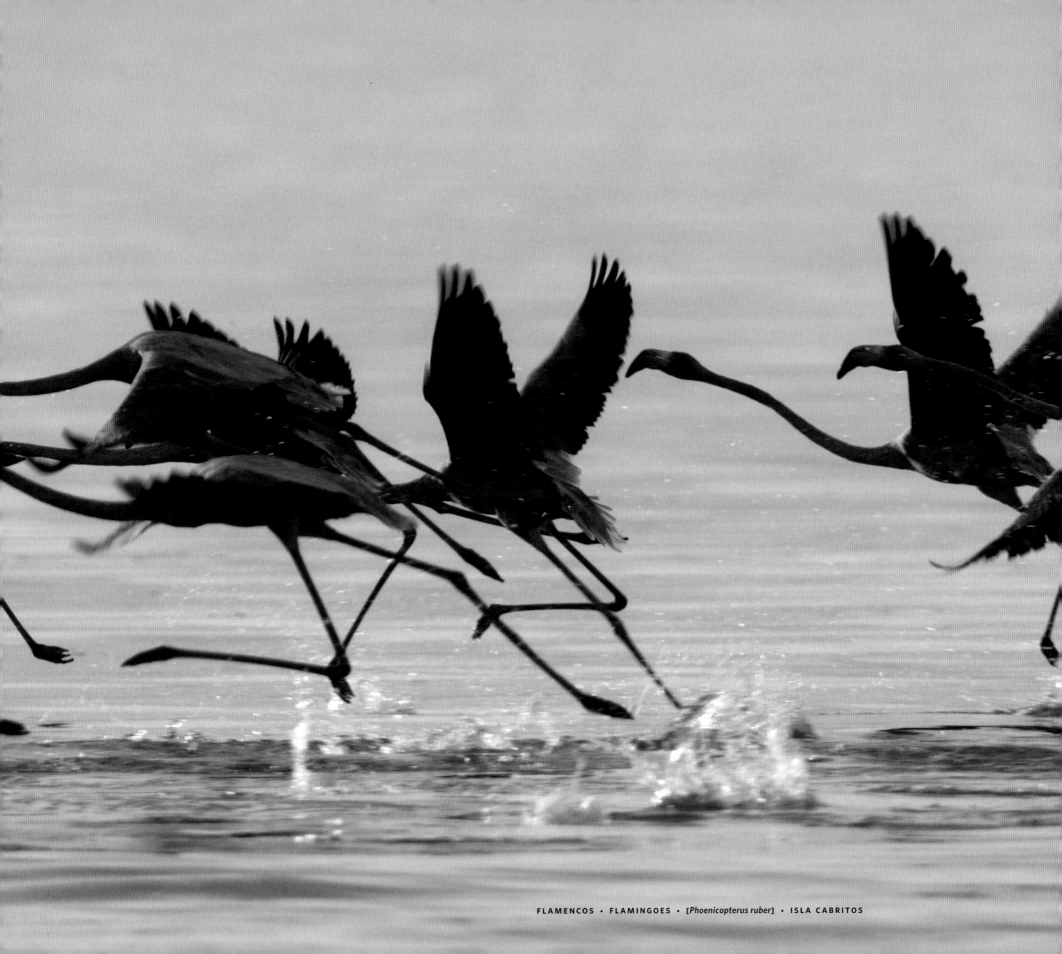

FLAMENCOS · FLAMINGOES · [*Phoenicopterus ruber*] · ISLA CABRITOS

DAMISELA · DAMSELFLY · [*Telebasis dominicana*] · LOS BORBOLLONES

GECKO DEL DESIERTO · DESERT GECKO · [*Aristelliger expectatus*] · LOS BORBOLLONES

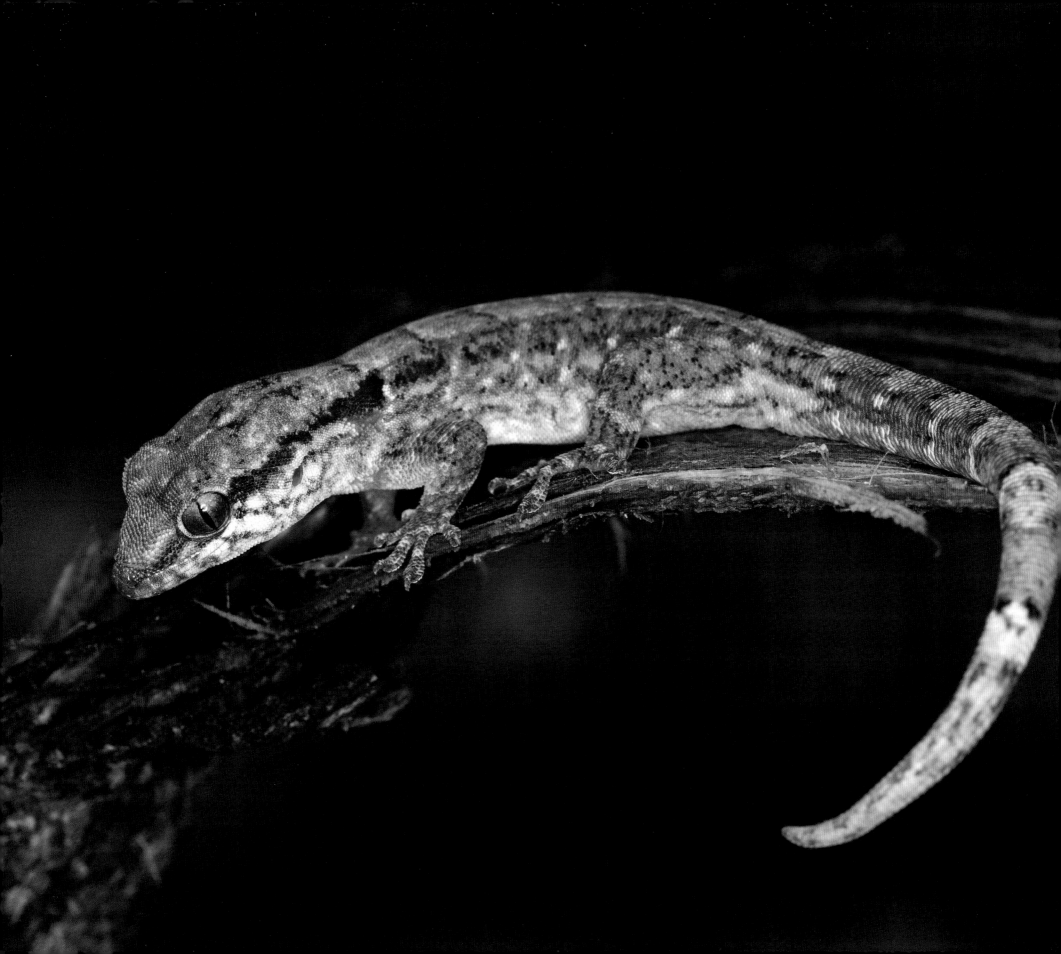

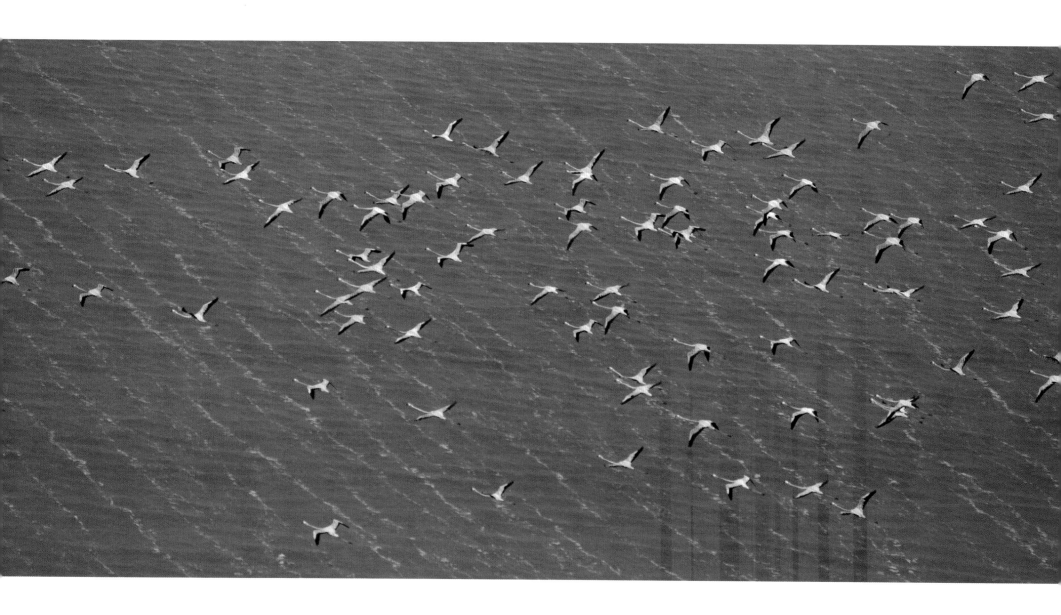

FLAMENCOS EN VUELO · FLYING FLAMINGOS · [*Phoenicopterus ruber*] · LOS RIOS

VISTA AÉREA DE HUMEDAL AL ESTE DEL LAGO ENRIQUILLO · AERIAL VIEW OF FLOODPLAIN EAST OF LAGO ENRIQUILLO

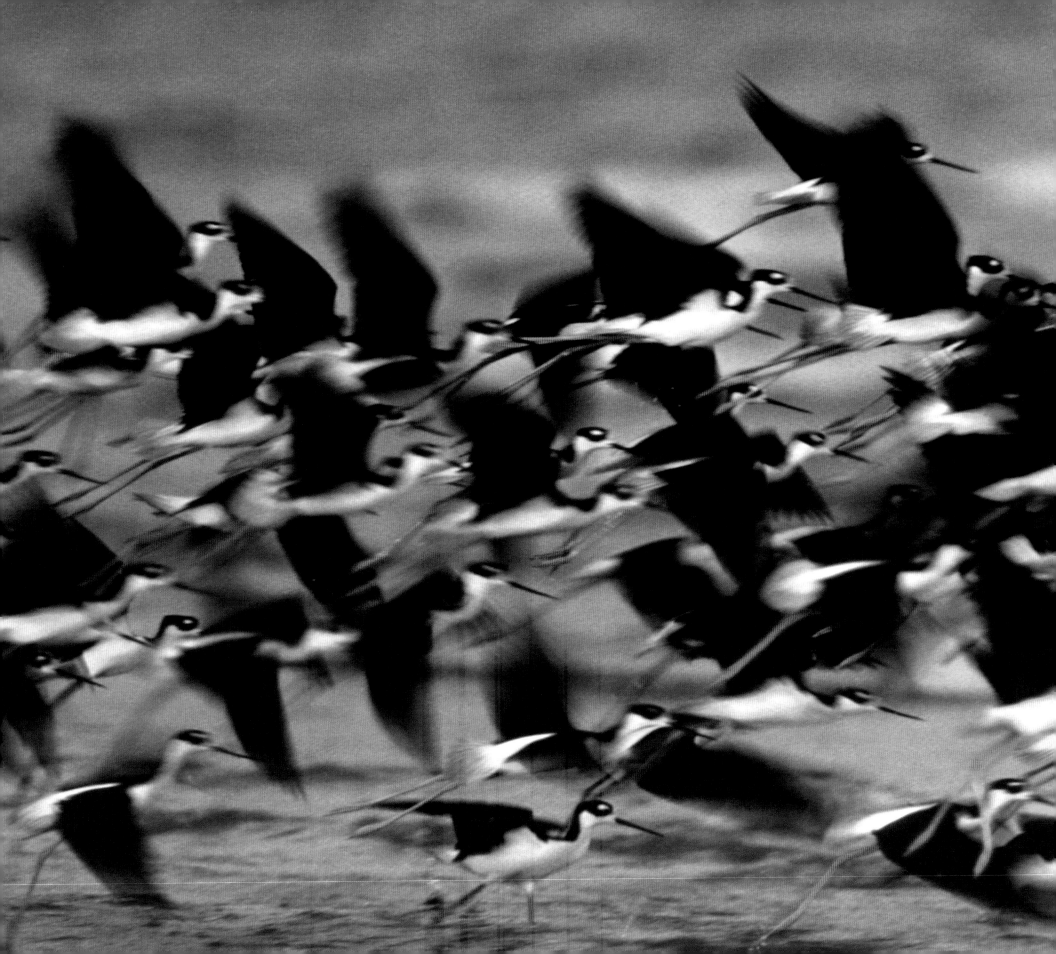

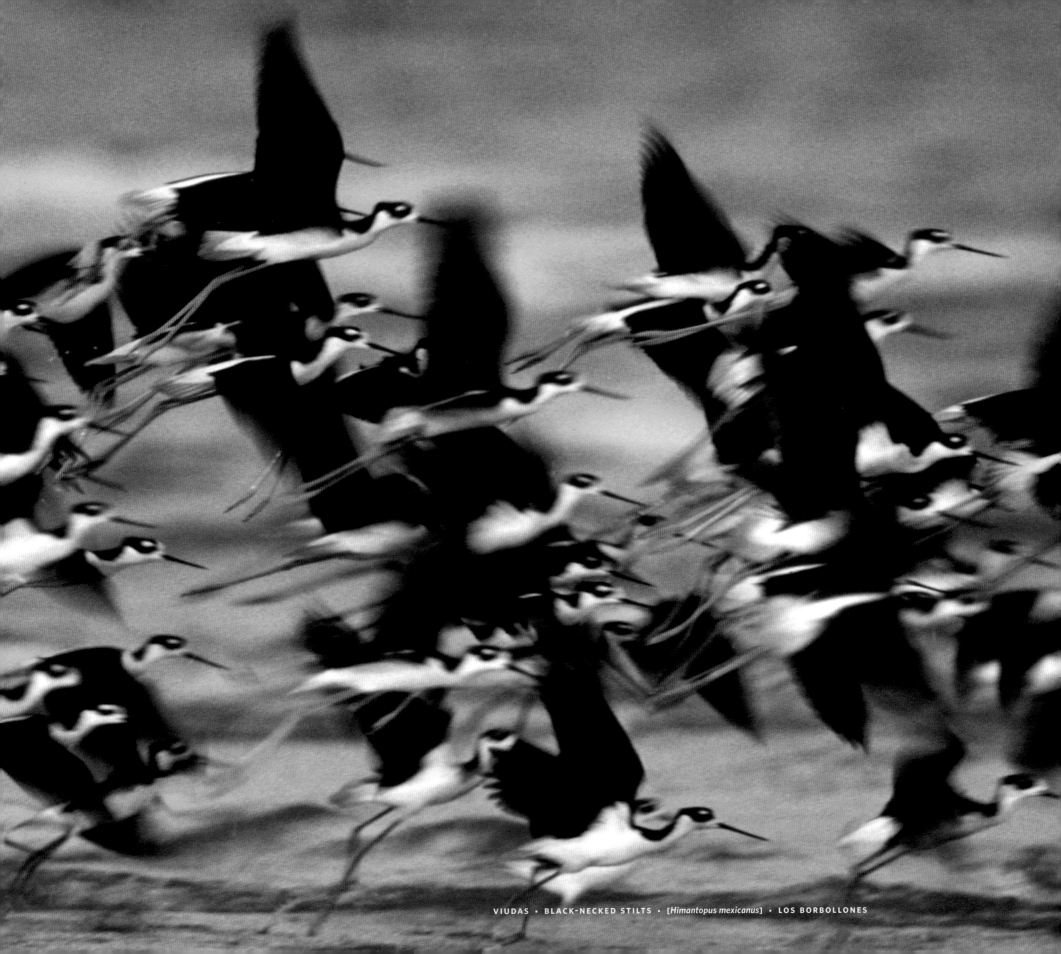

VIUDAS · BLACK-NECKED STILTS · [*Himantopus mexicanus*] · LOS BORBOLLONES

RESERVA BIOLÓGICA BAHORUCO ORIENTAL

LA PORCIÓN ESTE DE LA SIERRA DE BAHORUCO-MACIZO DE LA
Selle puede ser considerada como una región biológica separada. Se caracteriza principalmente por un denso bosque nublado que recibe una precipitación anual entre 3,000 y 4,000 mm. Esta es la fuente de los ríos Palomino, Nizaito, Cortico y Bahoruco, fuentes de agua que suplen el pueblo de Barahona y otras comunidades aledañas. El bosque de aquí es especialmente rico en orquídeas y unas pocas especies raras de reptiles, que incluye el Anolis de Bahoruco (*Anolis bahorucoensis*), una lagartija de mucho color muy cotizada por colectores. La Magnolia de Bahoruco (*Magnolia harmoni*) y la Palma Sierra de Bahoruco (*Reinhardtia paiewonskiana*) son ejemplos de la flora única que se encuentra en las laderas este de Bahoruco. Ambas especies están en alto peligro de extinción como resultado de la destrucción de su hábitat.

El mal manejo de las tierras, tales como tala y la quema de la vegetación, la siembra en laderas empinadas y la conversión de los bosques primarios en pastos para el ganado, han reducido gran parte de la cubierta del bosque. Al mismo tiempo proyectos de reforestación han introducido nuevas especies de plantas en áreas donde la vegetación original consistía de especies nativas de plantas latifoliadas.

THE EASTERN PORTION OF THE SIERRA DE BAHORUCO-MASSIF
de la Selle area may be considered a separate biological region. It is characterized primarily by a dense cloud forest that receives an annual rainfall between 3,000 and 4,000 mm. It is the source of the Palomino, Nizaito, Cortico, and Bahoruco rivers, water sources that supply the town of Barahona and other communities. The forest here is especially rich in orchids and a few rare species of reptiles, including the Bahoruco Bush Anole (*Anolis bahorucoensis*), a colorful lizard highly prized by collectors. The Bahoruco Magnolia (*Magnolia harmori*) and the Bahoruco Sierra Palm (*Reinhardtia paiewonskiana*) are examples of the unique flora encountered on the slopes of eastern Bahoruco. Both species are highly threatened as a result of habitat destruction.

Unsound land-management practices—involving slash-and-burn agriculture, planting on steep slopes, and converting primary forest into cattle pastures—have reduced a large portion of the forest cover. At the same time, some reforestation projects have been introducing new plant species in areas where the original vegetation consisted of native broadleaf species.

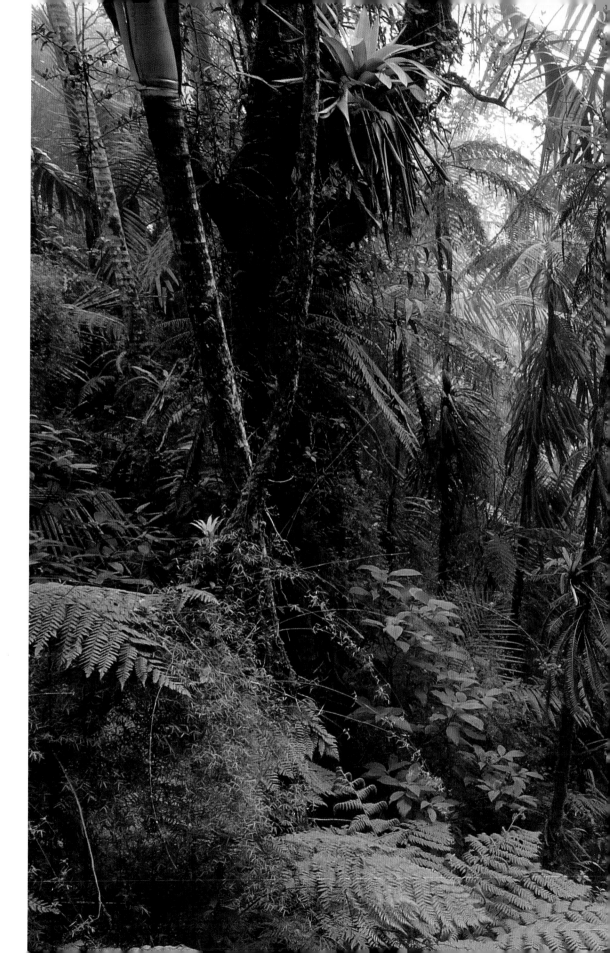

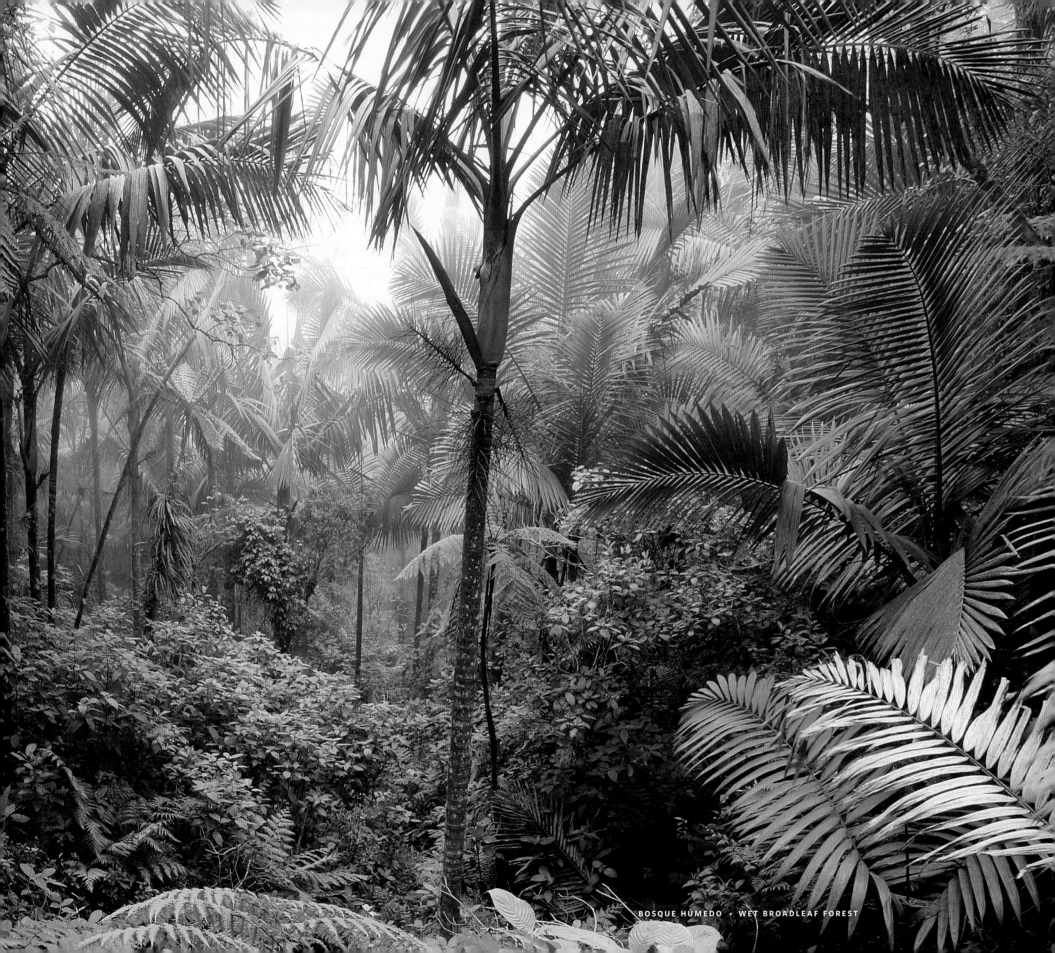

BOSQUE HÚMEDO · WET BROADLEAF FOREST

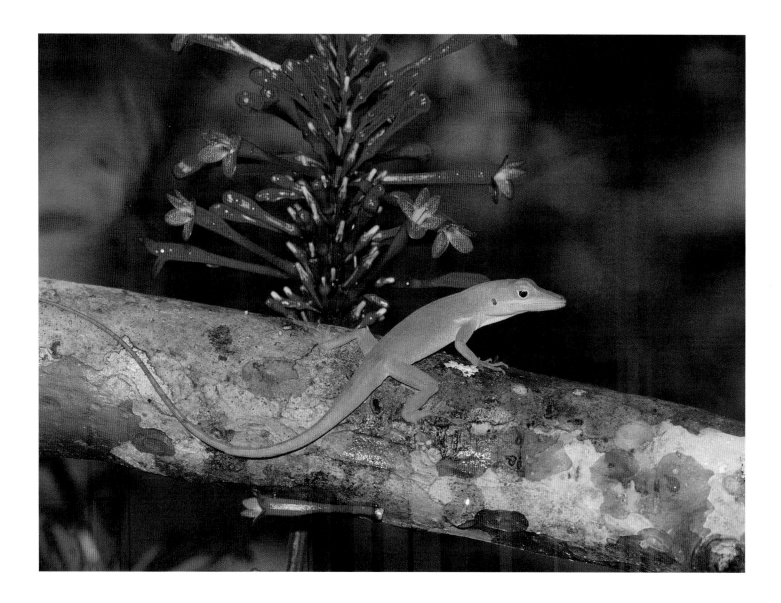

ANOLIS VERDE DEL SUR · SOUTHERN GREEN ANOLE · [*Anolis coelestinus*] · CACHOTE

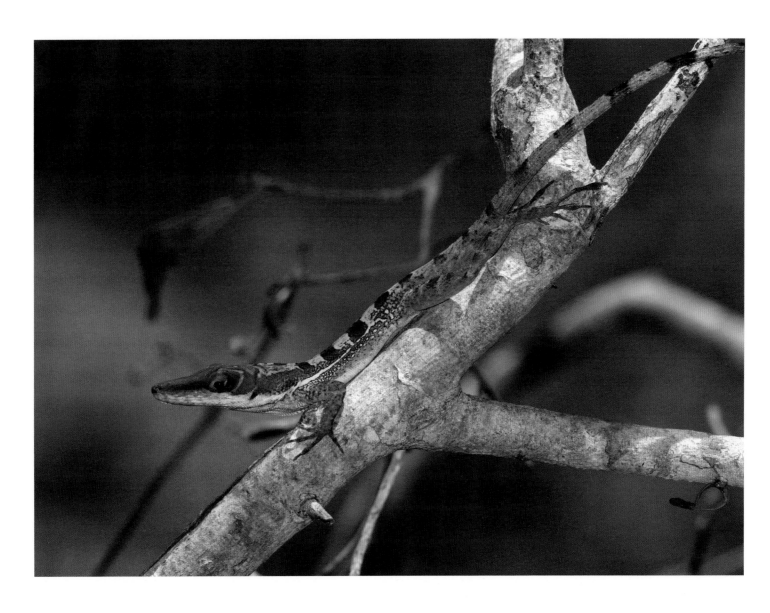

ANOLIS DE BAHORUCO • MALE BAHORUCO BUSH ANOLE • [*Anolis bahorucoensis*] • CORTICO

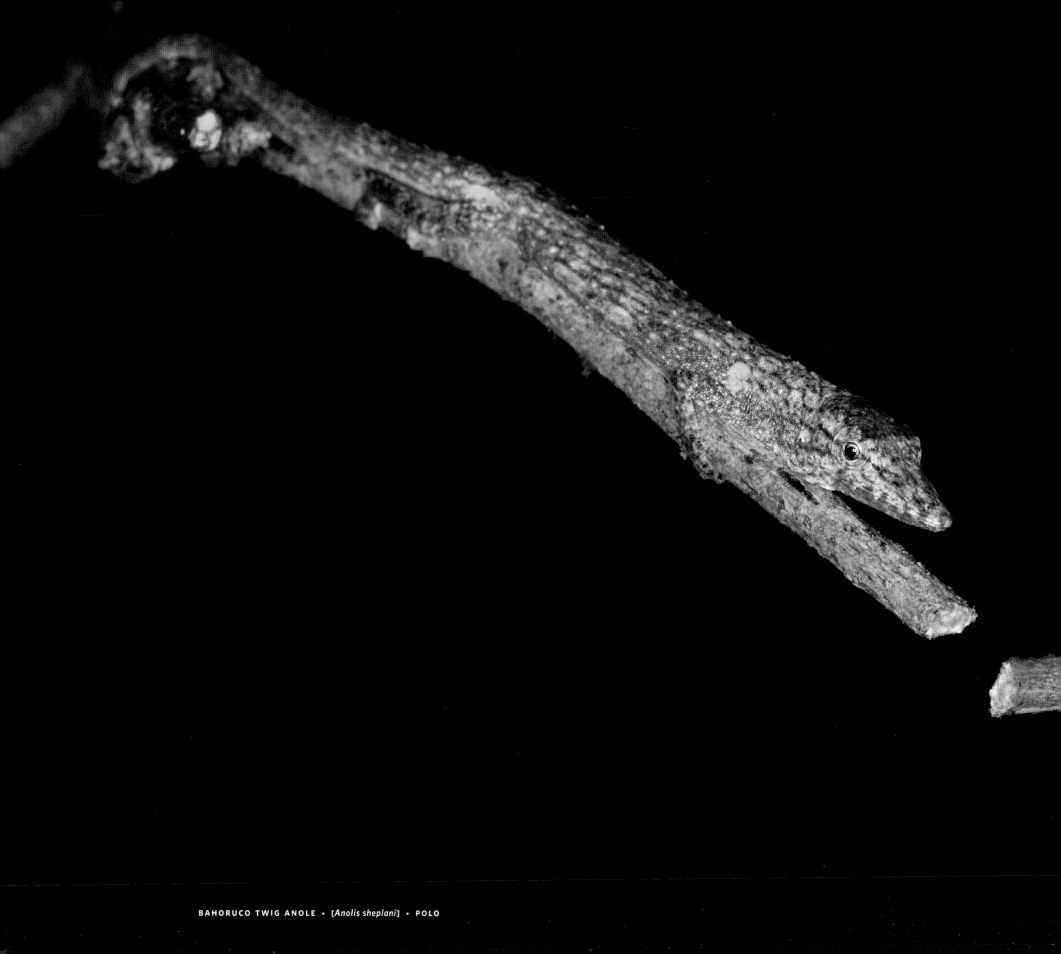

BAHORUCO TWIG ANOLE • [*Anolis sheplani*] • POLO

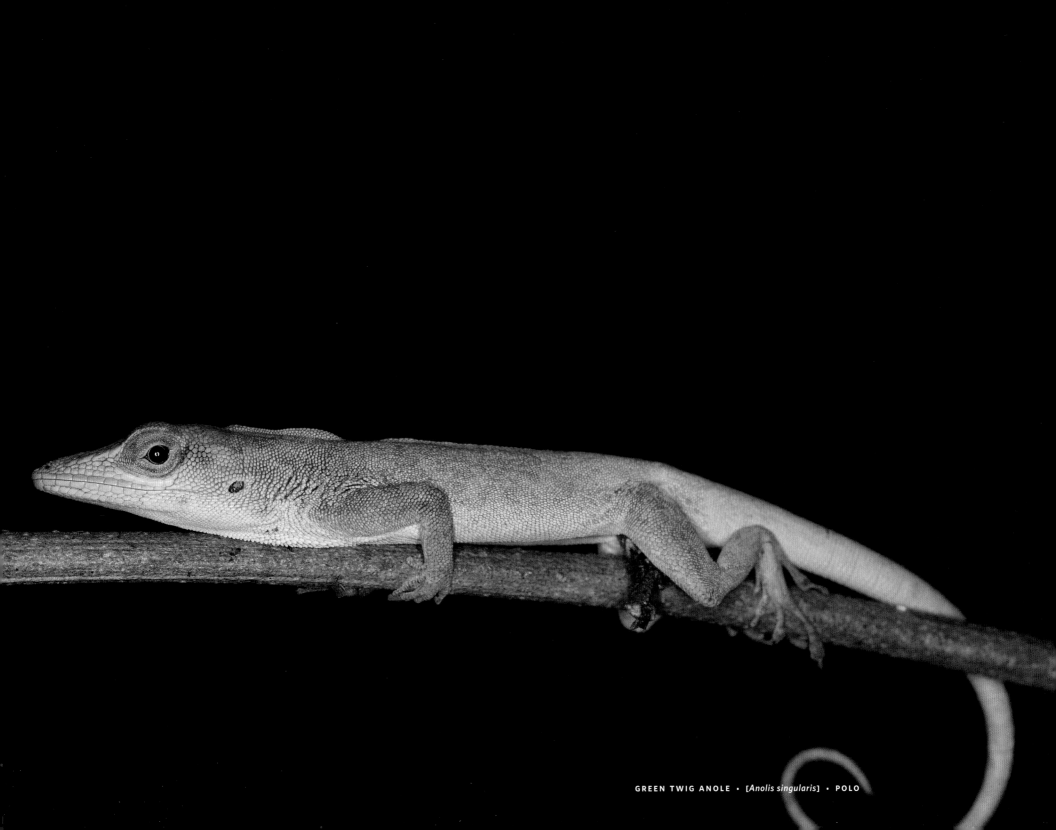

GREEN TWIG ANOLE · [*Anolis singularis*] · POLO

[*Prescottia stachyoides*] · CACHOTE

ORQUÍDEA · ORCHID · [*Trichopilia fragrans*] · CACHOTE

ORQUÍDEAS LEPANTHES • LEPANTHES ORCHIDS • [*Lepanthes spp.*] • CORTICO

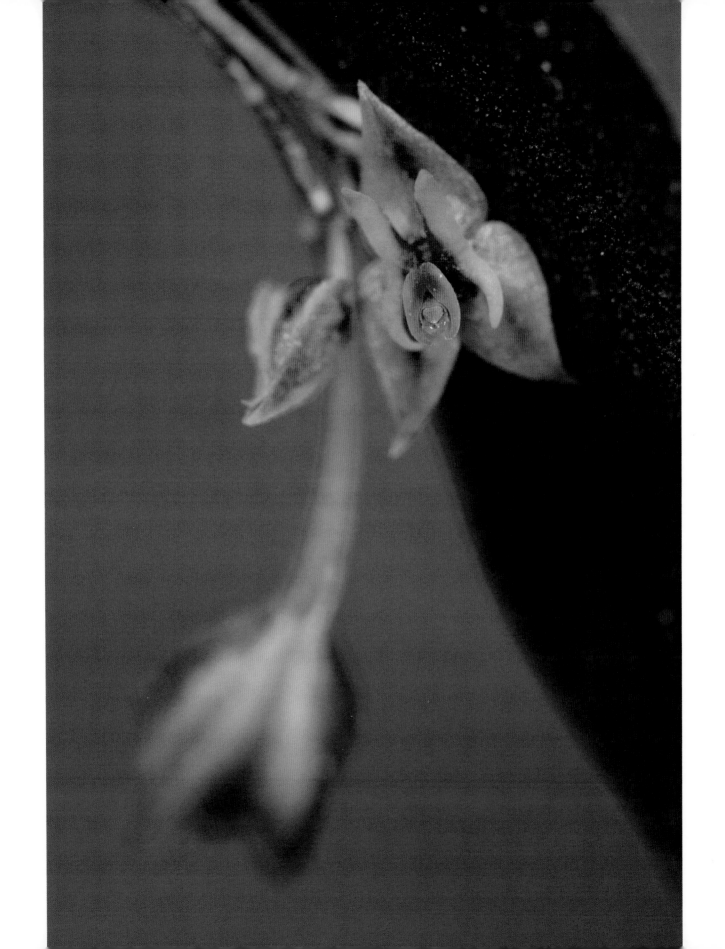

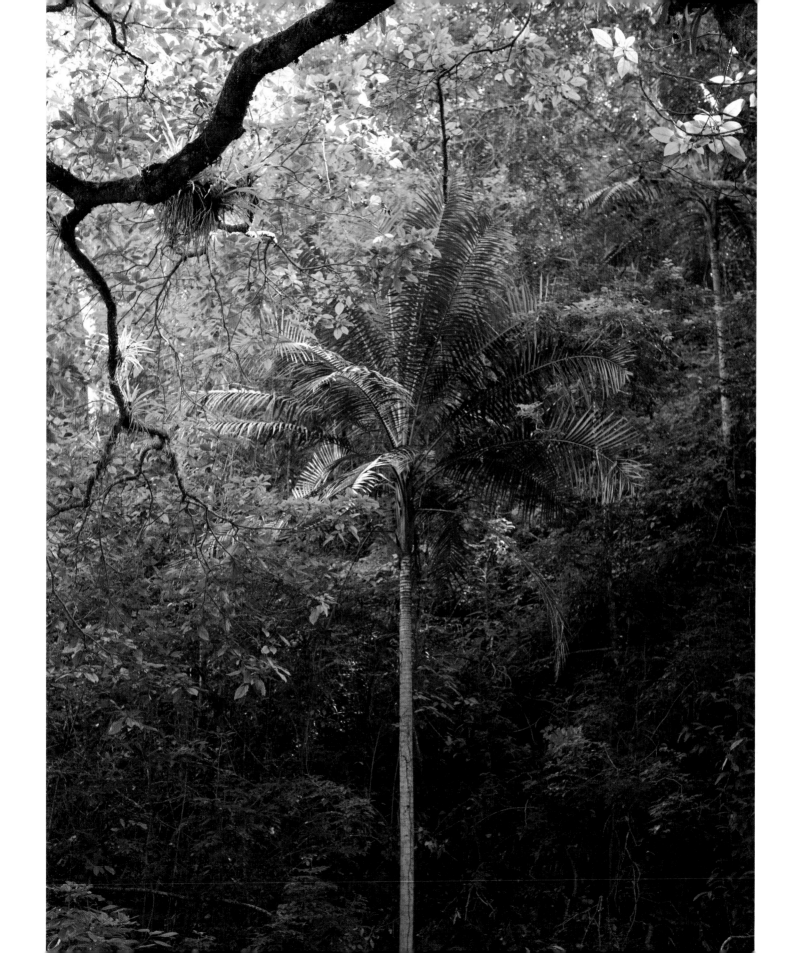

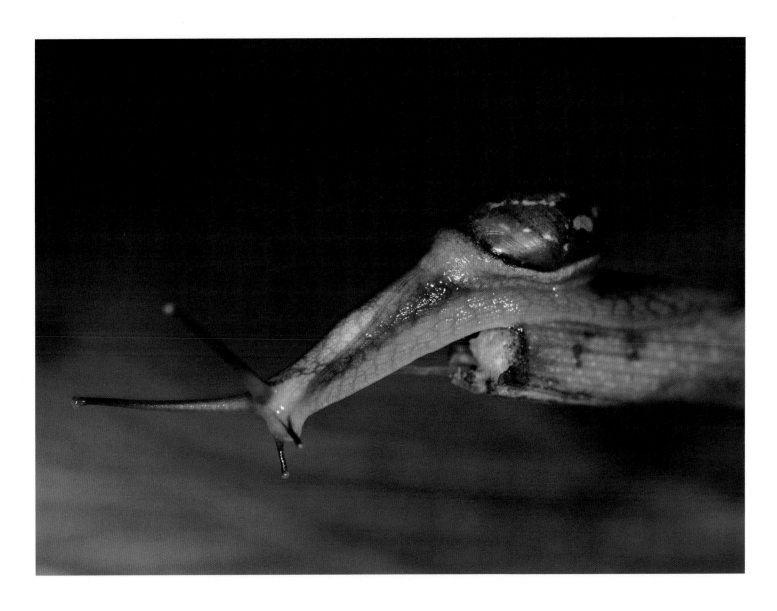

BABOSA DESCONOCIDA, POSIBLEMENTE DEL GÉNERO *Gaeotis* · UNKNOWN LAND SNAIL, POSSIBLY *Gaeotis* GENUS · CACHOTE

PALMA COQUITO · PALM · *[Reinhardtia paiewonskiana]* · EL MANIEL
ESPECIE EN ALTO RIESGO DE EXTINCIÓN │ CRITICALLY ENDANGERED SPECIES

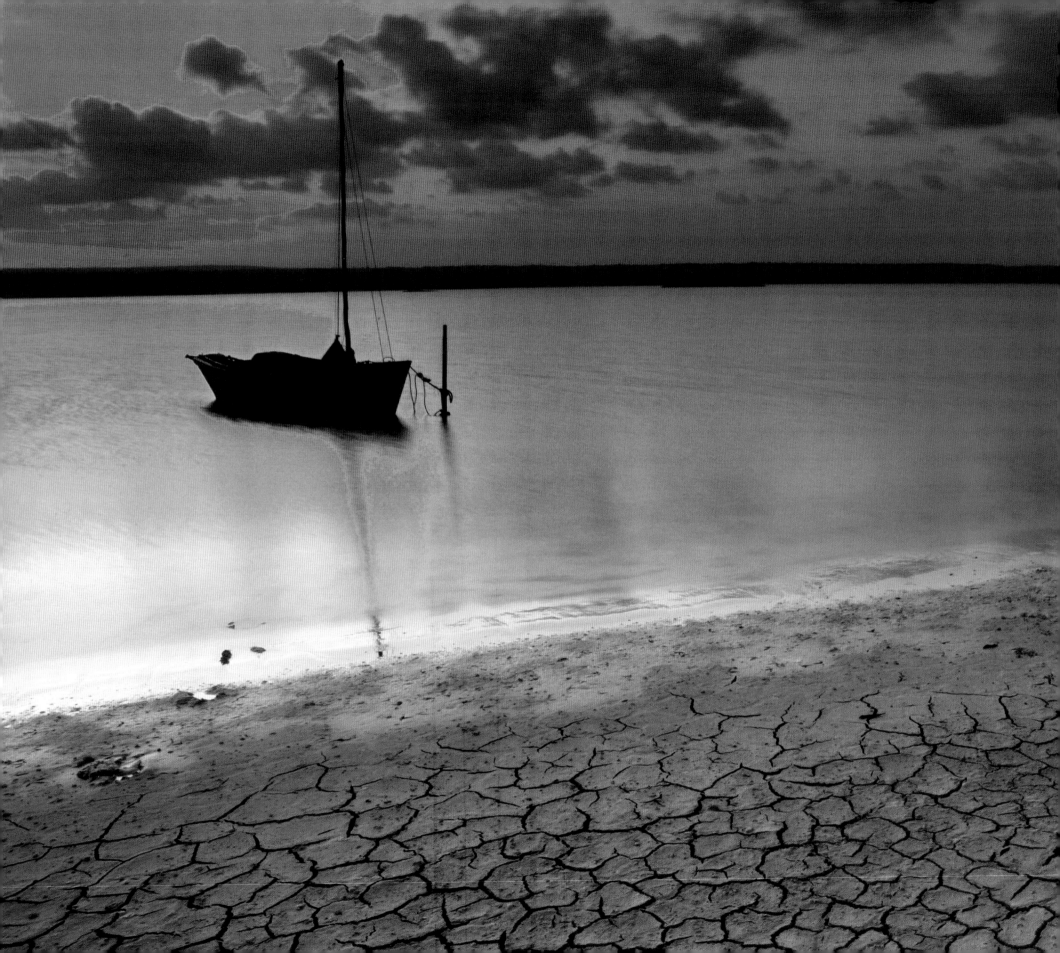

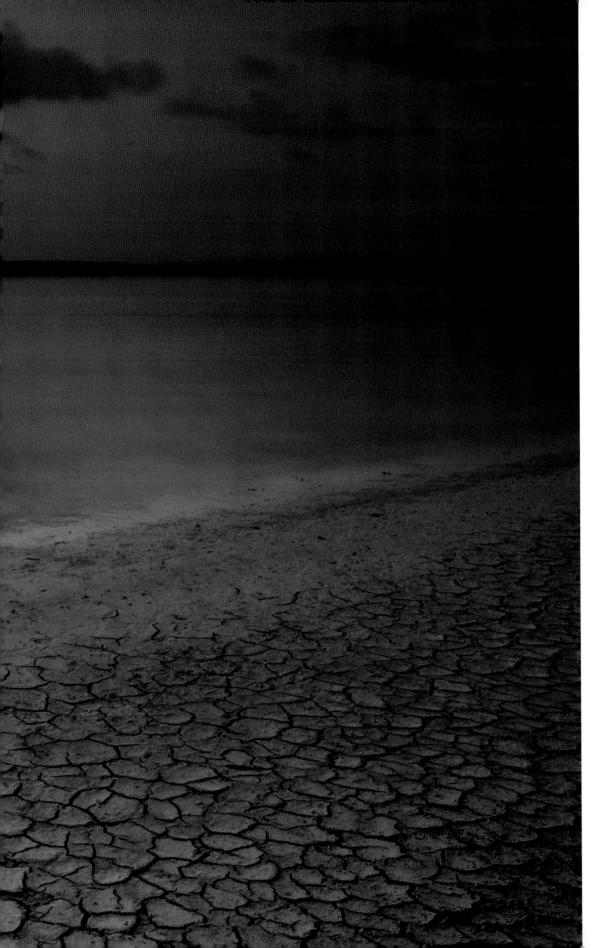

PARQUE NACIONAL
JARAGUA

EL PARQUE NACIONAL JARAGUA ES LA MAYOR ÁREA PROTEGIDA en la República Dominicana (1,374 Km²), sin embargo, una gran parte de ésta es parque marino. El paisaje terrestre esta dominado por un rico bosque seco subtropical con una extensa diversidad de cactus y otras plantas endémicas como es la Palma Jaragua (*Pseudophoenix ekmanii*), especie rara que crece exclusivamente dentro de los límites fronterizos del parque.

La mayor atracción del parque es La Laguna de Oviedo y sus flamencos (*Phoenicopterus ruber*), garzas, Palomas Coronita (*Patagioenas leucocephala*) y gaviotas. En los meses de verano la vasta mayoría de estas aves usan los cayos de la parte suroeste de la Laguna de Oviedo para anidar.

Bahía de las Águilas es una de las partes más visitadas y controversiales del Parque Nacional Jaragua. Esta hermosa playa esta siempre bajo constante amenaza de ser excluida del parque, ya que es muy cotizada por los promotores de inmobiliarias que la consideran unos de las más valiosas propiedades en la isla. Uno de los argumentos a favor de la preservación de esta área es que en estas aguas está la mayor población juvenil de careyes del mundo.

JARAGUA NATIONAL PARK IS THE LARGEST PROTECTED AREA in the Dominican Republic (1,374 km²), though a sizable portion of this area is a marine park. The terrestrial landscape is dominated by subtropical dry forests rich in a broad diversity of cacti and other endemic plants, such as the Jaragua Wine Palm (*Pseudophoenix ekmanii*), a rare species that grows exclusively within park boundaries.

A major attraction in the park is Laguna de Oviedo and its flamingos (*Phoenicopterus ruber*), egrets, White-crowned Pigeons (*Patagioenas leucocephala*), terns, and gulls. The vast majority of these birds use the cays in the southwestern part of the Laguna de Oviedo for nesting in the summer months.

Bahía de las Aguilas is one of the most visited and controversial spots in Jaragua National Park. This beautiful beach is under constant threat of being excluded from the park, as it is highly prized by developers who consider it one of the most valuable plots of real estate on the island. An argument in favor of preserving the area is the fact that the waters off Bahía de las Aguilas hold the largest population of juvenile Hawksbill Turtles in the world.

PLAYA PEDRO CAYMÁN

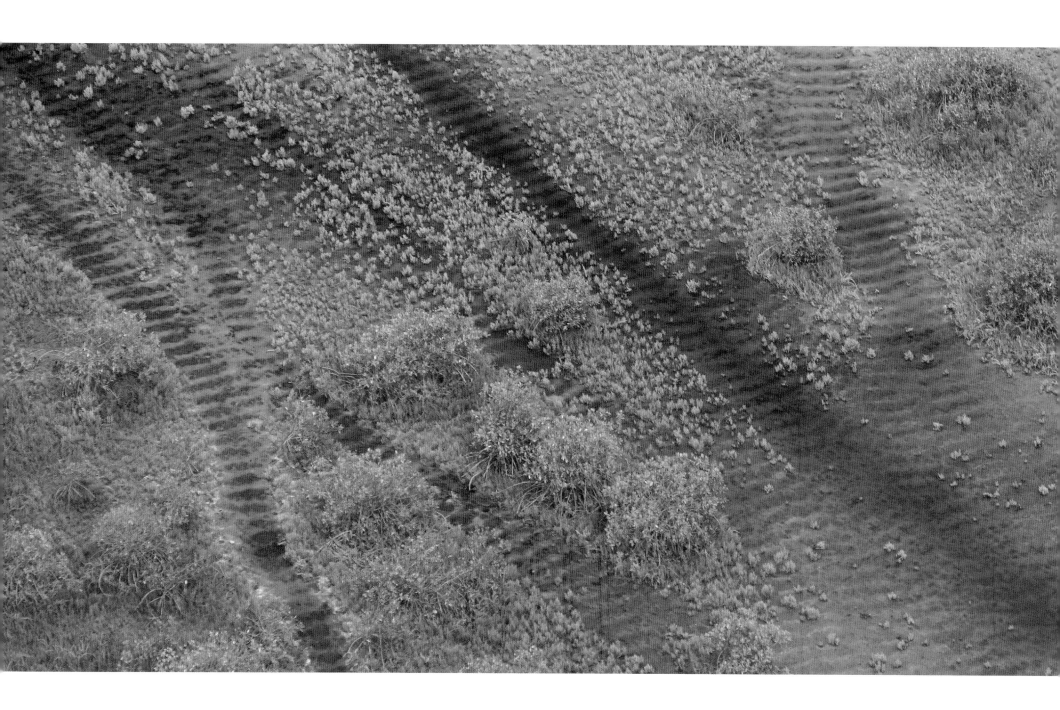

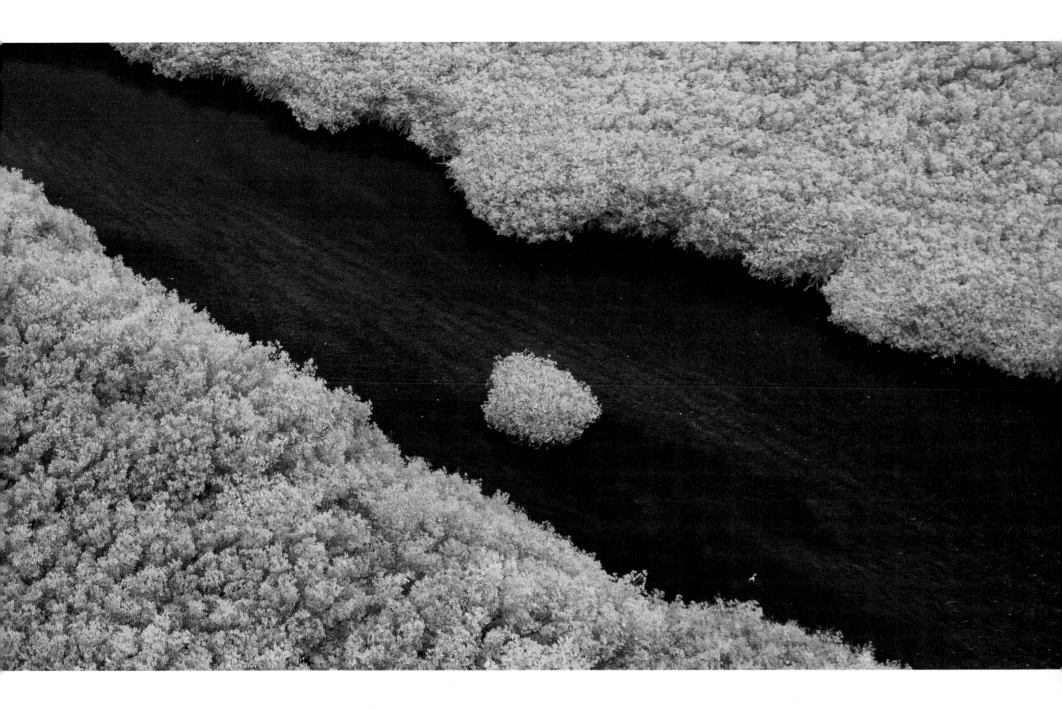

VISTA AÉREA DE HUMEDALES AL ESTE DE LA LAGUNA DE OVIEDO · AERIAL VIEW OF WETLANDS EAST OF LAGUNA DE OVIEDO

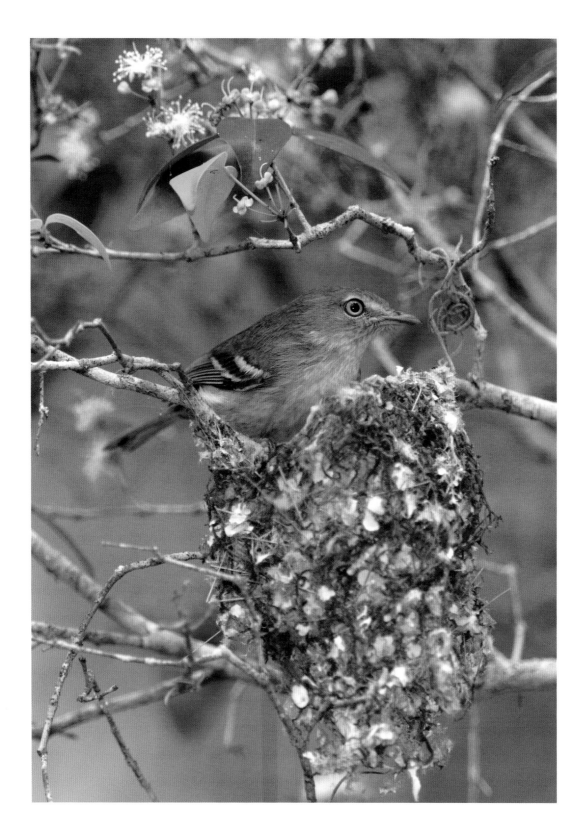

CIGÜITA JULIANA EN SU NIDO · FLAT-BILLED VIREO IN ITS NEST · [*Vireo nanus*] · FONDO PARADI

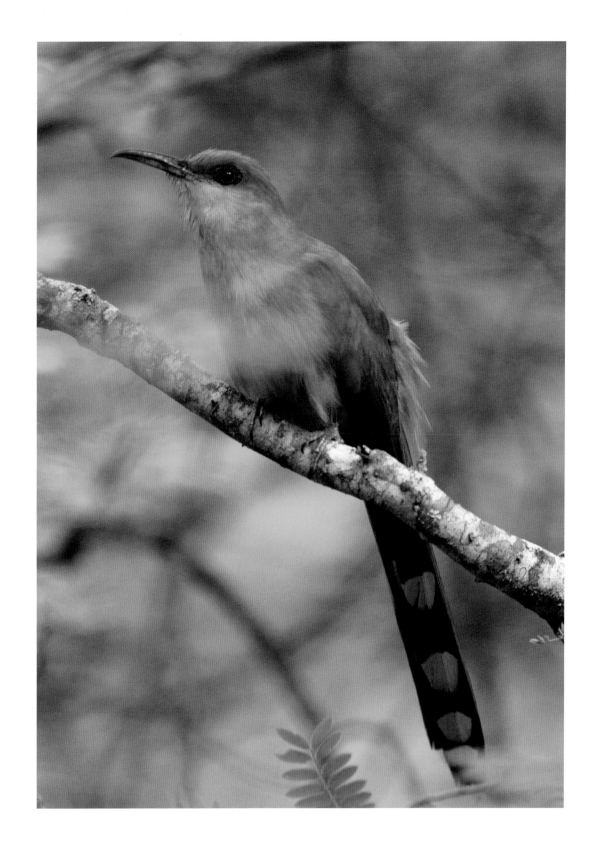

PÁJARO BOBO · HISPANIOLAN LIZARD CUKOO · *[Coccyzus longirostris]* · FONDO PARADI

PELÍCANOS · BROWN PELICANS · [*Pelecanus occidentalis*] · CAYO PUERTO RICO
COMPOSICIÓN DIGITAL | DIGITAL COMPOSITION

GARZA ROJIZA · REDDISH EGRET · [*Egretta rufescens*] · LAGUNA DE OVIEDO

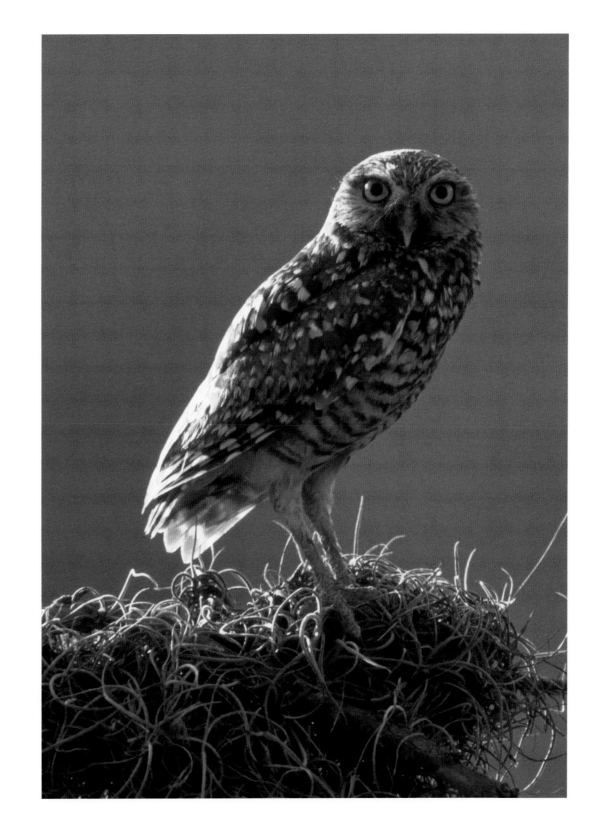

CUCU · BURROWING OWL · [*Athene cunicularia*] · FONDO PARADI

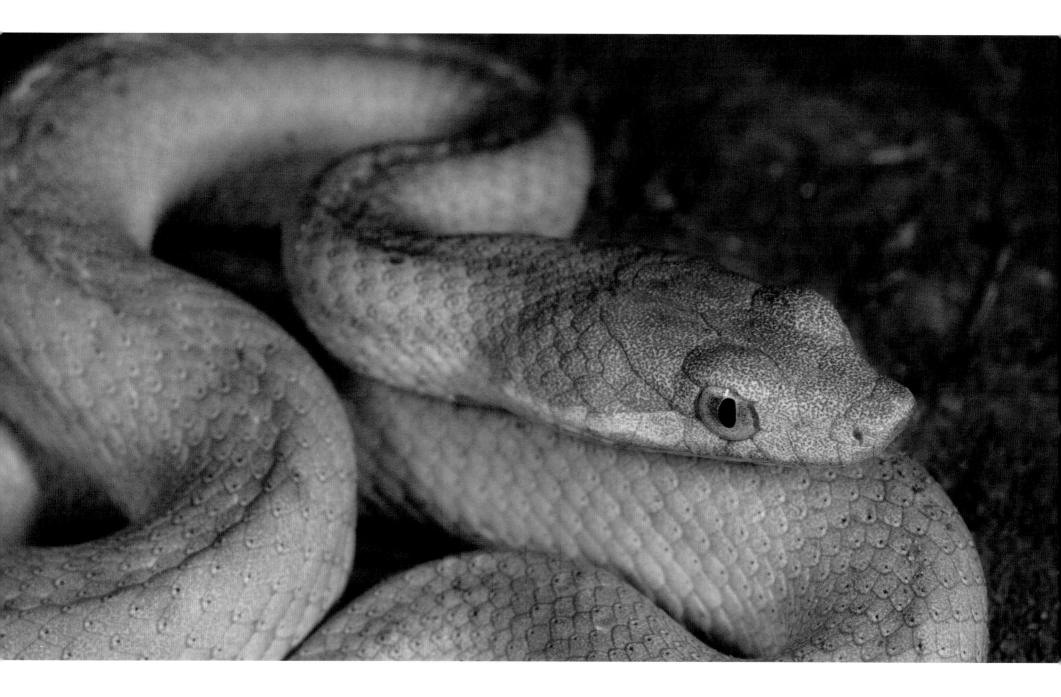

CORREDORA NARÍZ DE CERDO · HOG-NOSED RACER · [*Hypsirhynchus ferox*] · FONDO PARADI

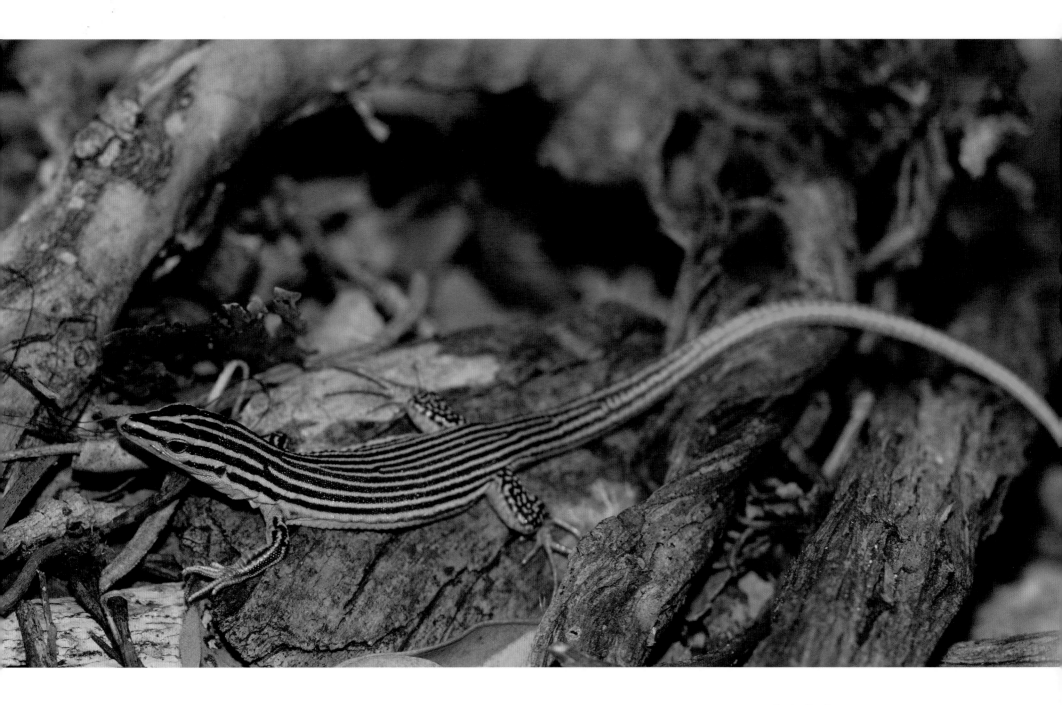

AMEIVA COLA AZUL · PYGMY BLUE-TAILED AMEIVA · [*Ameiva lineolata*] · FONDO PARADI

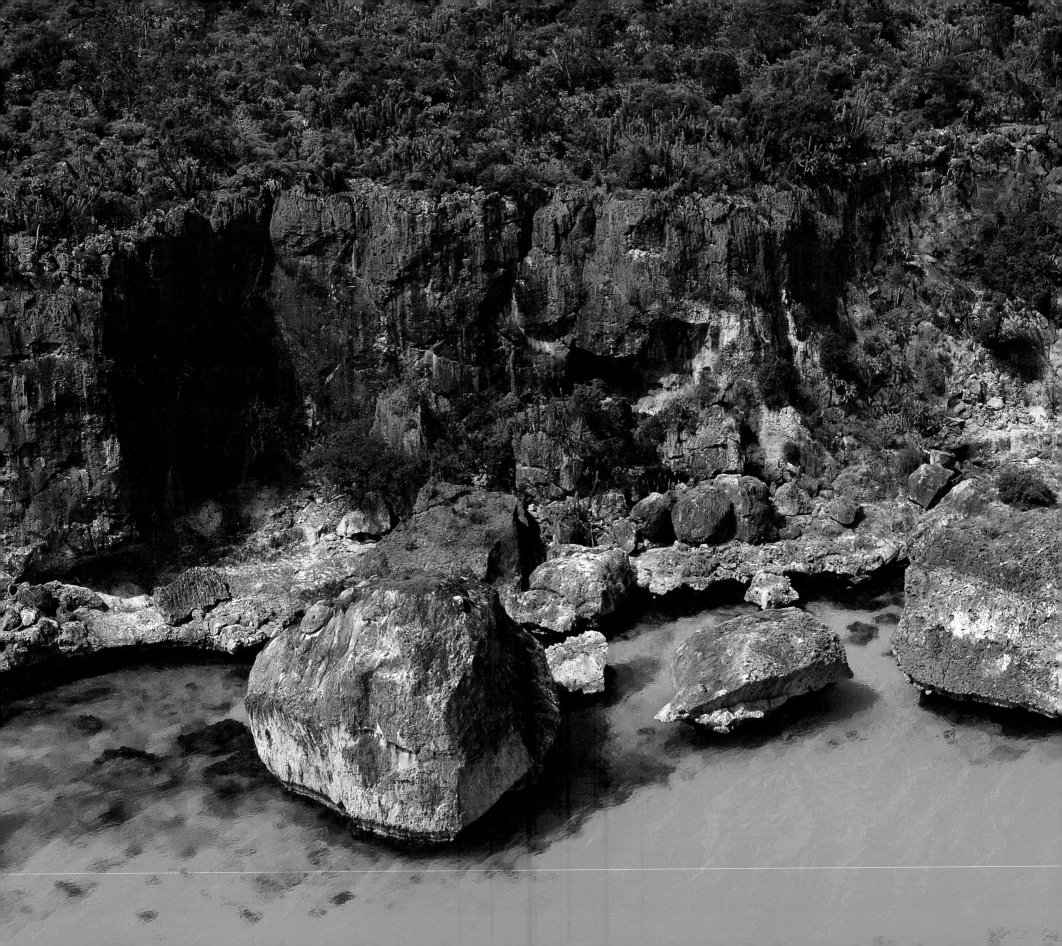

VISTA AÉREA DE ACANTILADOS · AERIAL VIEW OF ROCKY CLIFFS

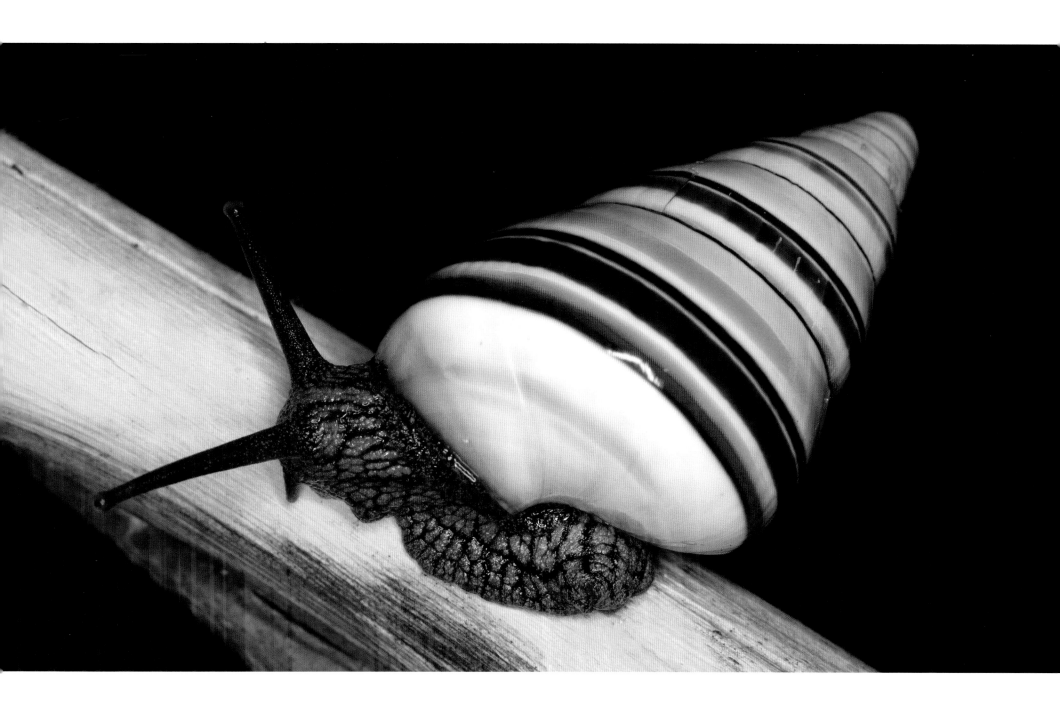

[Liguus virgineus] · FONDO PARADI

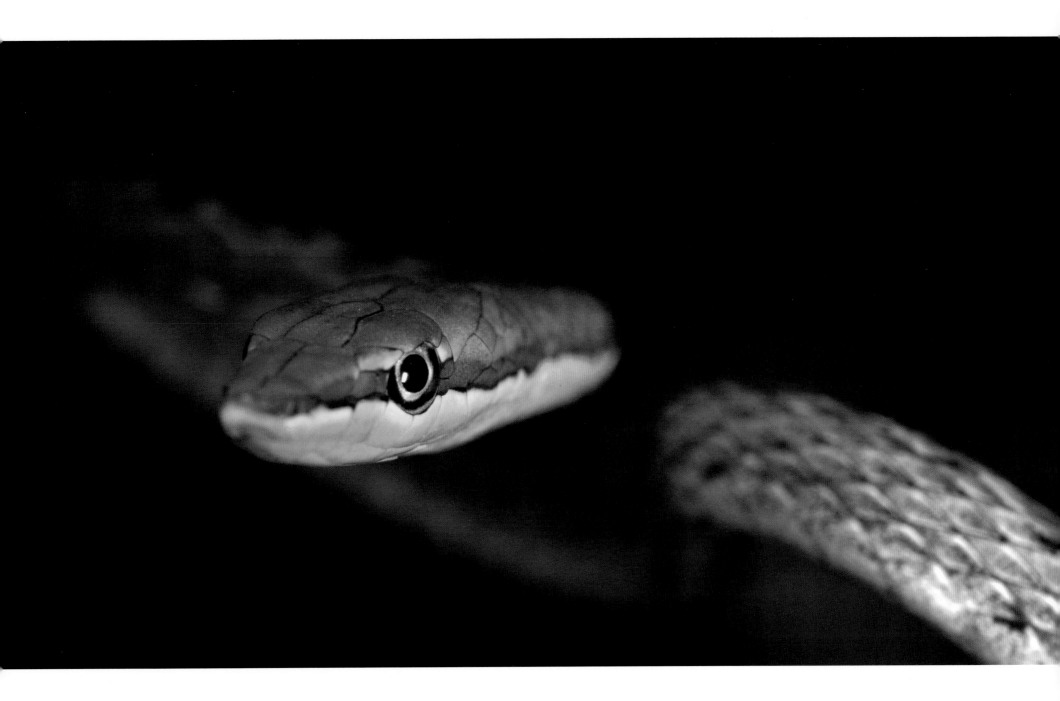

SHARP-NOSED VINESNAKE · [*Uromacer frenatus*] · FONDO PARADI

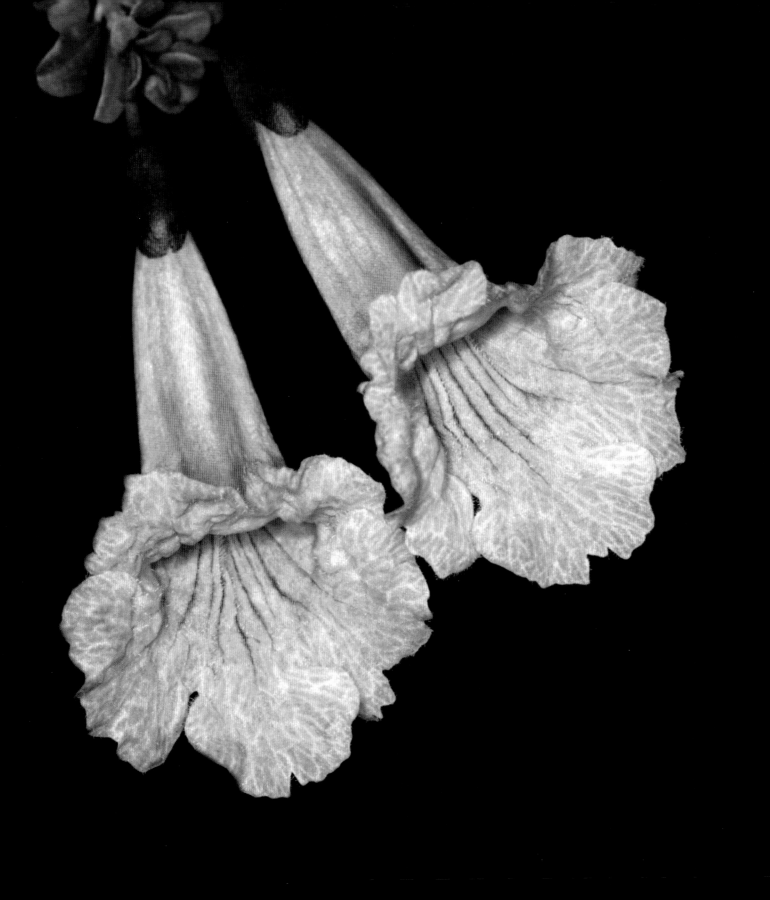

ROBLILLO • *[Tabebuia jaragua]* • BAHÍA DE LAS AGUILAS

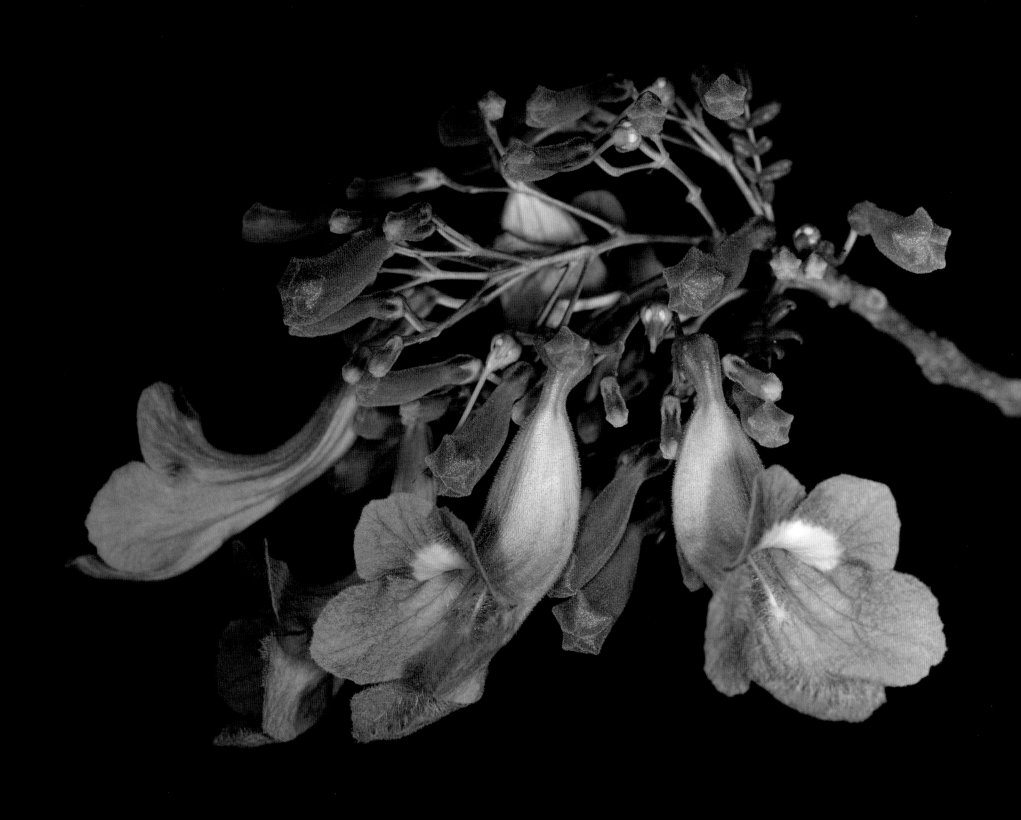

JACARANDA DE EKMAN • EKMAN'S JACARANDA • *[Jacaranda ekmanii]* • CABO ROJO

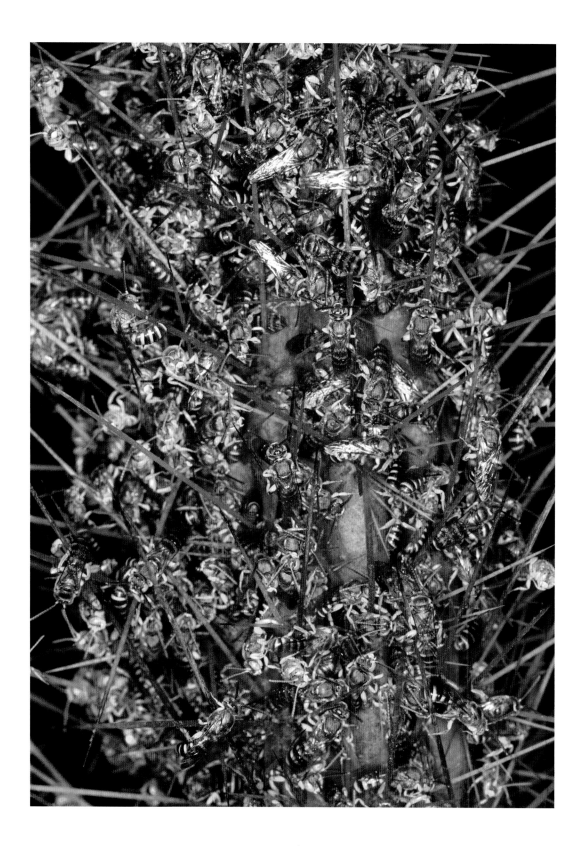

ABEJAS SOLITARIAS • BEES • [*family Halictidae*] • BAHÍA DE LAS AGUILAS

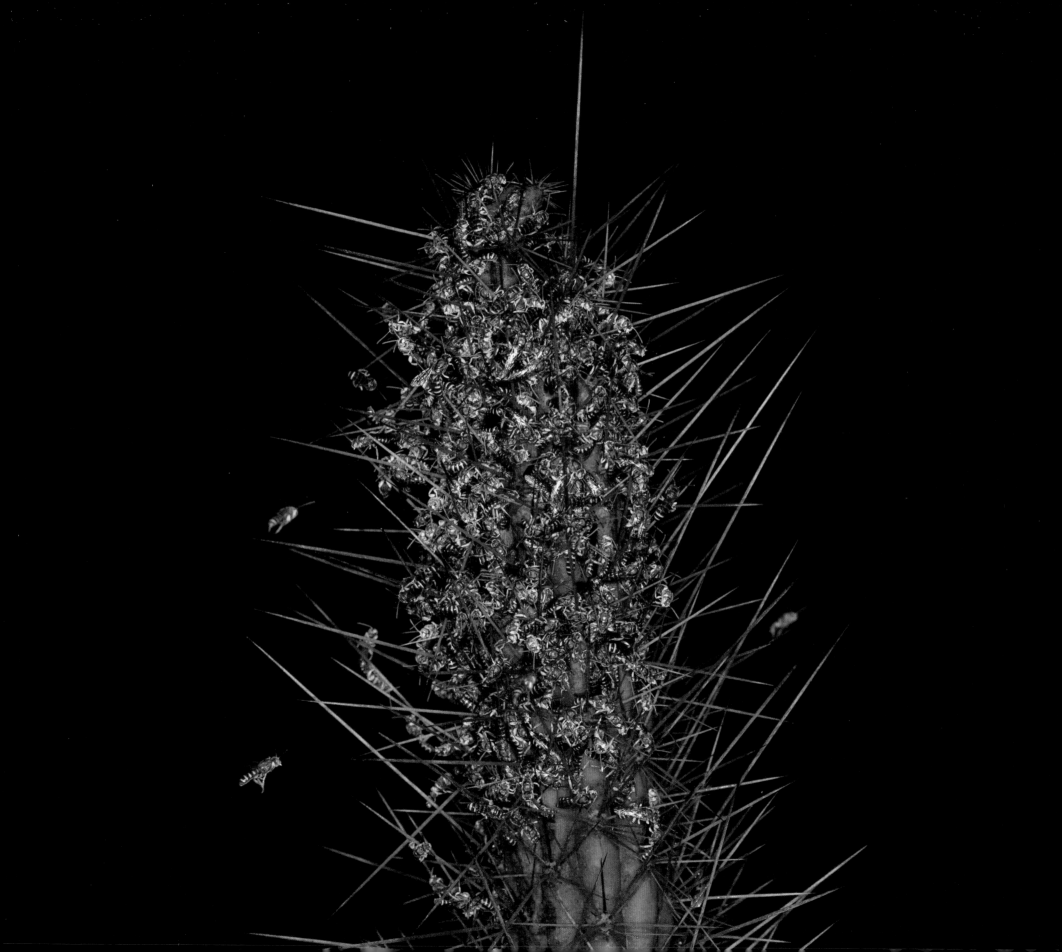

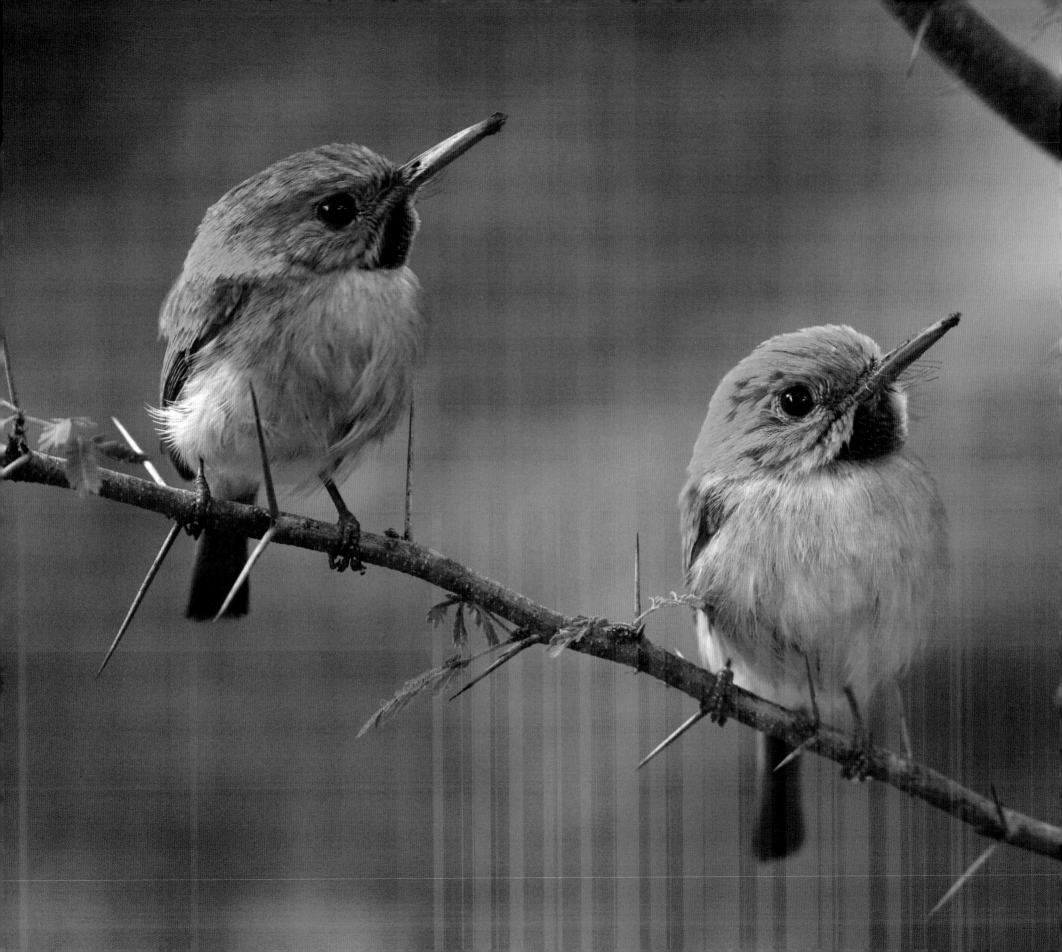

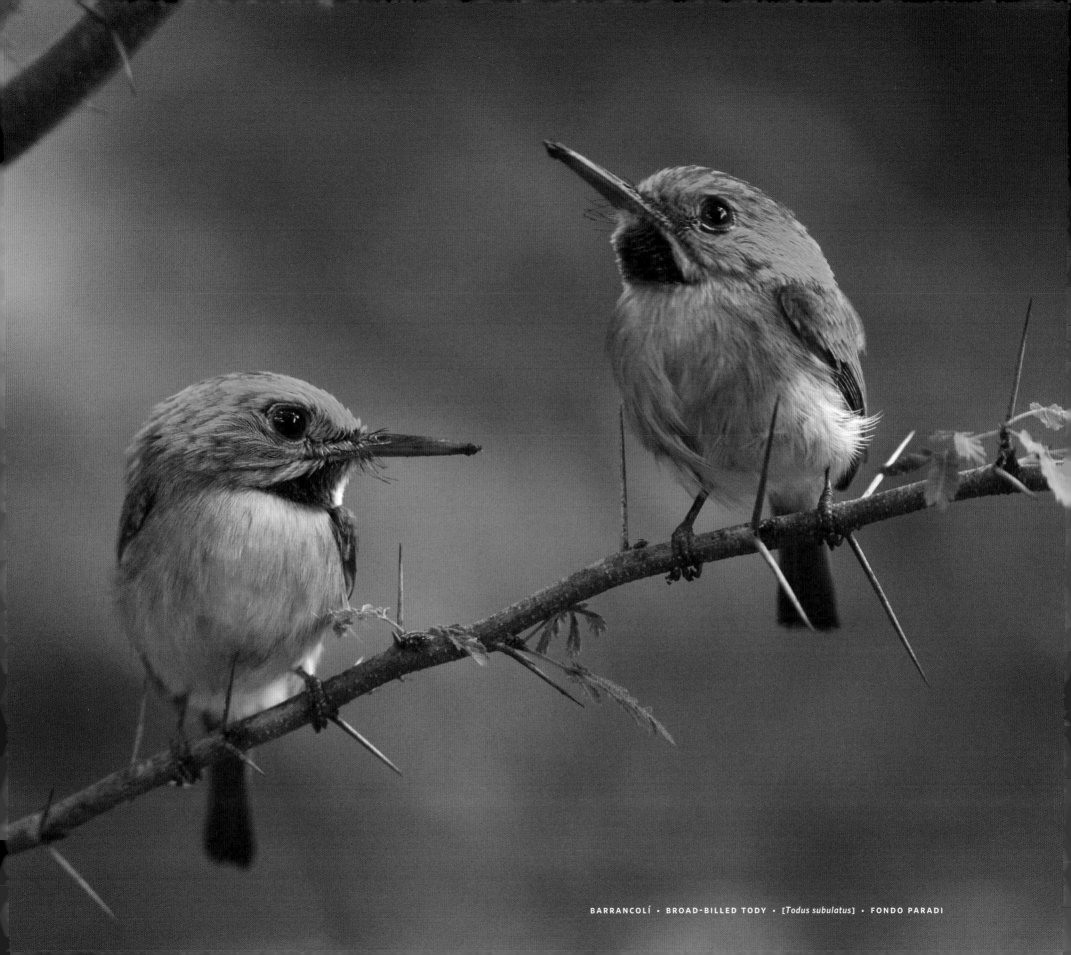

BARRANCOLÍ · BROAD-BILLED TODY · [*Todus subulatus*] · FONDO PARADI

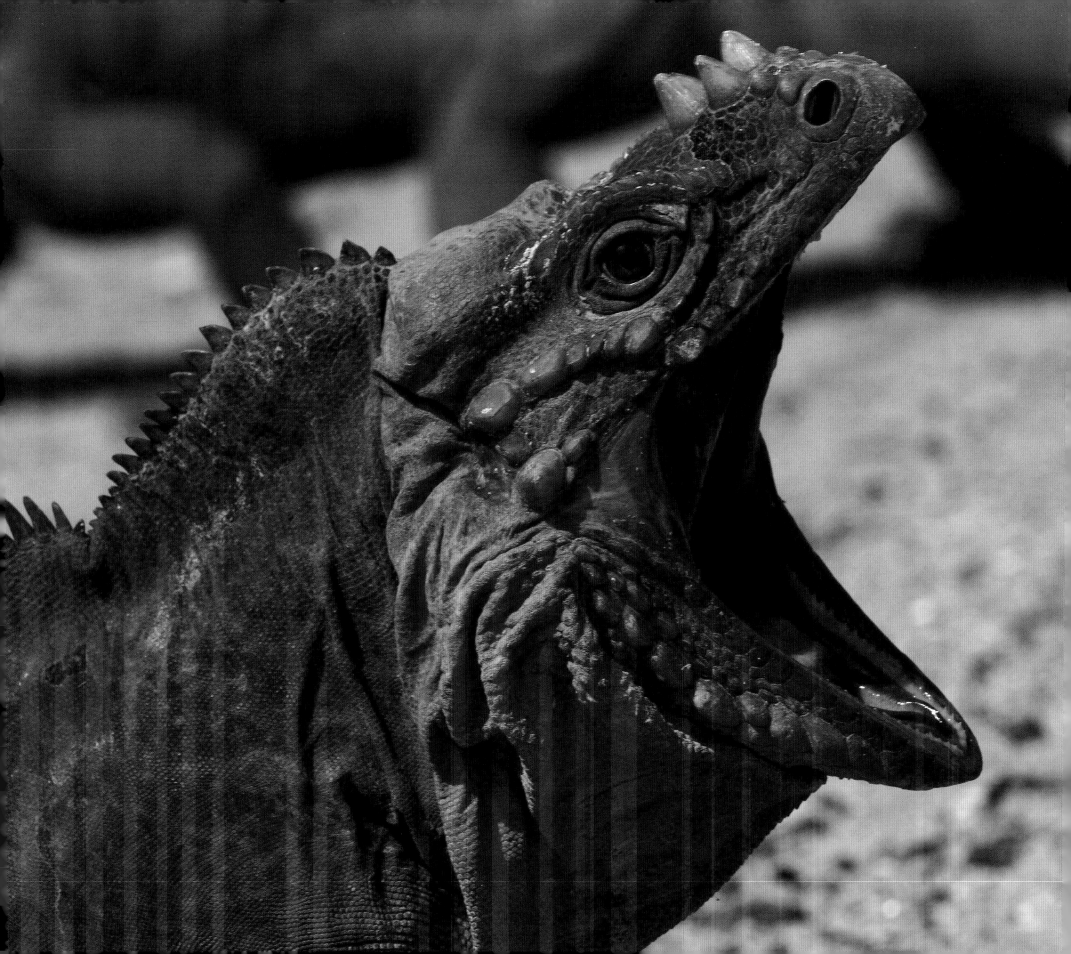

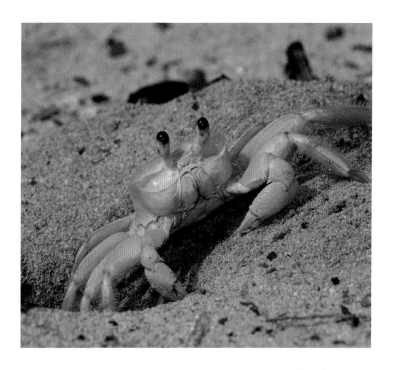

GHOST CRAB · [*Oxypode cuadrata*]

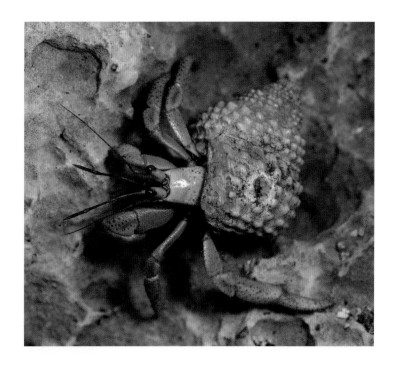

MAKEY · HERMIT CRAB · [*Zoenobita clypeatus*]

IGUANA RINOCERONTE · RHINOCEROS IGUANA · [*Cyclura cornuta*]

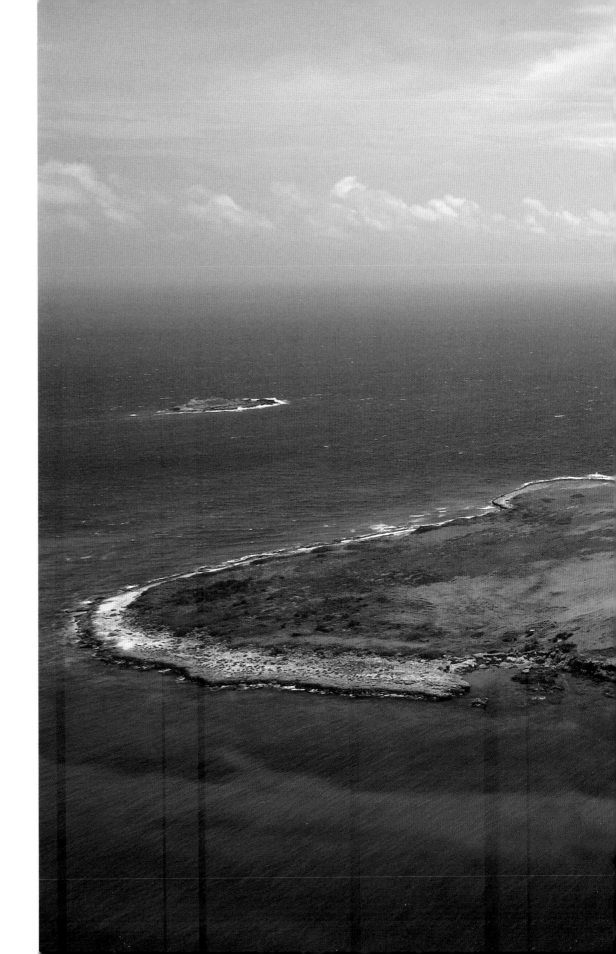

104

VISTA AÉREA DE LA ISLA ALTO VELO · AERIAL VIEW OF ISLA ALTO VELO

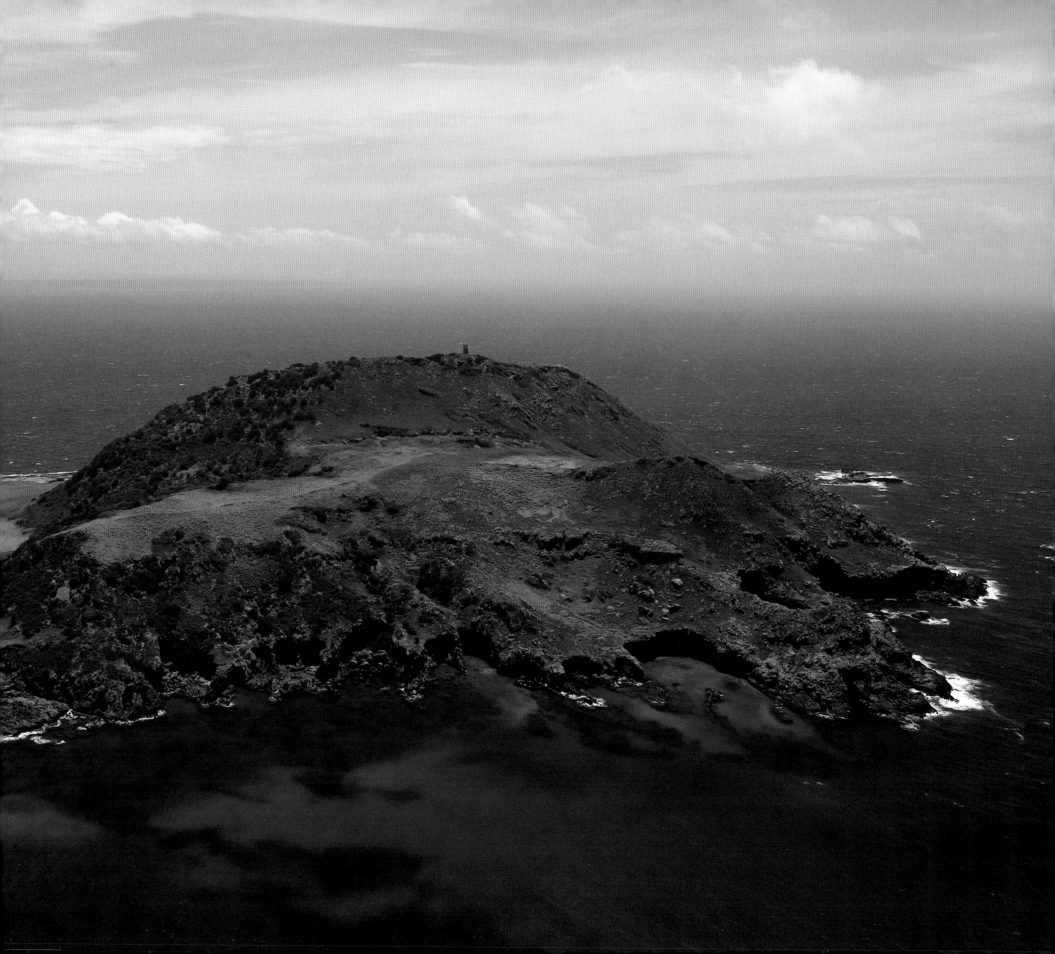

GAVIOTA OSCURA · SOOTY TERN · [*Onychoprion fuscata*] · ISLA ALTO VELO

GAVIOTA MONJA · BRIDLED TERN · [*Onychoprion anaethetus*] · ISLA ALTO VELO
COMPOSICIÓN DIGITAL │ DIGITAL COMPOSITION

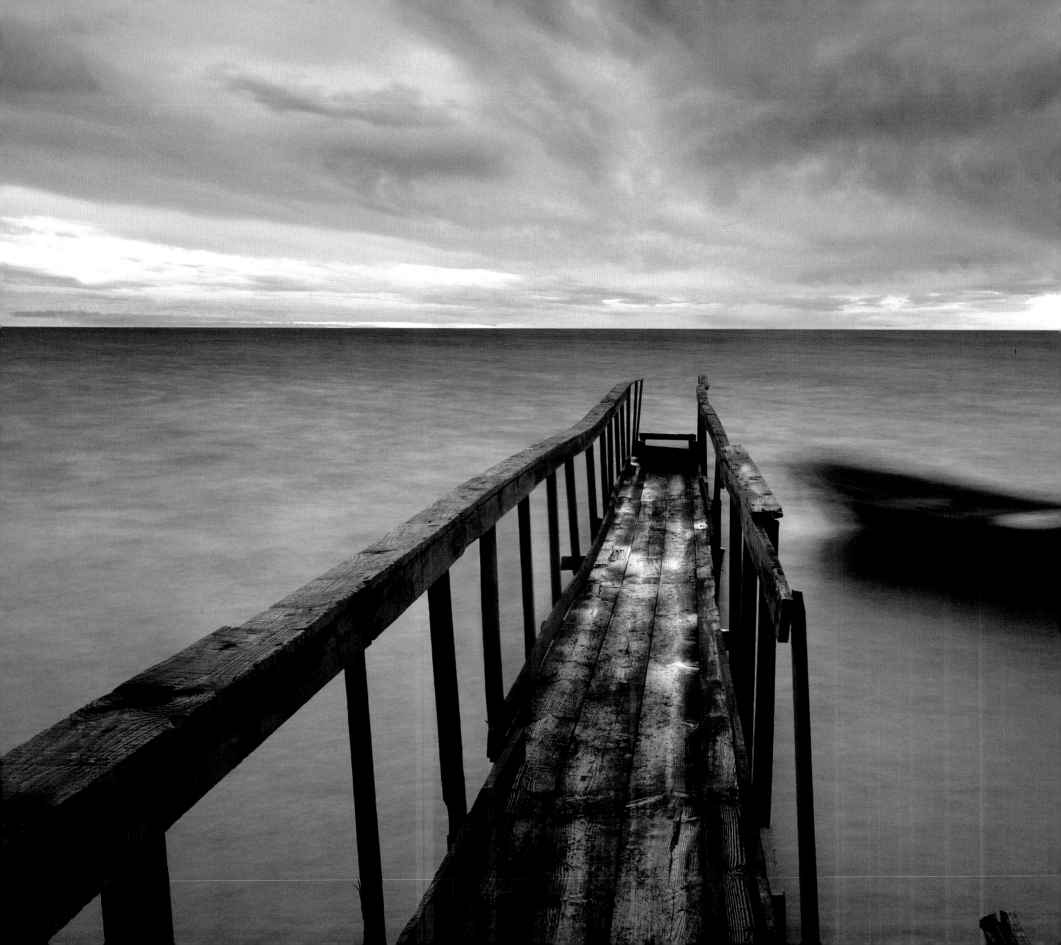

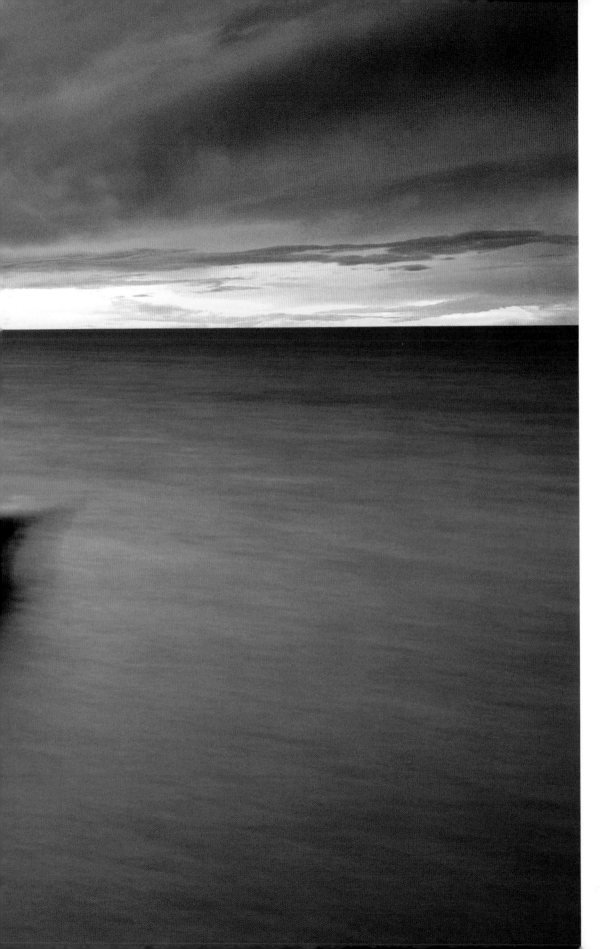

AMANECER EN LA LAGUNA DE OVIEDO · SUNRISE AT LAGUNA DE OVIEDO

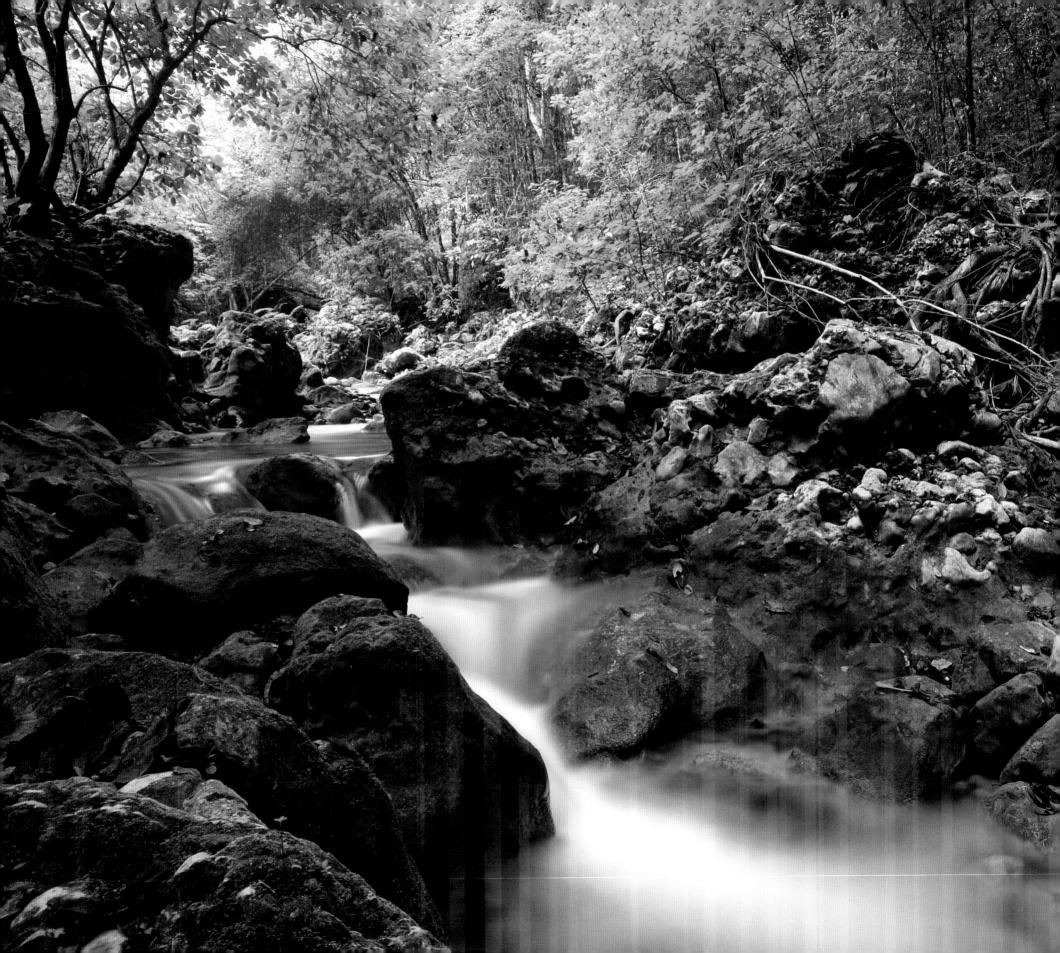

PARQUE NACIONAL SIERRA DE BAHORUCO

CON UNA SUPERFICIE APROXIMADA DE 1,000 KILÓMETROS cuadrados, el Parque Nacional Sierra de Bahoruco tiene la mayor diversidad de ambientes distribuidos en un amplio rango de altura. A nivel del mar, los bosques secos espinosos dominan el ambiente. Son seguidos por un bosque seco tropical, un bosque húmedo latifoliado y los bosque de pinos (*Pinus occidentalis*). La parte más alta es Loma del Toro, a 2,367 metros de altura.

Toda la cubierta boscosa sobre los 800 metros se considera el más importante hábitat en la isla debido al elevado índice de endemismo de plantas y animales en estos bosques. Es necesario aclarar que estos hábitats son también los más amenazados por la deforestación, el ganado y las prácticas agrícolas no sostenibles. Algunas áreas de importancia están fuera de los límites del parque, como son El Río Mulito, La Placa en Puerto Escondido y Rabo de Gato—todos tesoros naturales que merecen ser incluidos dentro del parque. Animales raros como el Solenodonte (*Solenodon paradoxus*) y la Hutía (*Plagiodontia aedium*) habitan en estos lugares.

El Parque Nacional Sierra de Bahoruco es también el único lugar en la isla donde 29 de las 31 aves endémicas han sido reportadas. Los primeros encuentros con Papagayos (*Priotelus roseigaster*), con el Barrancolí (*Todus subulatus*) y con las Cigüitas Aliblanca (*Xenoligea montana*) son experiencias inolvidables para los visitantes del parque.

A pesar de su gran importancia, porciones del parque en la frontera dominico-haitiana (incluyendo áreas con bosques primarios) están bajo constante presión de campesinos y taladores (que buscan madera para leña y para hacer carbón).

WITH AN APPROXIMATE SURFACE AREA OF 1,000 SQUARE kilometers, Sierra de Bahoruco National Park has the greatest diversity of habitats, which are distributed across a broad altitudinal range. At sea level, dry thorn scrub is the dominant habitat, followed by tropical dry forest, wet broadleaf, and pine forest (*Pinus occidentalis*). Its highest point is Loma del Toro, at 2,367 meters in altitude.

All forest cover above 800 meters is considered the most important habitat on the island, given the high level of endemic plants and

RÍO MULITO

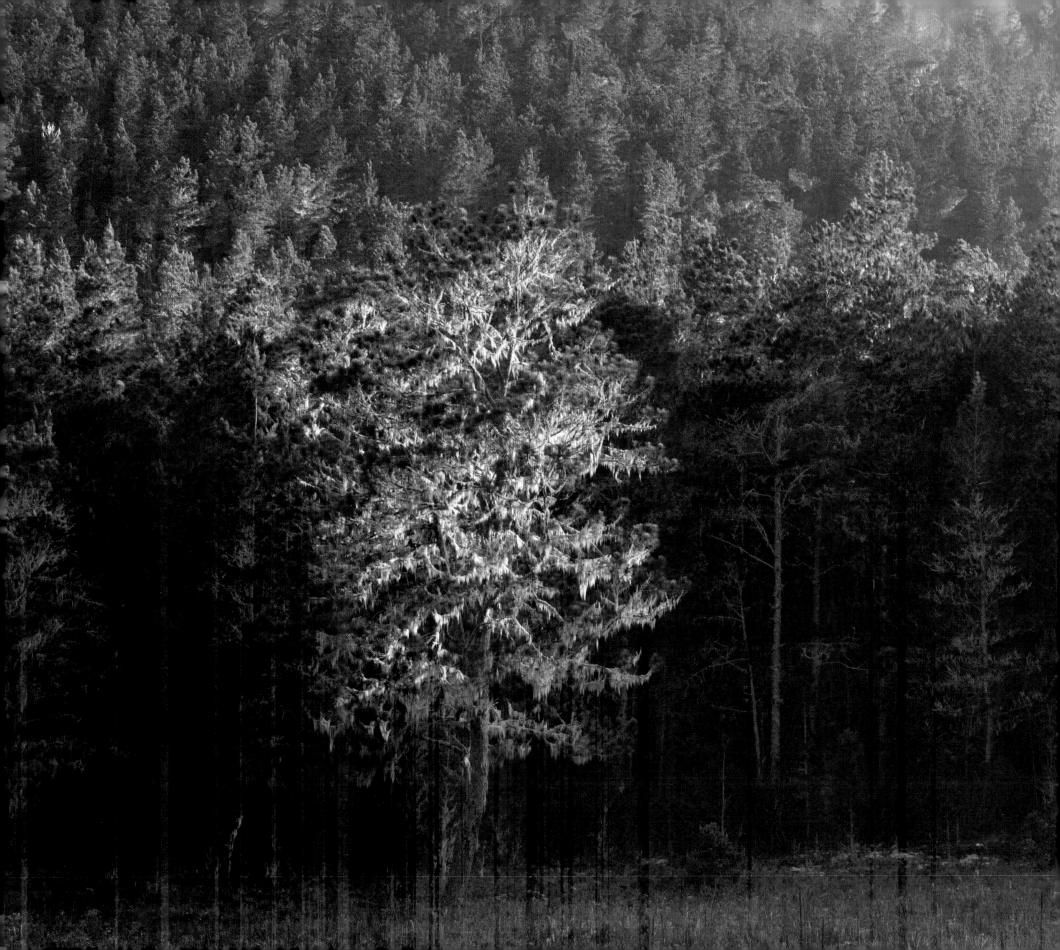

animals in these forests. Needless to say, these habitats are also the most threatened by deforestation, cattle grazing, and unsustainable agricultural practices. Some of these important areas are also outside park boundaries, such as Río Mulito, La Placa in Puerto Escondido, and Rabo de Gato—all true natural treasures that deserve to be included within the park's range. Rare animals such as the solenodon (*Solenodon paradoxus*) and the hutia (*Plagiodontia aedium*) inhabit these places.

Sierra de Bahoruco National Park is also the only place on the island where 29 out of 31 endemic birds have been reported. First encounters with Trogons (*Priotelus roseigaster*), Broad-billed Todies (*Todus subulatus*), and White-winged Warblers (*Xenoligea montana*) are unforgettable experiences for park visitors.

Regardless of its great importance, portions of the park on the Haiti–Dominican Republic border (including areas with primary forests) are under constant pressure from farmers and loggers (seeking both wood and charcoal).

BOSQUE DE PINOS · PINE FOREST · VILLA AIDA

LECHUZA OREJITA · STYGIAN OWL · [*Asio stygius*] · ACEITILLAR

ESPECIE AMENAZADA | THREATENED SPECIES

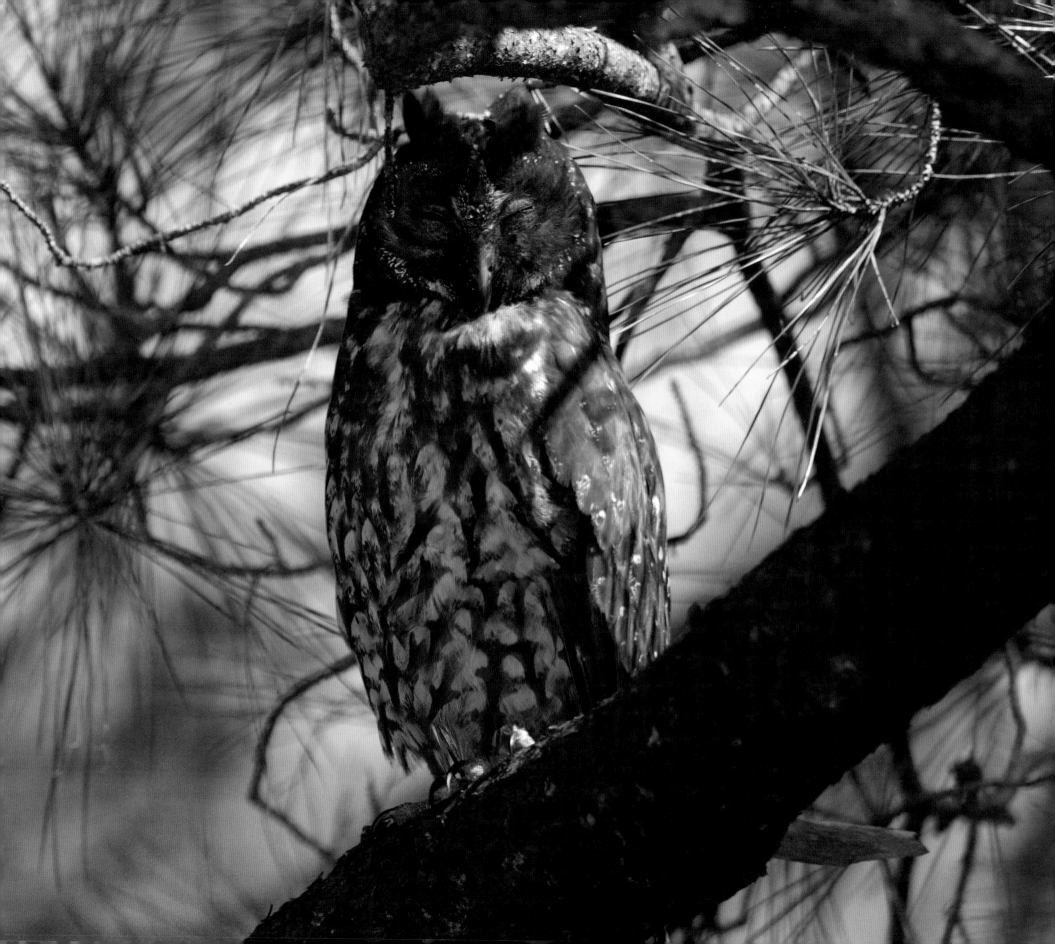

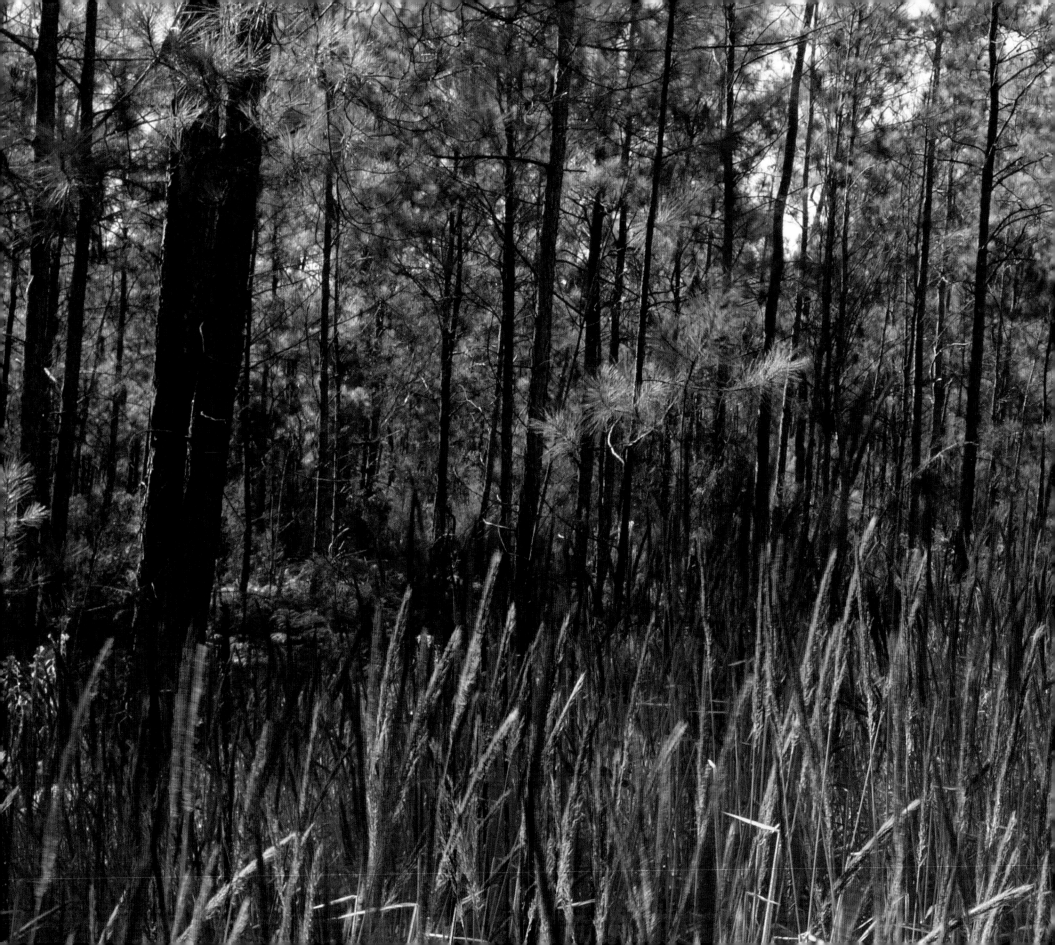

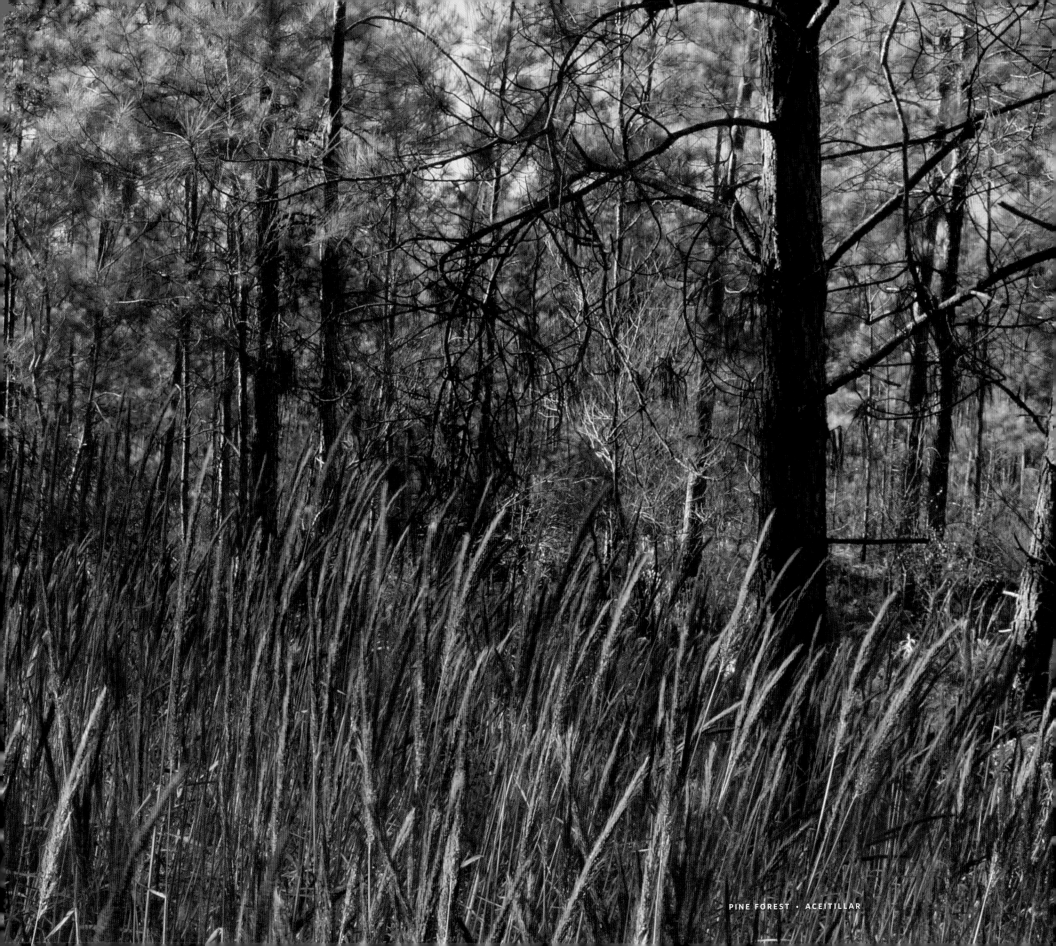

PINE FOREST • ACEITILLAR

MAGUEY · AGAVE · [*Agave antillarum*] · ACEITILLAR

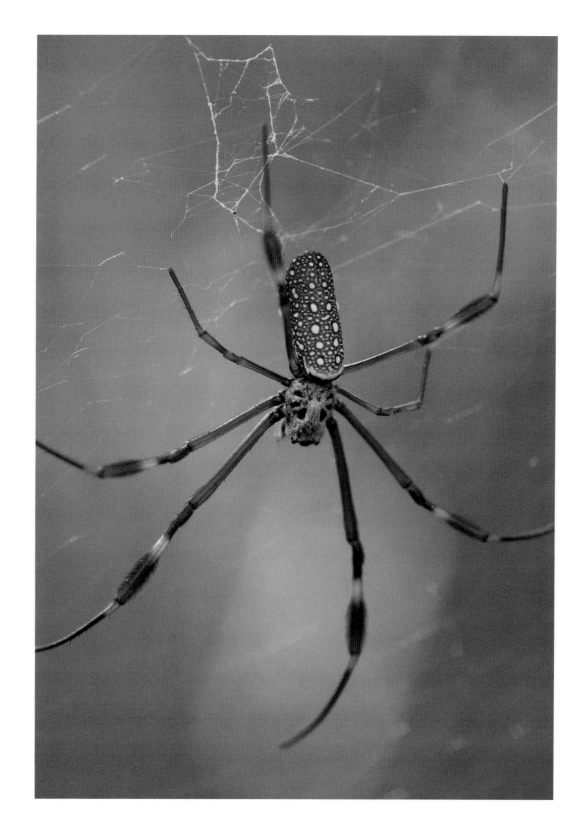

[*Nephila clavipes*] · **ACEITILLAR**

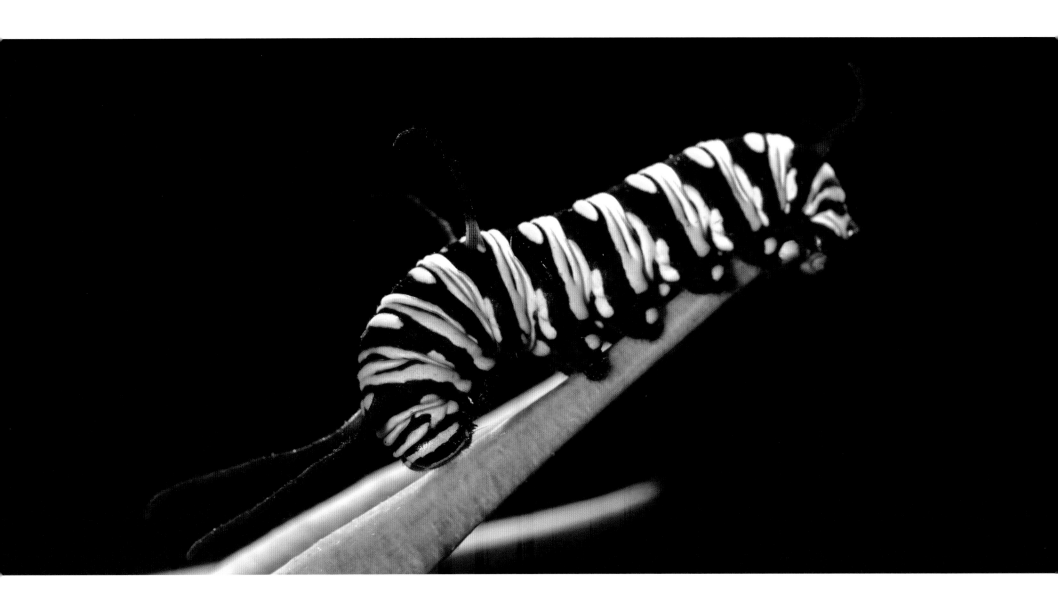

ORUGA • CATERPILLAR • [*Danaus gilippus*] • ACEITILLAR

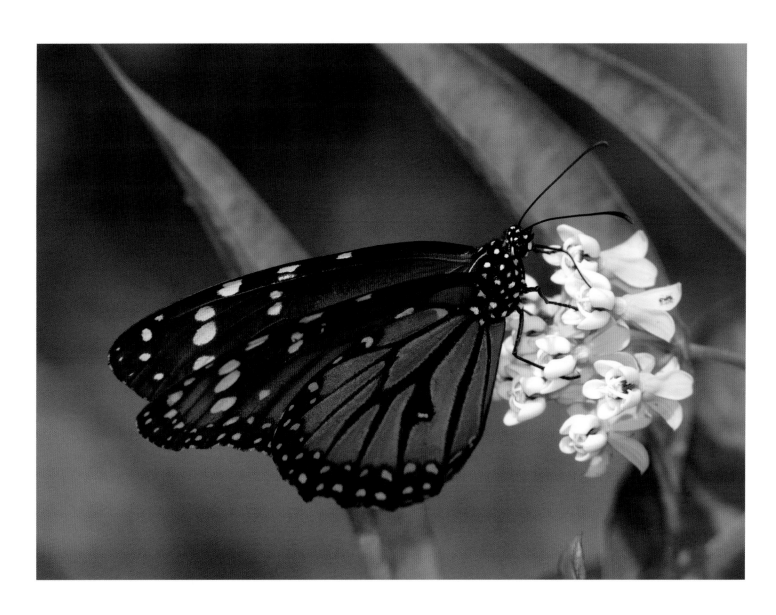

REINA · QUEEN · [*Danaus gilippus*] · ACEITILLAR

[*Coccothrinax scoparia*] · ACEITILLAR

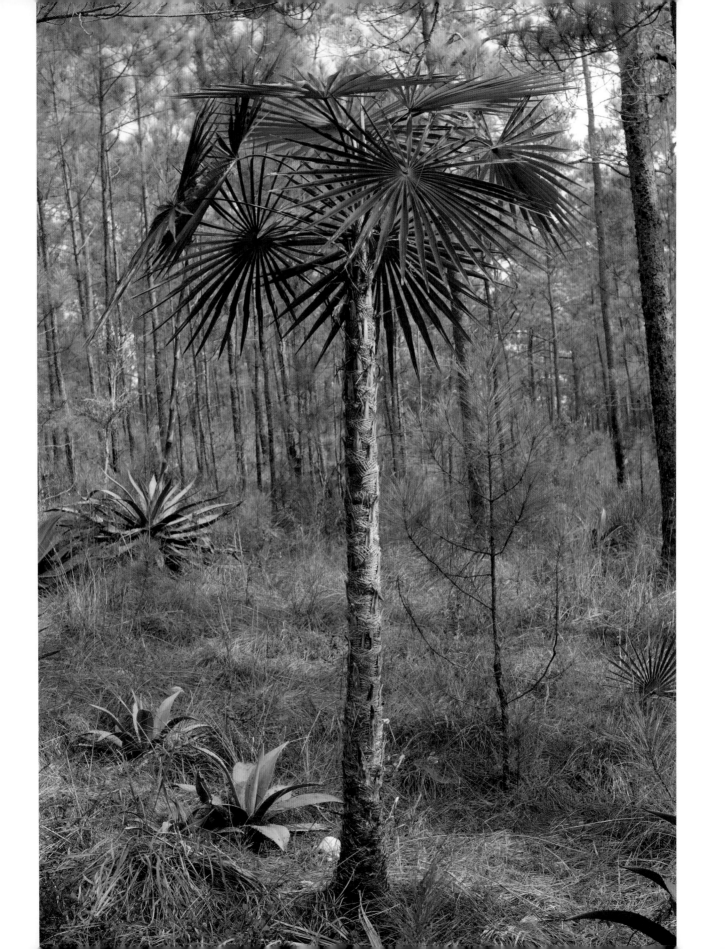

RÍO MULITO

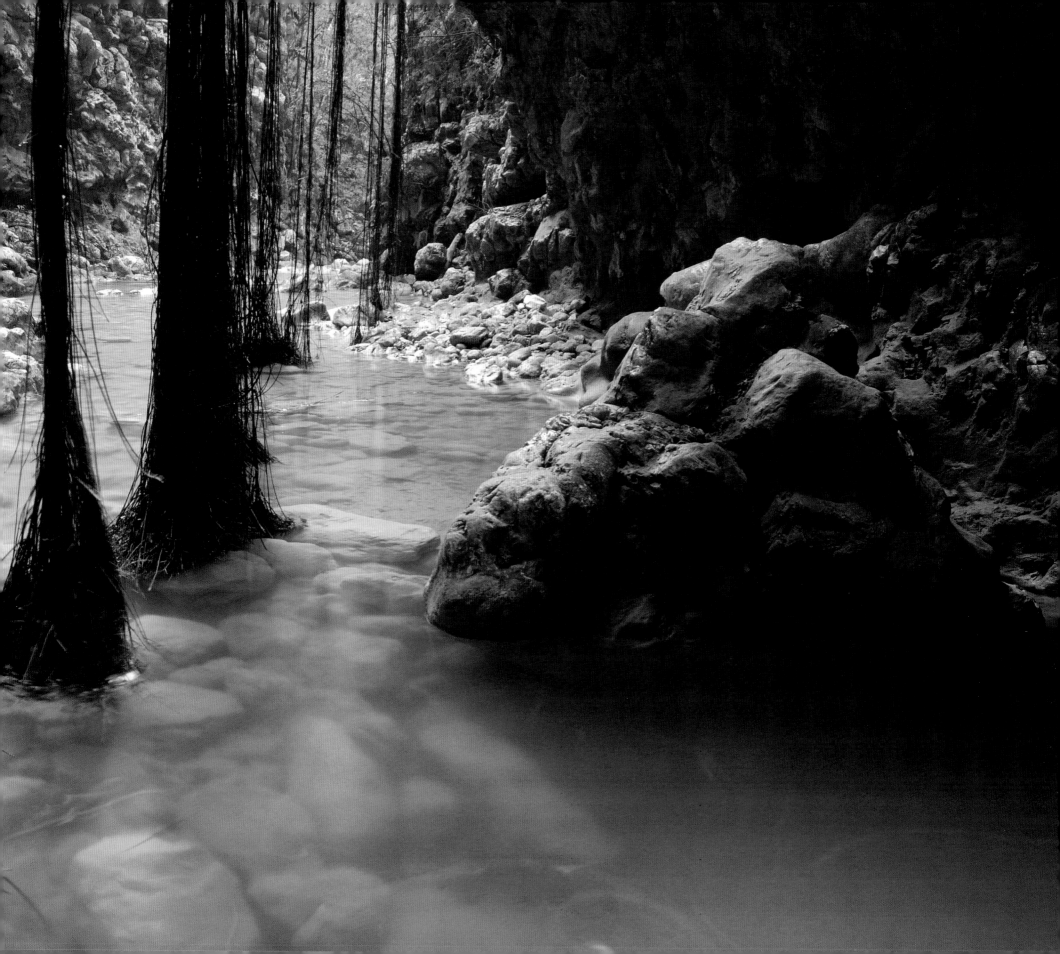

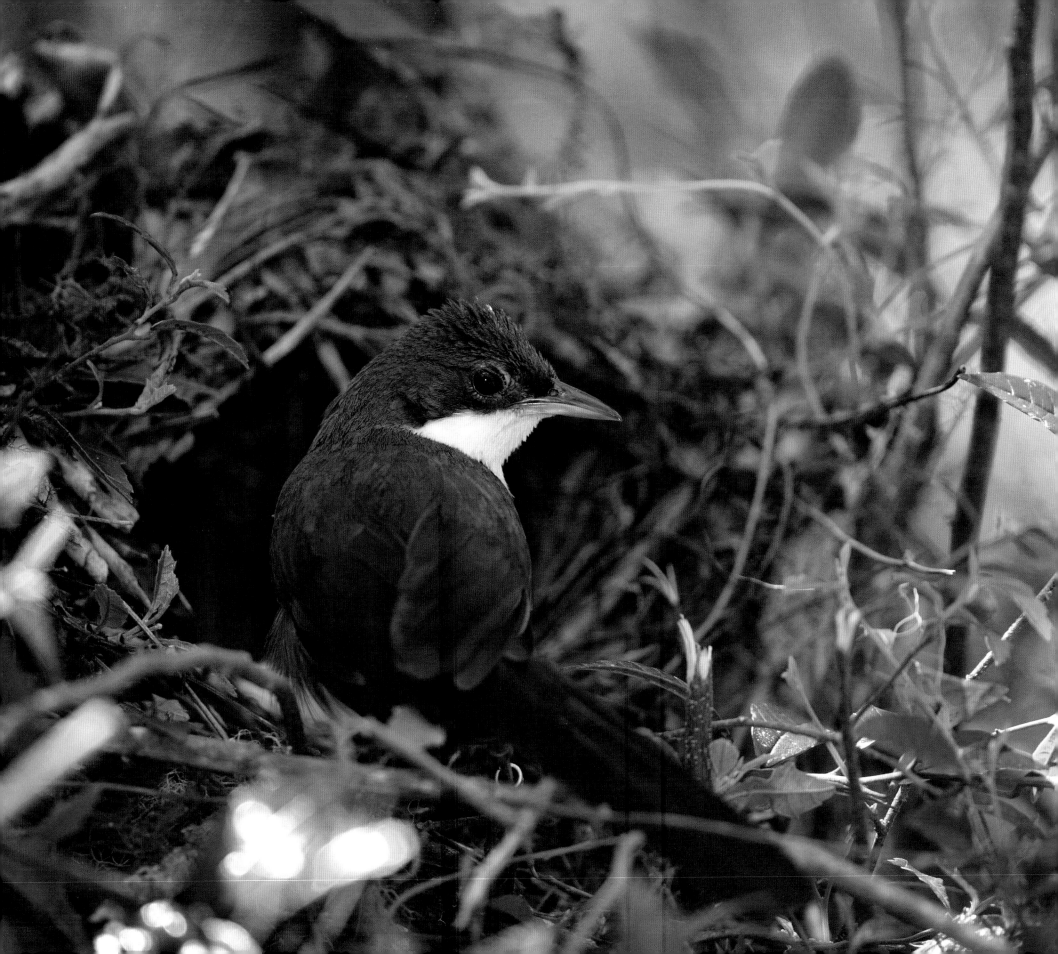

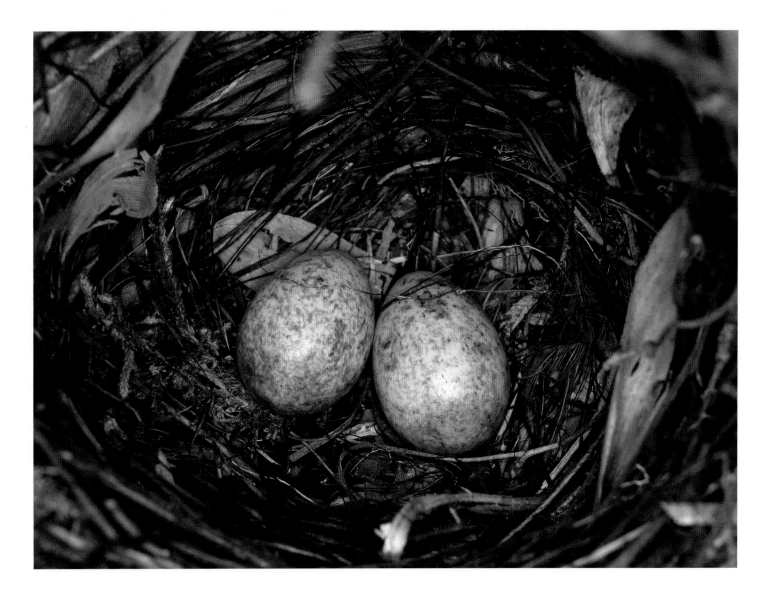

PRIMERA DOCUMENTACIÓN DEL NIDO DE CHIRRI DE BAHORUCO · FIRST WESTERN CHAT-TANAGER NEST EVER DOCUMENTED

CHIRRI DE BAHORUCO ENTRANDO AL NIDO · WESTERN CHAT-TANAGER ENTERING NEST · [*Calyptophilus tertius*] · PUEBLO VIEJO

ESPECIE EN ALTO RIESGO DE EXTINCIÓN | CRITICALLY ENDANGERED SPECIES

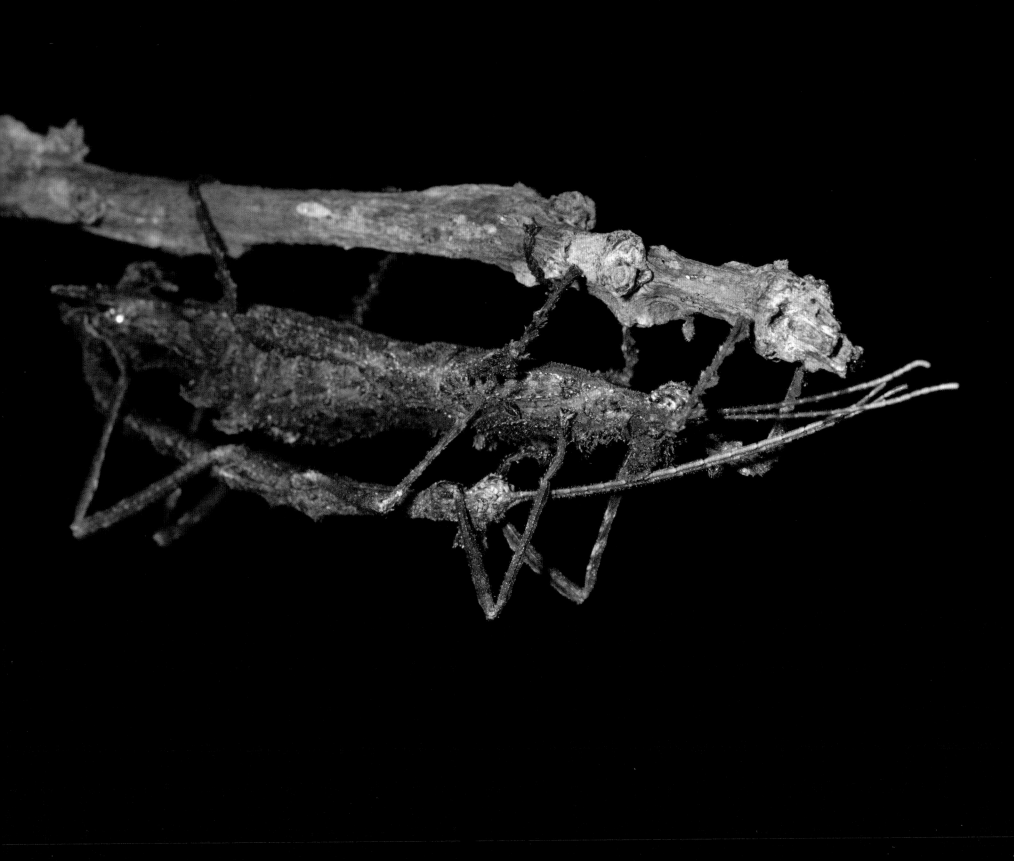

MARIAPALITOS COPULANDO · COPULATING STICK BUGS · PUEBLO VIEJO

[Platystele ovalifolia] · CHARCO DE LA PALOMA

[Antillanorchis gundlachii] · HOYO DE PELEMPITO

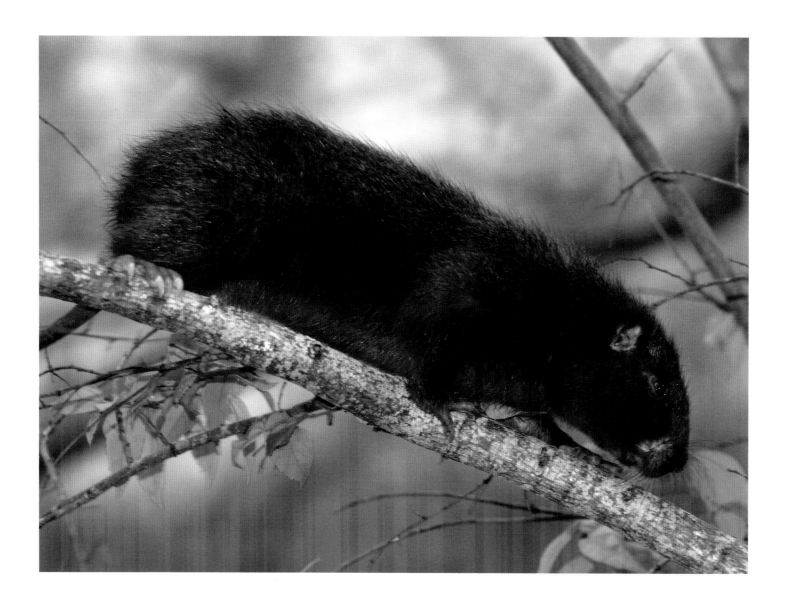

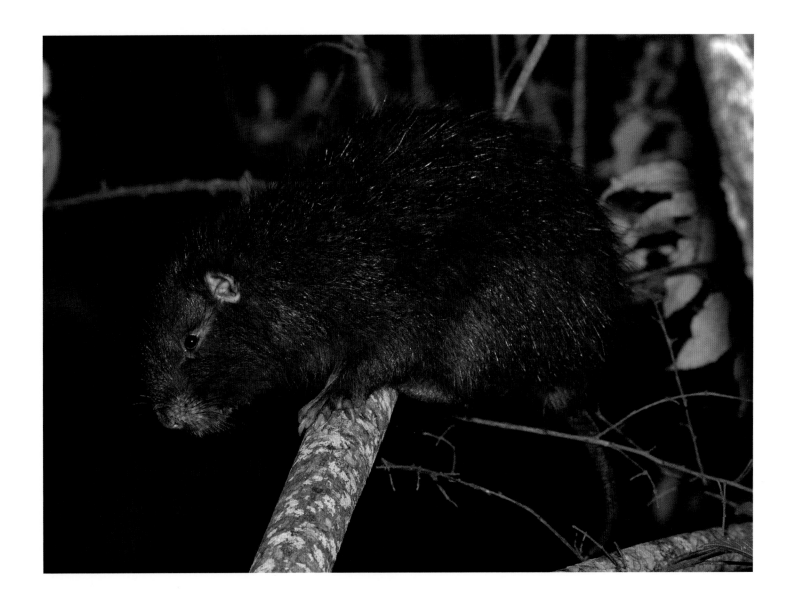

HUTIA · HISPANIOLAN HUTIA · *[Plagiodontia aedium]* · MENCÍA

134

RÍO MULITO

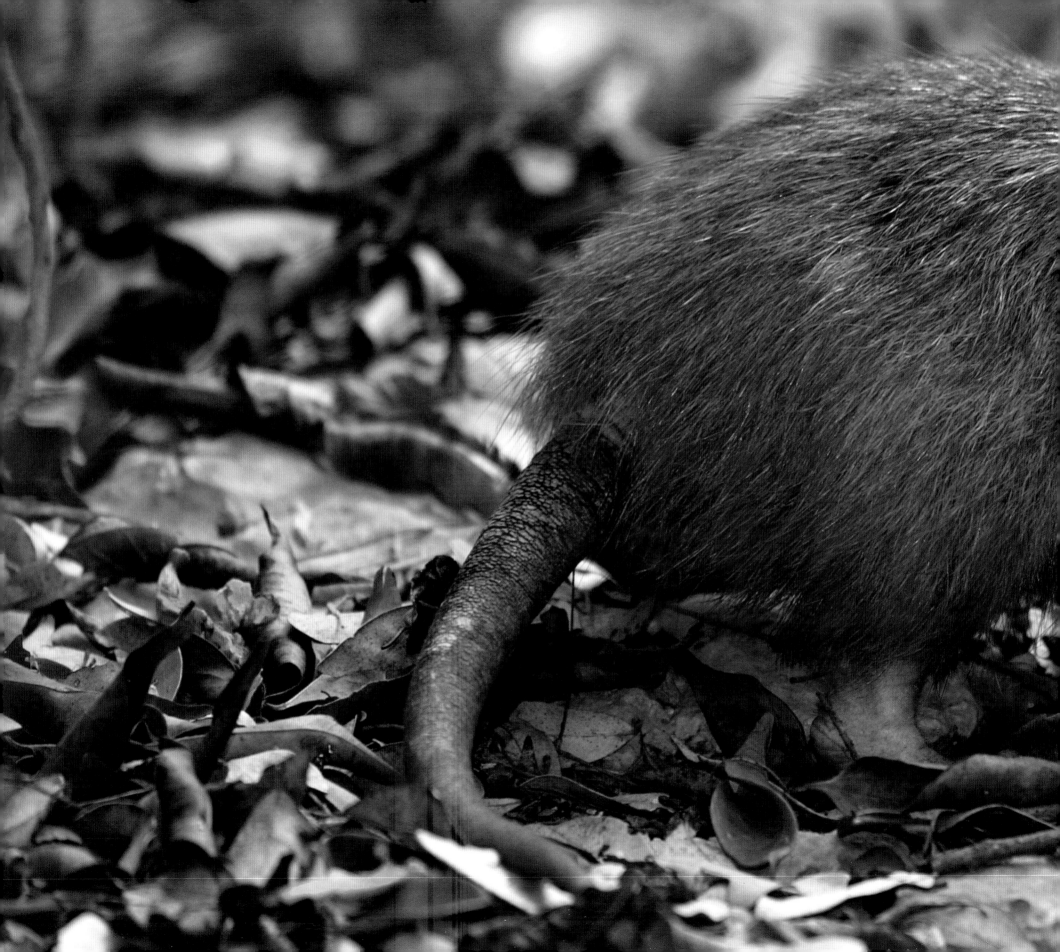

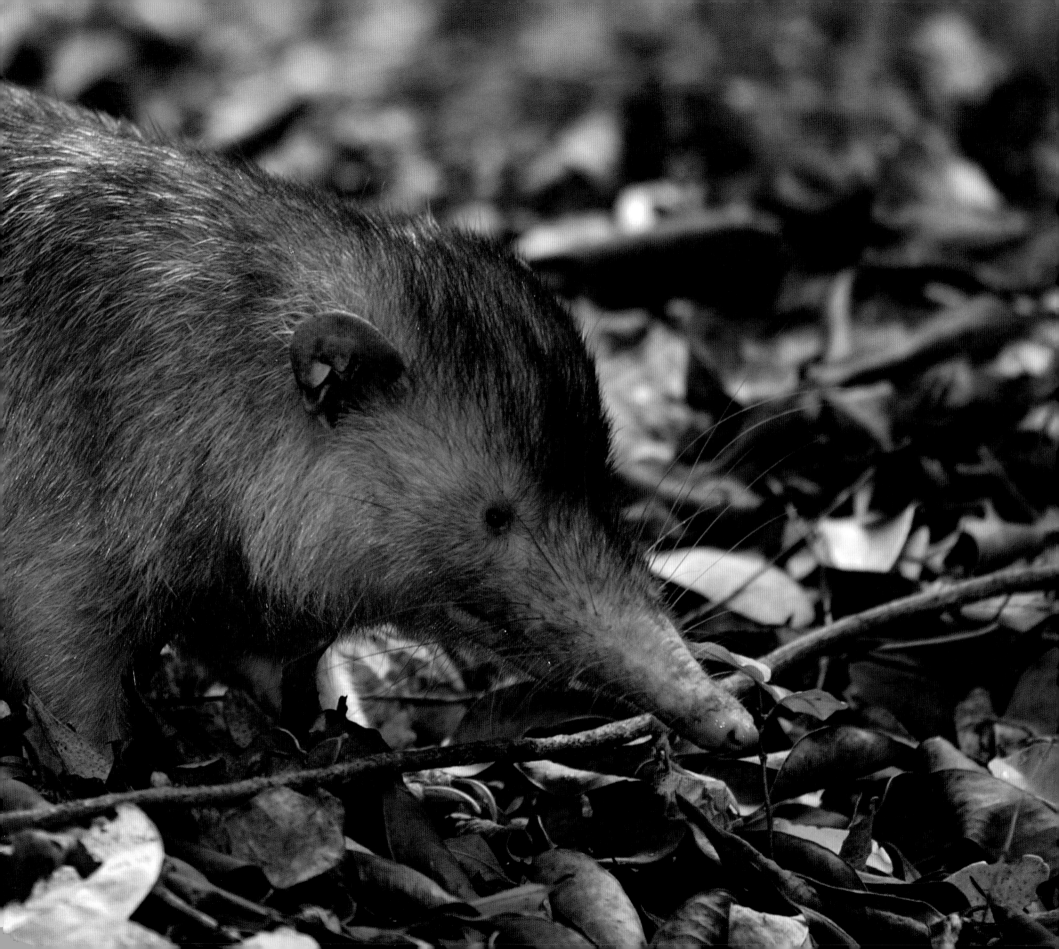

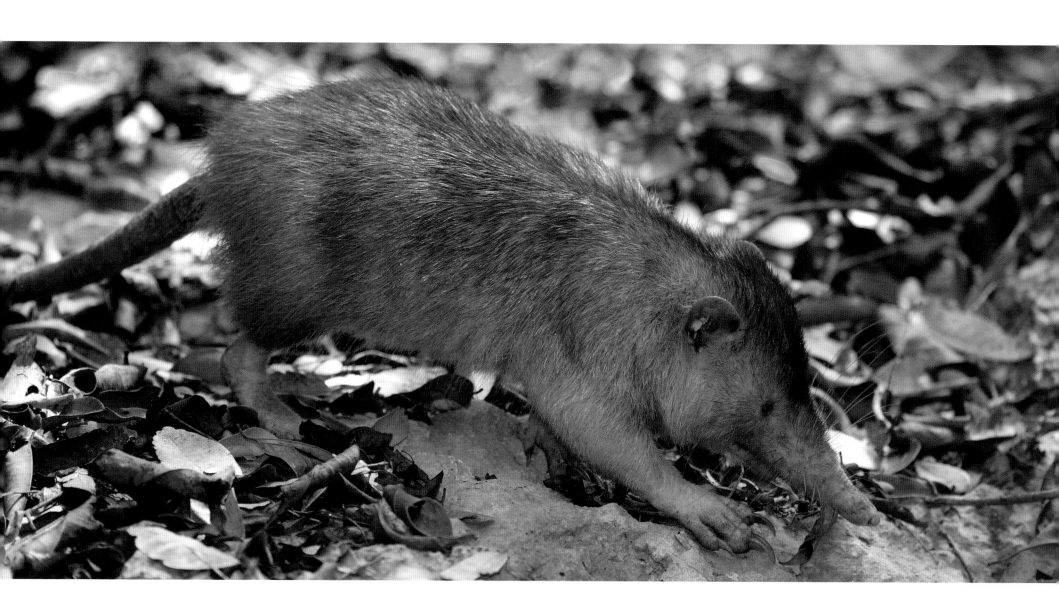

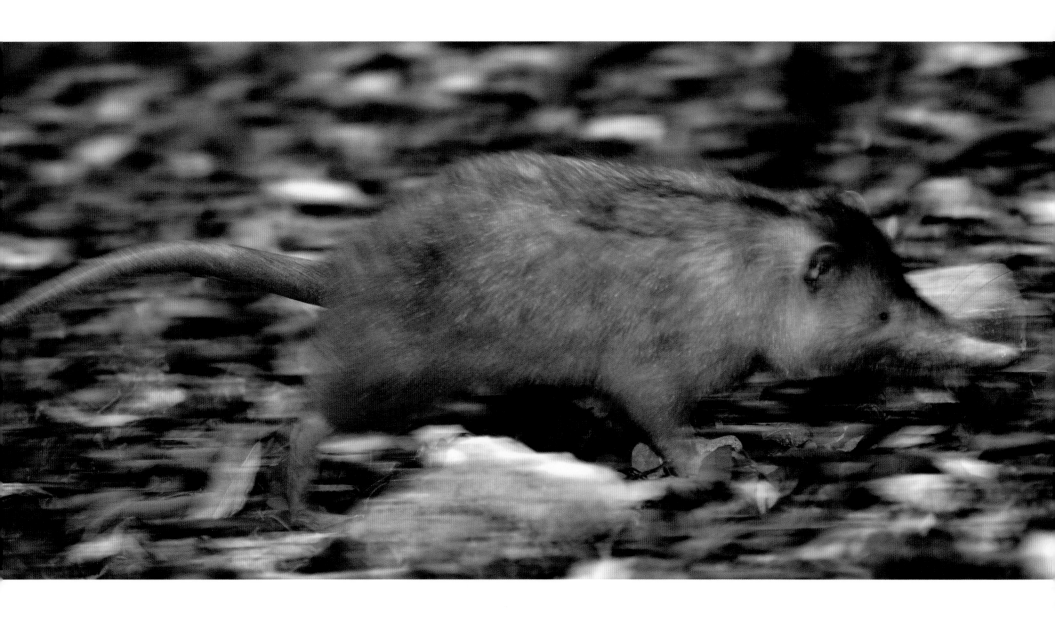

SOLENODÓN · HAITIAN SOLENODON · *[Solenodon paradoxus]* · MENCÍA

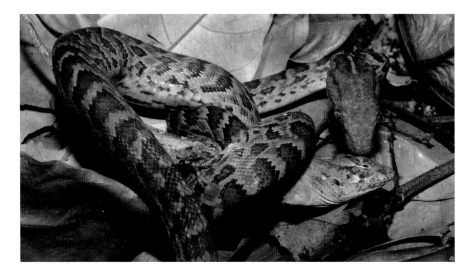

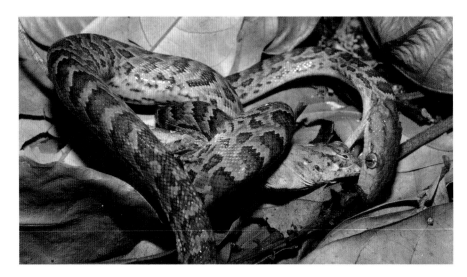

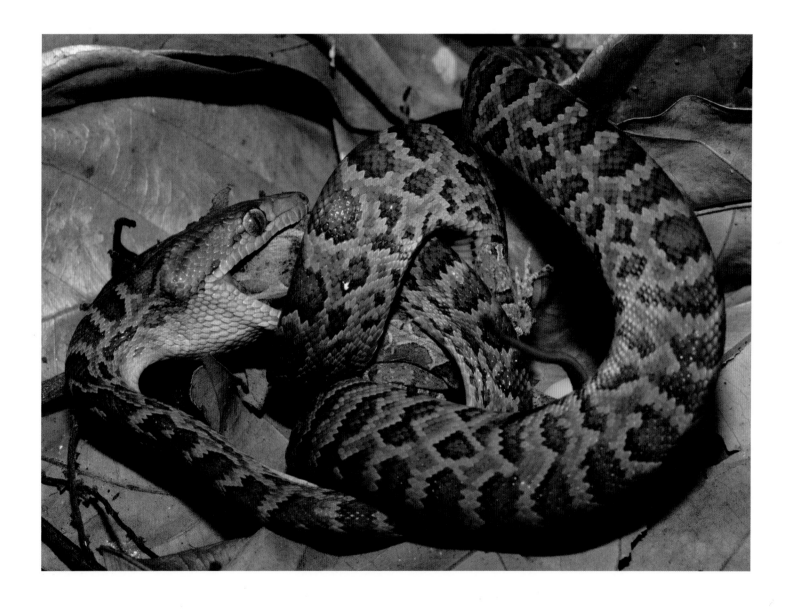

BOA DE LA HISPANIOLA COMIENDO ANOLIS CABEZÓN · HISPANIOLAN BOA EATING STOUT-HEADED ANOLE · MENCÍA

143

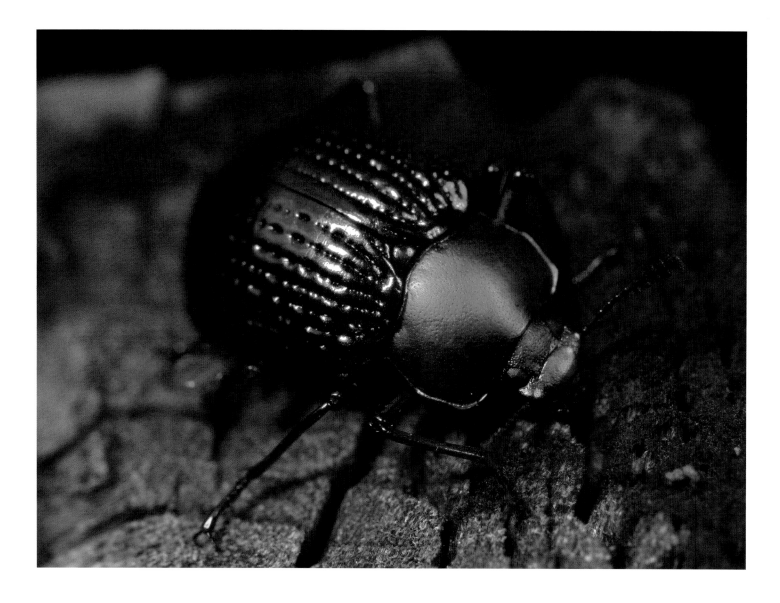

ESCARABAJO · [*Cnodalus sp., Tenebrionidae*] · PUERTO ESCONDIDO

CHINCHE · [*Pachycoris fabrici*] · MENCÍA

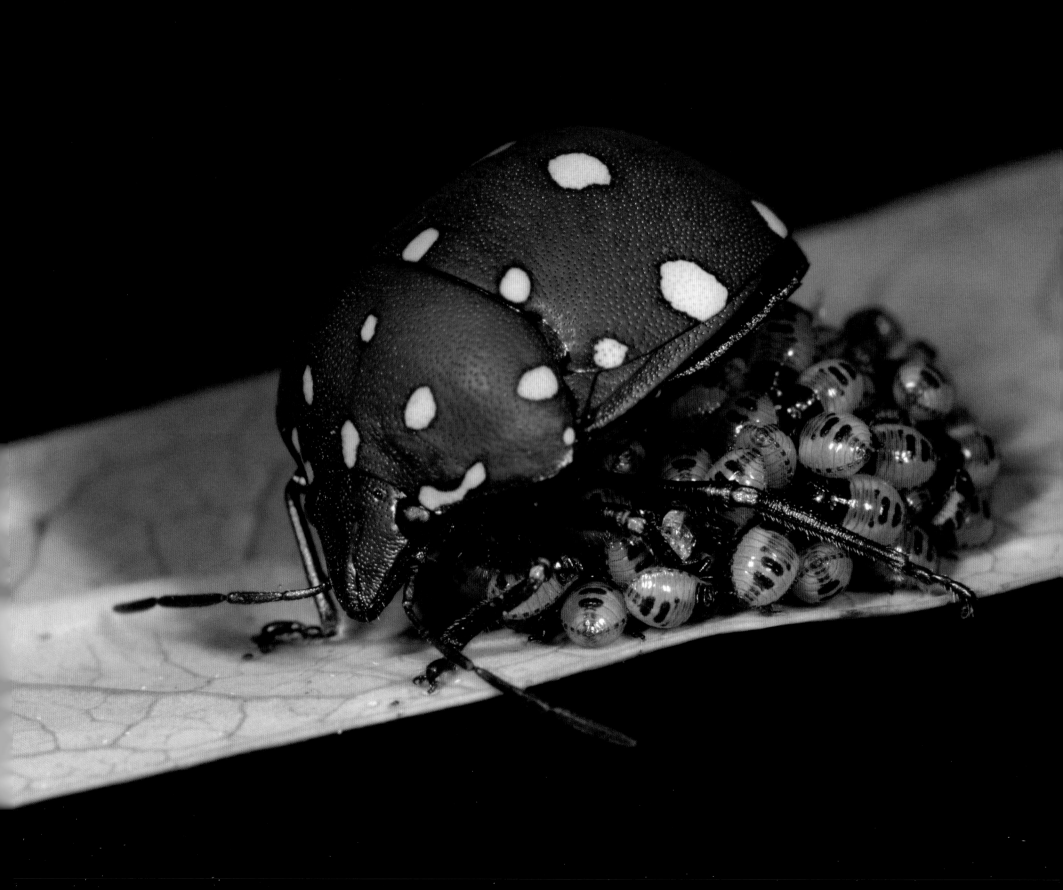

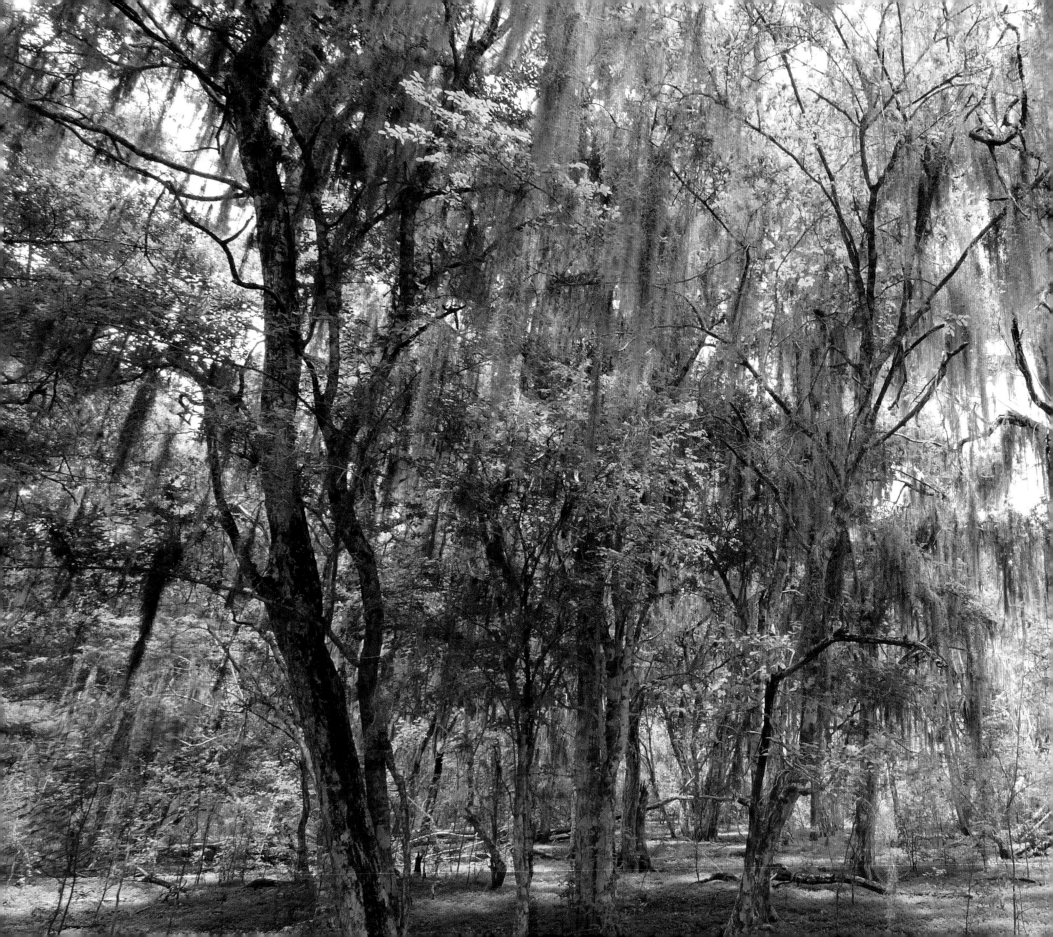

BOSQUE DE TRANSICIÓN · TRANSITIONAL FOREST · LA PLACA

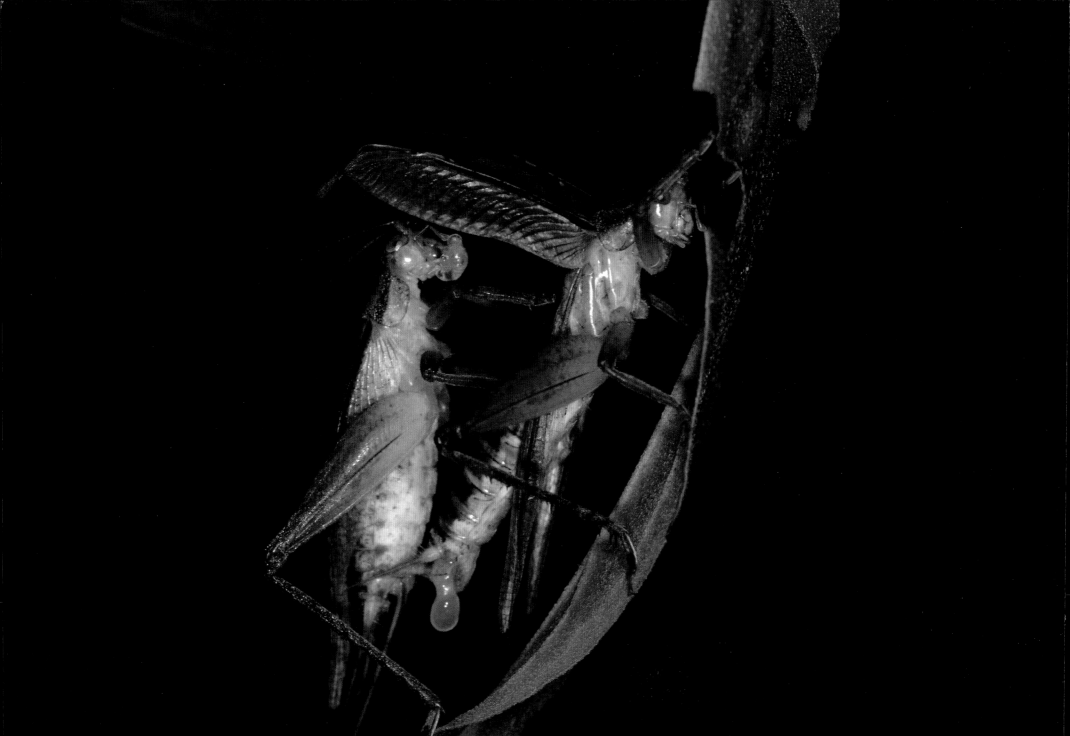

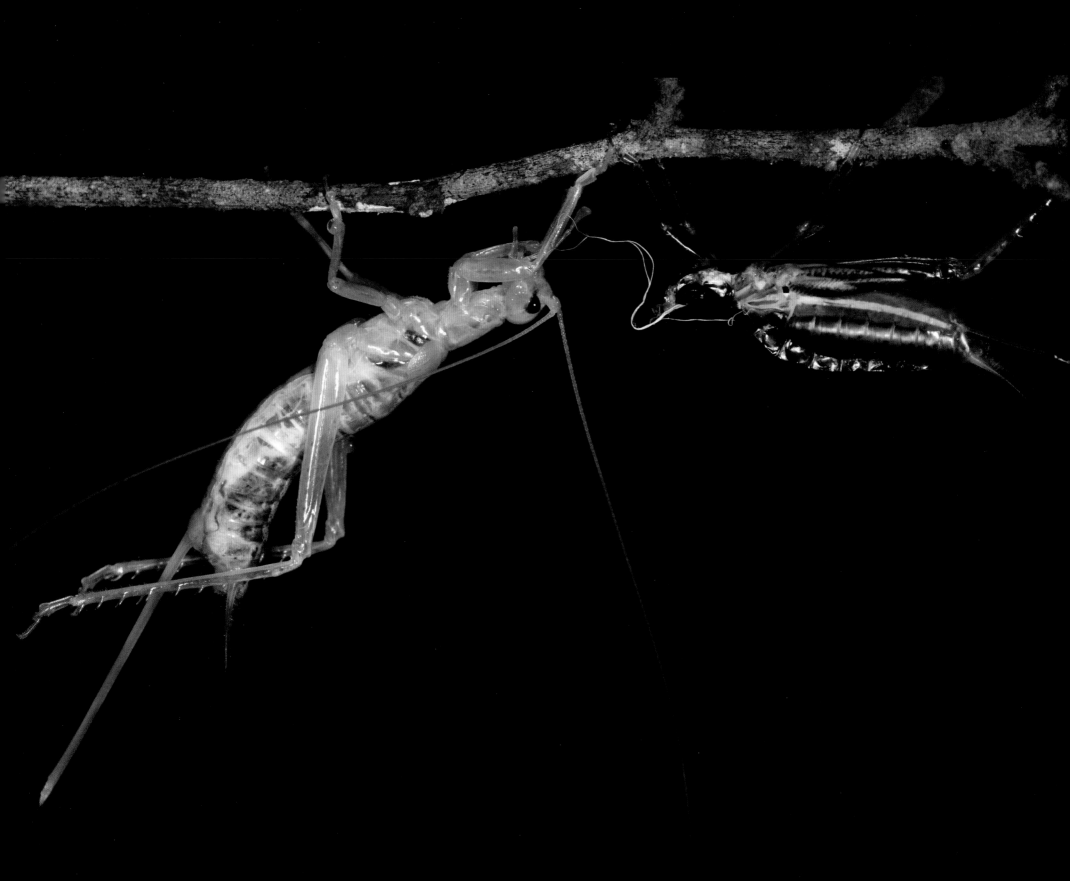

GRILLO MUDANDO PIEL · MOULTING CRICKET · PUEBLO VIEJO

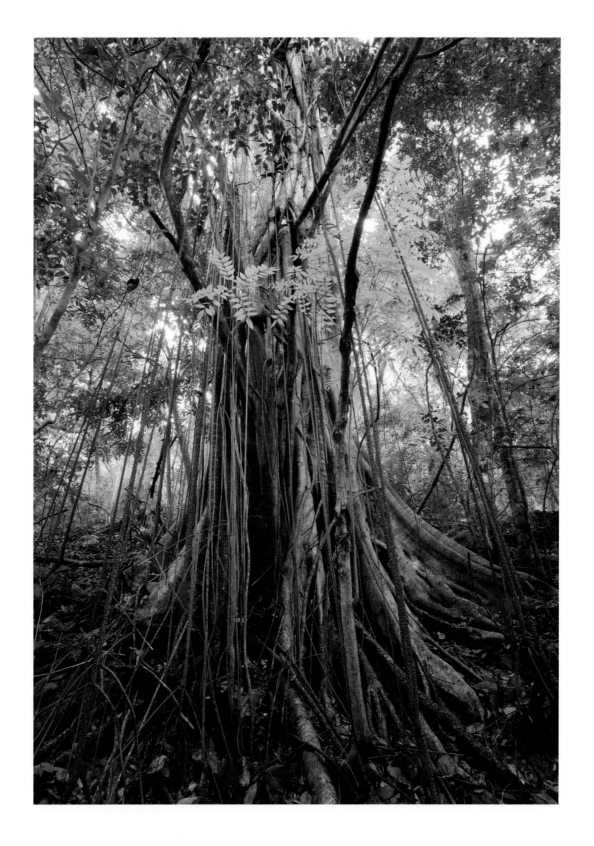

RAICES EXPUESTAS DE HIGO • FIG TREE WITH EXPOSED ROOTS • [*Ficus sp.*] • RABO DE GATO

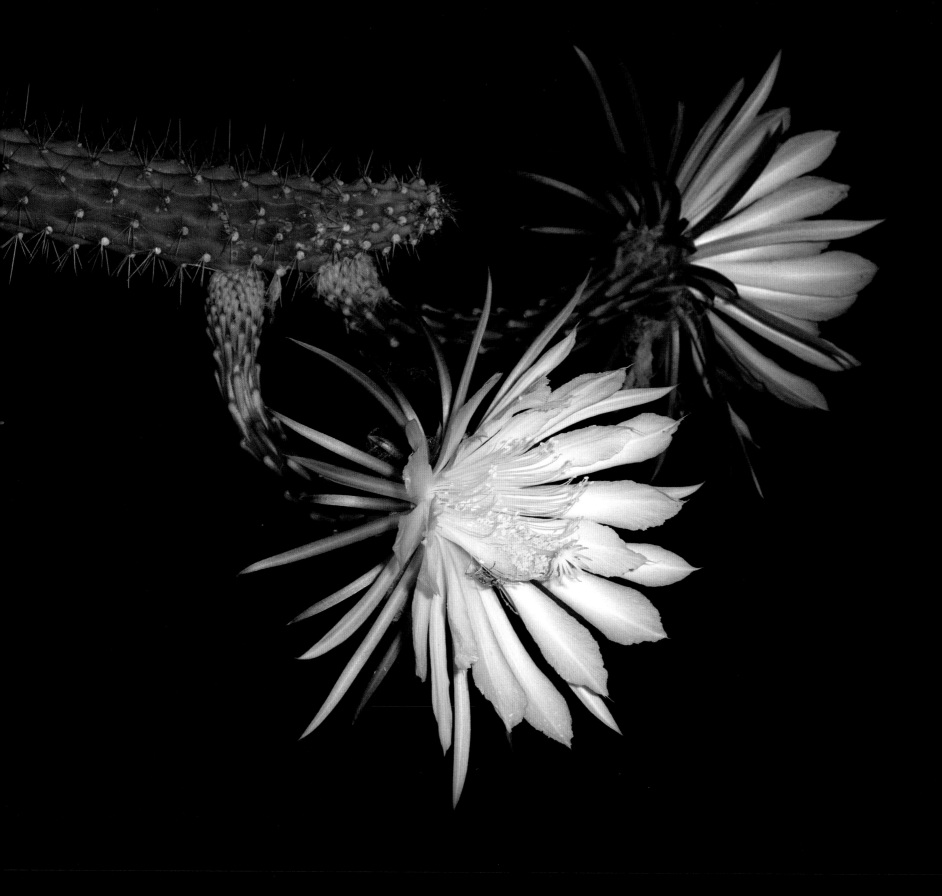

FLOR DE LA PITAHAYA • [*Harrisia nashii*] • **PUERTO ESCONDIDO**

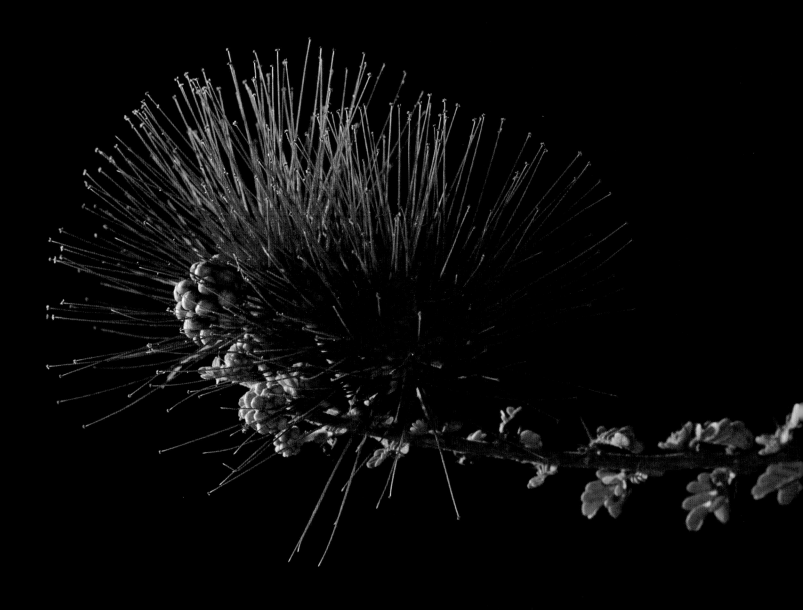

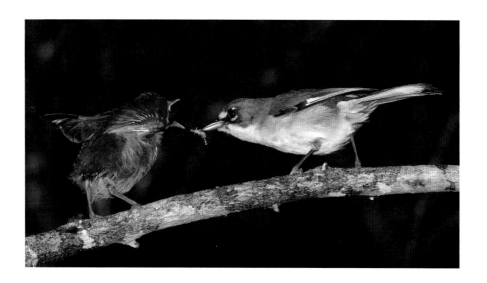

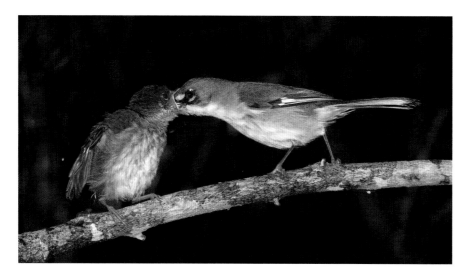

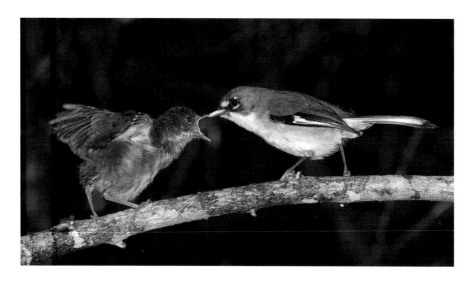

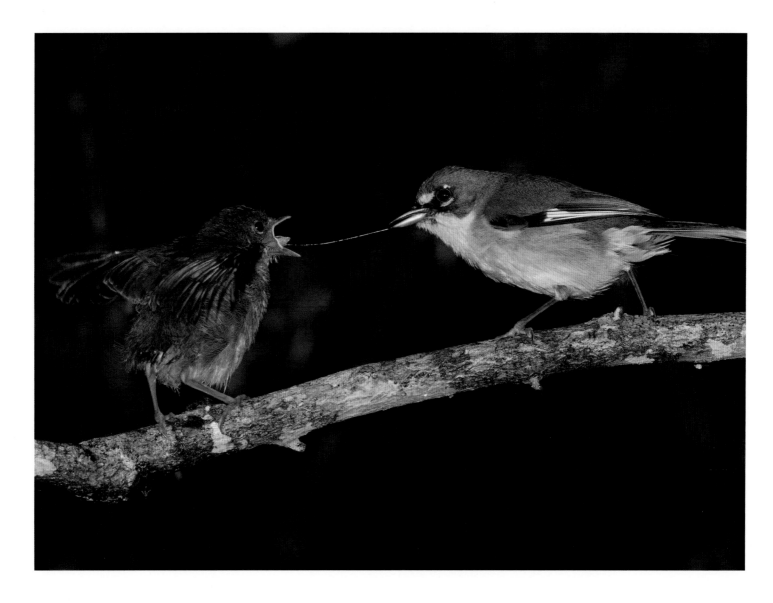

Luego de dejar el nido, los pichones aún dependen de sus padres para obtener su alimentación. En esta secuencia podemos ver a uno de los padres dando alimento a uno de sus pichones.

After leaving the nest, the fledglings depend on their parents for food. In this sequence we see how a parent feeds one of its chicks.

CIGÜITA ALIBLANCA · HISPANIOLAN HIGHLAND-TANAGER · [*Xenoligea montana*] · PUEBLO VIEJO
ESPECIE EN ALTO RIESGO DE EXTINCIÓN | CRITICALLY ENDANGERED SPECIES

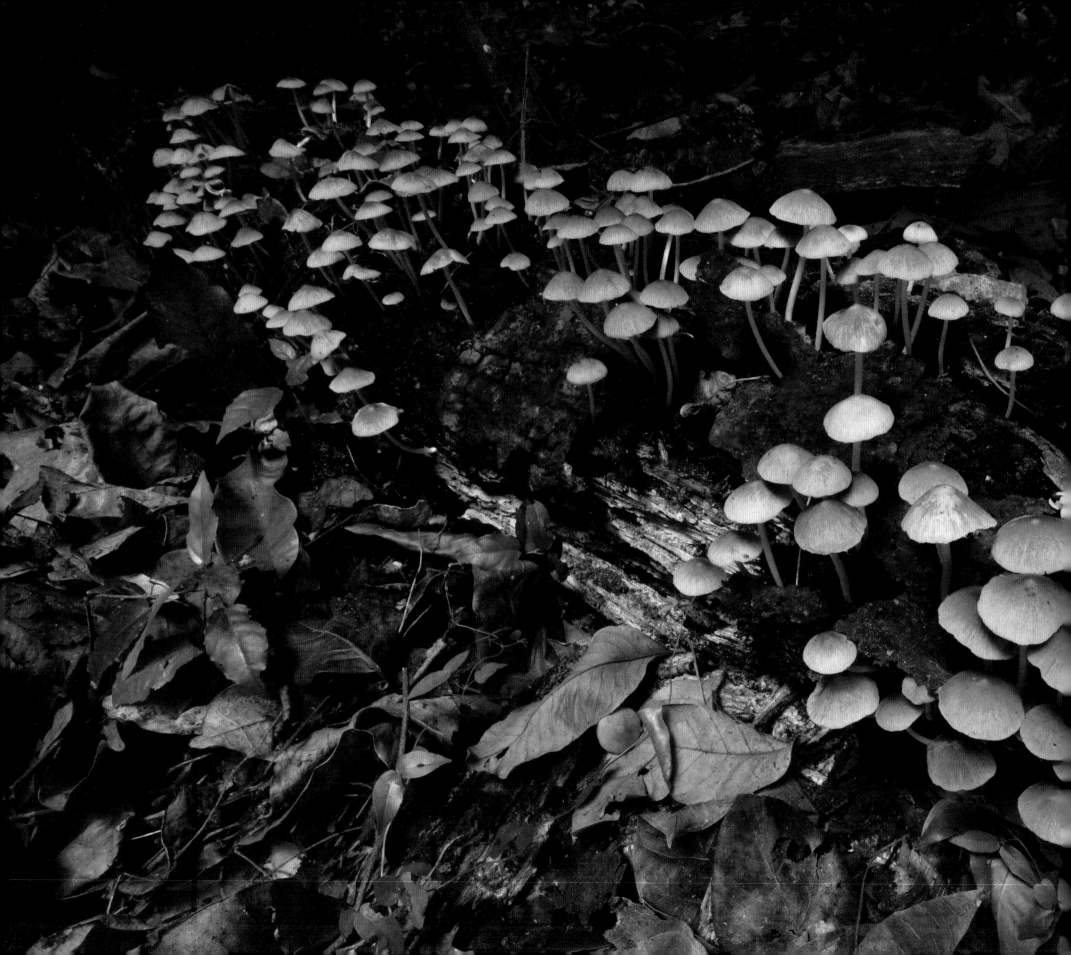

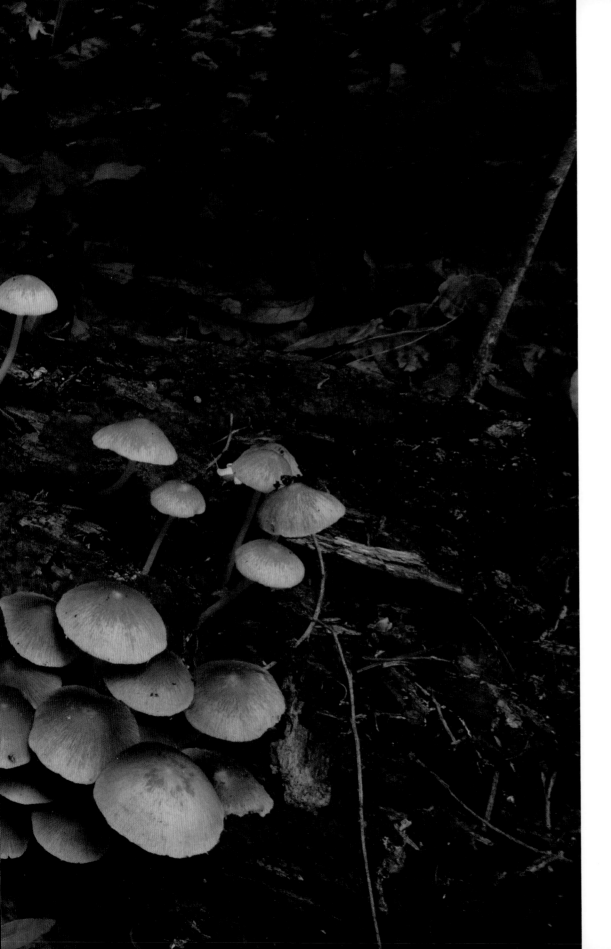

157

[*Psathyrella sp.*] · RABO DE GATO

LOS ARROYOS

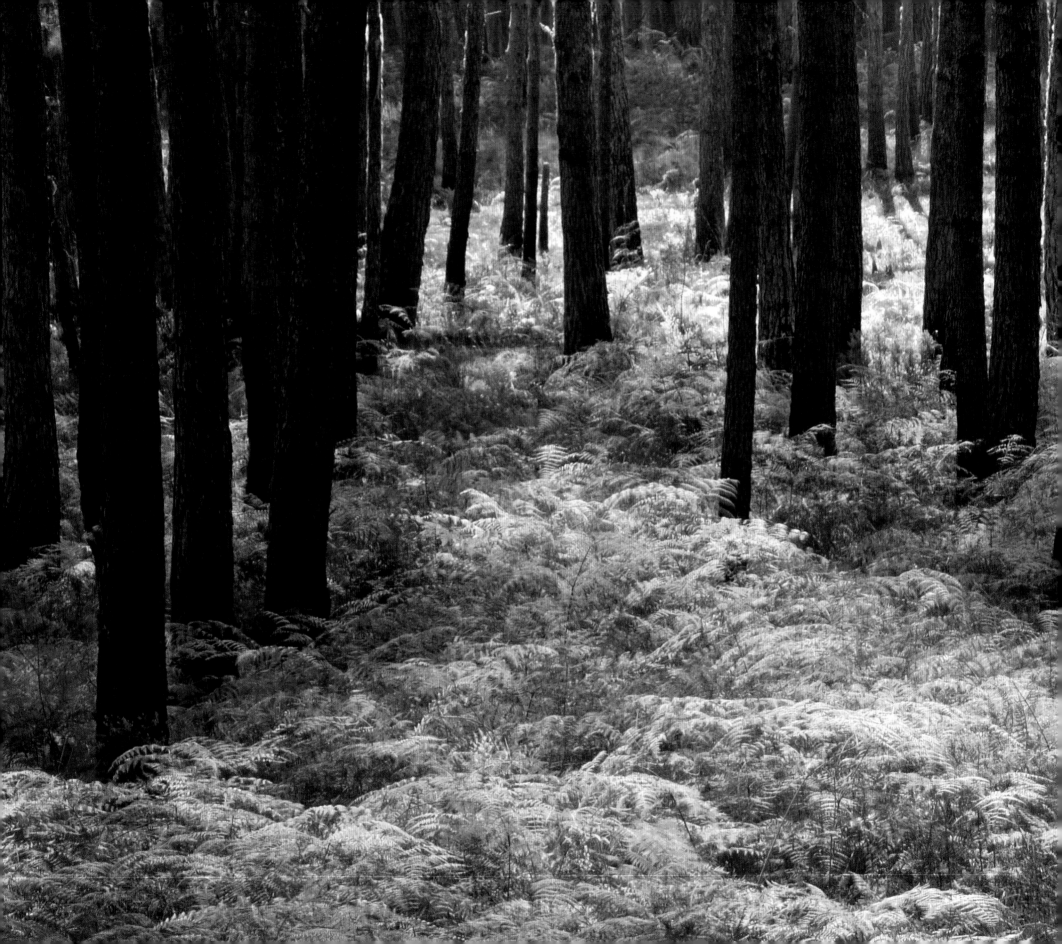

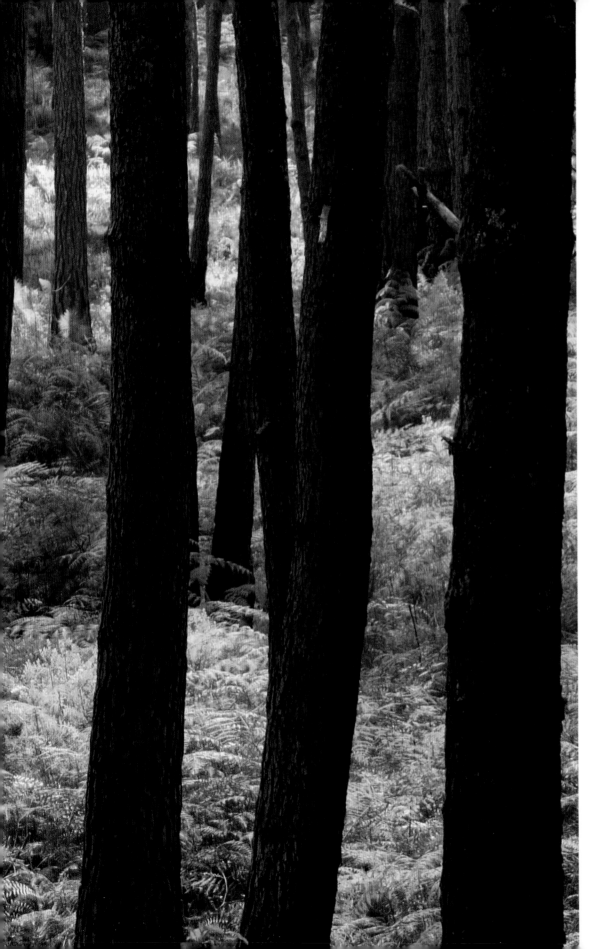

PARC NATIONAL LA VISITE

EL PARQUE NACIONAL LA VISITE ESTÁ LOCALIZADO A 22 kilómetros al sur de Puerto Príncipe, en el Macizo de La Selle (la misma cadena montañosa de Sierra de Bahoruco en la República Dominicana). Este parque contiene unas de las más largas franjas de pinos endémicos que quedan en Haití, con un rango aproximado de 3,000 hectáreas cubiertas de bosque de pinos (*Pinus occidentalis*) y un pequeño fragmento de montaña con bosques latifoliados. Tres picos sobre los 2,500 metros—La Visite, Cabaio y Tête Opaque—están localizados a lo largo de la ladera norte donde habita una de las últimas colonias de Pterodroma hasitata, ave conocida localmente como Diablotín. La población de esta ave de mar pelágica, la cual anida casi exclusivamente en las montañas de La Española, ha disminuido dramáticamente en las últimas décadas.

Teniendo en consideración que la mayor parte del paisaje haitiano ha sido extensamente deforestado, el Parque Nacional La Visite representa una de las últimas y más importantes áreas naturales y como tal merece que se le de prioridad en los esfuerzos de conservación.

PARC NATIONAL LA VISITE IS LOCATED 22 KILOMETERS SOUTH of Port-au-Prince, in the Massif de la Selle (the same mountain range as Sierra de Bahoruco in the Dominican Republic). This park contains one of the largest stands of endemic pine forest left in Haiti, with an approximate range of 3,000 hectares covered mainly by pine forest (*Pinus occidentalis*) and small relict fragments of mountain broadleaf. Three peaks above 2,150 meters—La Visite, Cabaio, and Tête Opaque—are located along the northern escarpment that is home to one of the last known colonies of Black-capped Petrels (*Pterodroma hasitata*), a bird locally known as the Diablotín. This pelagic seabird, which nests almost exclusively in the mountains of Hispaniola, has dramatically decreased in population over the last decades.

Considering that most of Haiti's landscape has been vastly denuded, Parc National La Visite represents one of the last and most important natural areas and as such it deserves to be a high priority of conservation efforts.

BOSQUE DE PINOS Y HELECHOS · PINE AND FERN FOREST

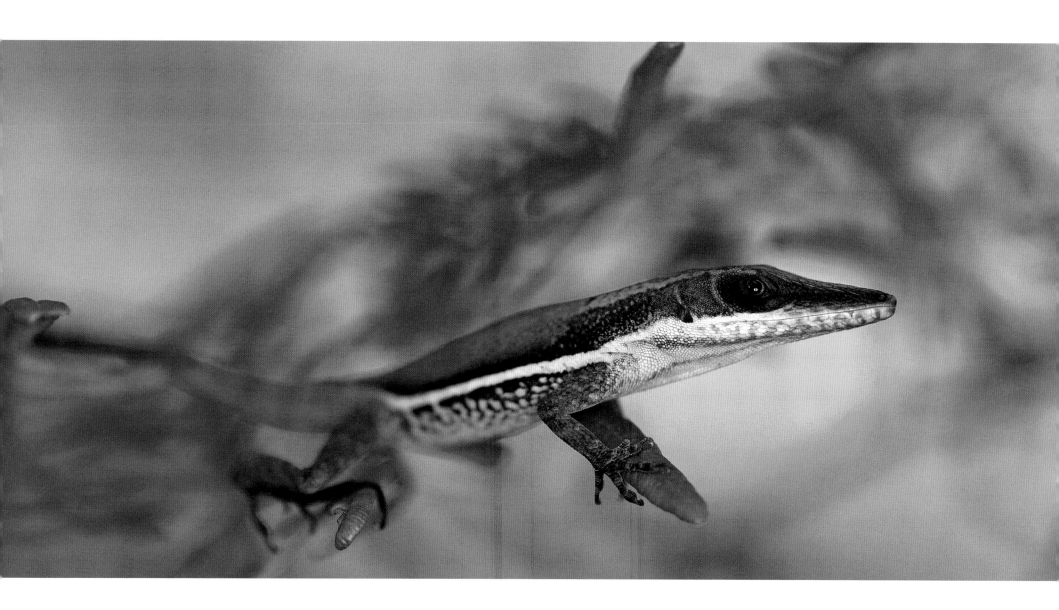

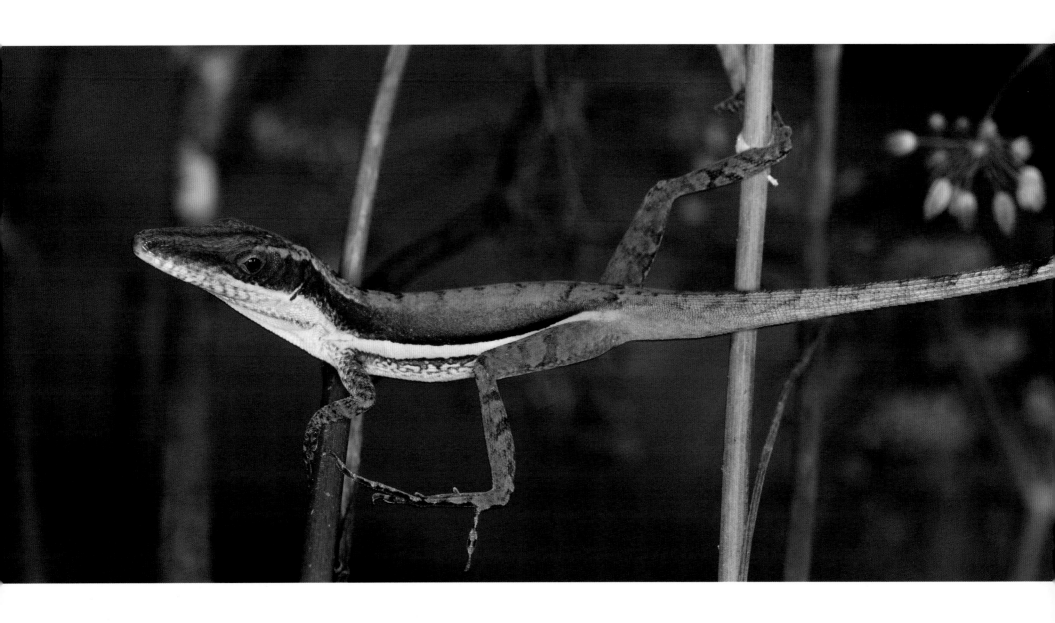

ANOLIS DE LA SELLE · LA SELLE LONG-SNOUTED ANOLE · [*Anolis hendersoni*] · LA SELLE

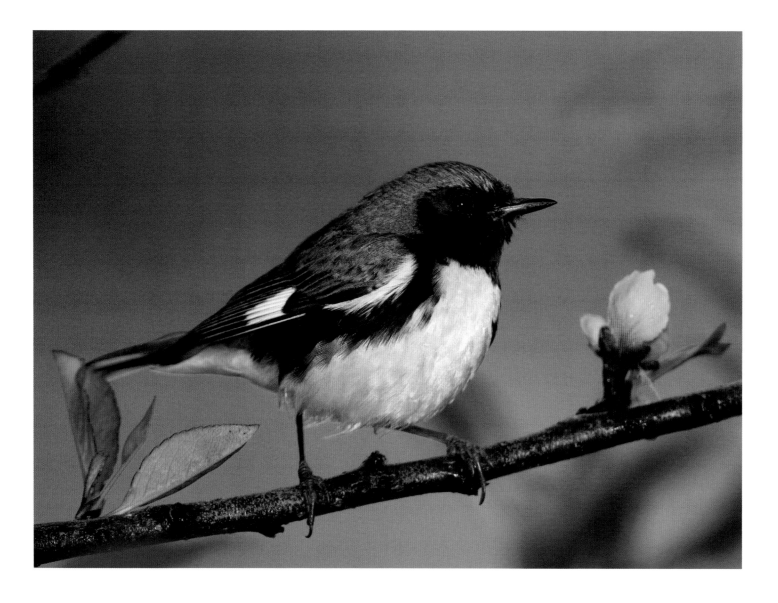

CIGÜITA AZUL • BLACK-THROATED BLUE WARBLER • [*Dendroica caerulescens*] • SEGUIN

CHI-CUI • NARROW-BILLED TODY • [*Todus angustirostris*] • SEGUIN

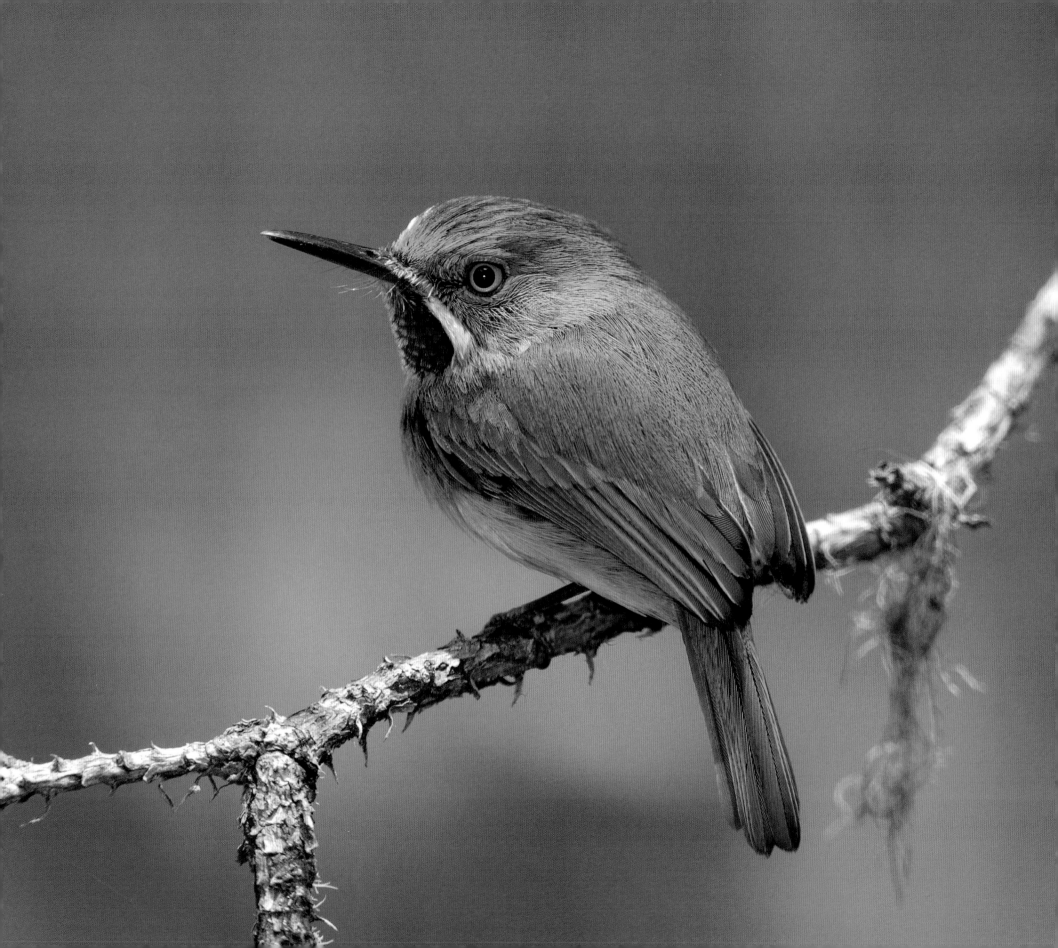

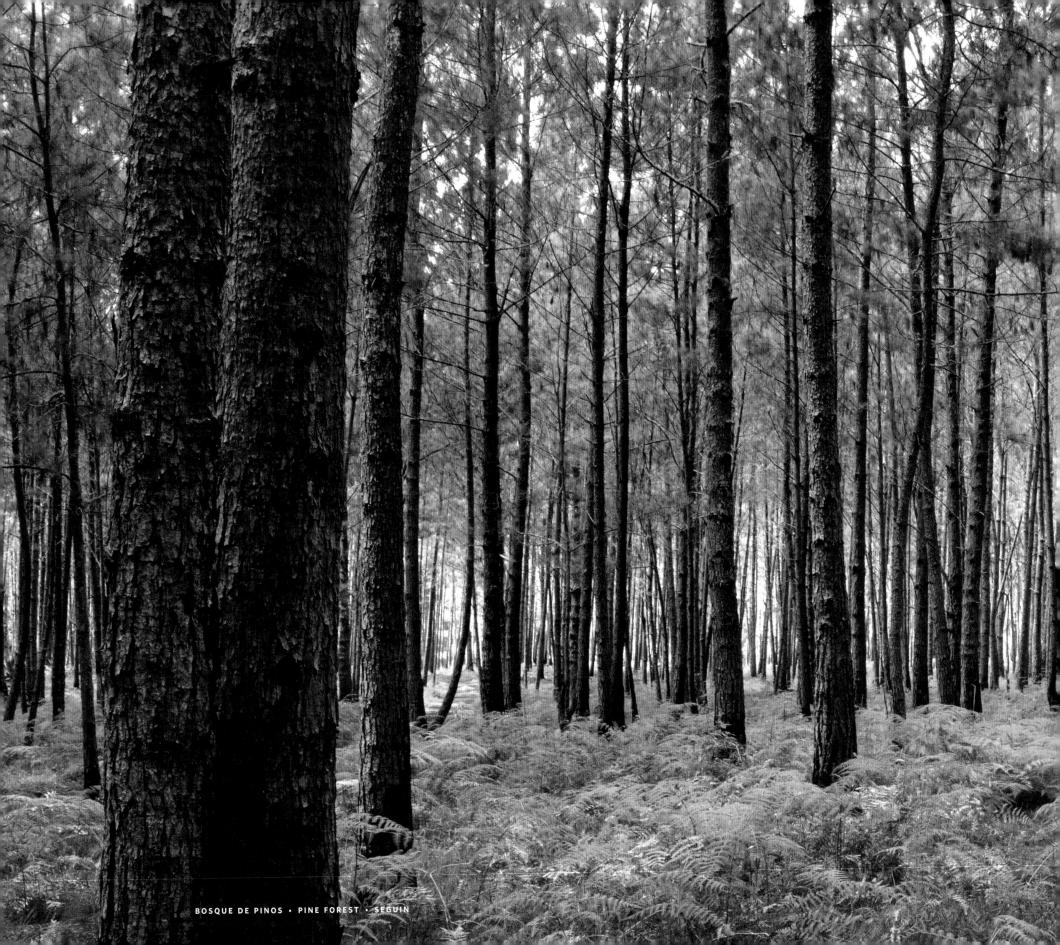

BOSQUE DE PINOS · PINE FOREST · SEGUIN

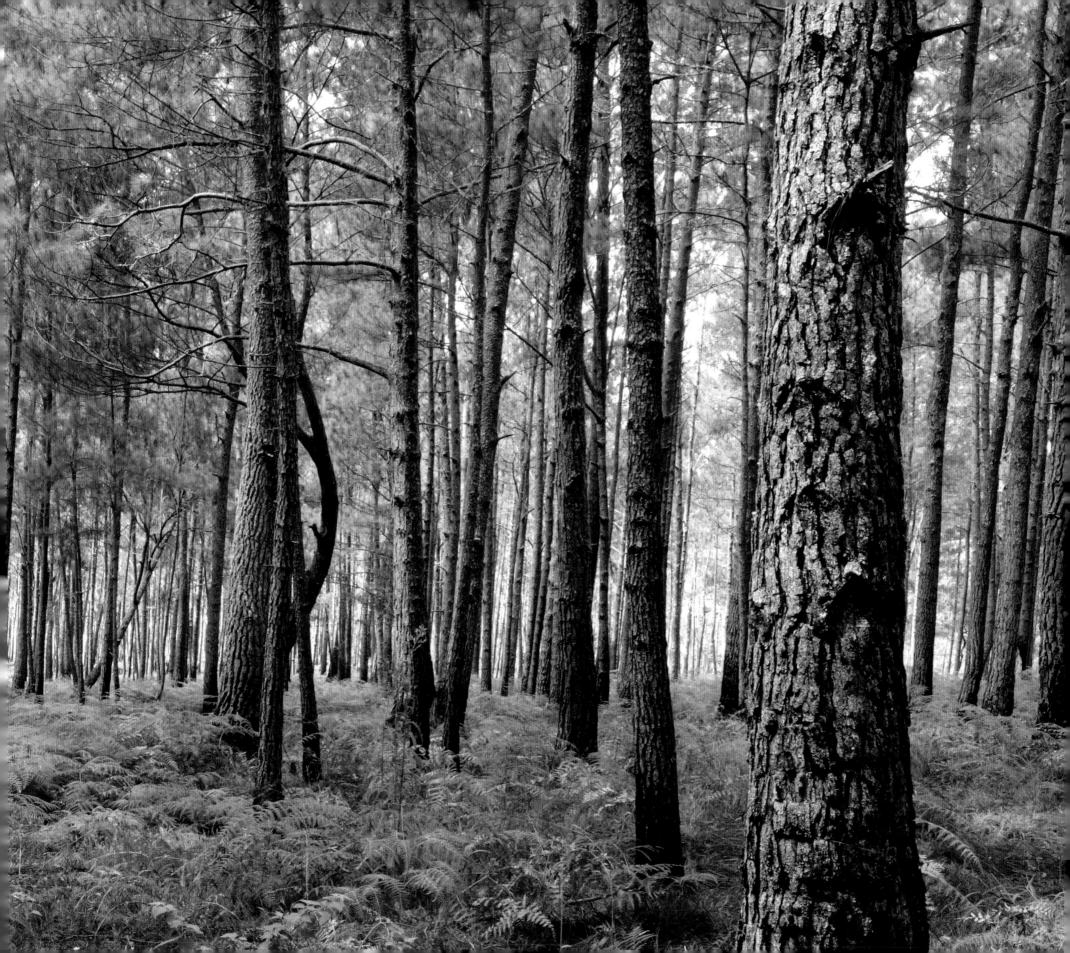

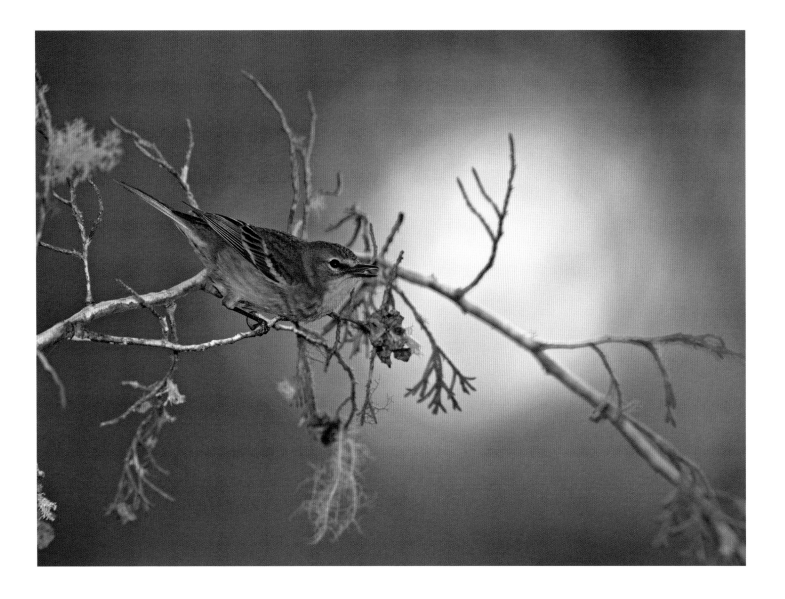

CIGÜITA DEL PINAR · PINE WARBLER · [Dendroica pinus]

TROGON CON ANOLIS · HISPANIOLAN TROGON WITH ANOLE · [Priotelus roseigaster]
ESPECIE AMENAZADA | THREATENED SPECIES

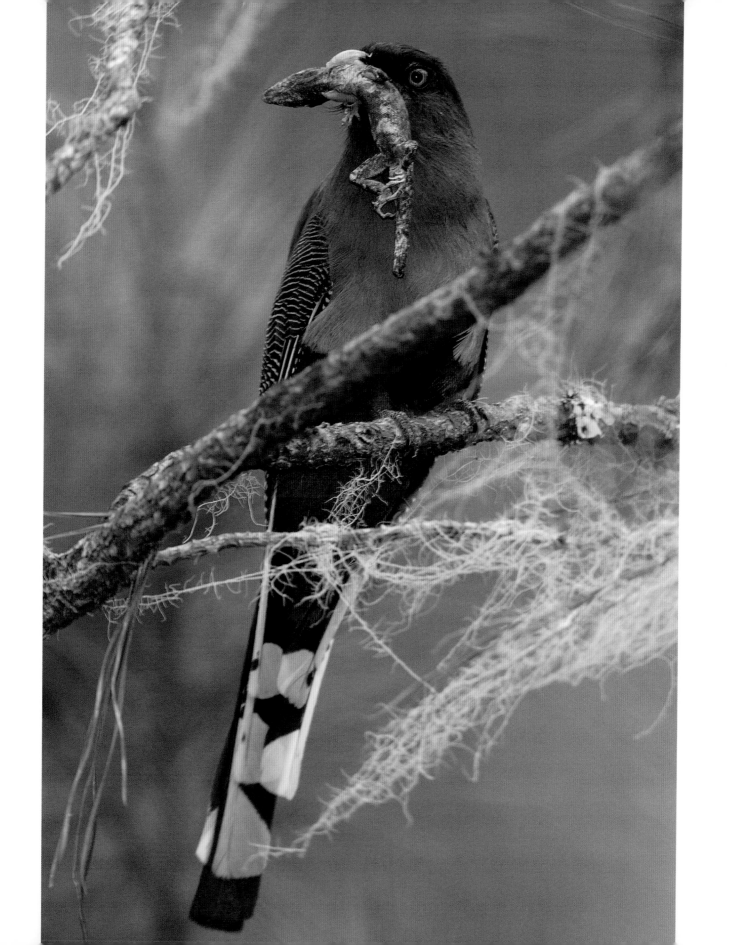

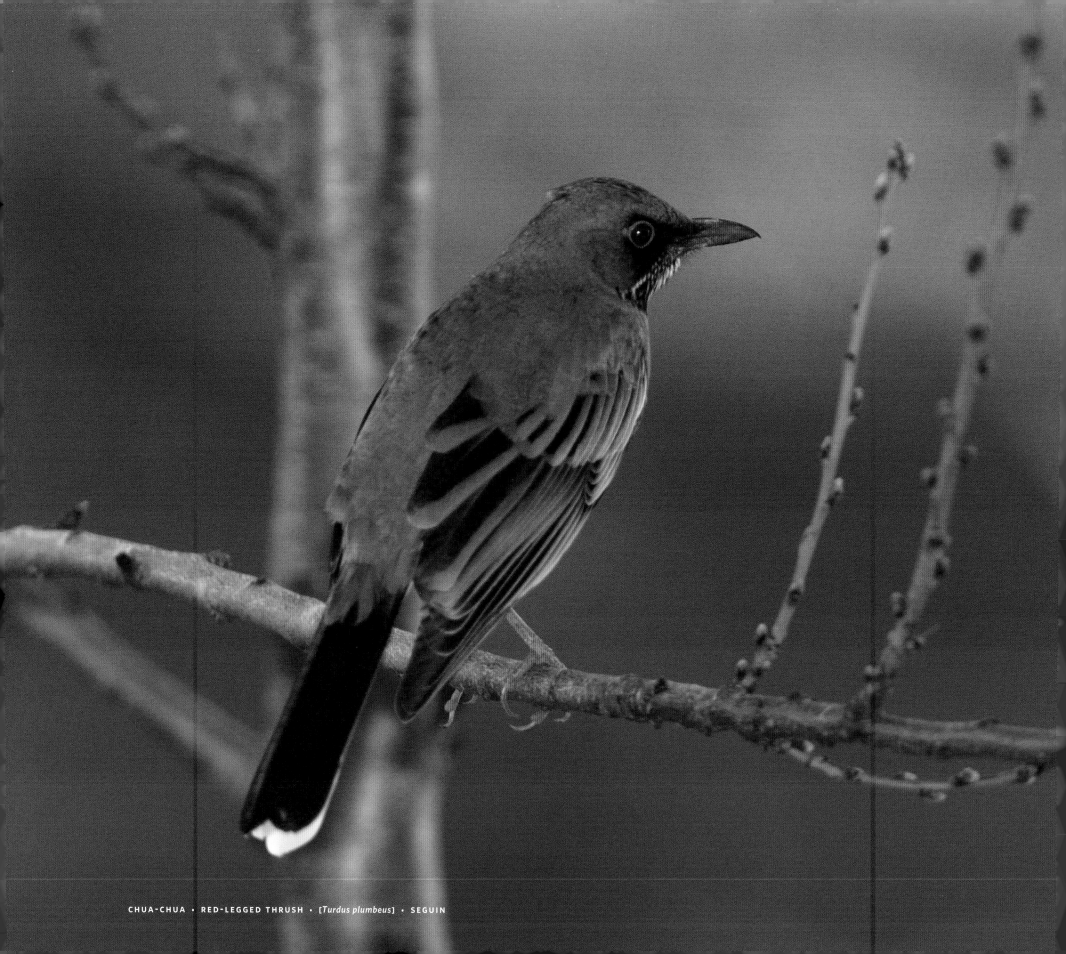

CHUA-CHUA · RED-LEGGED THRUSH · [*Turdus plumbeus*] · SEGUIN

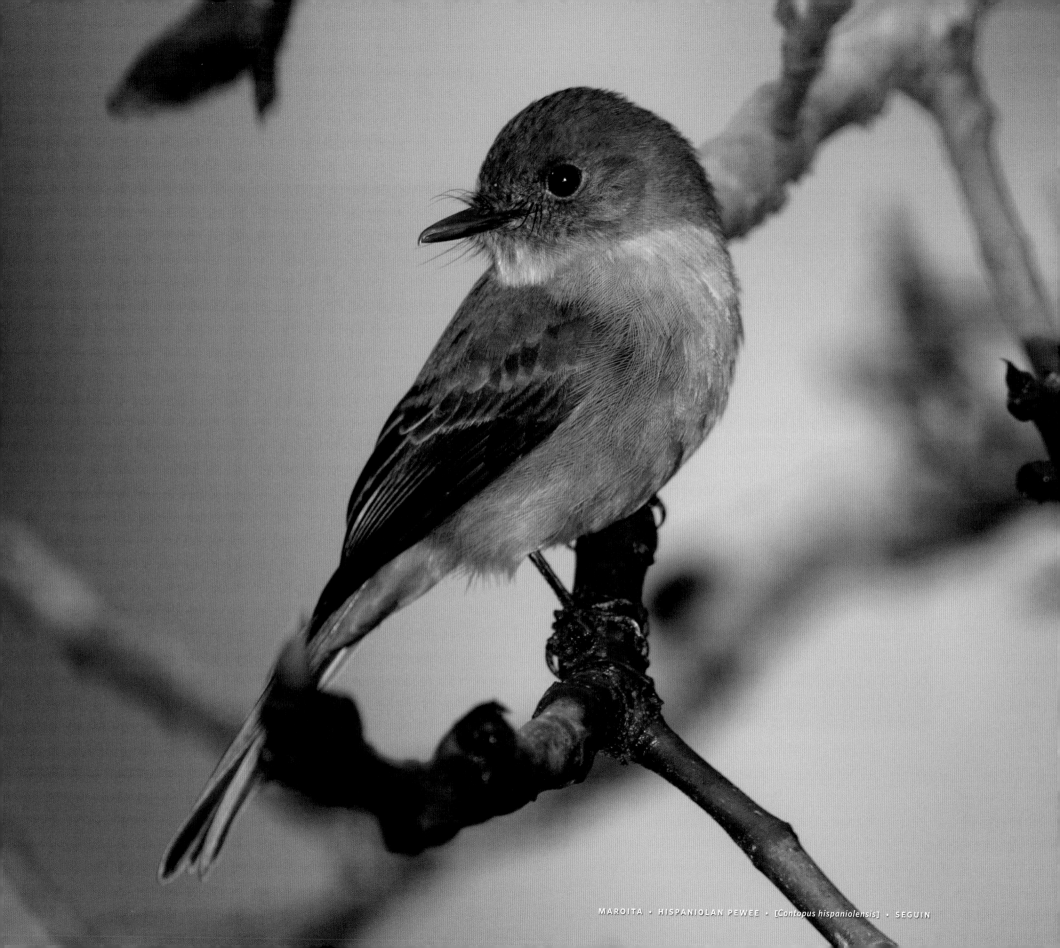

MAROITA • HISPANIOLAN PEWEE • [*Contopus hispaniolensis*] • SEGUIN

CARACOL TERRESTRE NO-IDENTIFICADO · UNIDENTIFIED LAND SNAIL · SEGUIN

TROPICAL ADMIRAL BUTTERFLY · [*Adelpha gelania*] · SEGUIN

PARC NATIONAL
PIC MACAYA

EL PARQUE NACIONAL PIC MACAYA ESTÁ LOCALIZADO EN EL Macizo de la Hotte en la parte sur-occidental de la Península Tiburón en Haití. Las 5,500 hectáreas contienen en la parte más elevada una mezcla de bosques de pinos y bosque nublados y a los 1,000 metros de altura una cubierta de vegetación latifoliada cársica. Los puntos más altos son Pic Macaya (2,347 metros), Pic Formond (2,219 metros) y Pic le Ciel (2,170 metros). Dentro de los límites del parque nacen cinco grandes ríos: el Grande Ravine du Sud, Rivière Port-a-Piment, Rivière de l Acul, Rivière des Roseaux y Rivière Glace.

Las deforestadas lomas cársicas al oeste de Plaine du Formond constituyen la parte más importante en cuanto a biodiversidad así como la área más amenazada por la intervención del hombre. El Parque Nacional Pic Macaya tiene unos de los niveles más altos de endemismo en plantas y animales. Dentro de los más importantes grupos de interés están las plantas de la familia Melastomataceae, las orquídeas, los insectos, los moluscos de tierra y los anfibios. De hecho, el parque aloja el mayor número de especies de anfibios en el Caribe y la mayoría de ellos están en la lista de especies en peligro.

175

PARC NATIONAL PIC MACAYA IS LOCATED IN THE MASSIF DE LA Hotte in the southwestern part of the Tiburon Peninsula in Haiti. The park's 5,500 hectares contain mixed pines and cloud forest at higher elevations and broadleaf-covered karst hills at 1,000 meters in elevation. The highest points are Pic Macaya (2,347 meters), Pic Formond (2,219 meters), and Pic le Ciel (2,170 meters). Five major rivers originate within the park boundaries: the Grande Ravine du Sud, Rivière Port-à-Piment, Rivière de l'Acul, Rivière des Roseaux, and Rivière Glace.

The forested karst hills west of the Plaine du Formond constitute the most important area in terms of biodiversity as well as the area most threatened by human encroachment. Parc National Pic Macaya has an extremely high level of plant and animal endemism. Among the most important groups of interest are plants from the family Melastomataceae, orchids, insects, land mollusks, and amphibians. In fact, the park holds the greatest number of amphibian species in the Caribbean, and most of them have been listed as endangered.

PLAINE BOEUFF

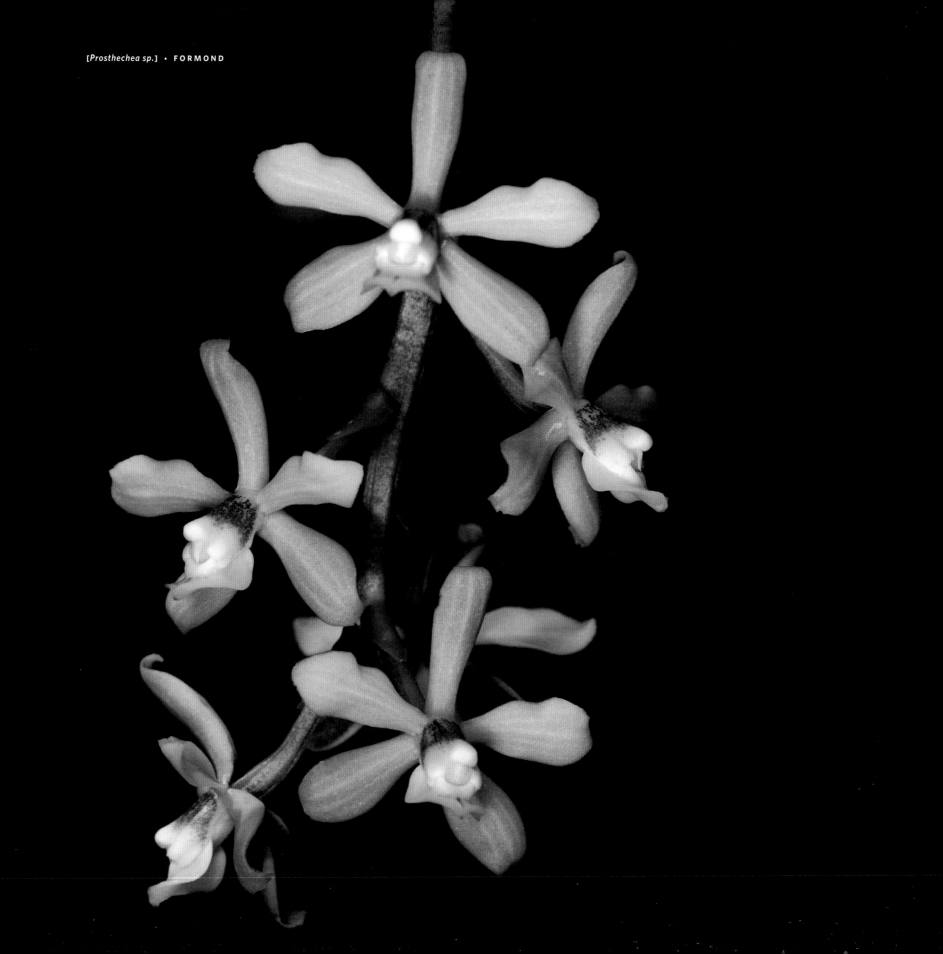

[Prosthechea sp.] • FORMOND

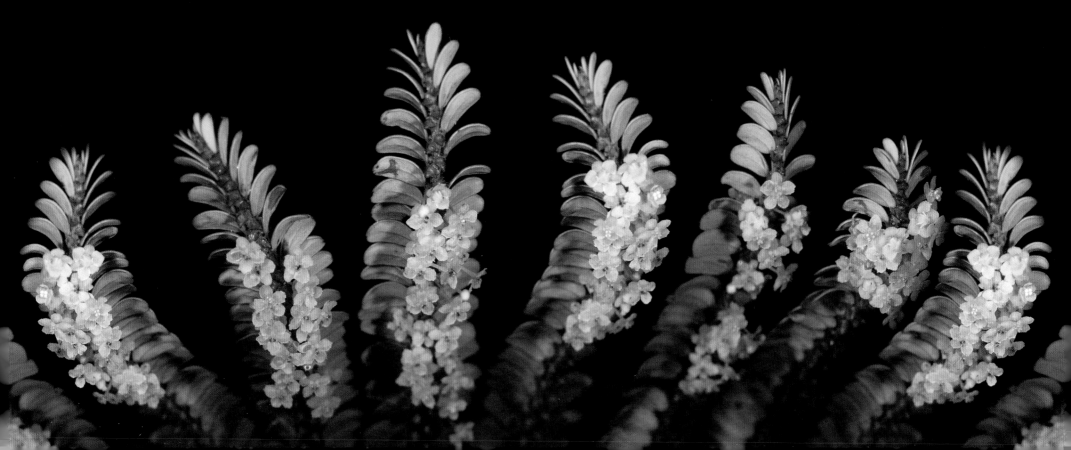

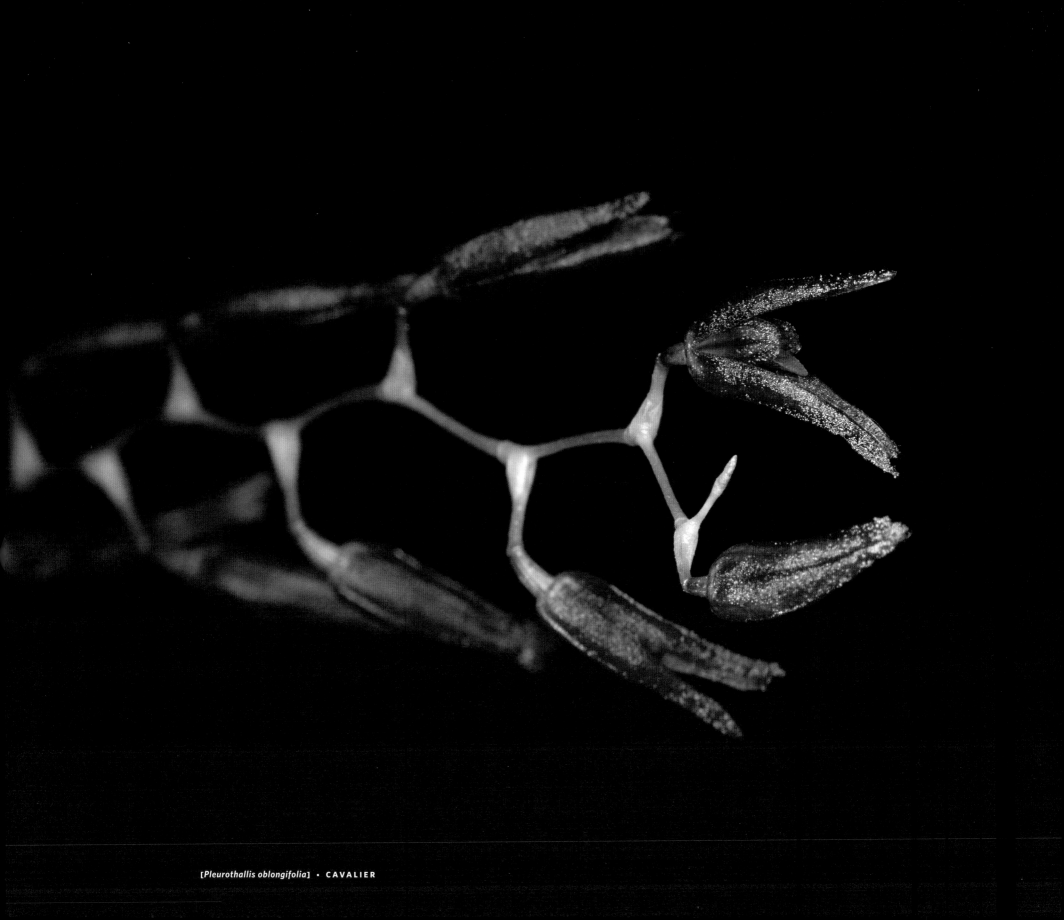

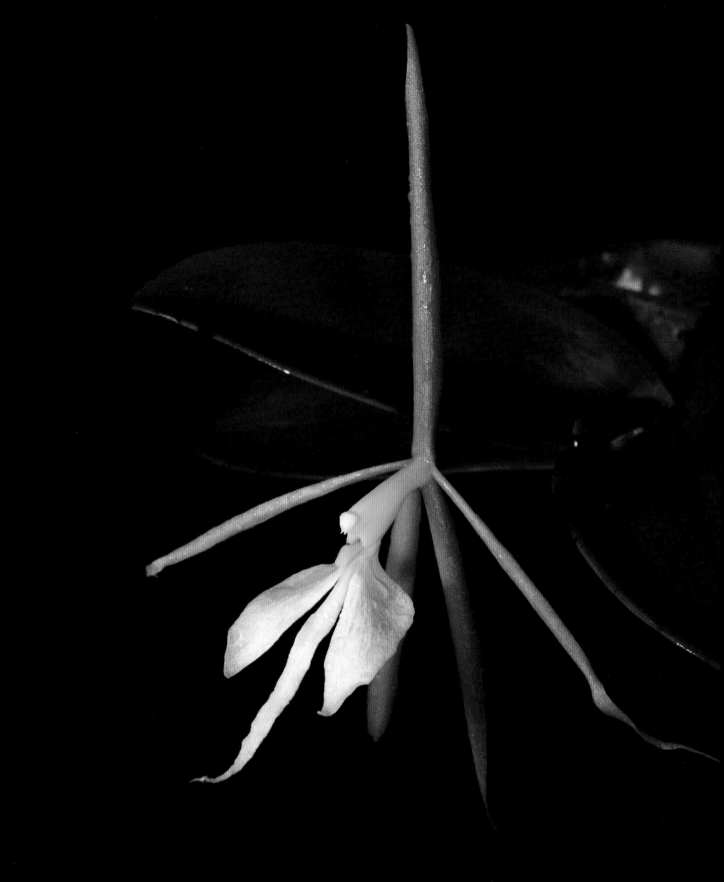

[*Epidendrum nocturnum*] • CAVALIER

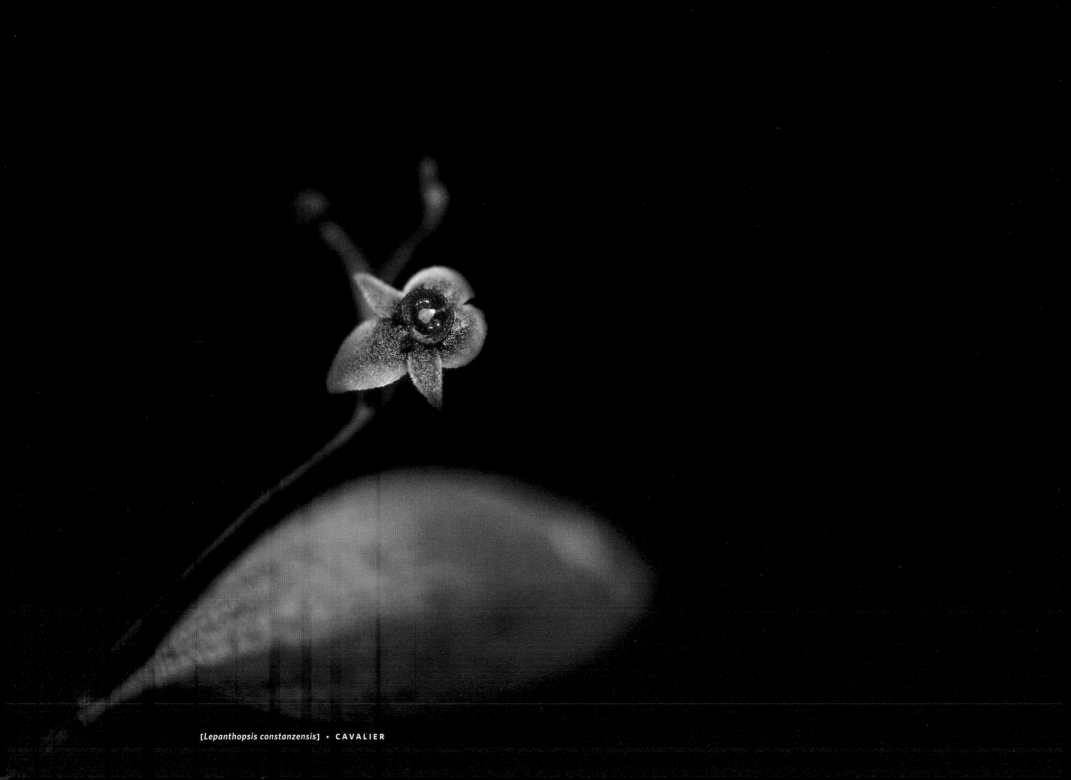

[*Lepanthopsis constanzensis*] · CAVALIER

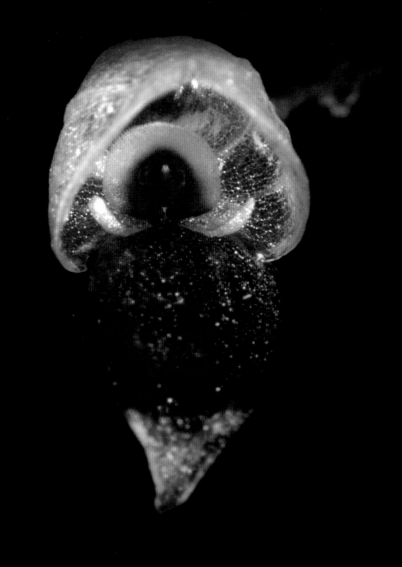

ORQUÍDEA DIMINUTA · [*Lepanthopsis cucullata*] · CAVALIER

BOSQUE MONTAÑO DE ALTAS ELEVACIONES · HIGH-ELEVATION MOUNTAIN FOREST · PIC FORMOND

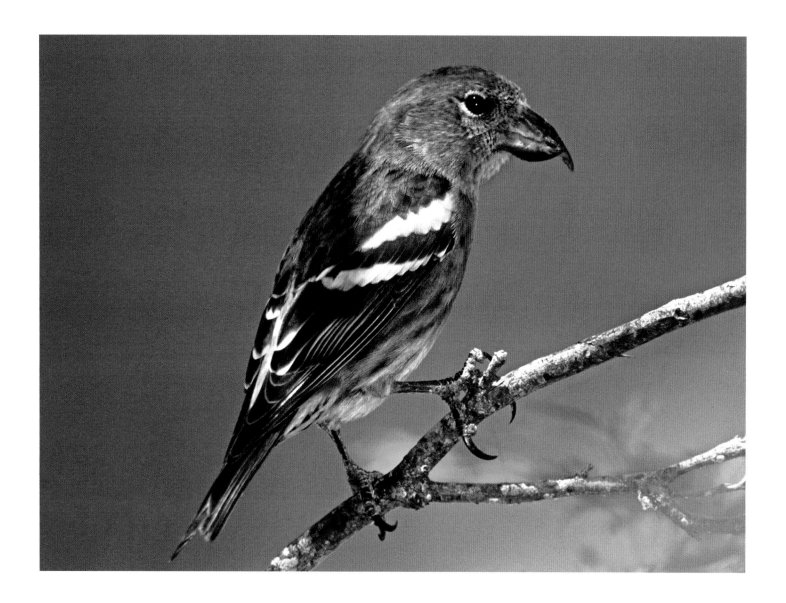

PICO CRUZADO · HISPANIOLAN CROSSBILL · [*Loxia megaplaga*] · PIC LE CIEL
ESPECIE EN ALTO RIESGO DE EXTINCIÓN | CRITICALLY ENDANGERED SPECIES

PALO DE VIENTO · TREMULUS TREE · [*Didymopanax tremulus*] · PIC LE CIEL

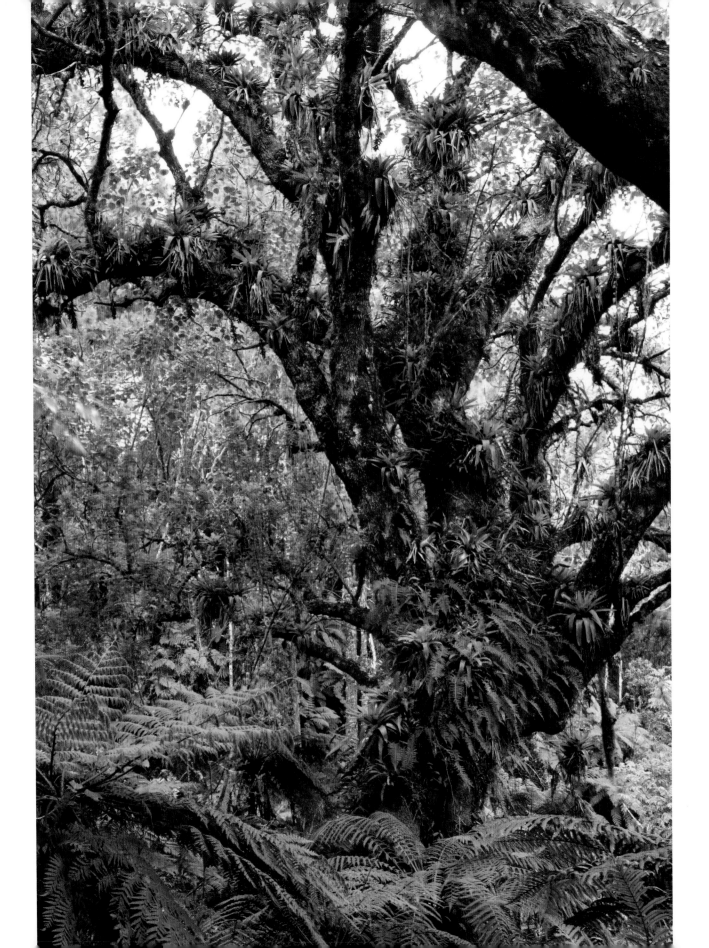

[*Eleutherodactylus aduanti*] · CAVALIER

ESPECIE AMENAZADA | THREATENED SPECIES

[*Eleutherodactylus sp.*] • CAVALIER
ESPECIE AMENAZADA | THREATENED SPECIES

[*Eleutherodactylus ventrilineatus*]

[*Eleutherodactylus bakeri*]

ESPECIES AMENAZADAS | THREATENED SPECIES

[*Eleutherodactylus apostates*]

[*Eleutherodactylus glaphycompus*]

[Eleutherodactylus lamprotes]

[Eleutherodactylus brevirostris]

[Eleutherodactylus eunaster]

[Eleutherodactylus nortoni]

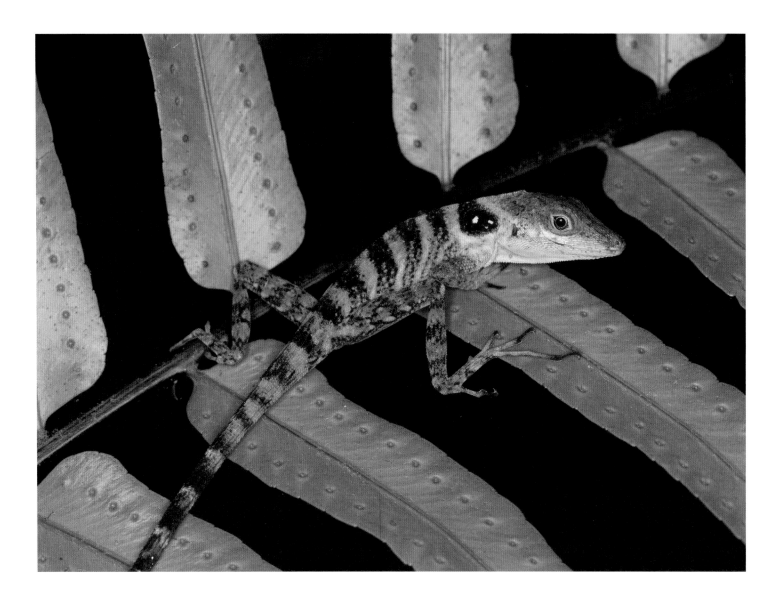

LA HOTTE BUSH ANOLE · [*Anolis monticola*] · CASTILLON

BANDED RED-BELLIED ANOLE · [*Anolis rupinae*] · CASTILLON

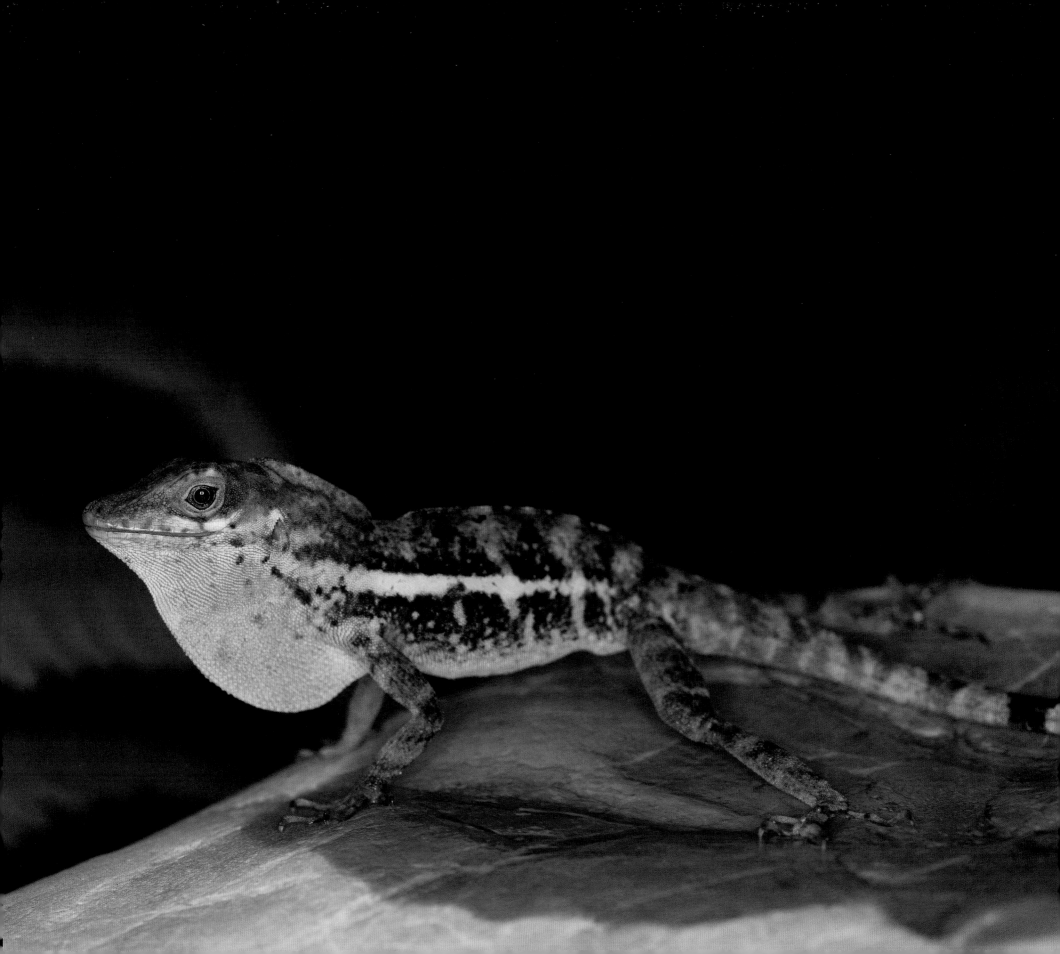

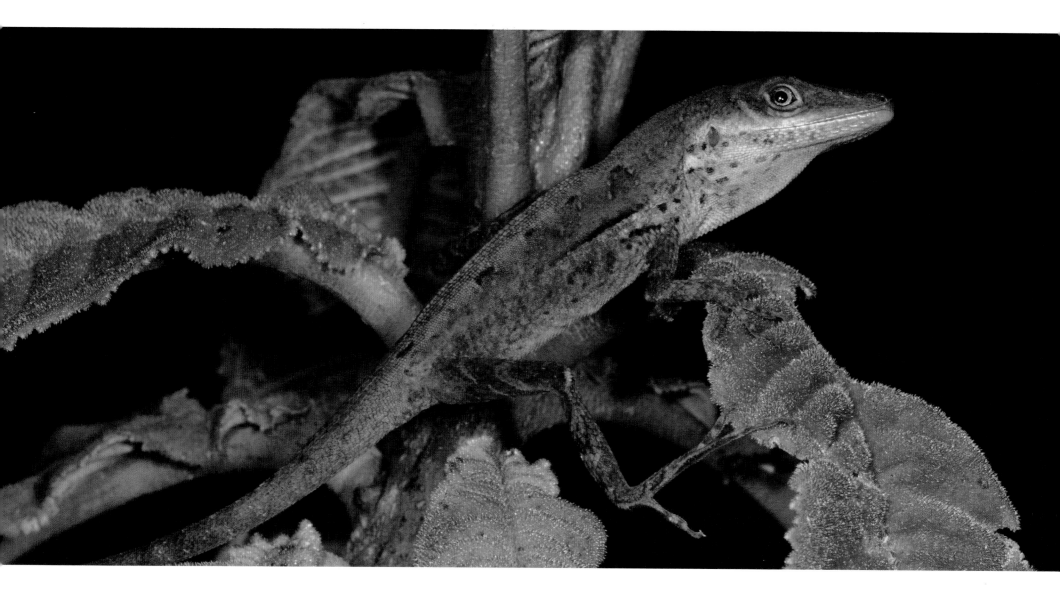

[*Anolis koopmani*] • LES PLATONS

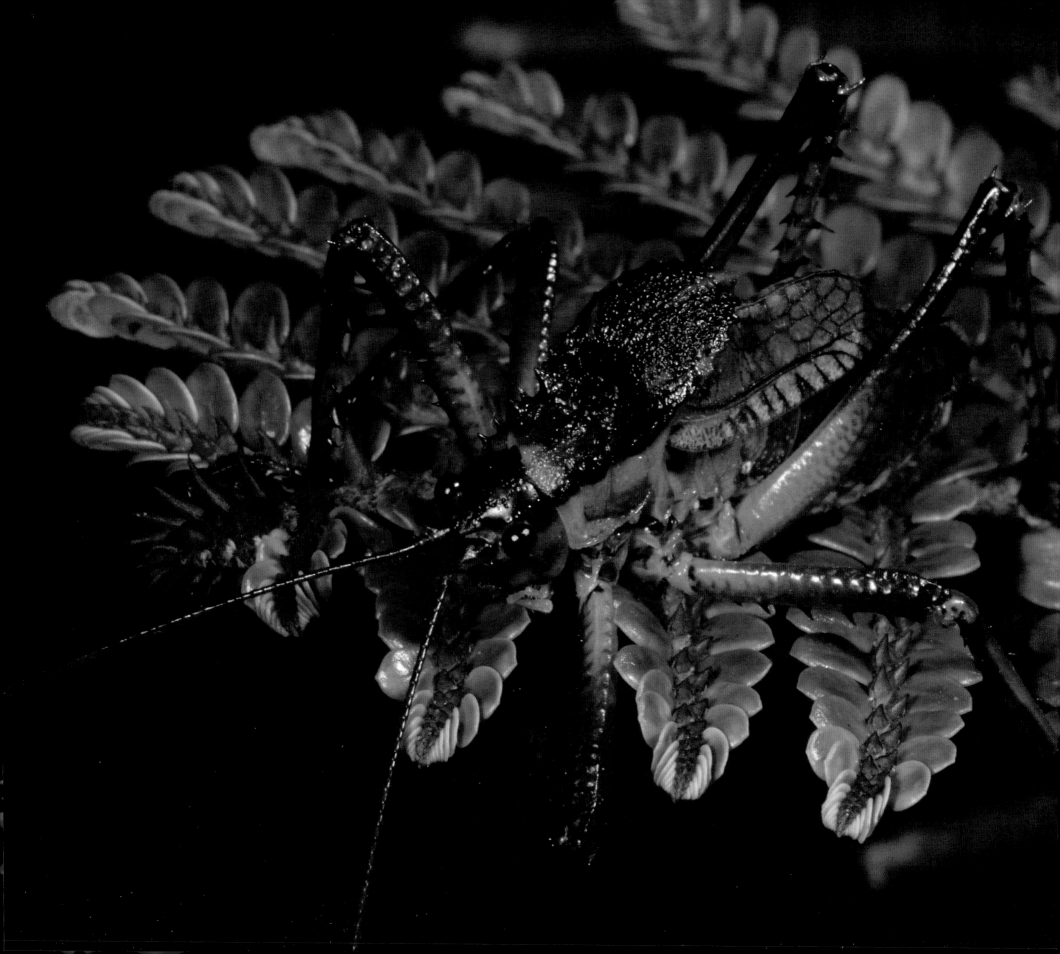

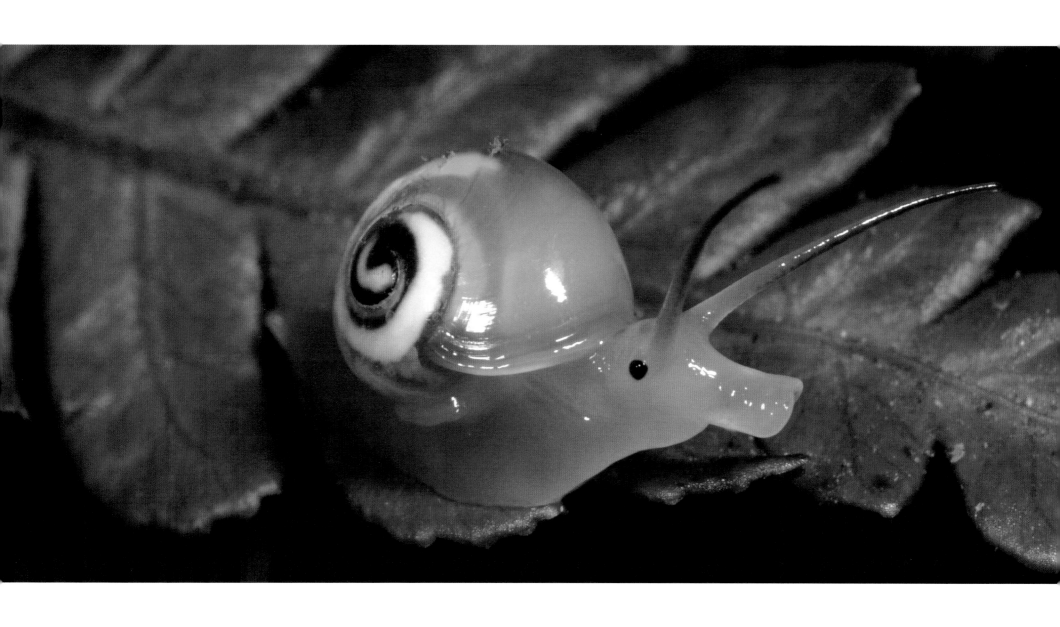

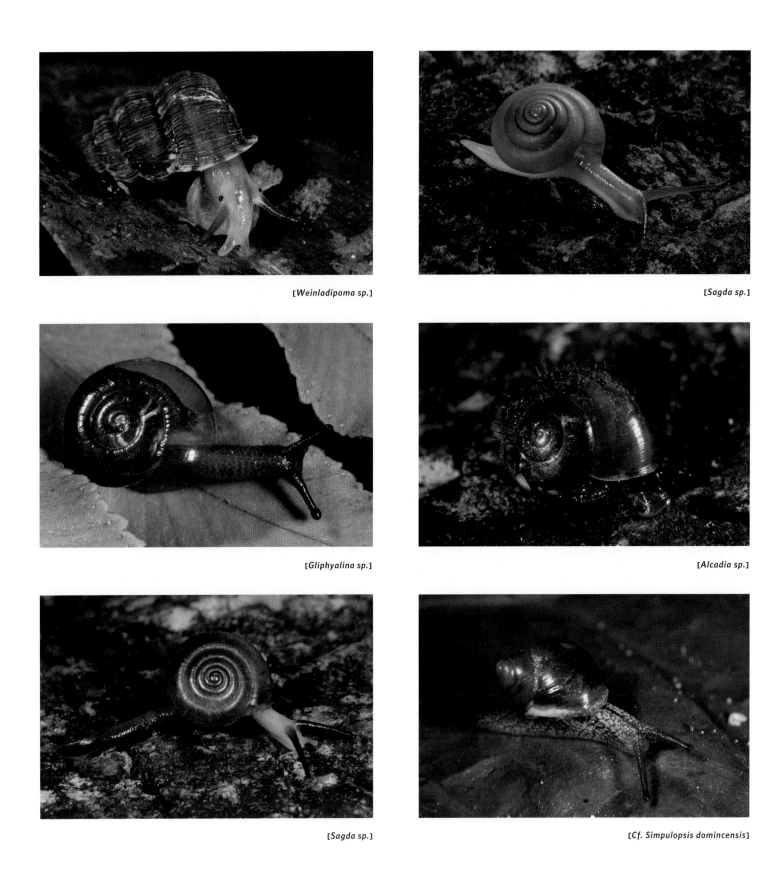

[*Weinladipoma sp.*]

[*Sagda sp.*]

[*Gliphyalina sp.*]

[*Alcadia sp.*]

[*Sagda sp.*]

[*Cf. Simpulopsis domincensis*]

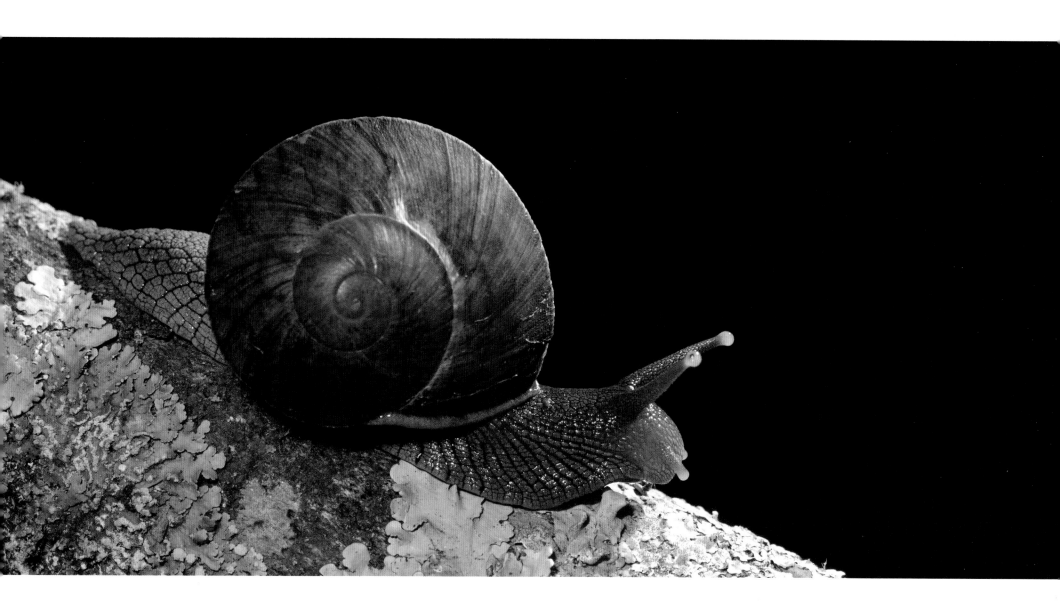

[*Pleurodonte excellens*] · FORMOND

ORUGA ESFÍNGIDO • SPHINX MOTH LARVA • FORMOND

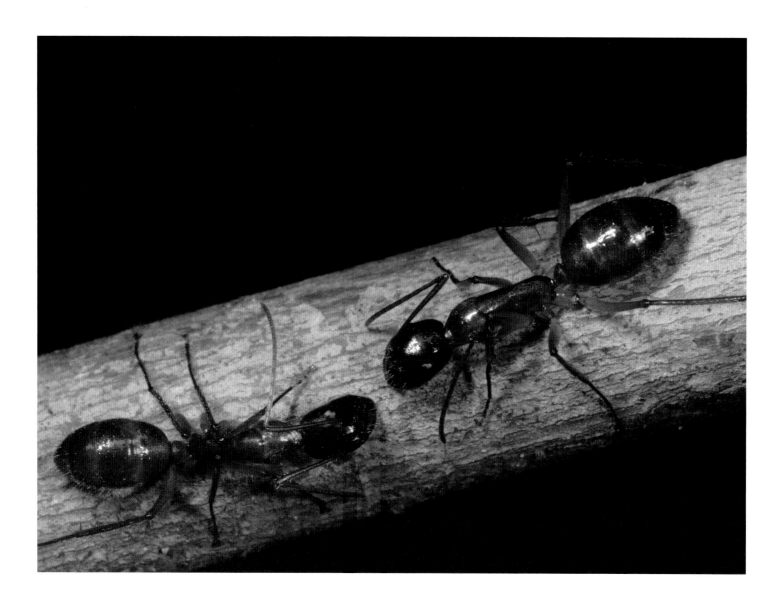

[*Camponotus cf. atriceps*] · FORMOND

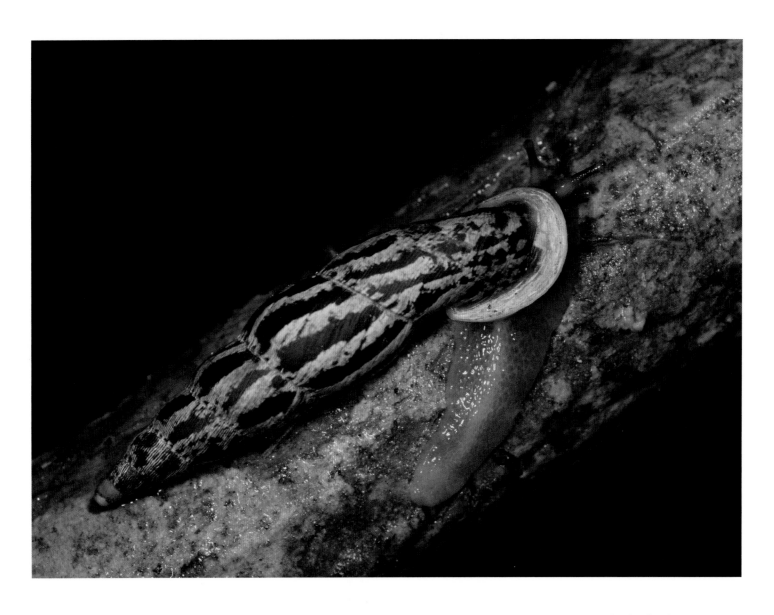

[Nenisca franzi] · CASTILLON

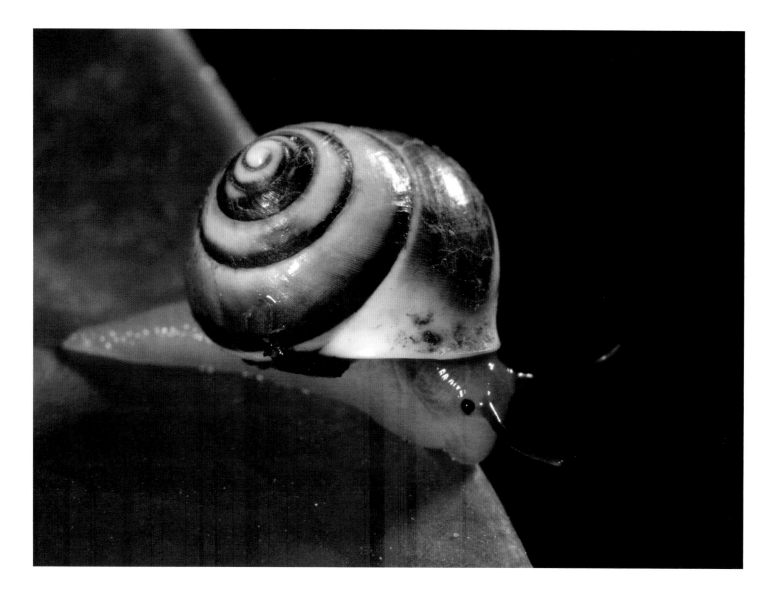

CARACOL TERRESTRE NO-IDENTIFICADO · UNIDENTIFIED LAND SNAIL · FORMOND

OLEACINA LIMPIANDO LA CONCHA · OLEACINA CLEANING THE SHELL · [Oleacina muelleri] · CASTILLON

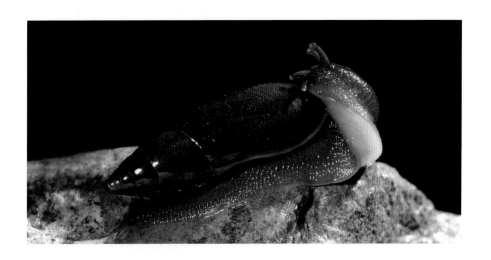

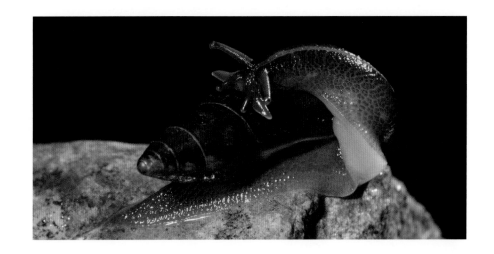

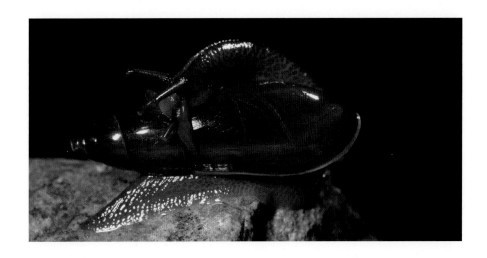

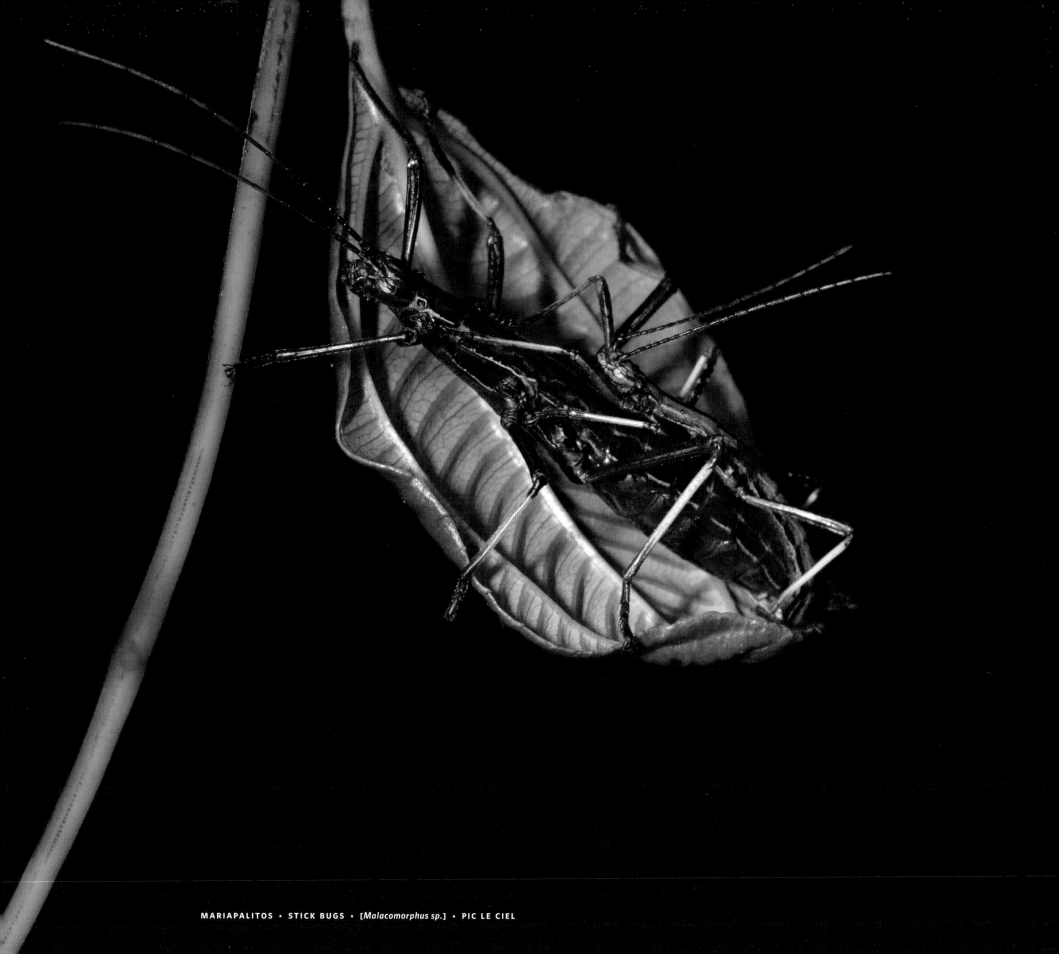

MARIAPALITOS • STICK BUGS • [*Malacomorphus sp.*] • PIC LE CIEL

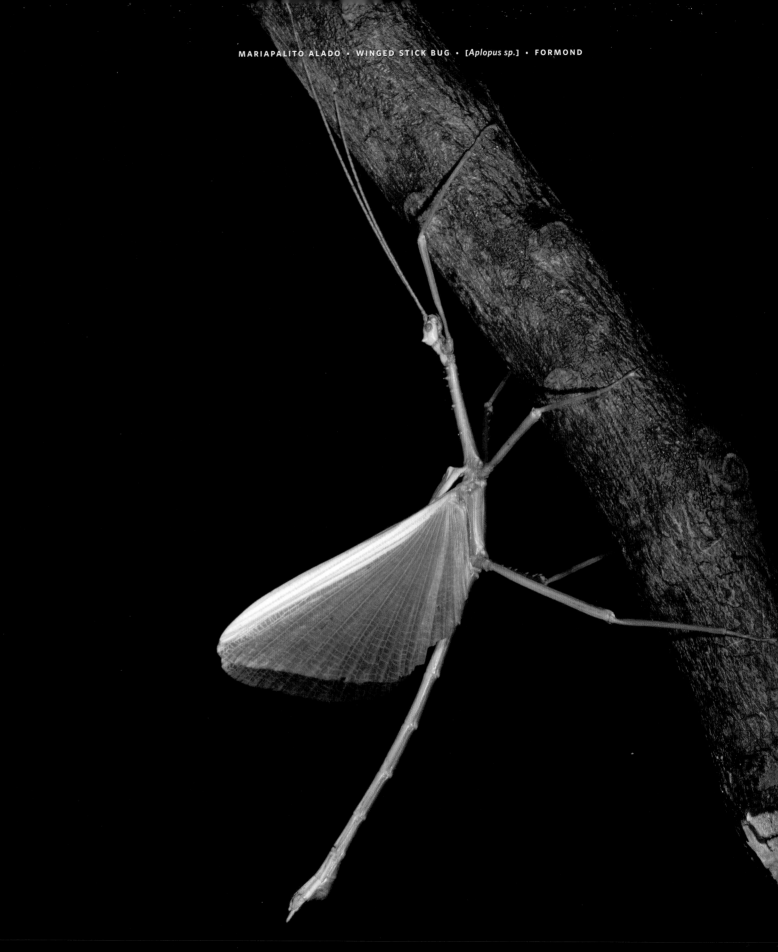

MASSIF DU NORD

EL MACIZO DU NORD EMPIEZA AL NORESTE DE HAITÍ, AL NORTE
del Río Guayamouc y se extiende 129 kilómetros hacia el pueblo de
Port-de-Paix. Esta cadena montañosa esta muy a menudo cubierta de
nubes y algunos de sus puntos más altos pueden alcanzar una altitud
de 1,100 metros sobre el nivel del mar. A pesar de haber perdido la
mayor parte de su vegetación original, muchos fragmentos retienen un
nivel muy alto de endemismos en plantas, reptiles y anfibios. Algunas
de estas especies como es *Anolis eugenegrahami*, están restringidas a
una localidad en particular.

THE MASSIF DU NORD BEGINS IN NORTHEASTERN HAITI,
north of the Guayamouc River, and extends 129 kilometers toward
the town of Port-de-Paix. This mountain range is often covered in
clouds, as some of its highest points can reach an altitude of 1,100
meters above sea level. Despite having lost most of its original vege-
tation, many fragments retain a high level of endemic plants, reptiles,
and amphibians. Some of these species, such as the rare Black Stream
Anole (*Anolis eugenegrahami*), are restricted to a particular locality.

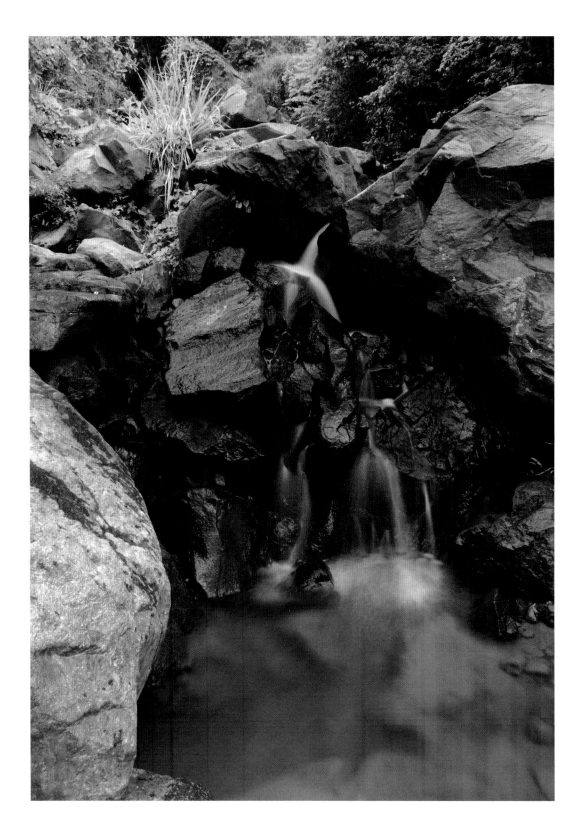

HABITAT DEL ANOLIS EUGENEGRAHAMI • BLACK STREAM ANOLE'S HABITAT

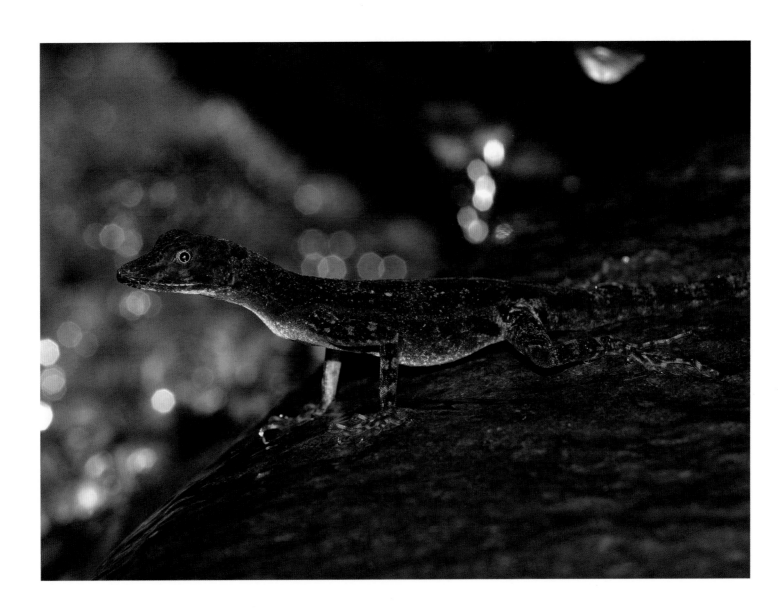

ANOLIS EUGENEGRAHAMI • BLACK STREAM ANOLE • [*Anolis eugenegrahami*] • PUILBORO

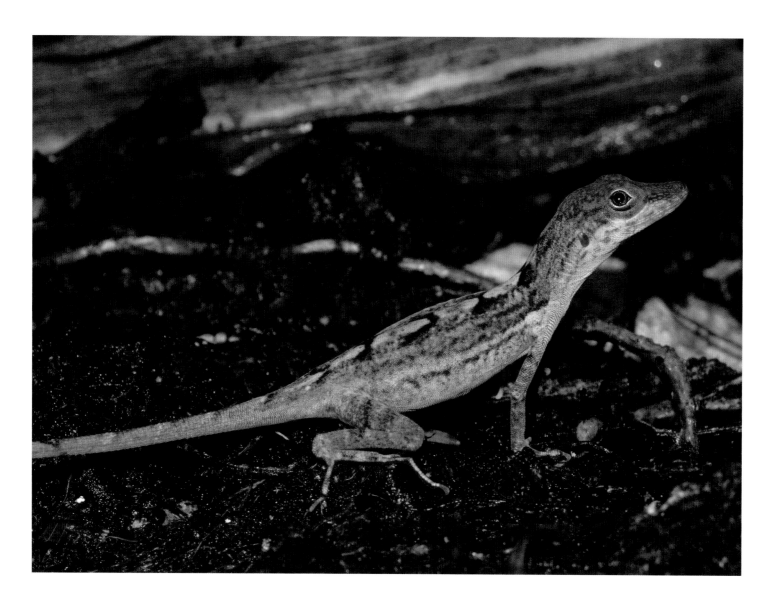

208

ARTIBONITE BUSH ANOLE · [*Anolis rimarum*] · PUILBORO

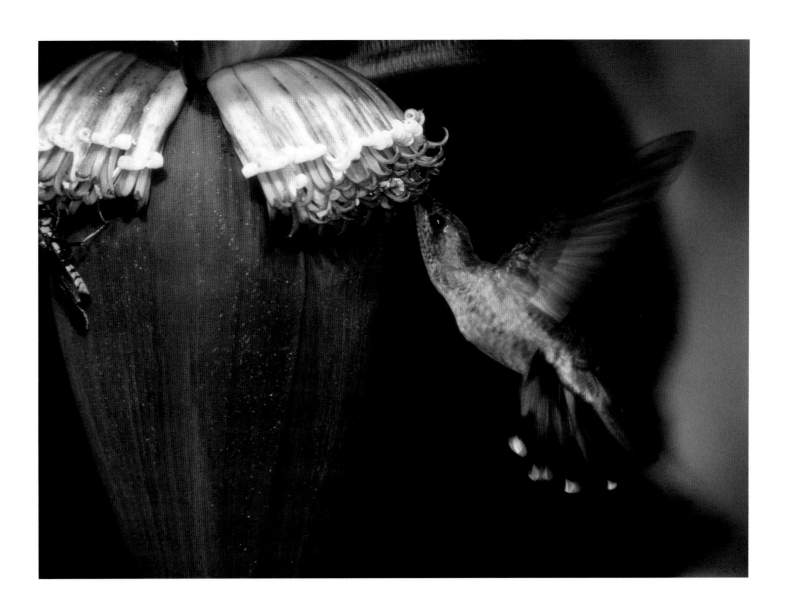

ZUMBADOR GRANDE Y AVISPA LIBANDO LAS FLORES DEL PLÁTANO · ANTILLEAN MANGO AND WASP FEEDING ON PLANTAIN FLOWERS

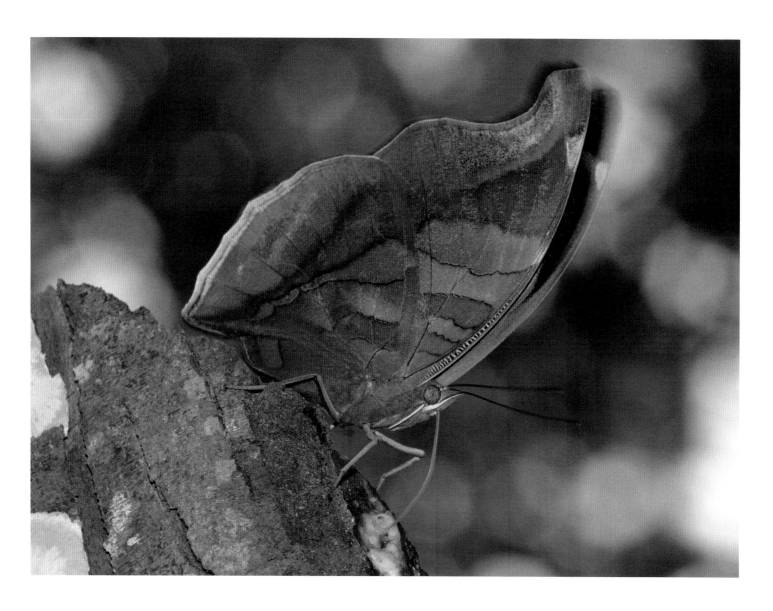

ORION · [*Phytolestes odius*] · PUILBORO

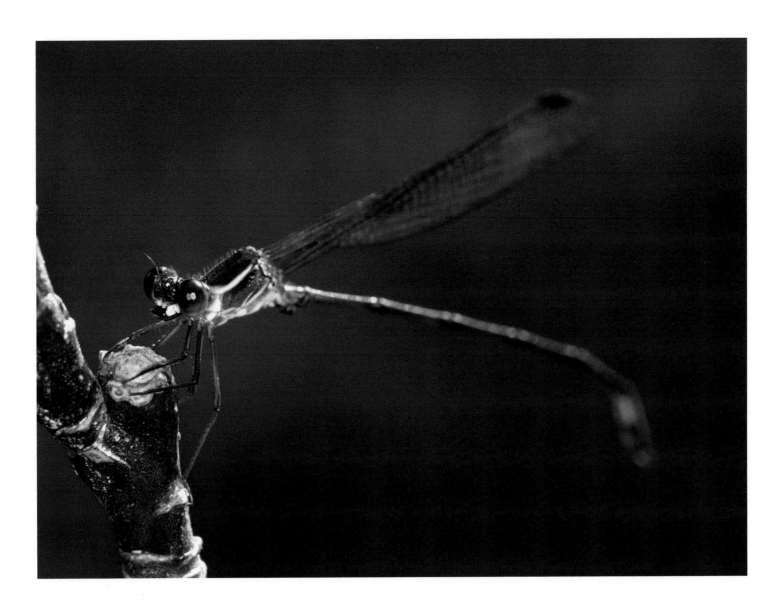

[*Phytolestes ethelae*] • PUILBORO

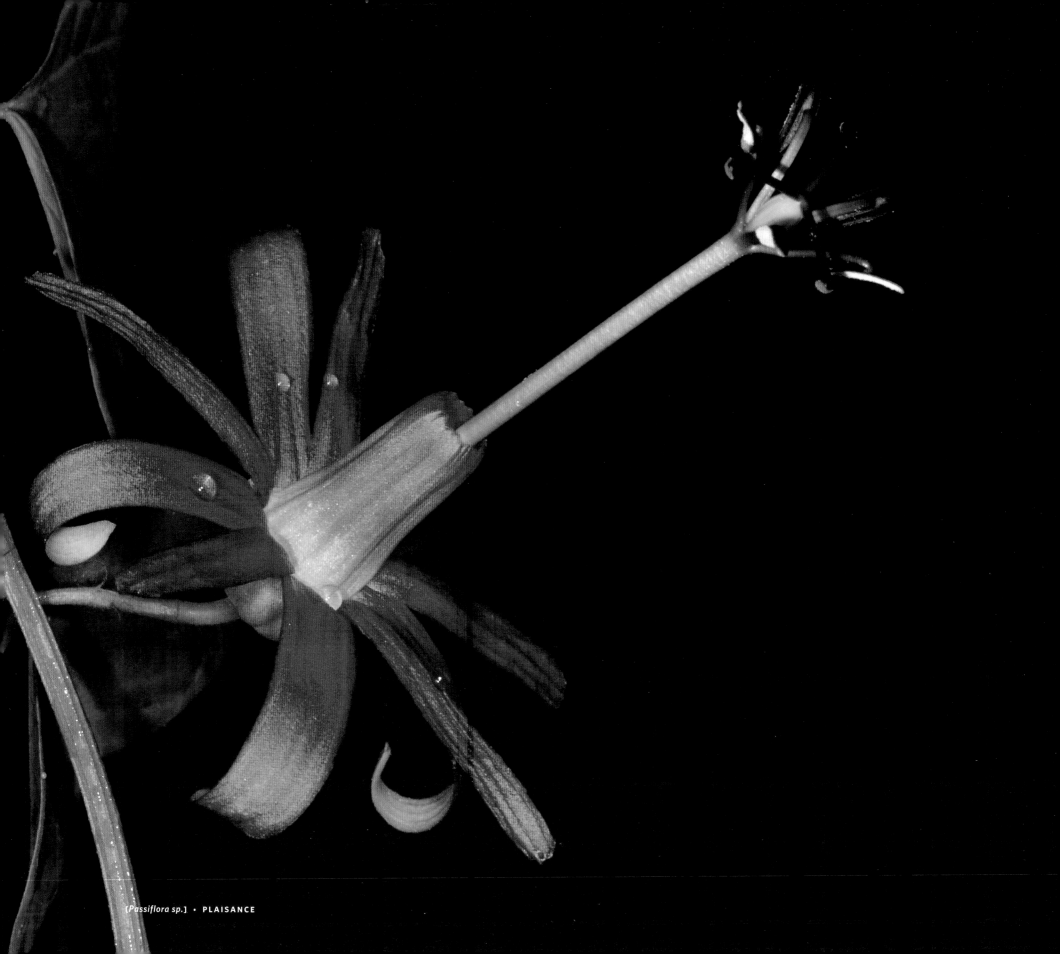

[Passiflora sp.] · PLAISANCE

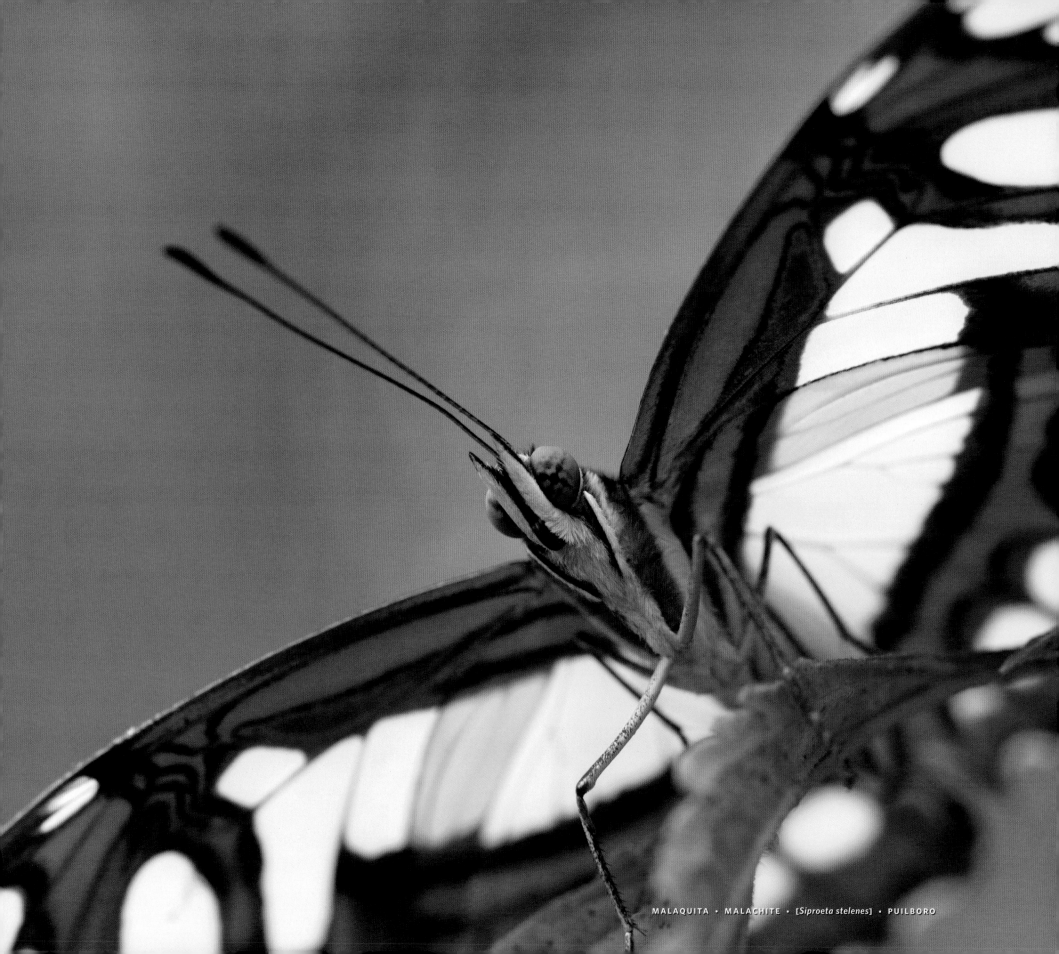

MALAQUITA • MALACHITE • [*Siproeta stelenes*] • PUILBORO

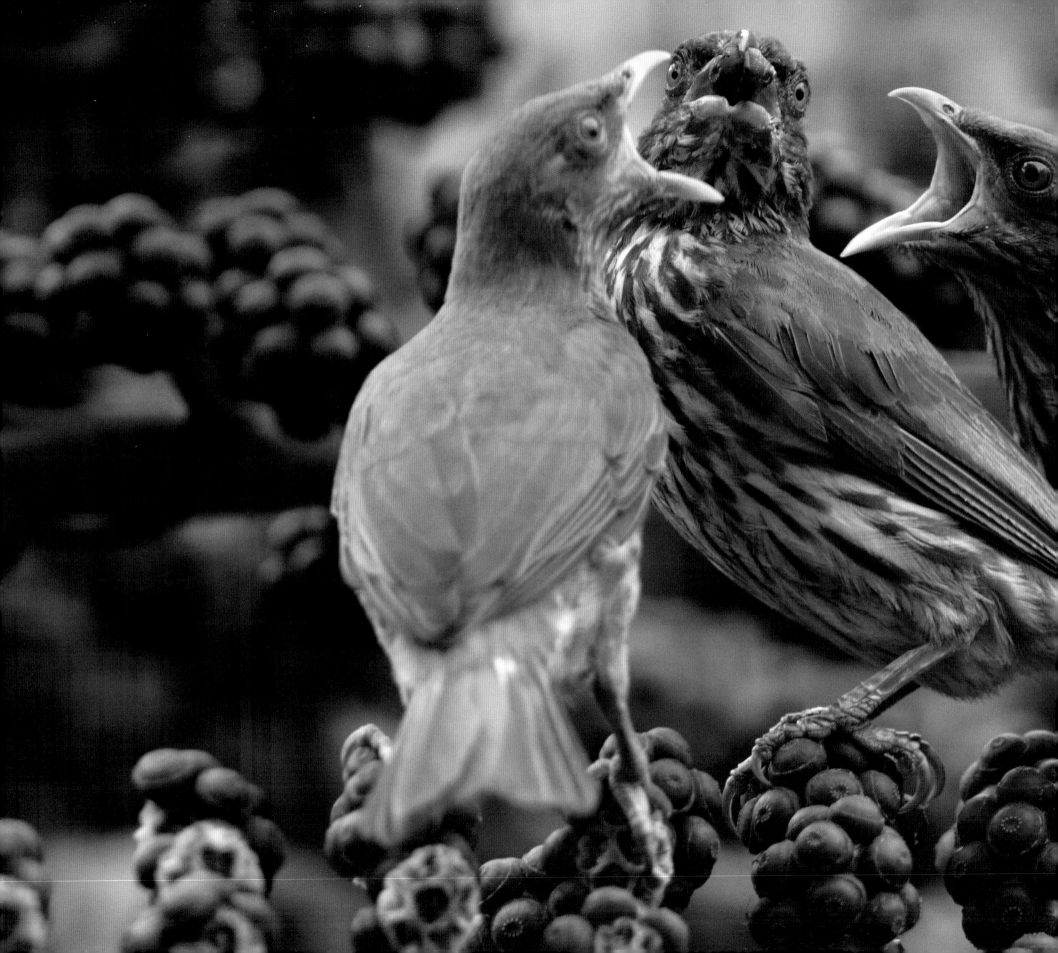

215

CIGUA PALMERA ALIMENTANDO PICHONES · PALM CHAT FEEDING FLEDGLINGS

[*Dulus dominicus*] · PLAISANCE

PARQUE NACIONAL MONTECRISTI

LOCALIZADO AL NOROESTE DE LA REPÚBLICA DOMINICANA, el Parque Nacional Montecristi tiene una superficie de 530 kilómetros cuadrados, incluyendo las áreas costeras y marinas. Dos de sus principales atracciones son El Morro y los Cayos Los Sietes Hermanos. El Morro, la atracción más popular, es una meseta de 300 metros con varias especies de plantas endémicas restringidas a su cima.

En la primavera las aves marinas usan varios de los cayos que forman Los Sietes Hermanos para anidar. Desafortunadamente, estas áreas están en constante ataque por los pescadores locales que utilizan los huevos de las aves y los pichones como fuentes alternas de proteína.

216

LOCATED IN THE NORTHWESTERN PART OF THE DOMINICAN Republic, Montecristi National Park has a surface area of 530 square kilometers, including coastal and marine areas. Two of its principal attractions are El Morro and the Cayos Los Siete Hermanos. El Morro, the park's most popular feature, is a 300-meter plateau with several endemic plant species restricted to its top.

In the spring, seabirds use several of the cays that form the "seven brothers" as their nesting grounds. Unfortunately, these nesting areas are under constant attack from local fishermen, who traditionally use the seabird eggs and chicks as an alternate source of protein.

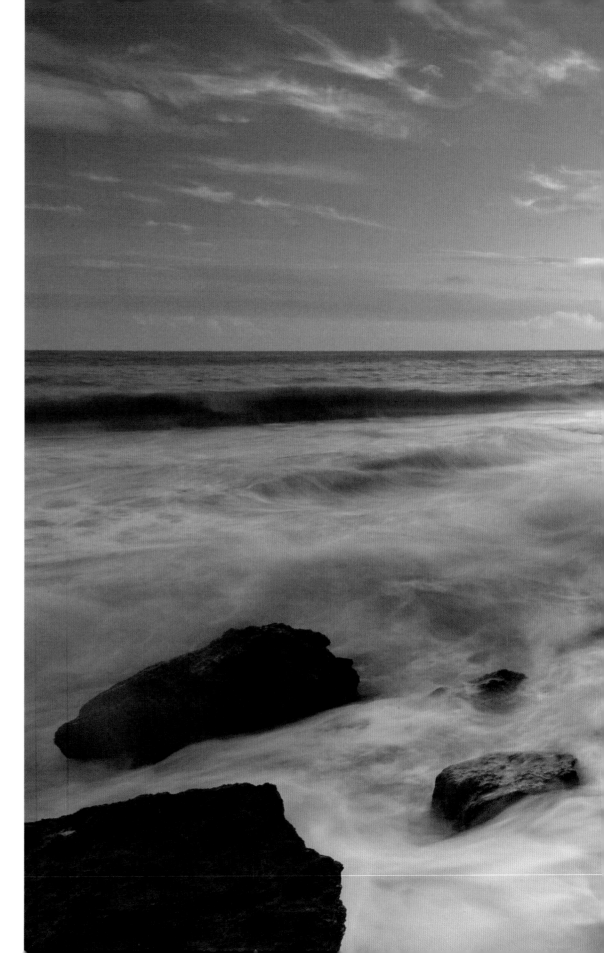

PLAYA EL MORRO

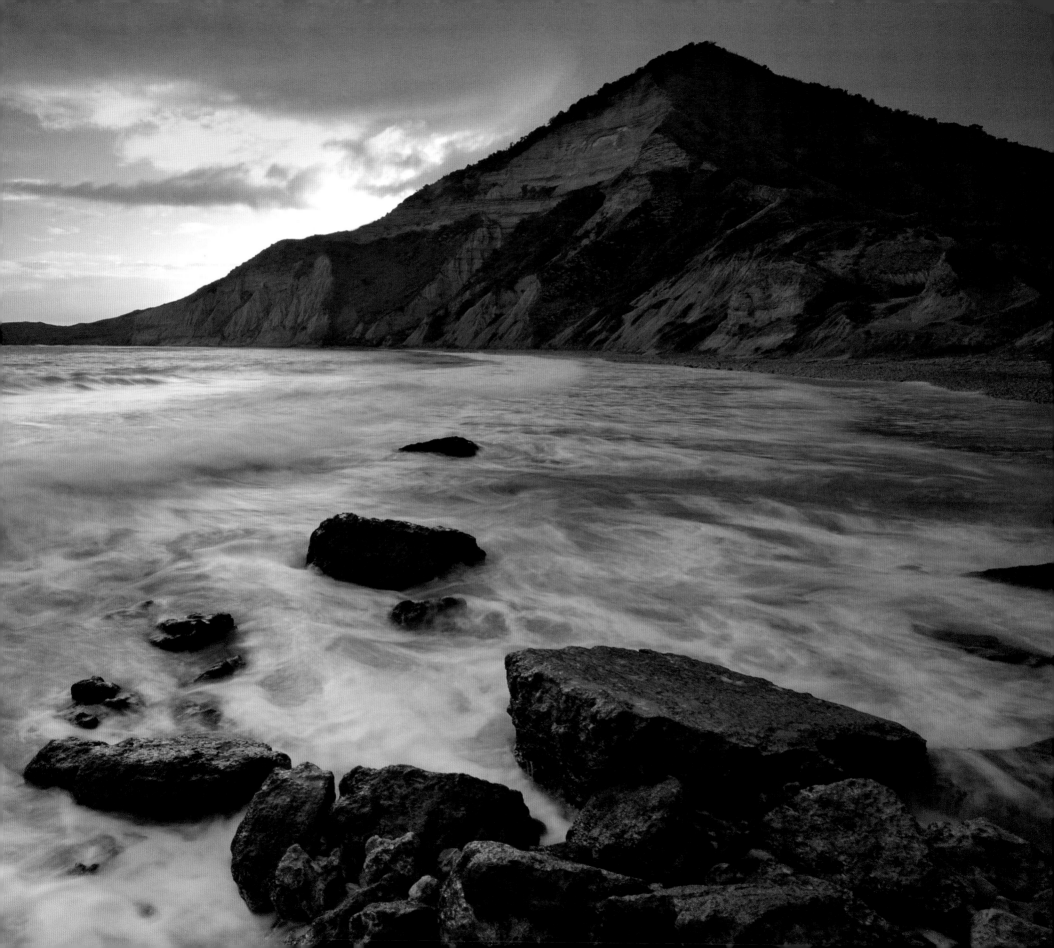

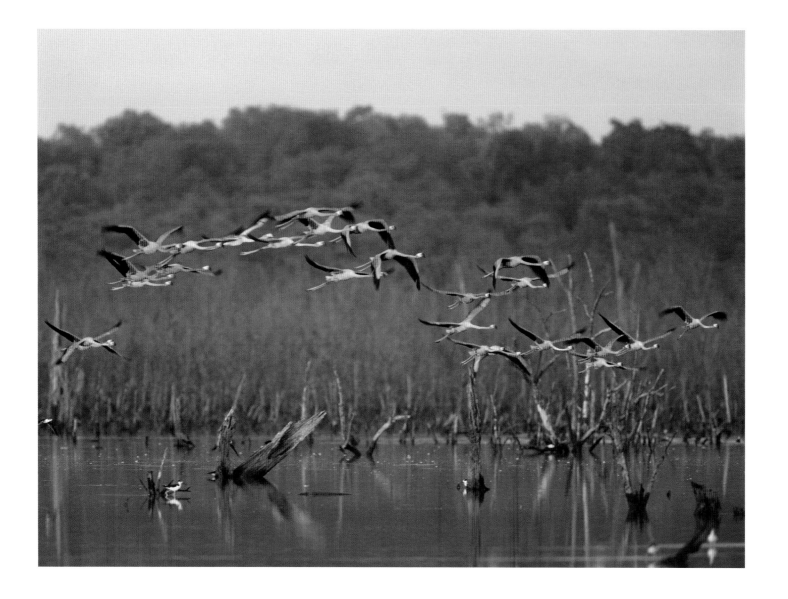

FLAMENCO · FLAMINGO · [*Phoenicopterus ruber*] · LAGUNA NELSON

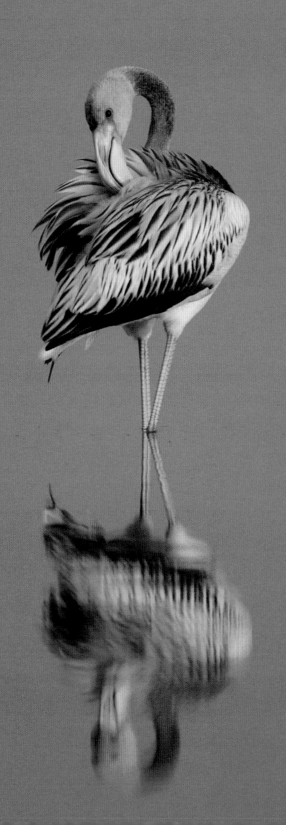

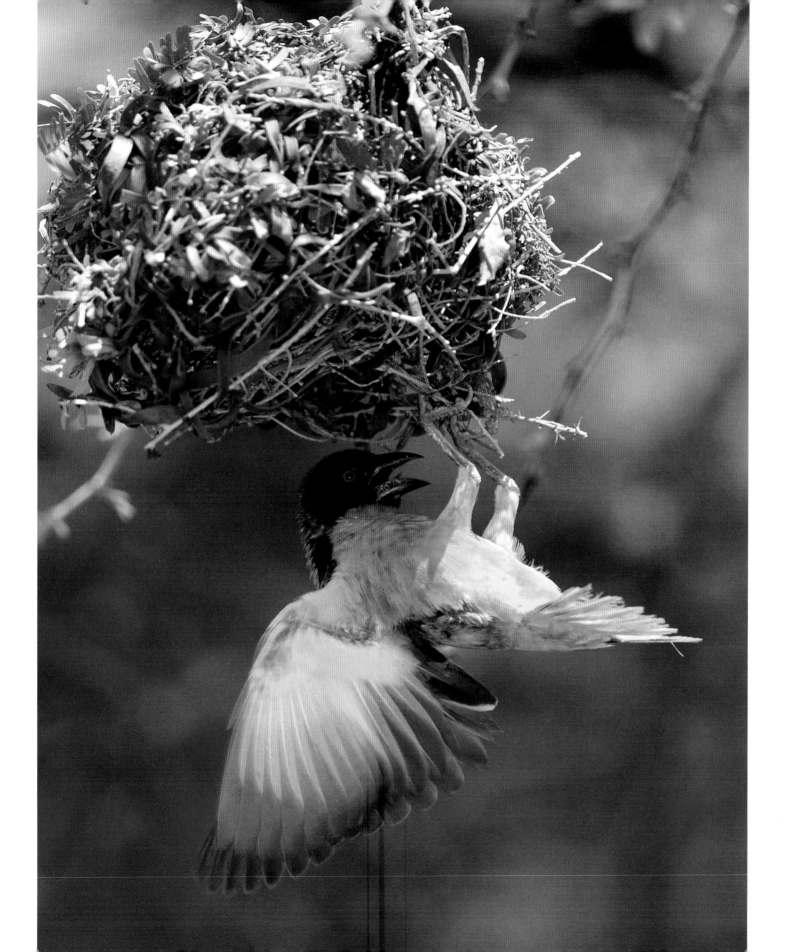

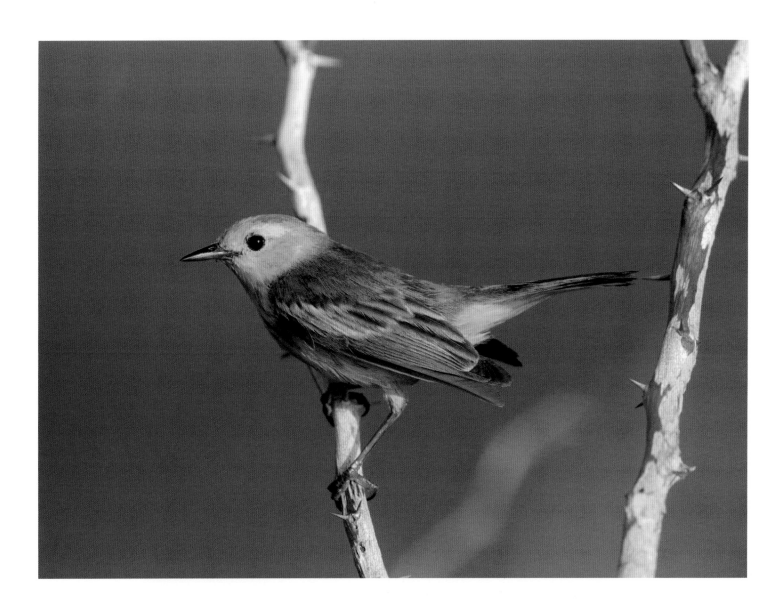

221

CANARIO DE MANGLAR · YELLOW WARBLER · [*Dendroica petechia*] · CAYO TUNA

MADAME ZAGA · VILLAGE WEAVER · [*Ploceus cuculatus*] · EL COPEY

NINFA DE MANTIS · [*Stagmomantis domingensis*] · LAGUNA SALINA

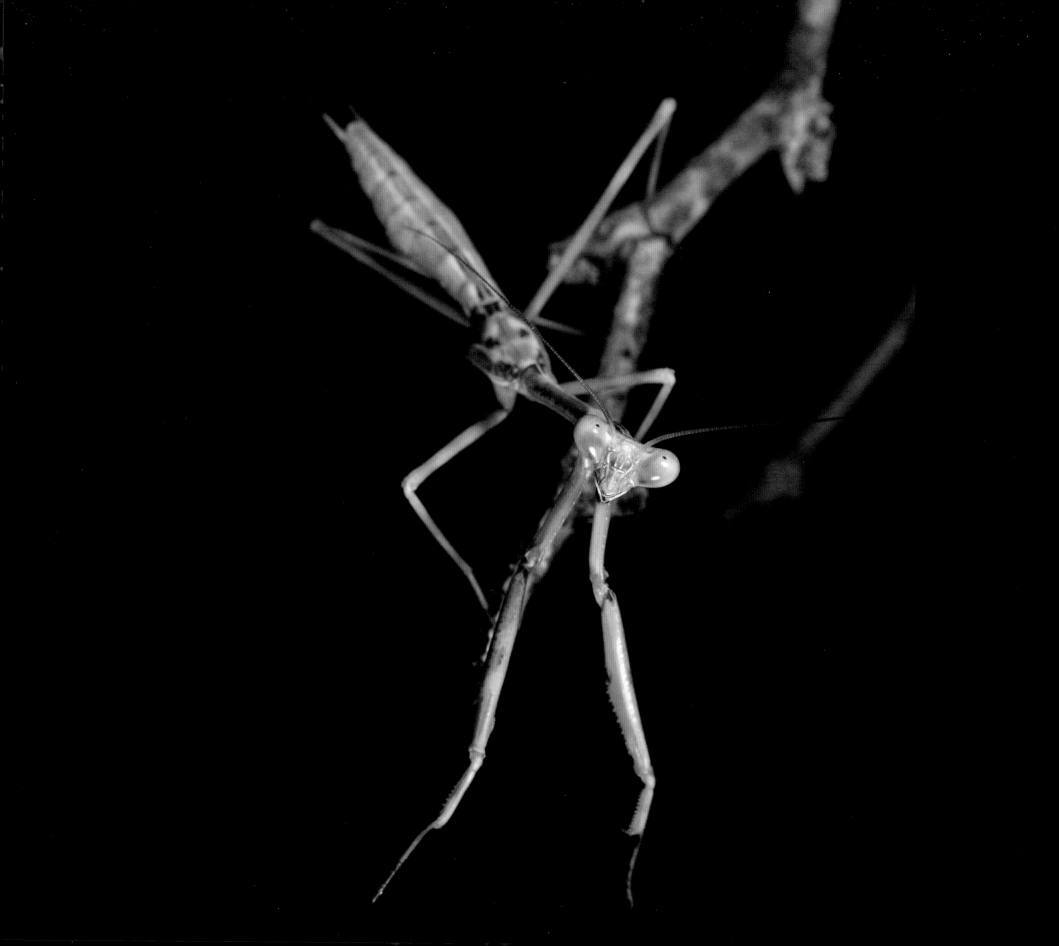

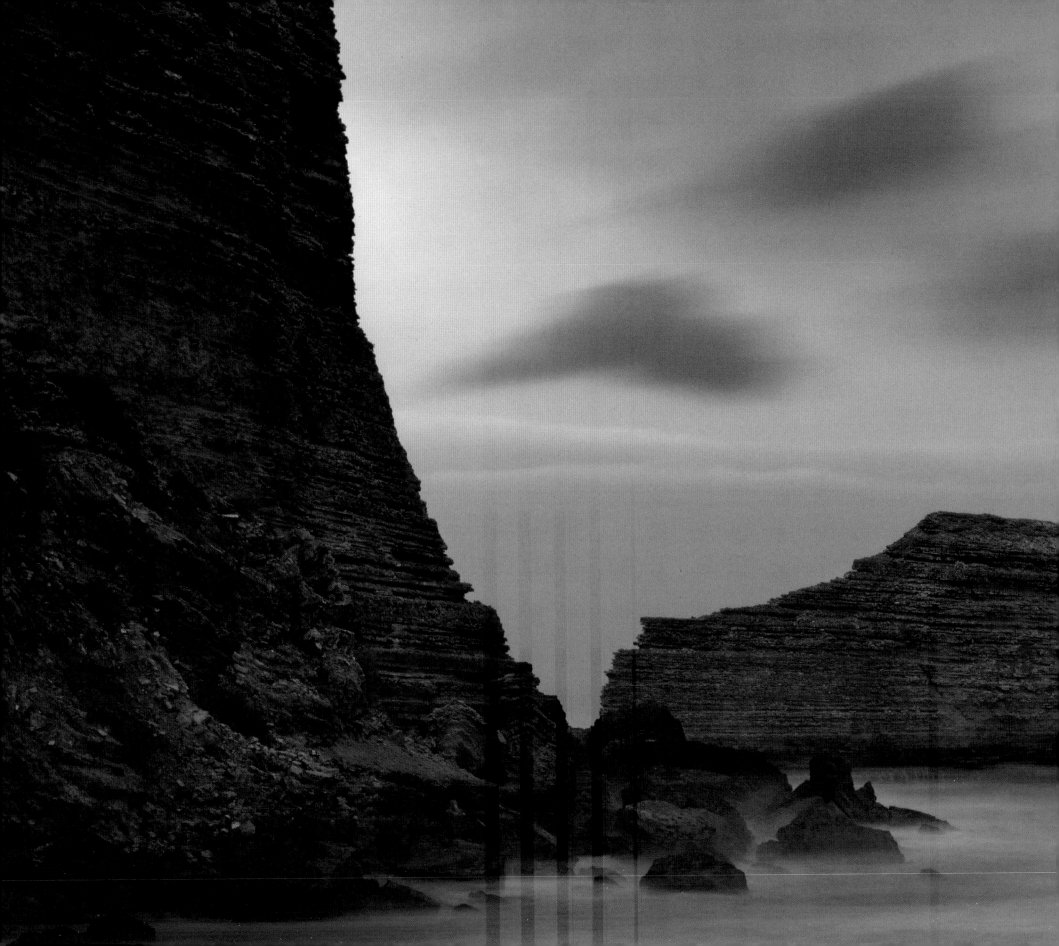

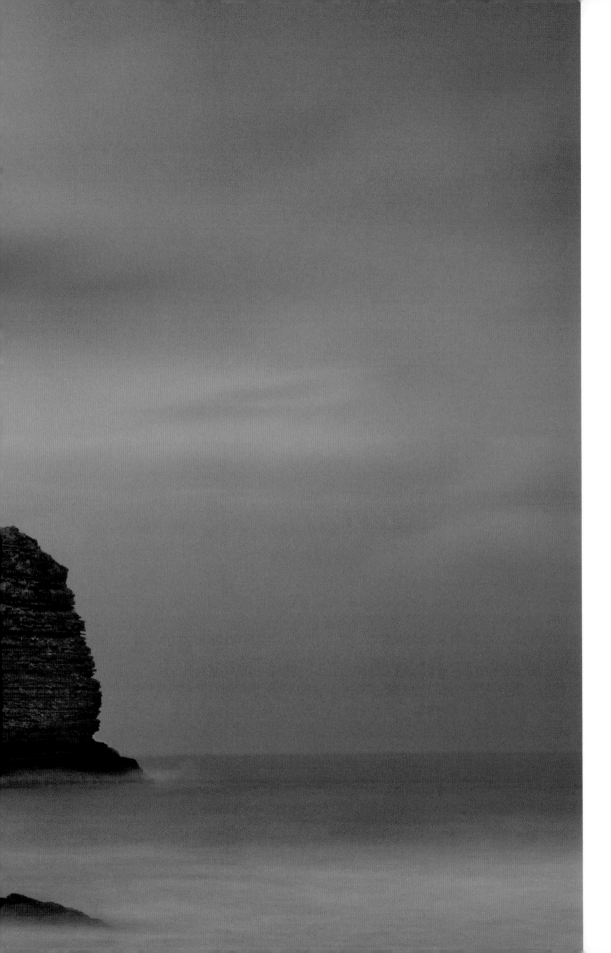

PLAYA EL MORRO

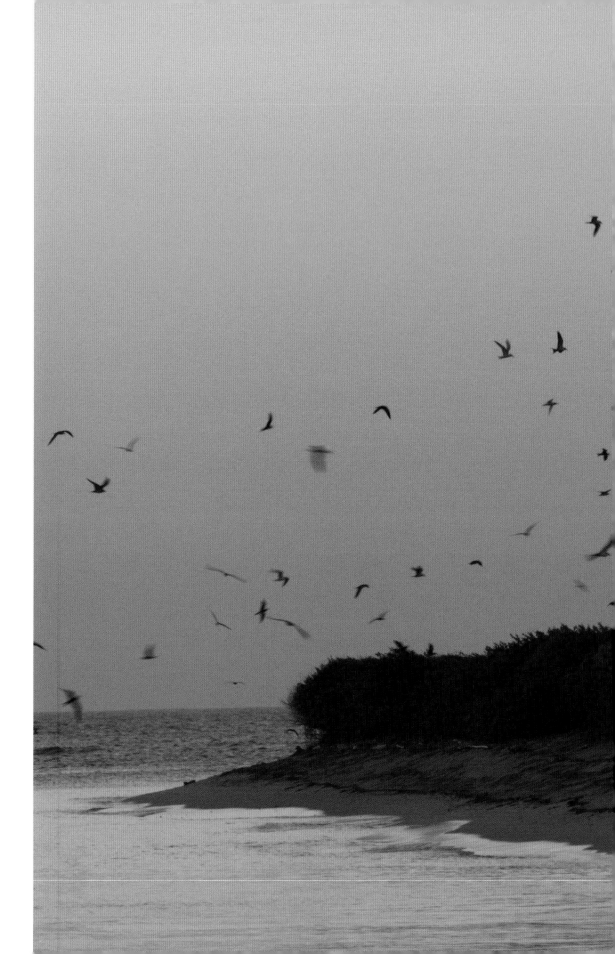

CAYOS
LOS SIETE HERMANOS

CONSIDERADOS COMO PARTE DEL PARQUE NACIONAL MONTECRISTI, los Cayos Los Siete Hermanos son unas de las mayores atracciones de la parte noroeste de la República Dominicana. Distando de 5 a 15 kilómetros de Punta Luna, estas isletas o cayos están divididos en dos grupos: Tororu y Monte Chico al sureste; Terreno,⌈in the Eng. It says Terrero⌉ Monte Grande, Ratas (Tuna), Muertos y Arenas al noroeste.

Los Cayos Los Siete Hermanos sirven de refugio a varias aves marinas durante su ciclo reproductivo, de las cuales resaltan tres especies: la Gaviota Oscura (*Onychoprion anaethetus*), y los erróneamente llamados Bubí, *Onychoprion fuscata* y *Anous stolidus*.

Las comunidades locales conocen erradamente estas dos especies bajo el nombre de Bubí, nombre que se refiere a otra especie, el Bubí Pardo (*Sula leucogaster*). Estas especies están en constante acecho por los cazadores furtivos de huevos tanto haitianos como dominicanos.

226

CONSIDERED PART OF MONTECRISTI NATIONAL PARK, CAYOS LOS Siete Hermanos is one of the main natural attractions of the northwestern part of the Dominican Republic. Located at 5 to 15 kilometers from Punta Luna, these small isles or keys are divided into two groups: Tororú and Monte Chico to the southeast, and Terrero, Monte Grande, Ratas (Tuna), Muertos, and Arenas to the northwest.

Cayos Los Siete Hermanos serves as refuge for various marine birds during their reproductive cycle, among which three main species stand out: the Bridled Tern (*Onychoprion anaethetus*), the Sooty Tern (*Onychoprion fuscata*), and the Brown Noddy (*Anous stolidus*). Local communities erroneously know these terns as bubí, a name that refers to another species, the Brown Booby (*Sula leucogaster*). These species are under constant pressure from both Haitian and Dominican egg poachers.

EL MORRO, MONTECRISTI

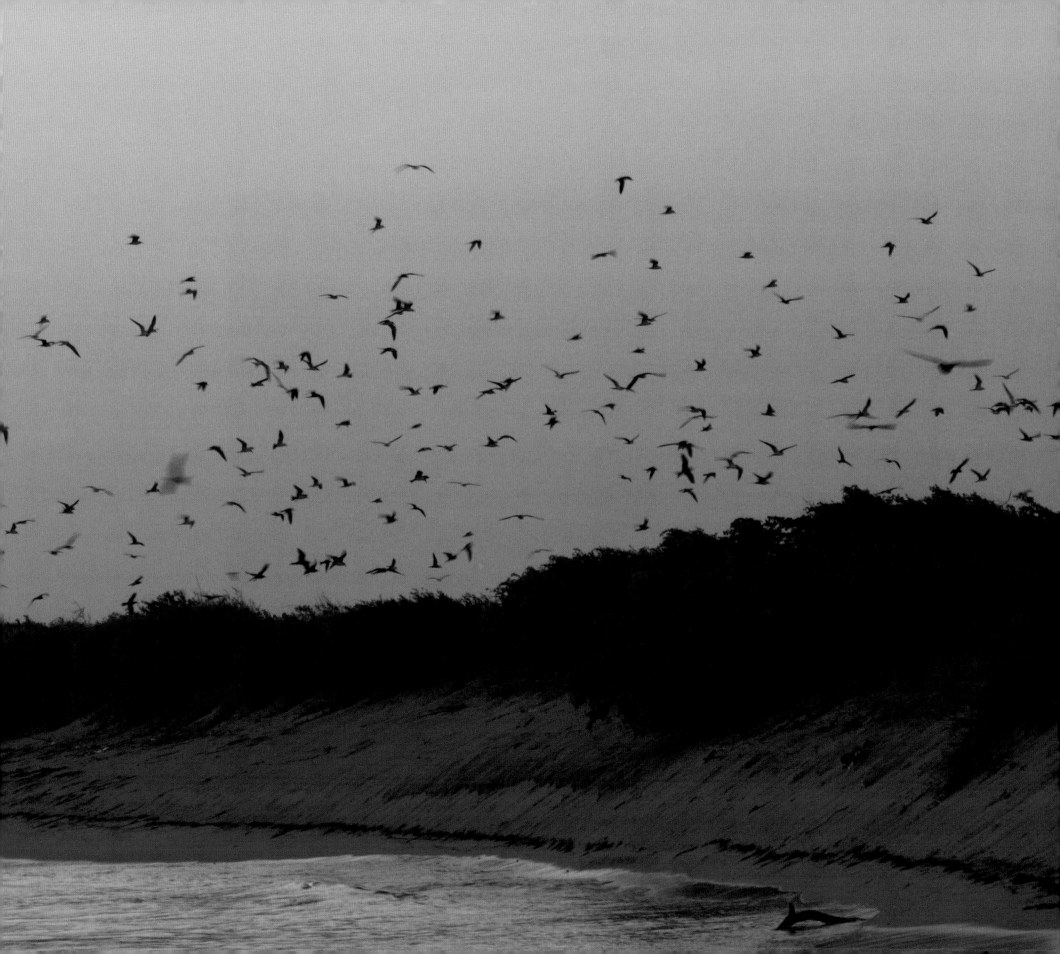

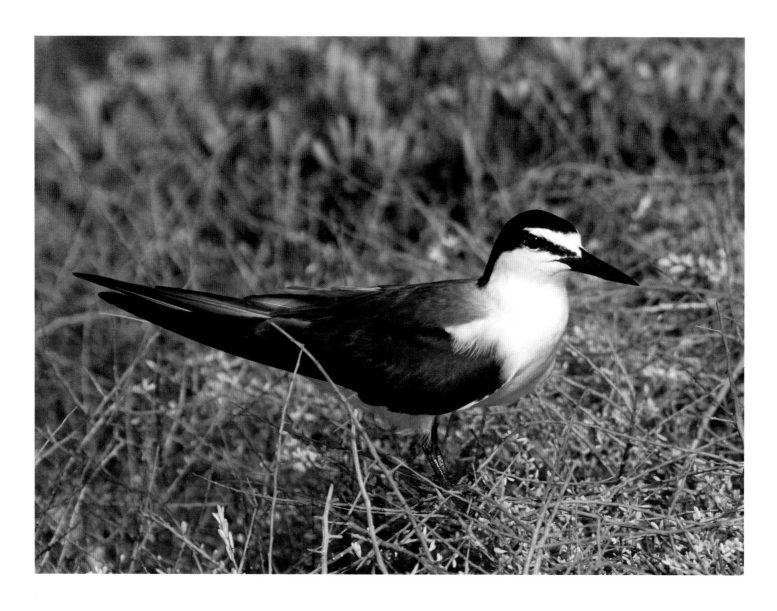

GAVIOTA MONJA · BRIDLED TERN · [*Onychoprion anaethetus*] · CAYO TUNA

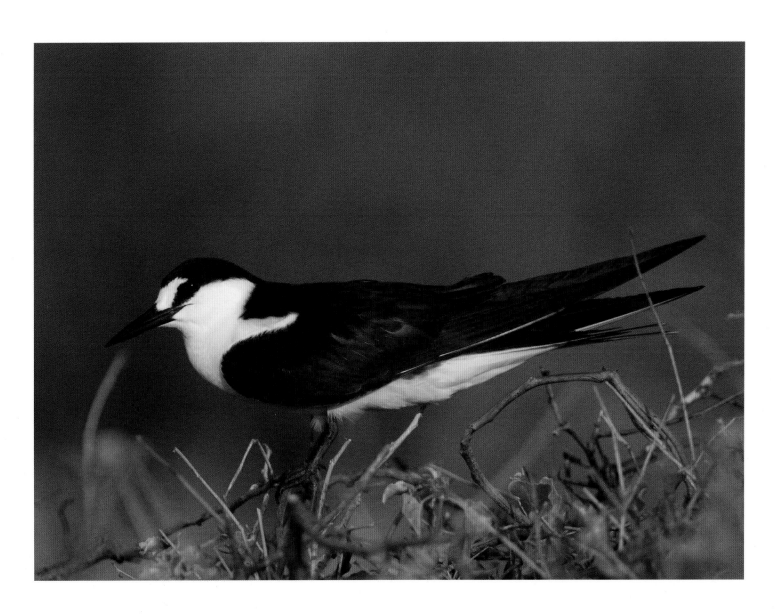

GAVIOTA OSCURA · SOOTY TERN · [*Onychoprion fuscata*] · CAYO TUNA

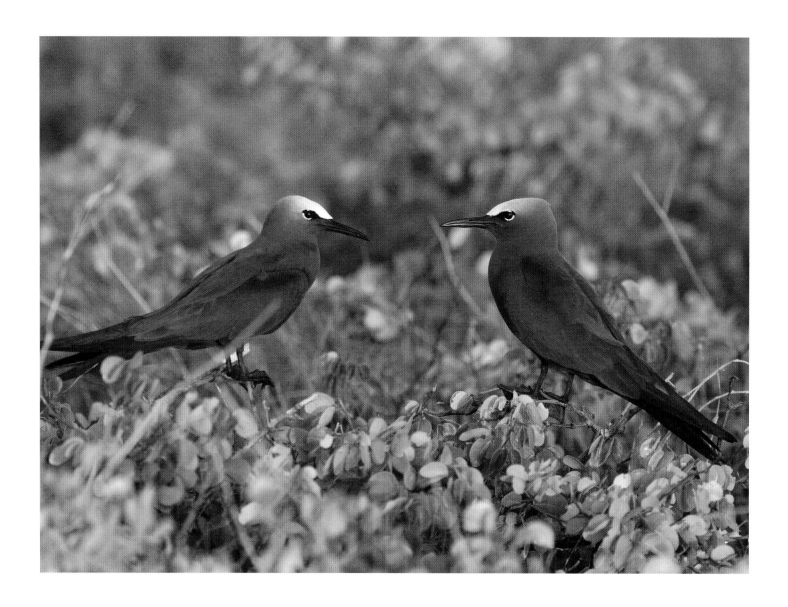

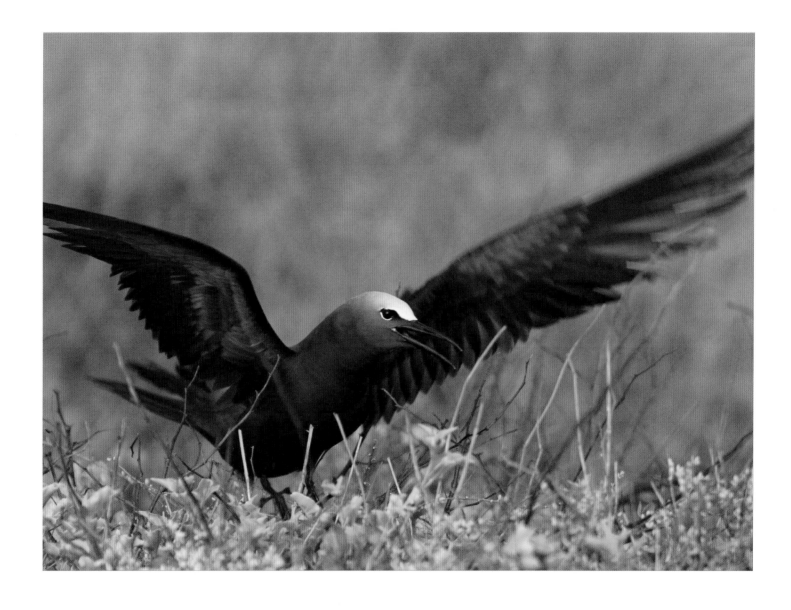

CERVERA · BROWN NODDY · [*Anous stolidus*] · CAYO TUNA

RESERVA CIENTÍFICA ÉBANO VERDE

LA RESERVA CIENTÍFICA ÉBANO VERDE ES LA ÚNICA ÁREA protegida de la República Dominicana que esta manejada en su totalidad por una institución privada, la Fundación Progressio. Localizada en el extremo este de la Cordillera Central, esta reserva es pequeña (23 kilómetros cuadrados). Inicialmente se creó para proteger el Ébano Verde de La Española (*Magnolia palescens*), un árbol endémico, cuya población ha disminuido como resultado de la tala ilegal. La madera de este árbol es considerada una de las más finas de la isla y era usada para la construcción de muebles.

Esta reserva también protege el nacimiento de los ríos Camú, Jimenoa y Jatubey, que proporcionan el agua a varias comunidades del Valle del Cibao. Esta área recibe una precipitación anual de unos 1,500 a 3,000 mm, convirtiéndola en unos de las regiones más húmedas de la isla. De esta región, 621 especies de plantas vasculares han sido reportadas, 153 de las cuales son endémicas a la reserva. La reserva también es rica en especies de anfibios, moluscos, aves y reptiles.

233

THE ÉBANO VERDE SCIENTIFIC RESERVE IS THE ONLY protected area in the Dominican Republic that is managed entirely by a private institution, Fundación Progressio. Located in the easternmost part of the Cordillera Central, the reserve is small (23 square kilometers). It was initially created to protect the Hispaniolan Green Ebony (*Magnolia palescens*), an endemic tree, whose populations have diminished as a result of illegal logging. Wood from this tree is considered one of the finest on the island and was popularly used for furniture construction.

The reserve also protects the birthplaces of the Camú, Jimenoa, and Jatubey rivers, which provide water to several communities in the Cibao Valley. This area receives an annual rainfall between 1,500 and 3,000 cubic millimeters, making it one of the most humid regions on the island. From this region 621 species of vascular plants have been reported, 153 of which are endemic to the reserve. The reserve is also rich in amphibians, mollusks, birds, and reptiles.

EL ARROYAZO

234

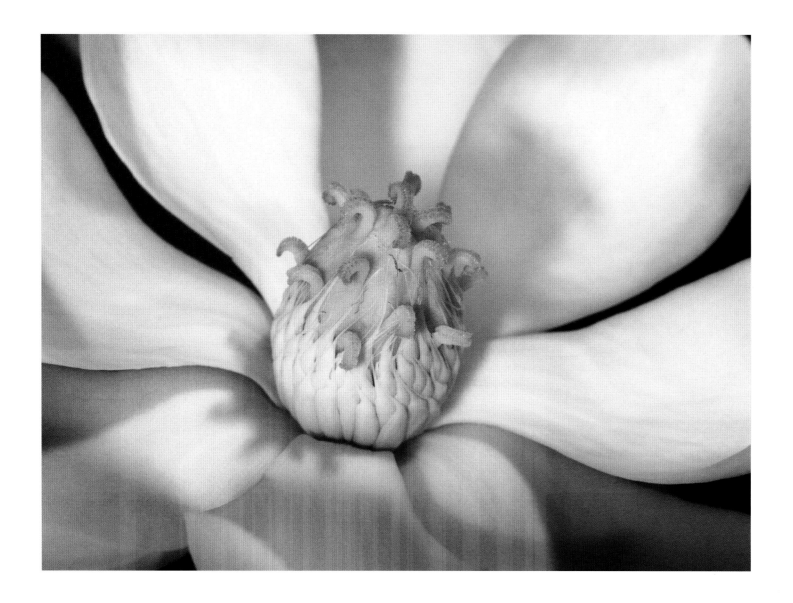

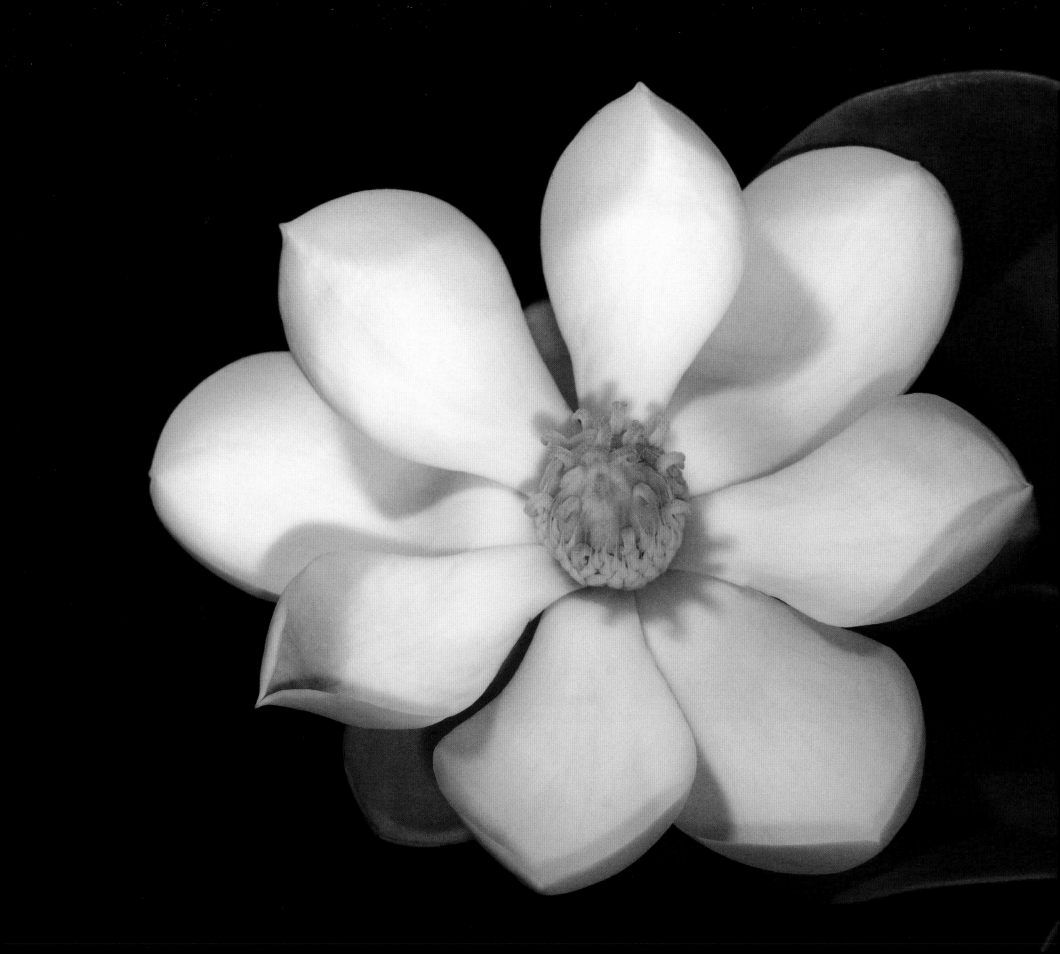

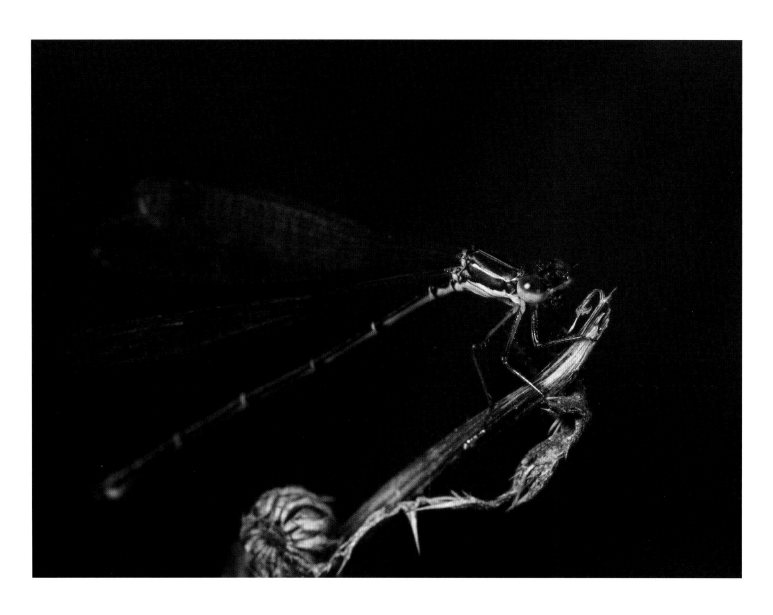

DAMISELA · DAMSELFLY · [*Hypolestes clara*] · EL ARROYAZO

HELECHO CALIMETE · BRACKEN FERN · [*Pteridium aquilinum*] · LOMA DE LA SAL

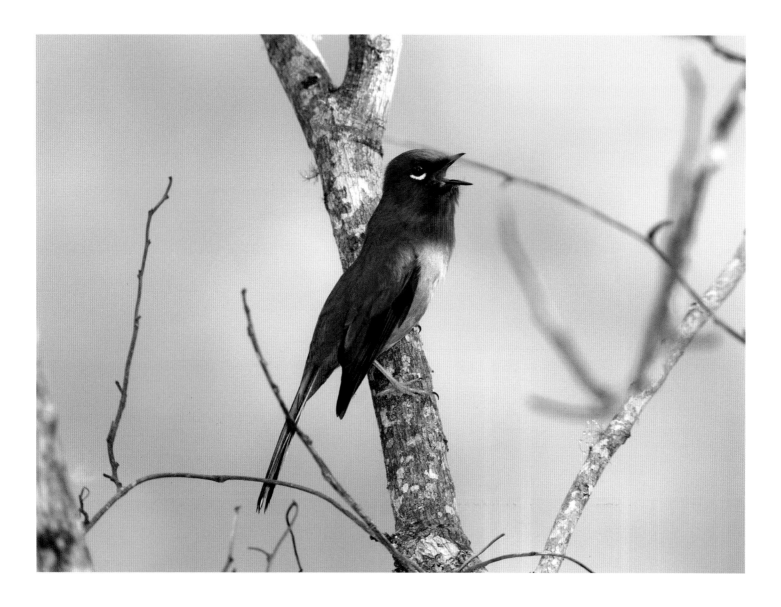

JILGUERO · RUFOUS-THROATED SOLITAIRE · [*Myadestes genibarbis*]

ZUMBADOR ESMERALDA · HISPANIOLAN EMERALD · [*Chlorostilbon swainsonii*]

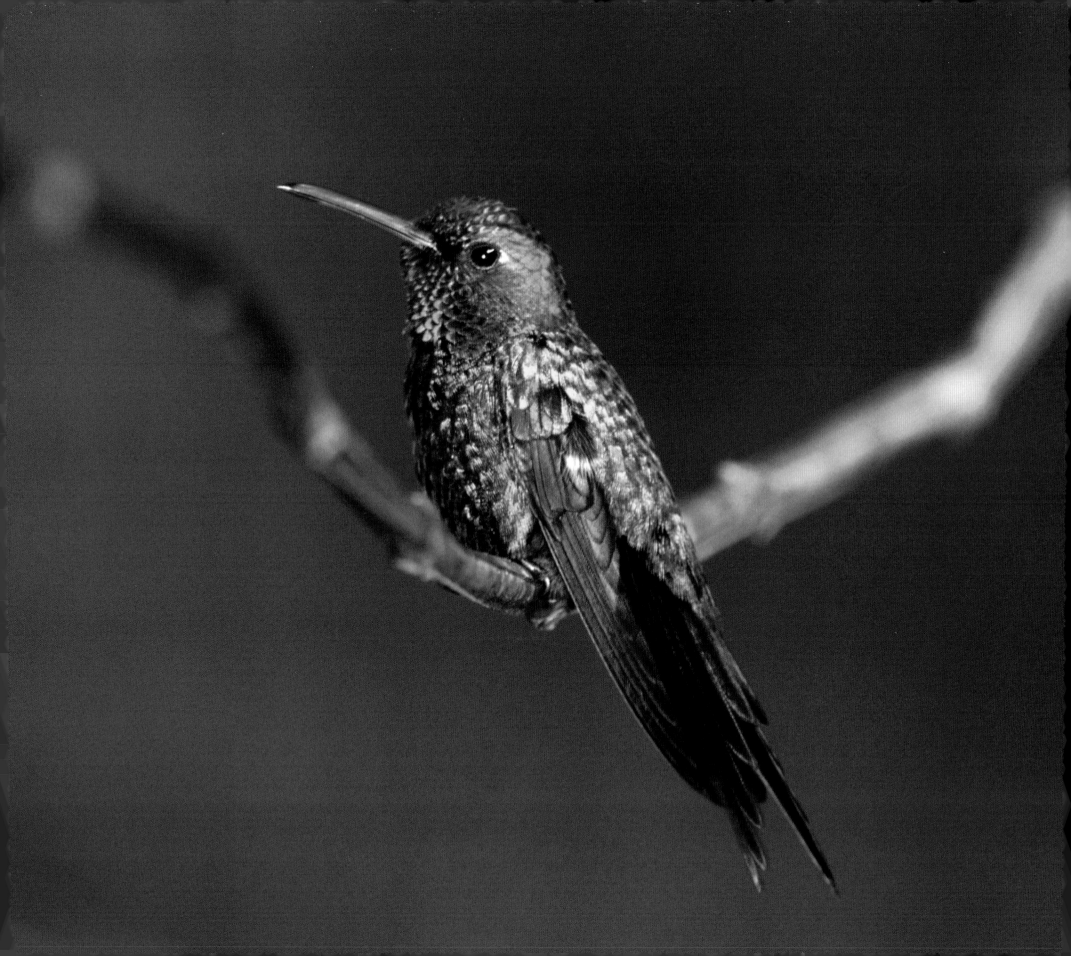

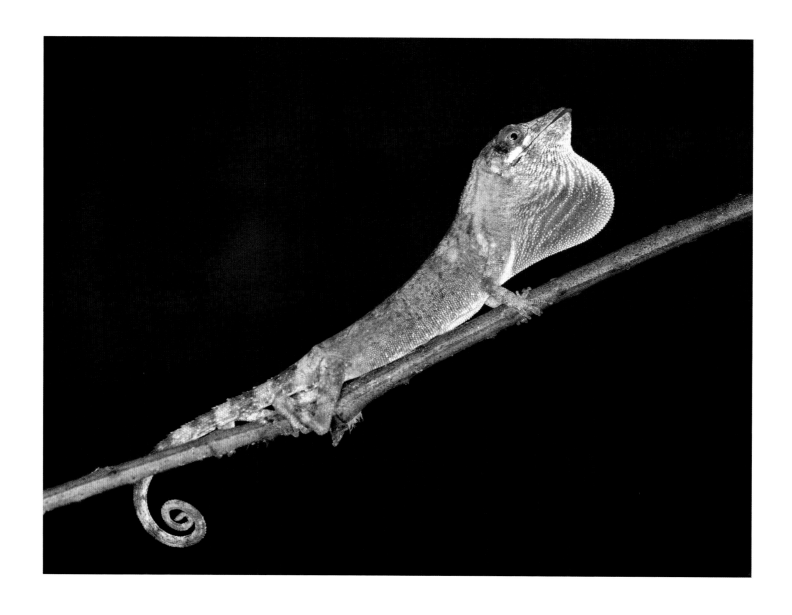

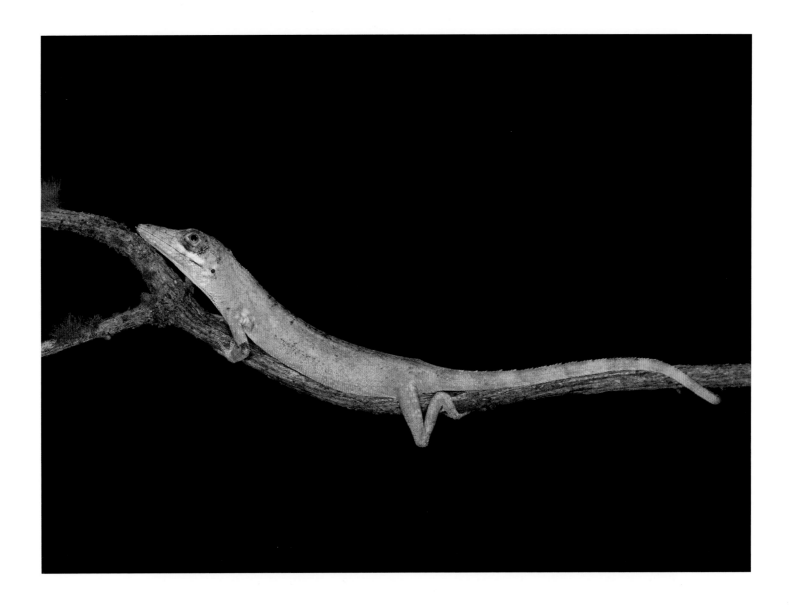

CORDILLERA CENTRAL TWIG ANOLE · [*Anolis insolitus*] · **EL ARROYAZO**

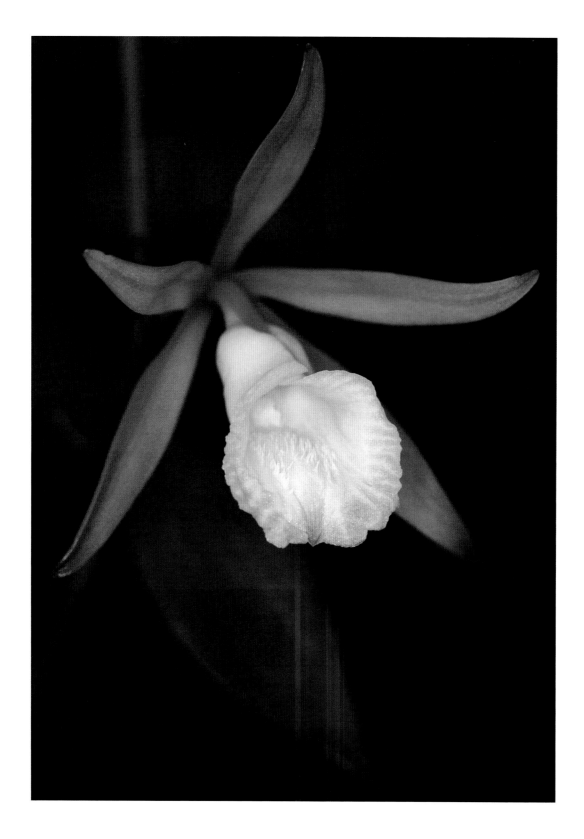

VAINILLA · VANILLA · [*Vanilla bicolor*] · EL ARROYAZO

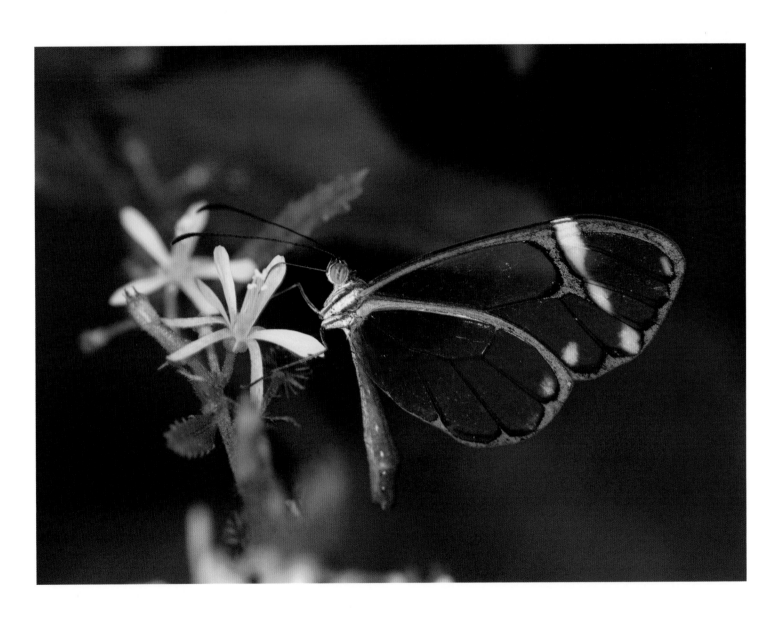

CLEARWING BUTTERFLY · [*Greta diaphana*] · EL ARROYAZO

244

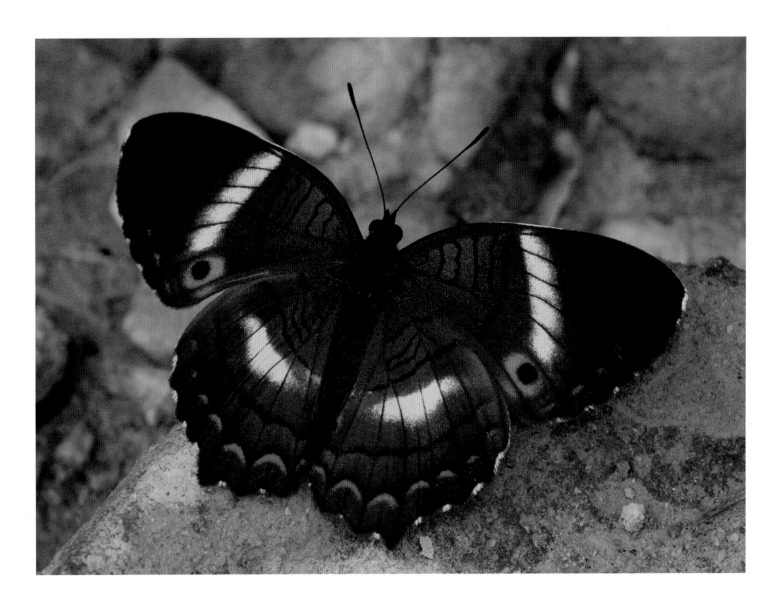

GODDARD'S ANARTIA · [*Anartia litrea*] · EL ARROYAZO

HELECHO · FERN · [*Hymenophyllum sp.*] · EL ARROYAZO

246

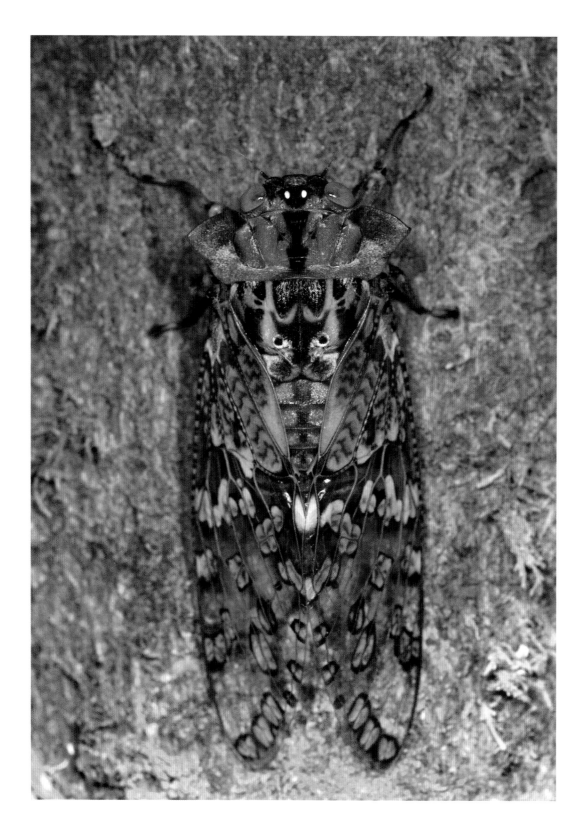

CHICHARRA · CICADA · [*Chinaria viviana*] · EL ARROYAZO

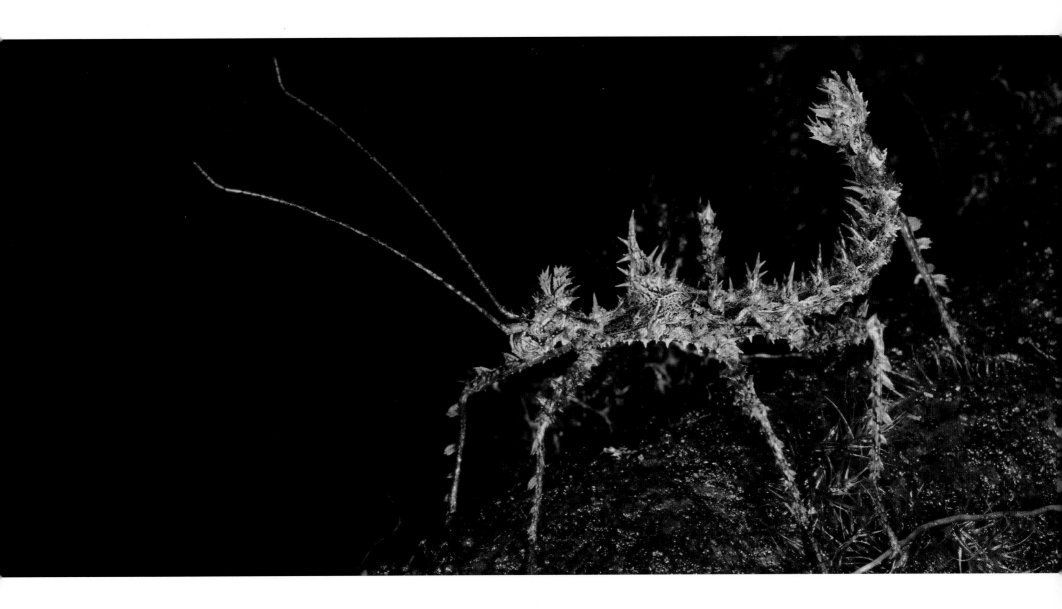

[Taraxippus paliurus] • LOMA DE LA SAL

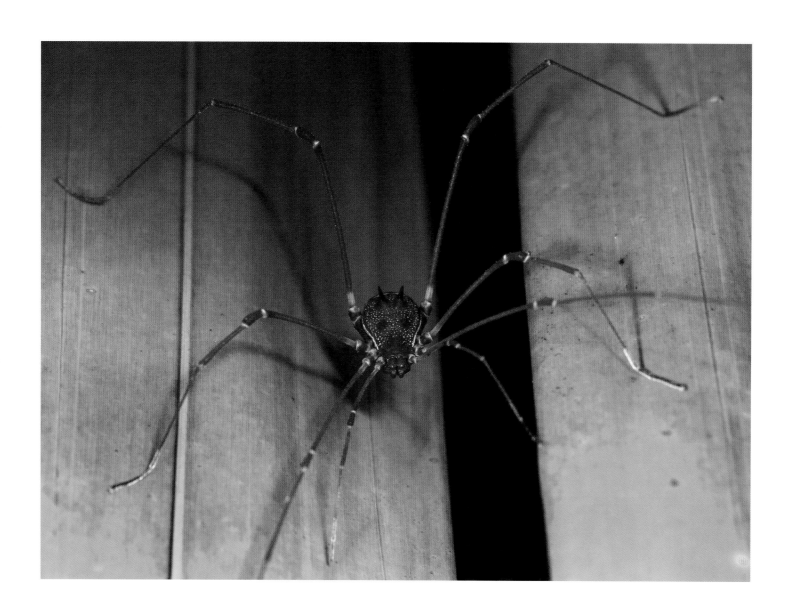

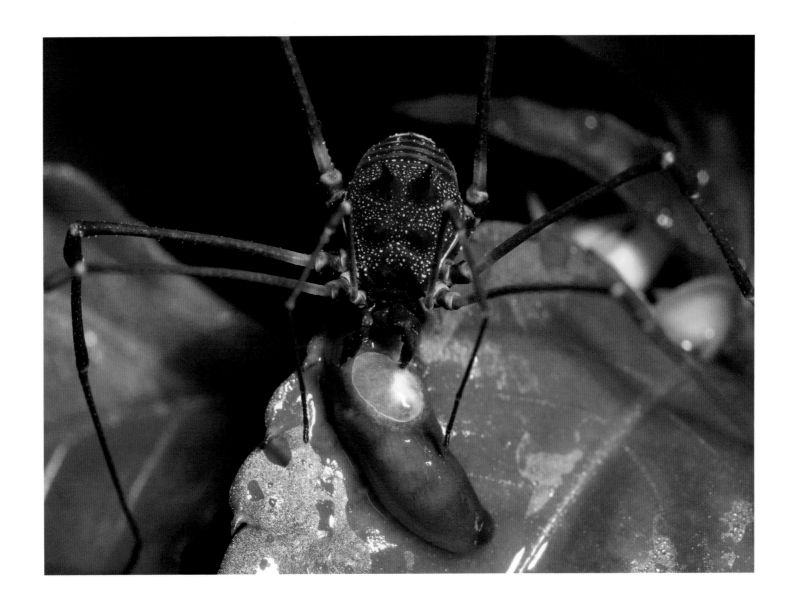

OPILIONID · HARVESTMAN · [*Family Cosmetidae*] · EL ARROYAZO

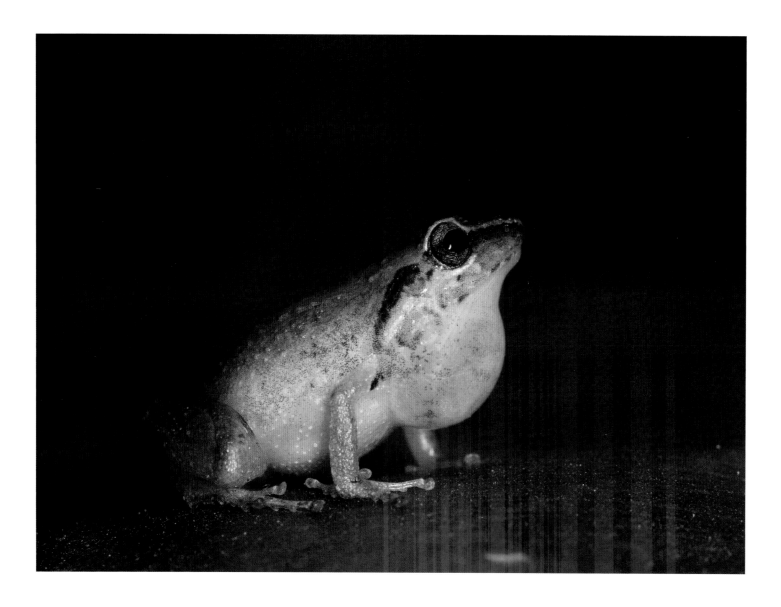

TUCK-WHEEP FROG · *[Eleutherodactylus abbotti]* · **LOMA DE LA SAL**

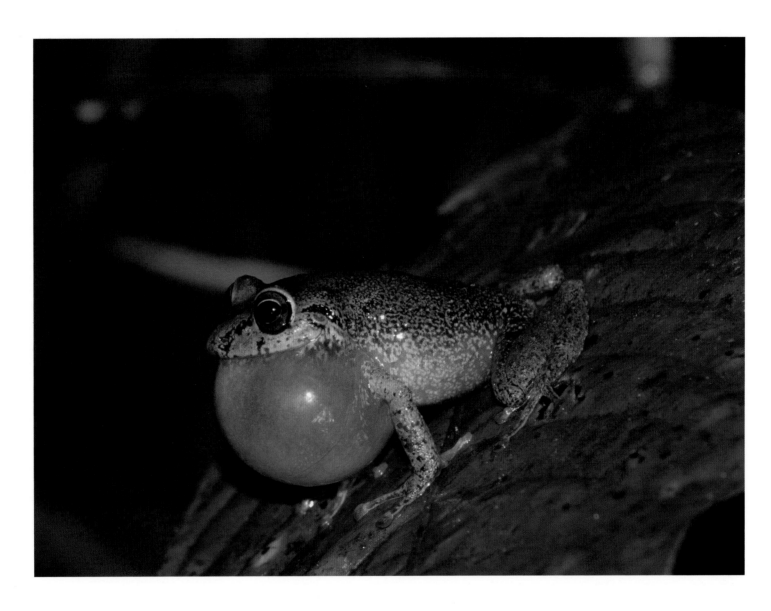

[*Eleutherodactylus sp.*] • **SENDERO DE NUBES**

253

Parque Nacional Armando Bermúdez

Parque Nacional José del Carmen Ramírez

SITUADOS EN LA CORDILLERA CENTRAL DE LA REPÚBLICA Dominicana, los parques mellizos, Parque Nacional Armando Bermúdez (779 km²) y Parque Nacional José del Carmen Ramírez (764 km²), cubren un vasto rango de hábitats, que incluyen una gran extensión de bosques de pinos, sabanas de pajones, bosques de palma y bosques húmedos latifoliados. En esta área se encuentran las montañas más altas del Caribe, destacándose el Pico Duarte como el pico más alto de esta región, el cual se eleva a 3,087 metros.

Estos dos parques, y el resto de la Cordillera Central, dan nacimiento al sistema más importante de ríos de La Española. Esta área se conoce como "Madre de todas las Aguas".

Las amenazas mayores a estos dos parques son la tala de árboles, los incendios forestales y el ganado que ambula libremente.

SITUATED IN THE CORDILLERA CENTRAL OF THE DOMINICAN Republic, the twin parks, Armando Bermúdez National Park (779 km²) and José del Carmen Ramírez National Park (764 km²), cover a wide range of habitats, including great extensions of pine forest, tussock savannahs, sierra palm forests, and wet broadleaf forests. In this area are the highest mountains in the Caribbean, a highlight being Pico Duarte, the tallest peak in the Caribbean, which rises to 3,087 meters.

These two parks, and the rest of the Cordillera Central, give birth to the most important river system on the island of Hispaniola. The area has come to be known as the "Mother of All Waters."

The main threats to these two parks are logging, forest fires, and free-ranging cattle.

VALLE DEL RÍO BAO

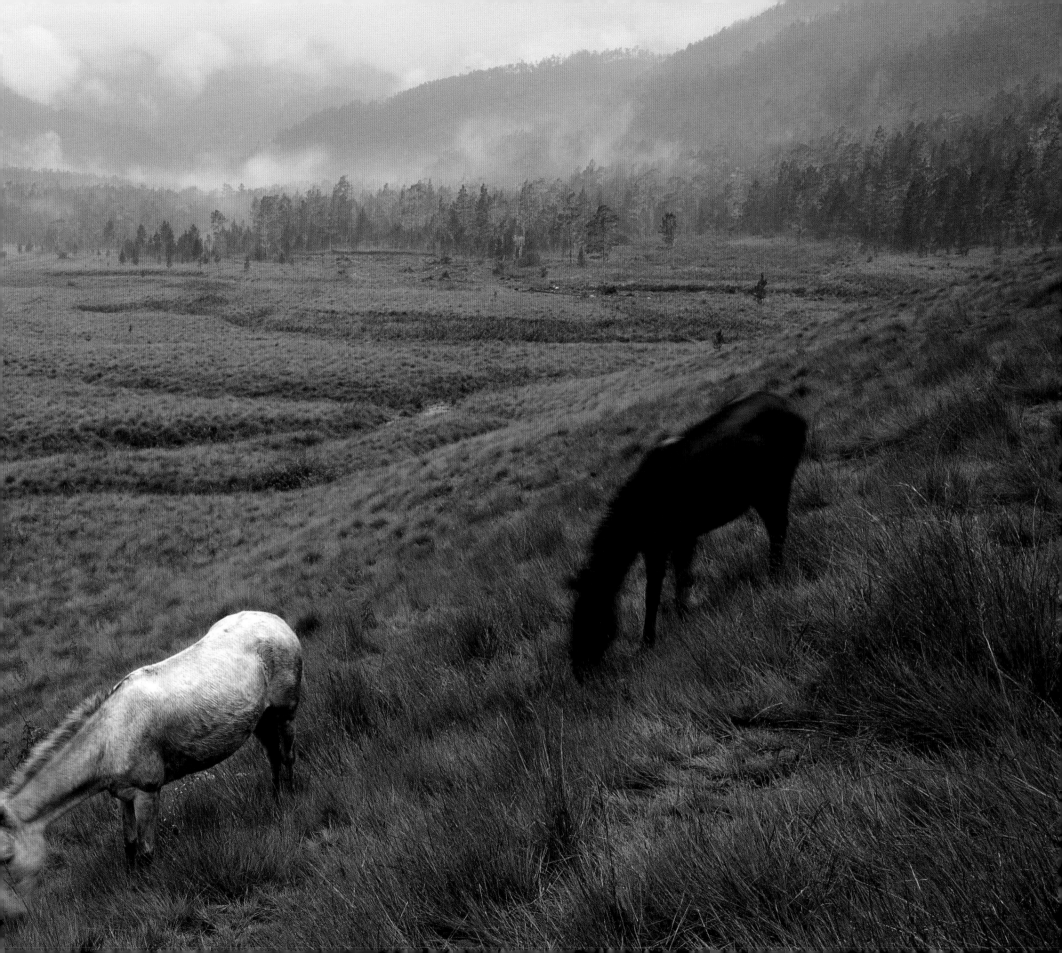

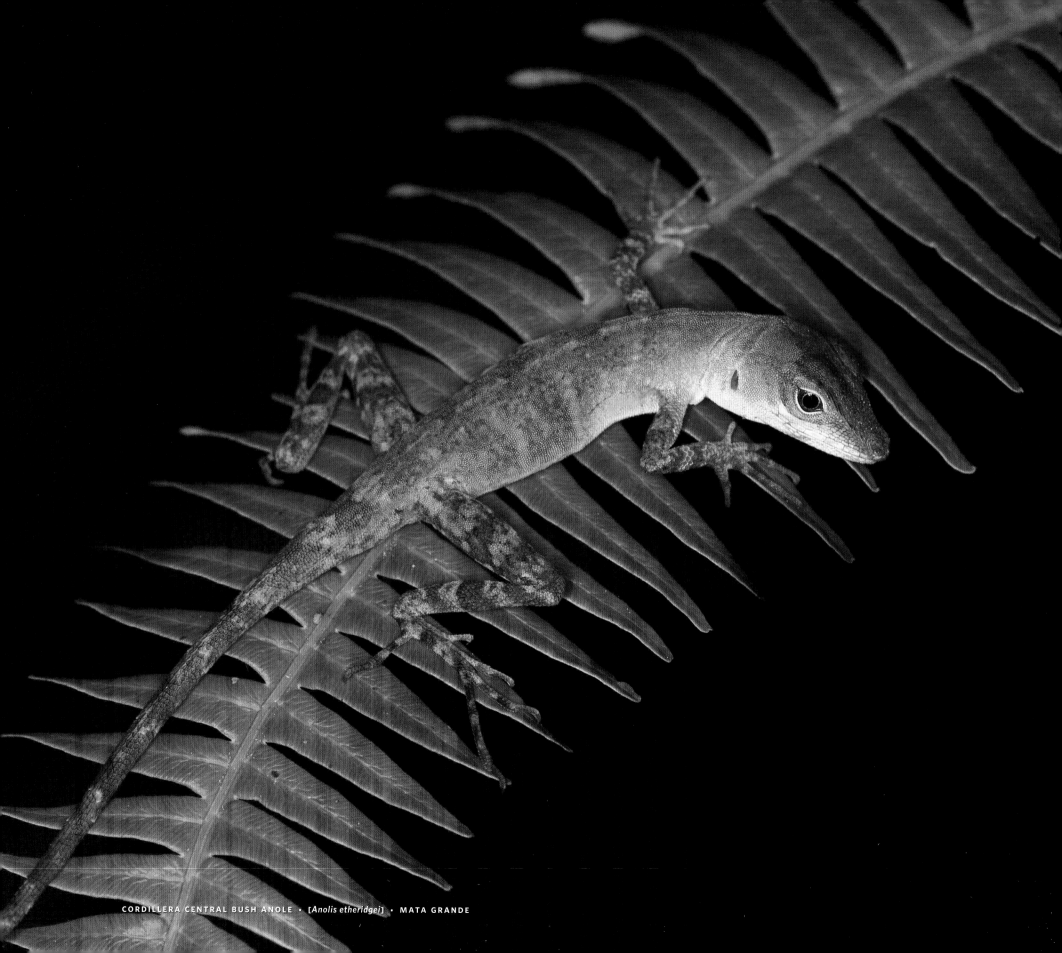

CORDILLERA CENTRAL BUSH ANOLE • [*Anolis etheridgei*] • MATA GRANDE

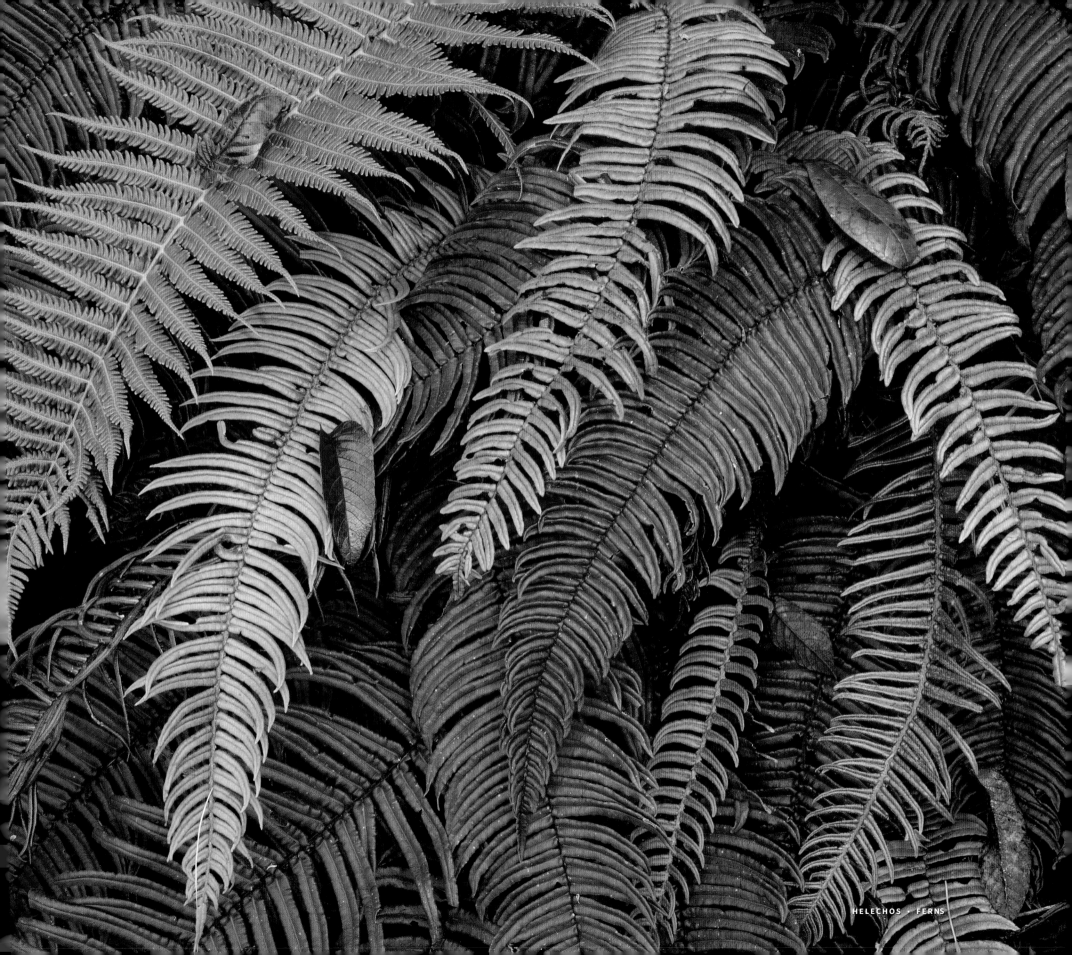

HELECHOS · FERNS

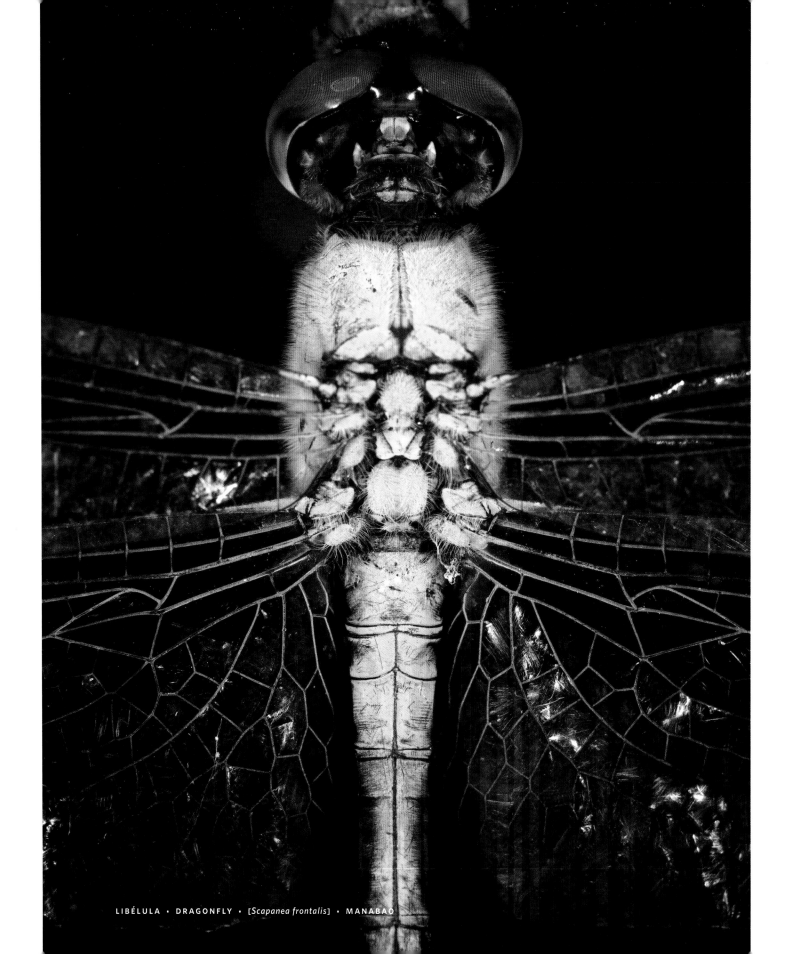

258

LIBÉLULA · DRAGONFLY · [*Scapanea frontalis*] · MANABAO

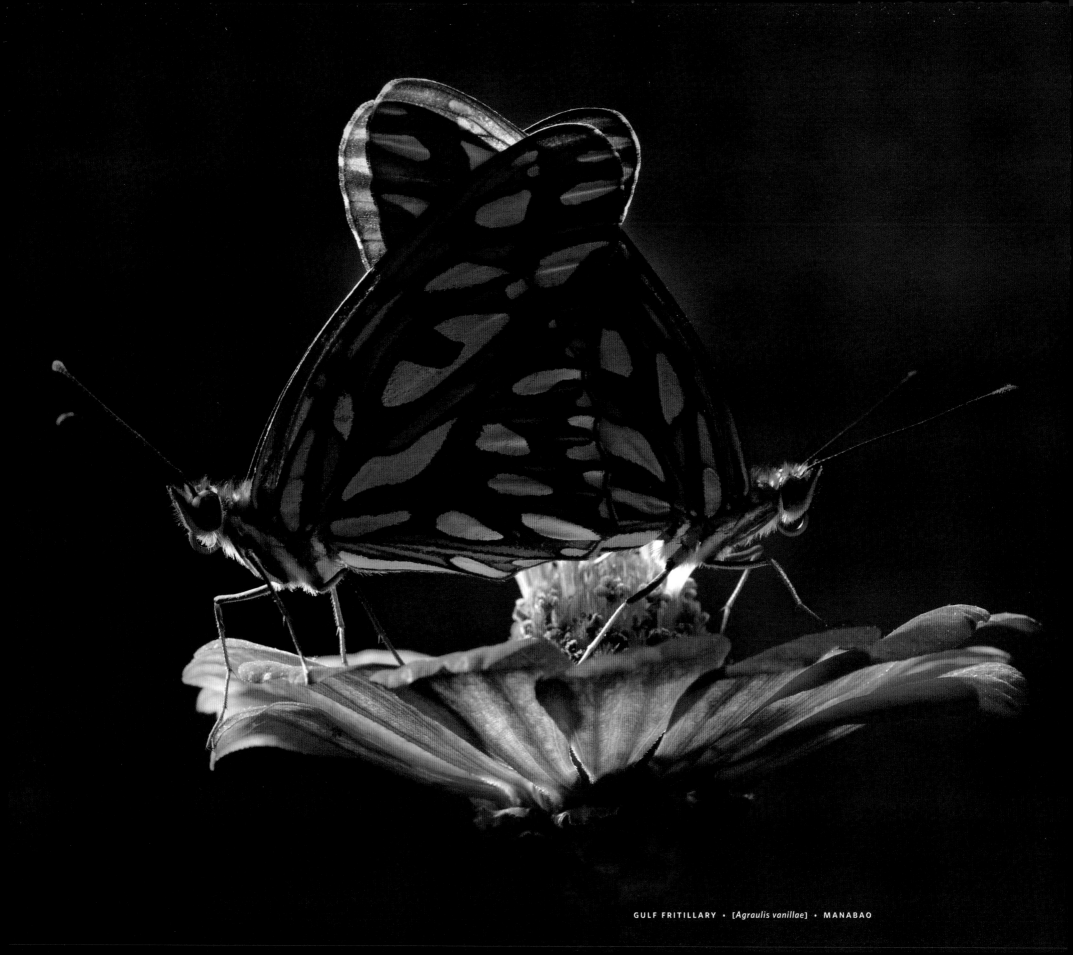

GULF FRITILLARY · [*Agraulis vanillae*] · MANABAO

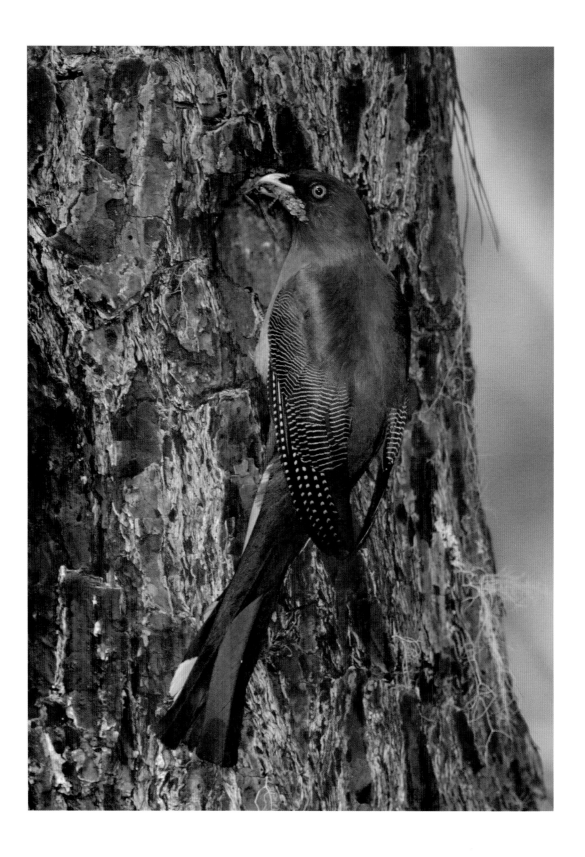

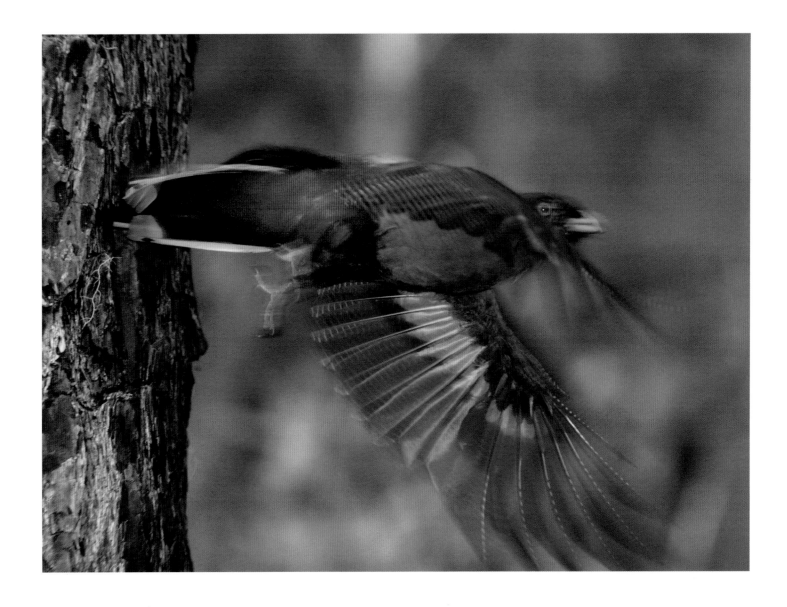

TROGÓN · **HISPANIOLAN TROGON** · *[Priotelus roseigaster]* · VALLE DEL TETERO

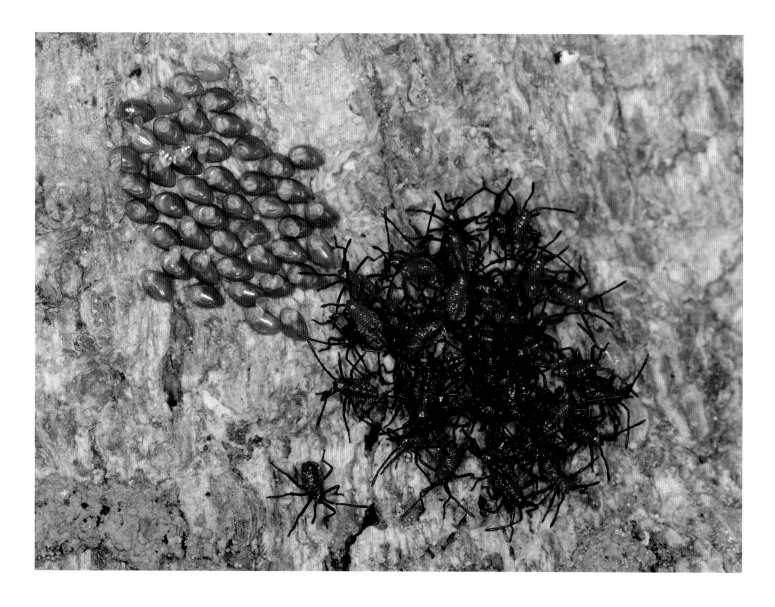

MOULTING LYGAEID BUGS · MATA GRANDE

ARAÑA CORNUDA COMIENDO UNA MOSCA · HORNED SPIDER EATING FLY · [*Micrathena obtusispina*] · LA CIÉNAGA

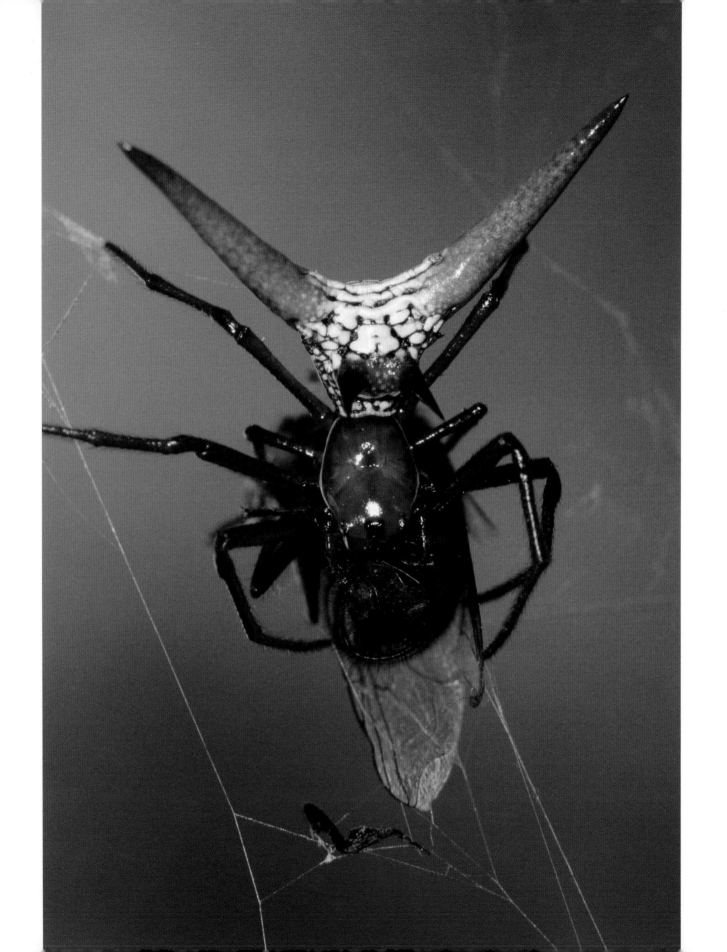

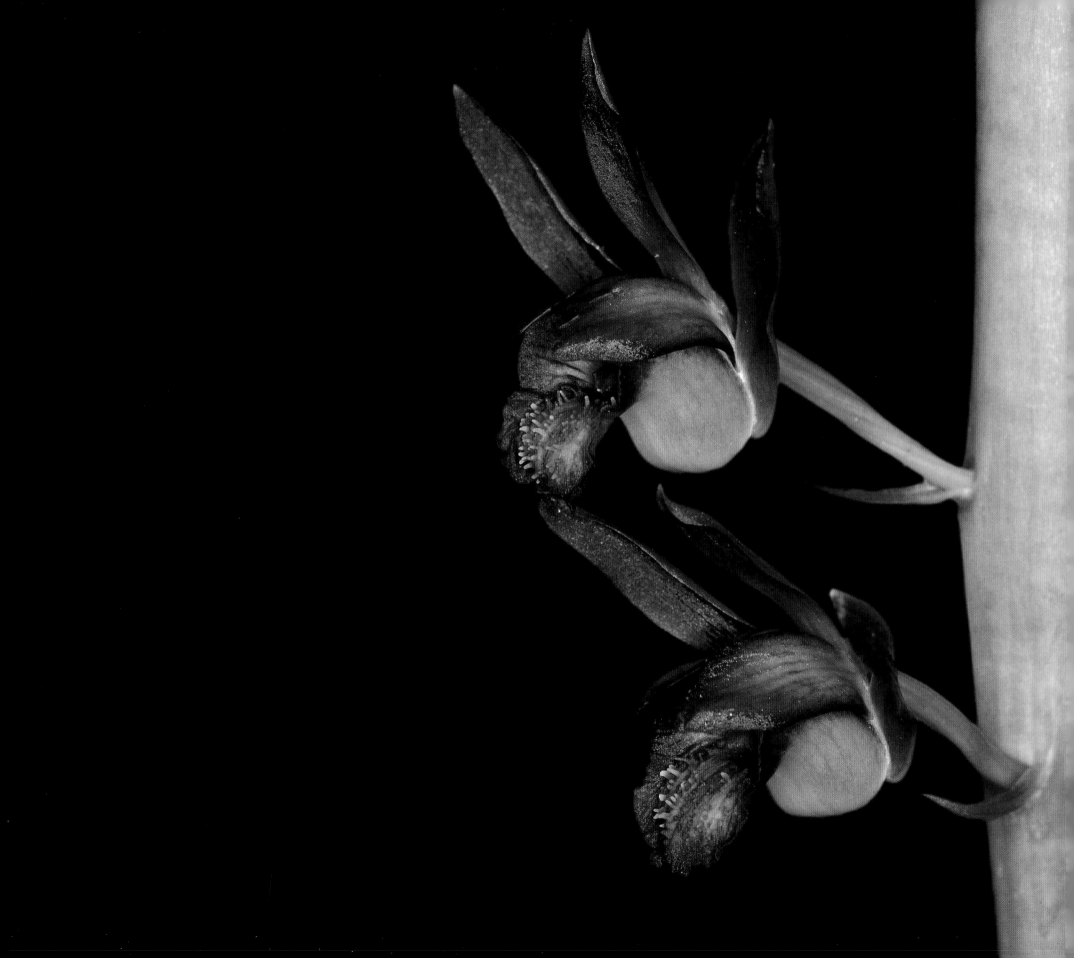

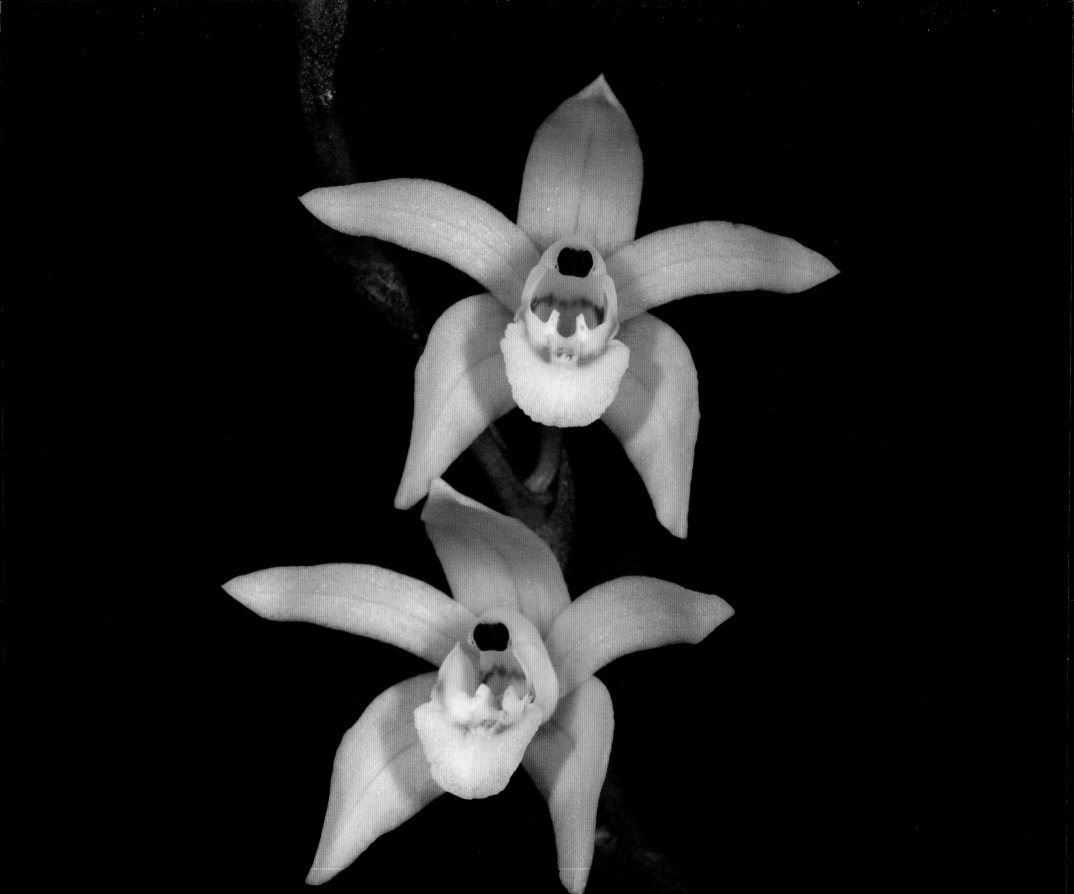

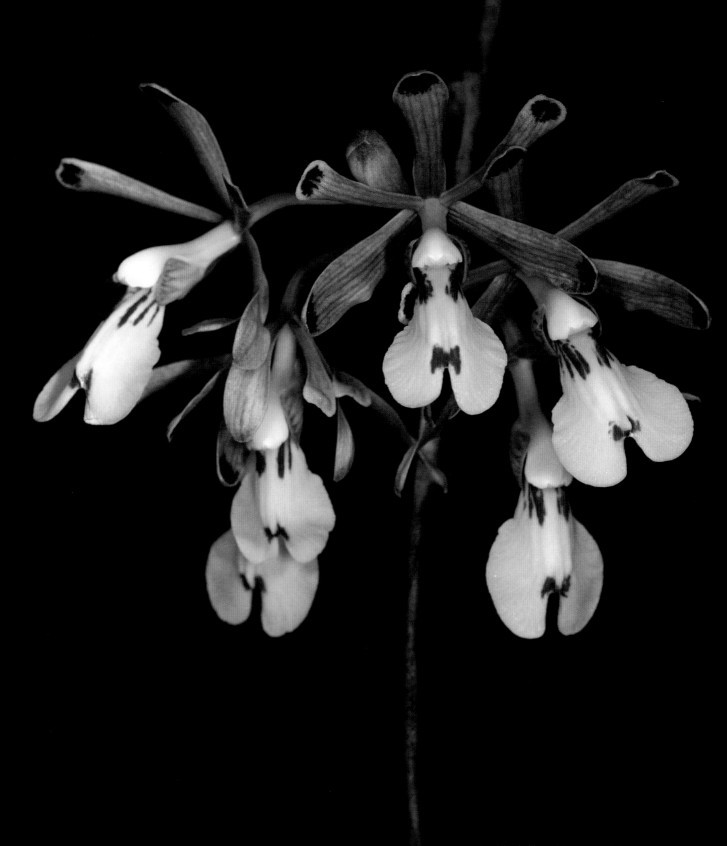

[*Psychilis dodii*] • EL AGUACATE

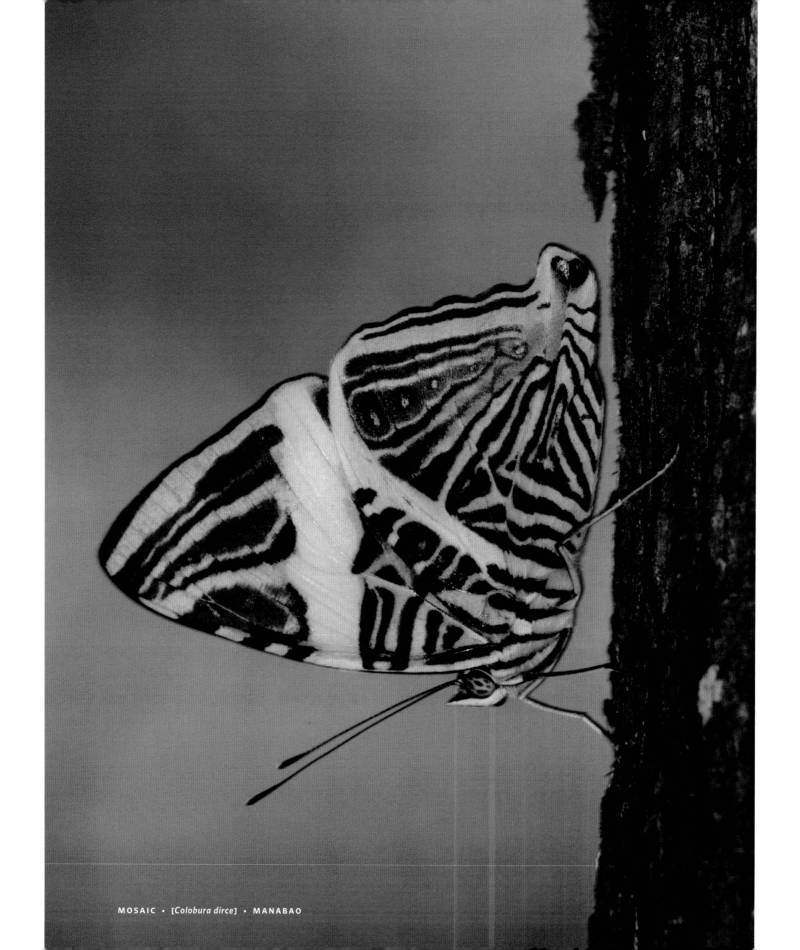

268

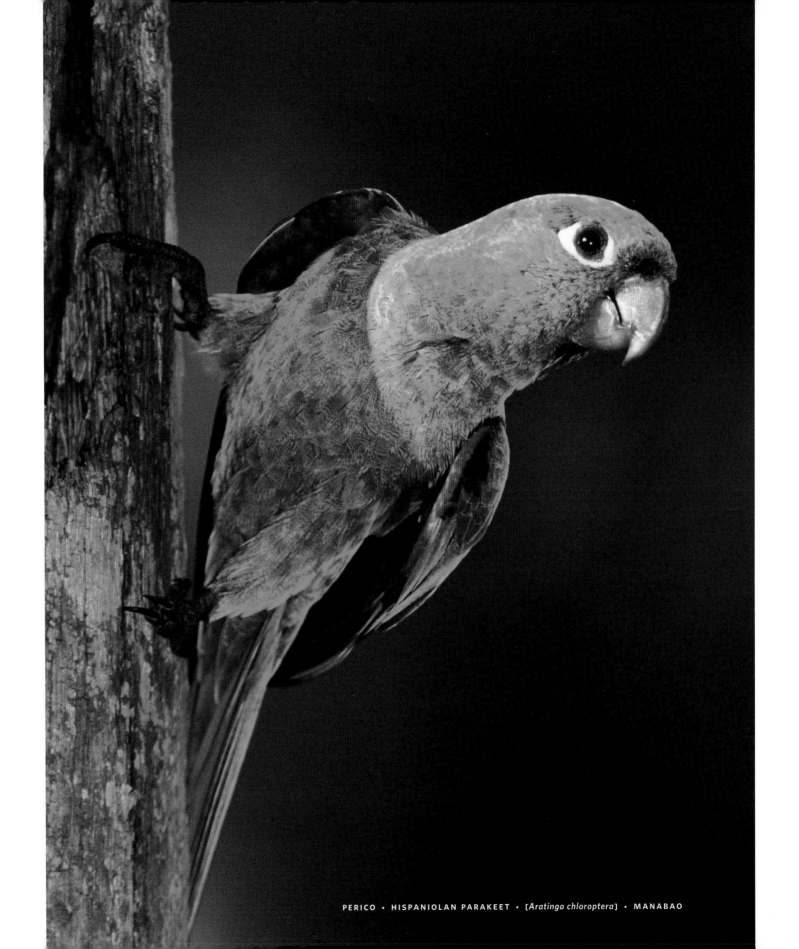

PERICO • HISPANIOLAN PARAKEET • [*Aratinga chloroptera*] • MANABAO

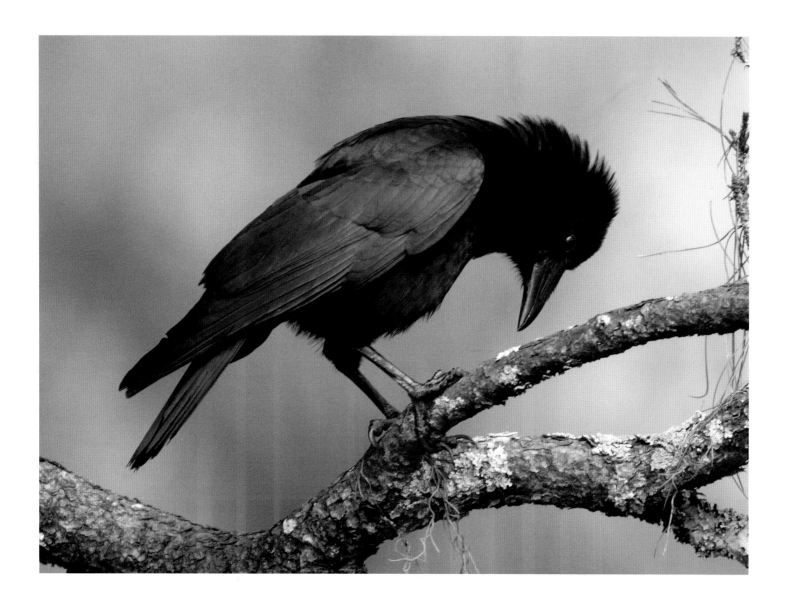

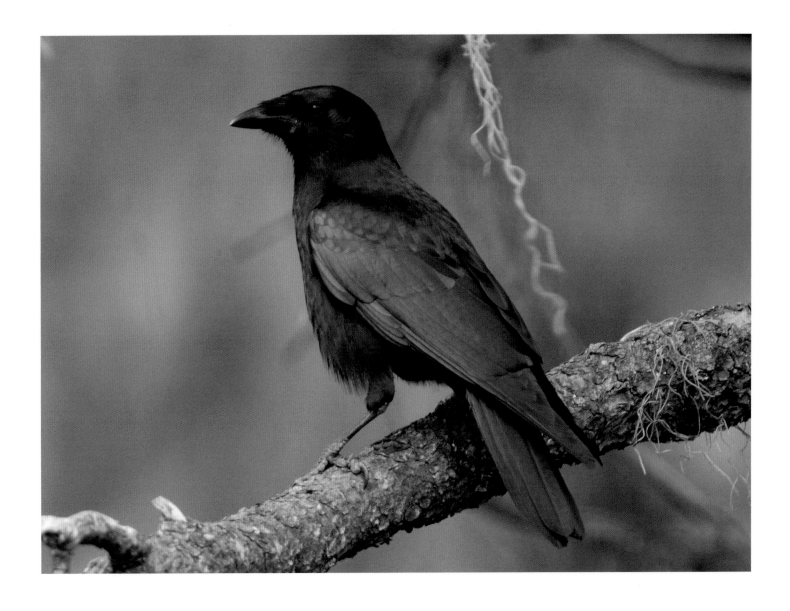

271

CAO • PALM CROW • [*Corvus palmarum*] • VALLE DEL TETERO

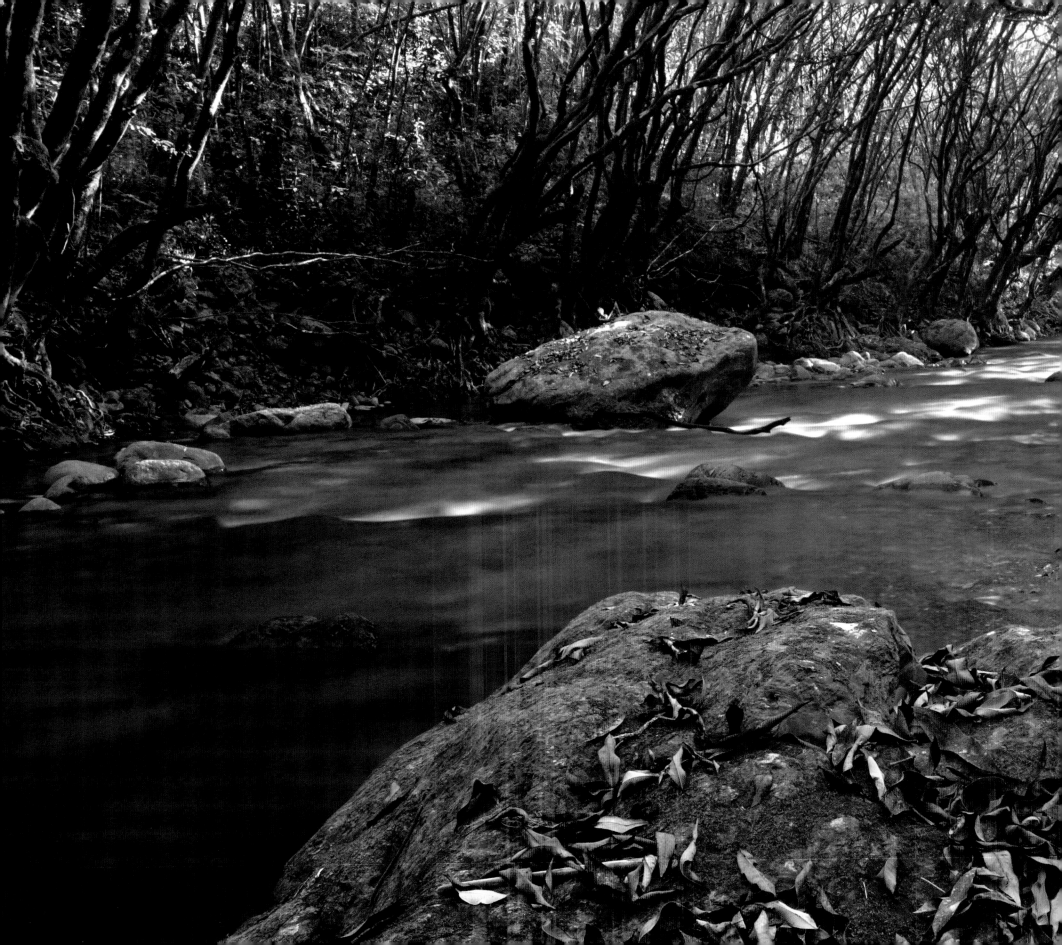

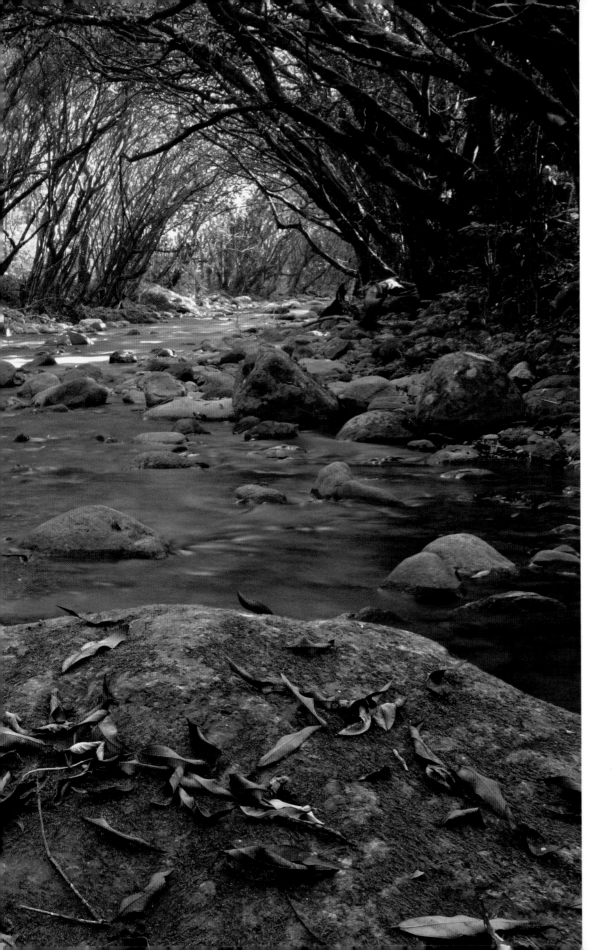

273

RÍO AMINA

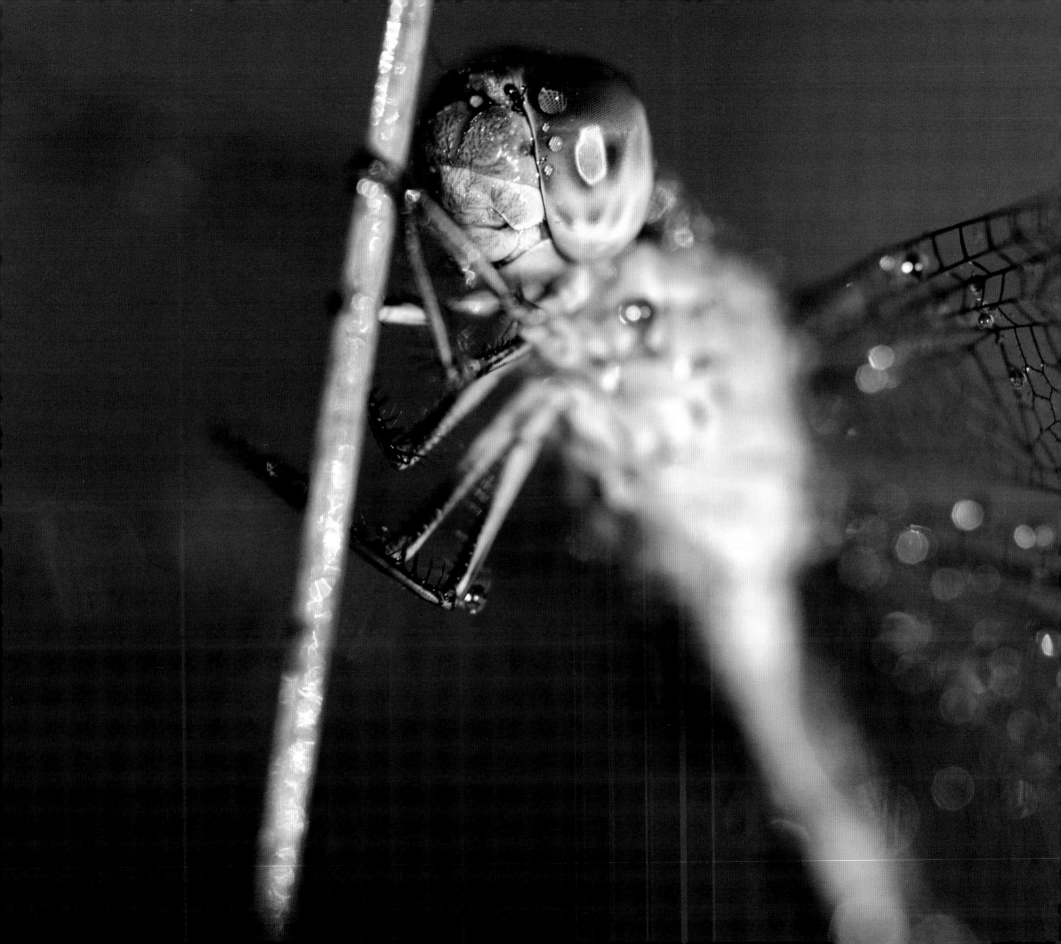

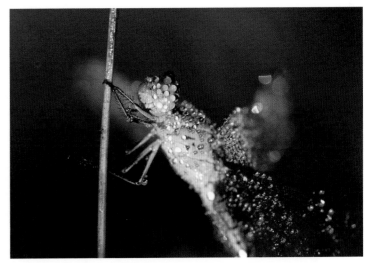

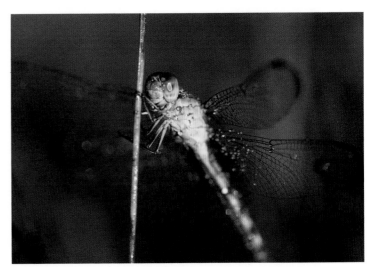

LIBÉLULA · DRAGONFLY · [*Erythrodiplax umbrata*] · VALLE DEL TETERO

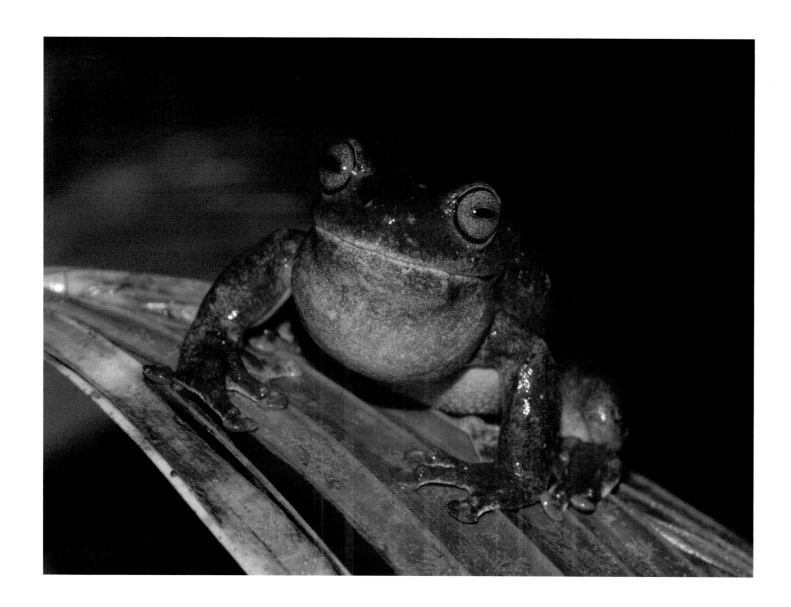

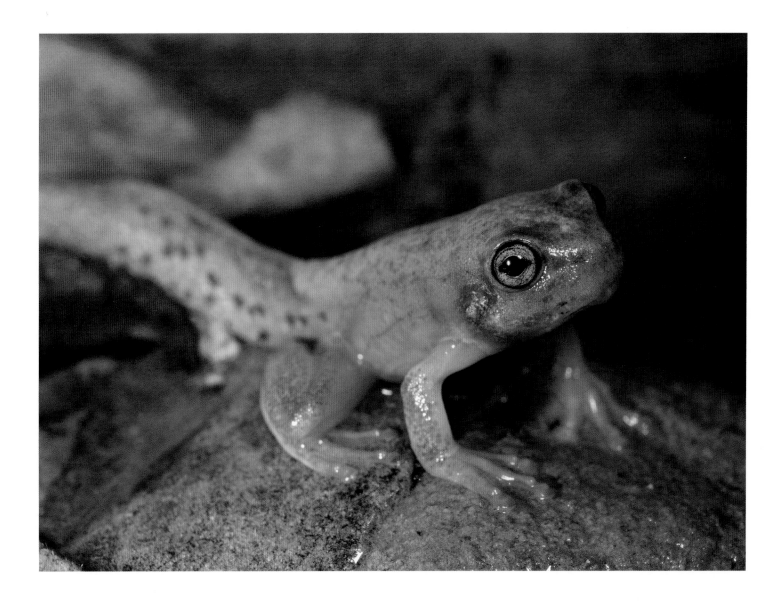

HISPANIOLAN GREEN STREAMFROG · [*Hyla heilprini*] · ARROYO ANTÓN SAPE BUENO

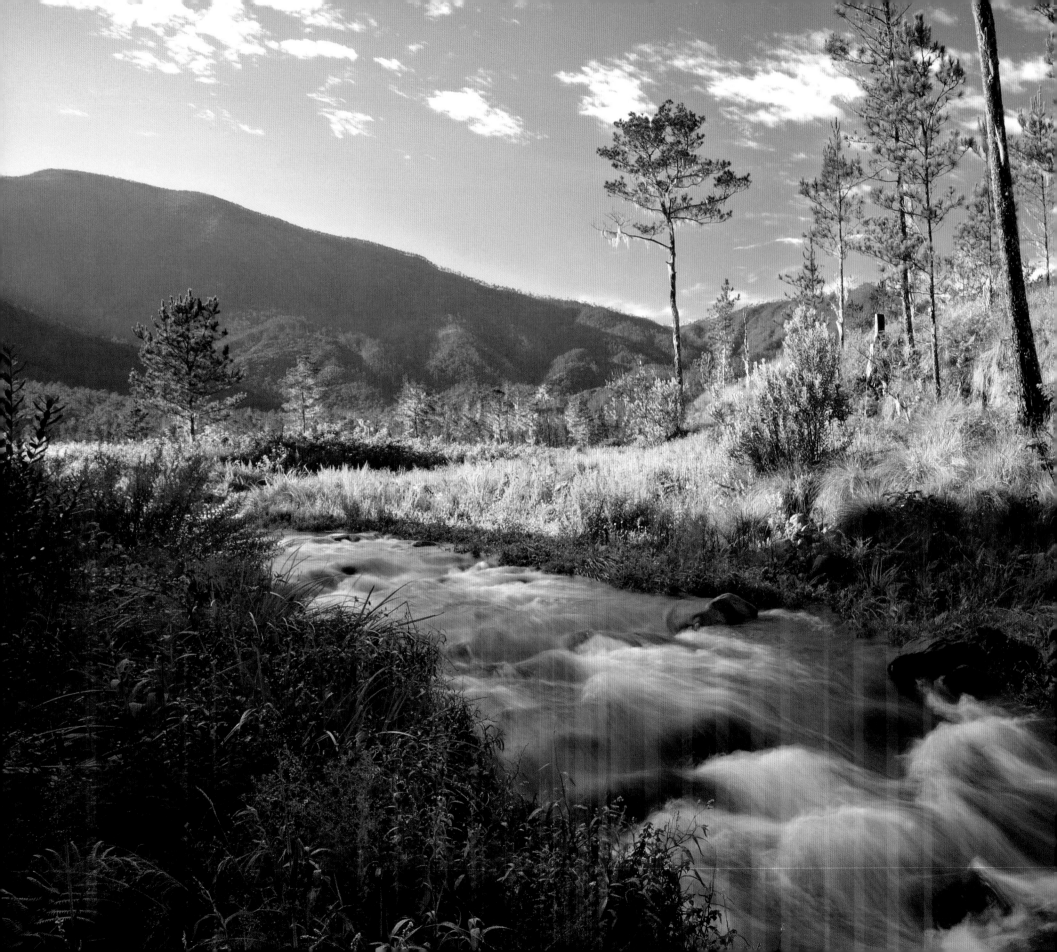

279

NACIMIENTO DEL RÍO BAO · BIRTHPLACE OF RÍO BAO

280

RÍO LOS GUANOS

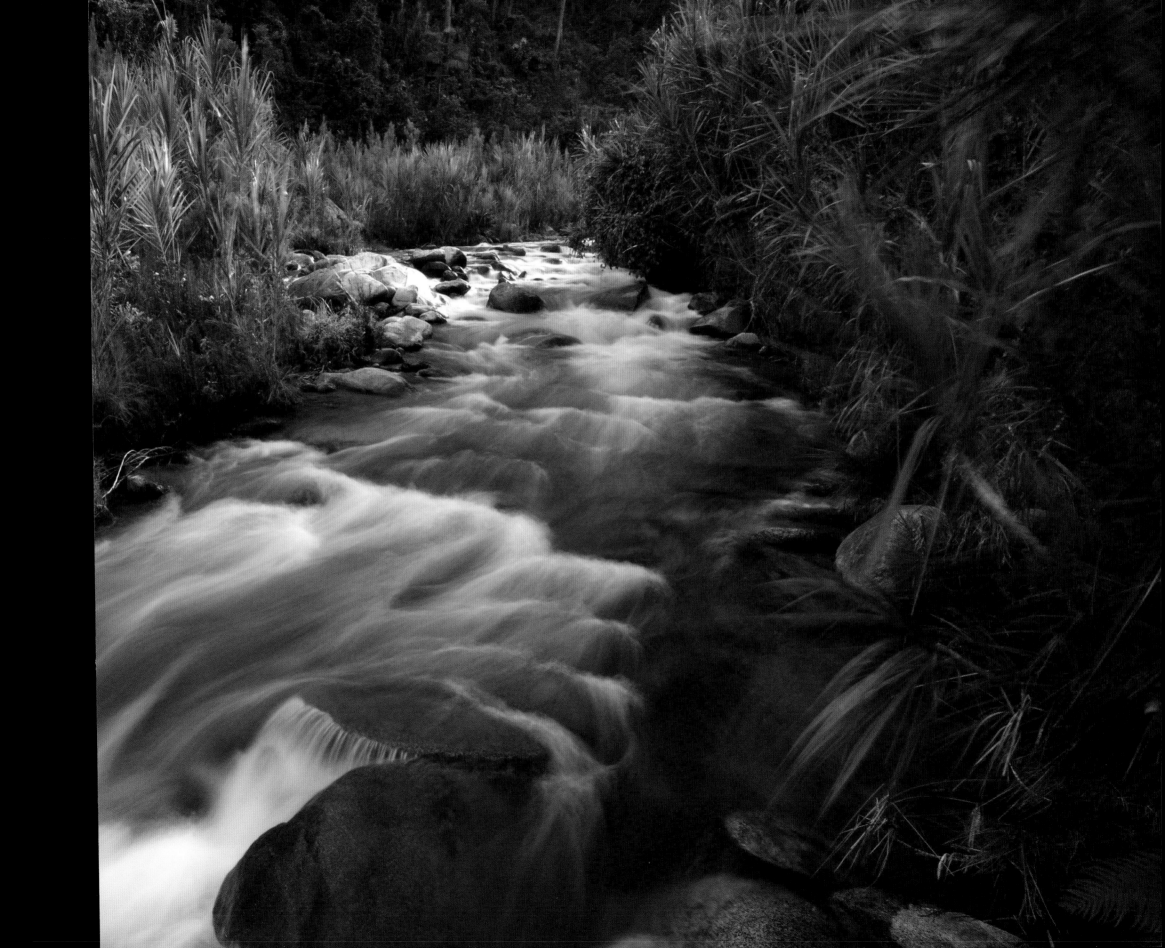

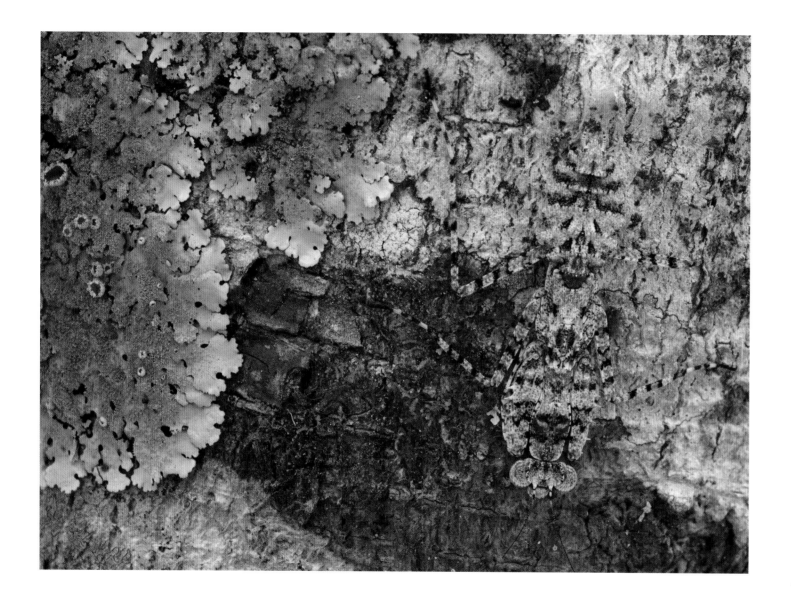

MANTIS MIMETIZANDO LIQUEN · MANTIS MIMICKING LICHEN · MATA GRANDE

282

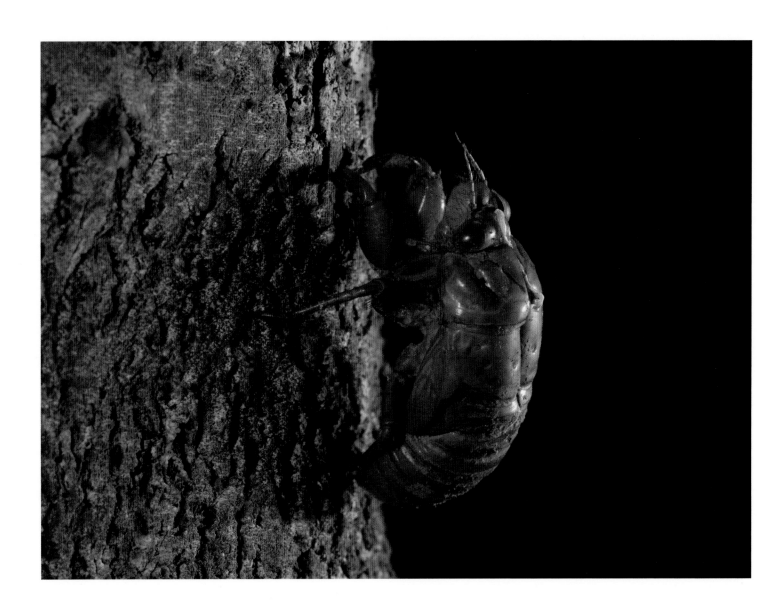

PIEL DE CHICHARRA SOBRE LIQUEN ROJO · CICADA MOLT ON RED LICHEN · MATA GRANDE

MAMPETE · [*Dormitator maculatus*]

DAJAO · [*Agonostomus monticola*]

PARQUE NACIONAL JUAN B. PÉREZ RANCIER (VALLE NUEVO)

CON UNA ALTITUD PROMEDIA DE 2,200 METROS Y UN ÁREA aproximada de 910 kilómetros cuadrados, el Parque Juan. B. Pérez Rancier, conocido también como Valle Nuevo, esta localizado al sureste de los Parques Armando Bermúdez y José del Carmen Ramírez. Este parque es una meseta alpina con una vegetación predominante de pinos (*Pinus occidentalis*) y sabanas de pajones. La altura extrema y el clima frío han contribuido a la evolución de plantas y animales restringidas a estas temperaturas. De las 249 especies de plantas reportadas, 97 son endémicas al hábitat montañoso de la Cordillera Central. Aunque la temperatura promedia anual es de 17 grados Celsius, es muy común que descienda a bajo cero durante las noches de invierno.

WITH AN AVERAGE ALTITUDE OF 2,200 METERS AND AN approximate area of 910 square kilometers, the Juan B. Pérez Rancier National Park, also known as Valle Nuevo, is located southeast of the Armando Bermúdez and José del Carmen Ramírez National Parks. This park is an alpine plateau whose vegetation is dominated primarily by pine (*Pinus occidentalis*) and tussock (*Danthonia dominguensis*) savannahs. The extreme elevation and the cold climate have led to the evolution of animal and plant species restricted to these temperate areas. Of the 249 plant species reported in the park, 97 are endemic to mountain habitats of the Cordillera Central. Although the average annual temperature is 17 degrees Celsius, it is common for it to fall below zero during winter nights.

SABANA DE PAJONES · TUSSOCK GRASS SAVANNAH

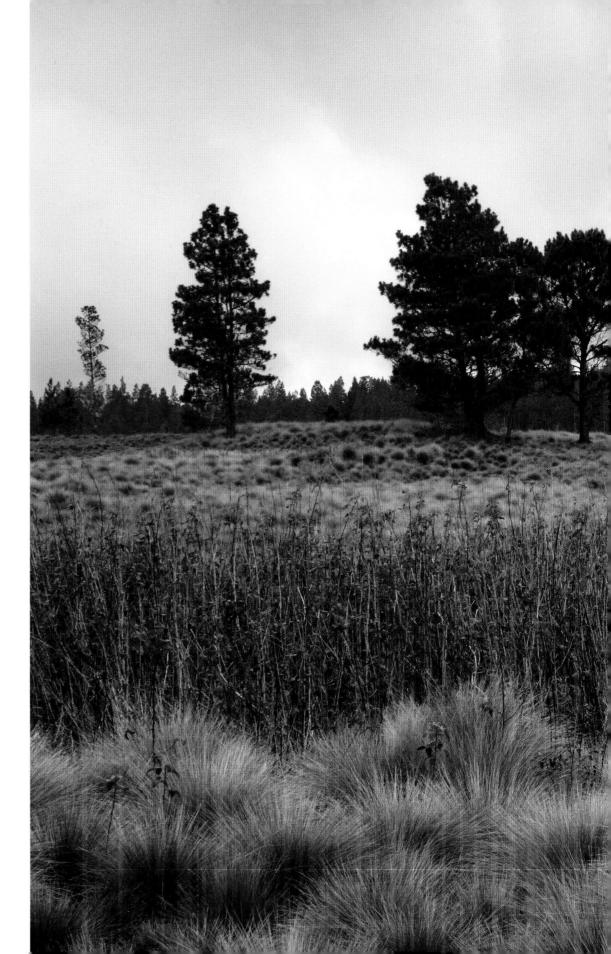

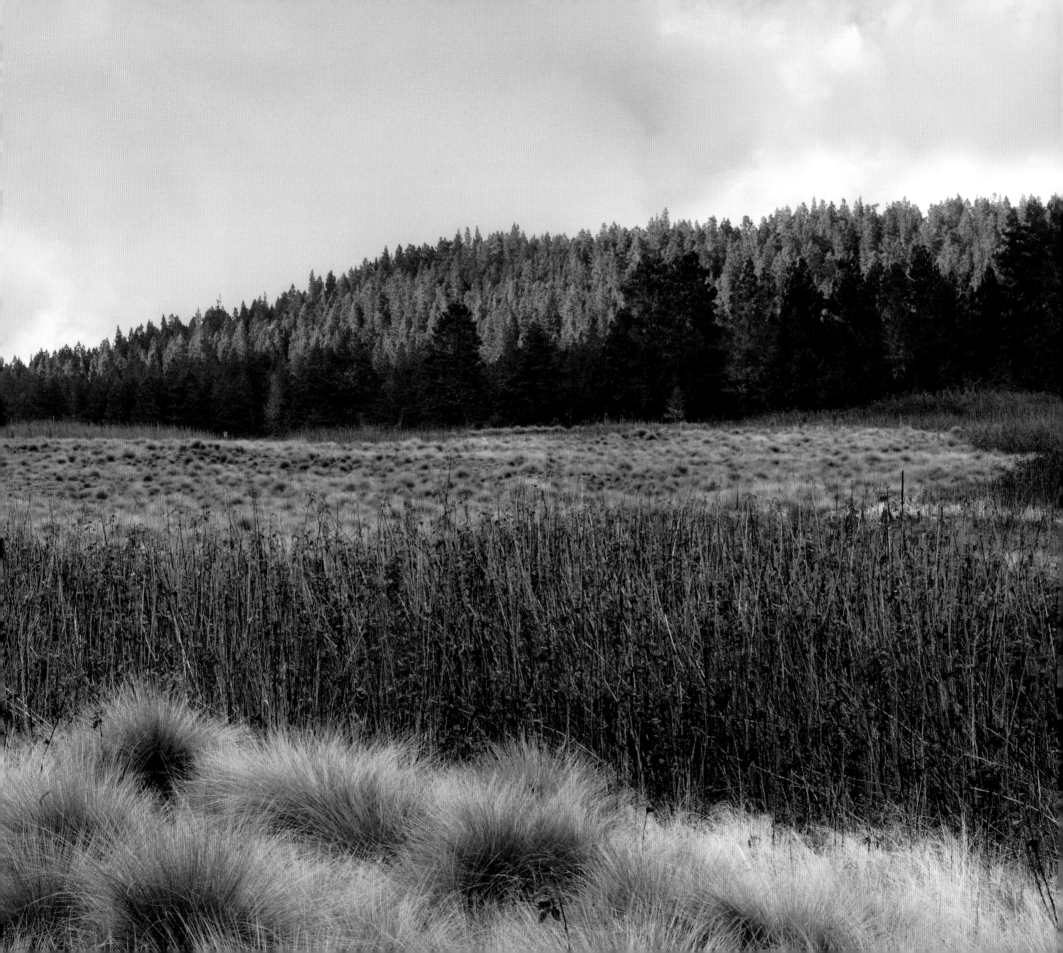

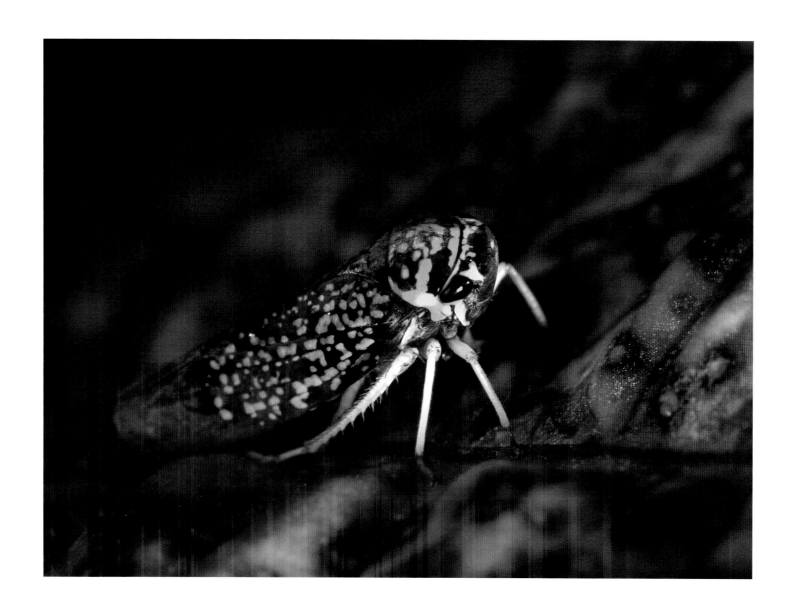

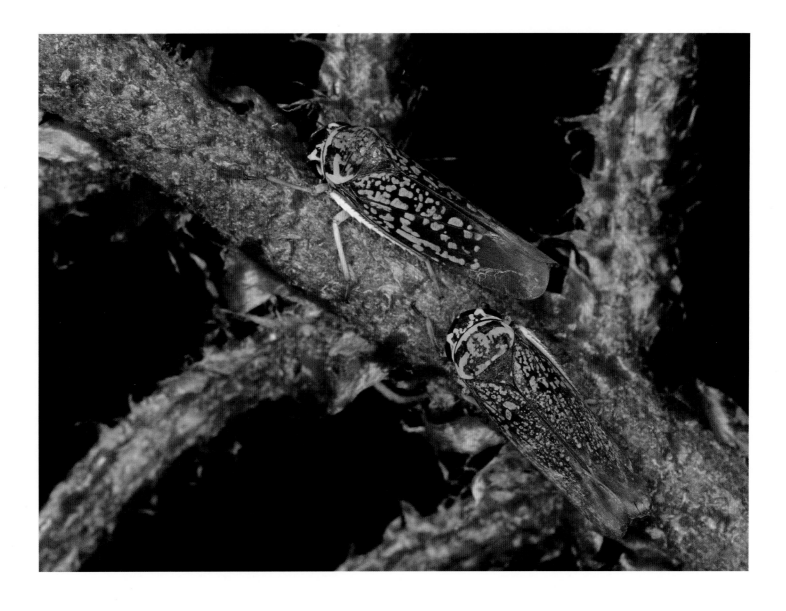

LEAFHOPPER · [*Caribovia plagata*] · LECHUGUILLA

COCUYO · FIREFLY · [*family Lampyridae*] · LECHUGUILLA

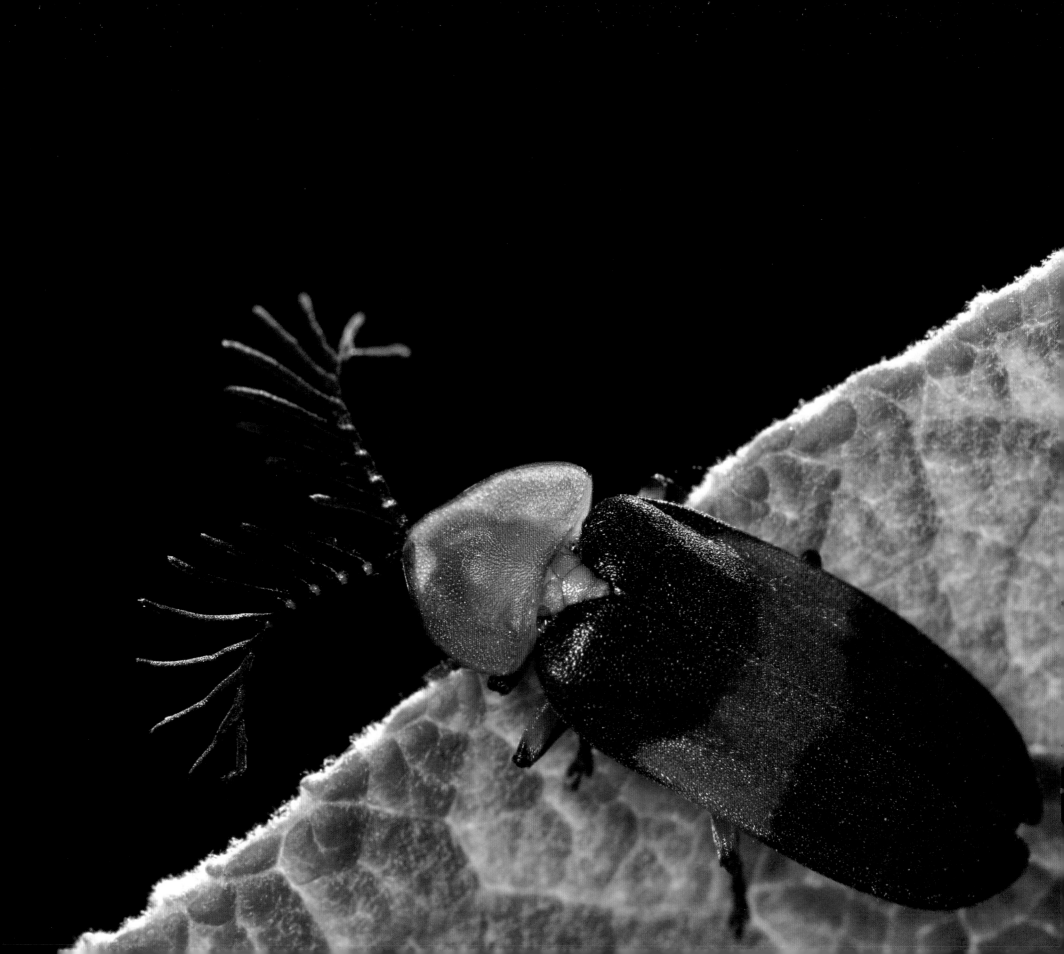

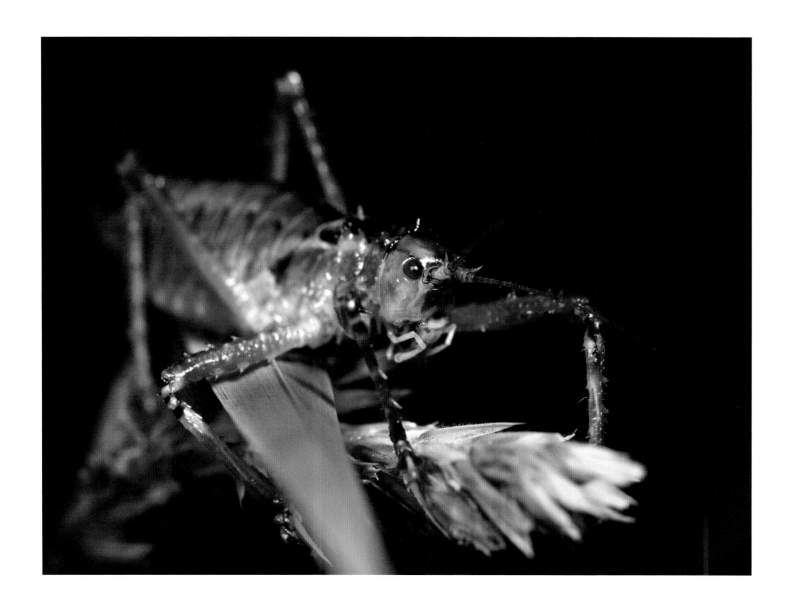

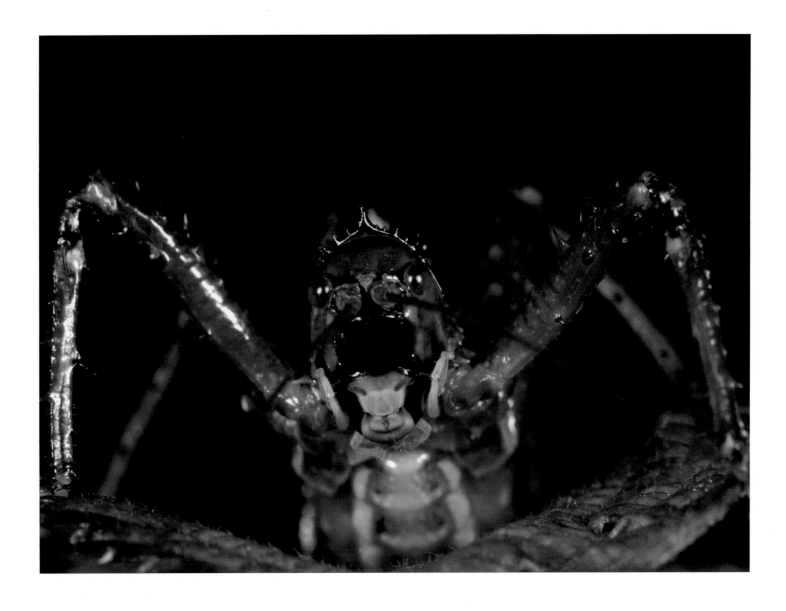

ESPERANZA • KATYDID • [*Espeleala sp.*] • LA NEVERA

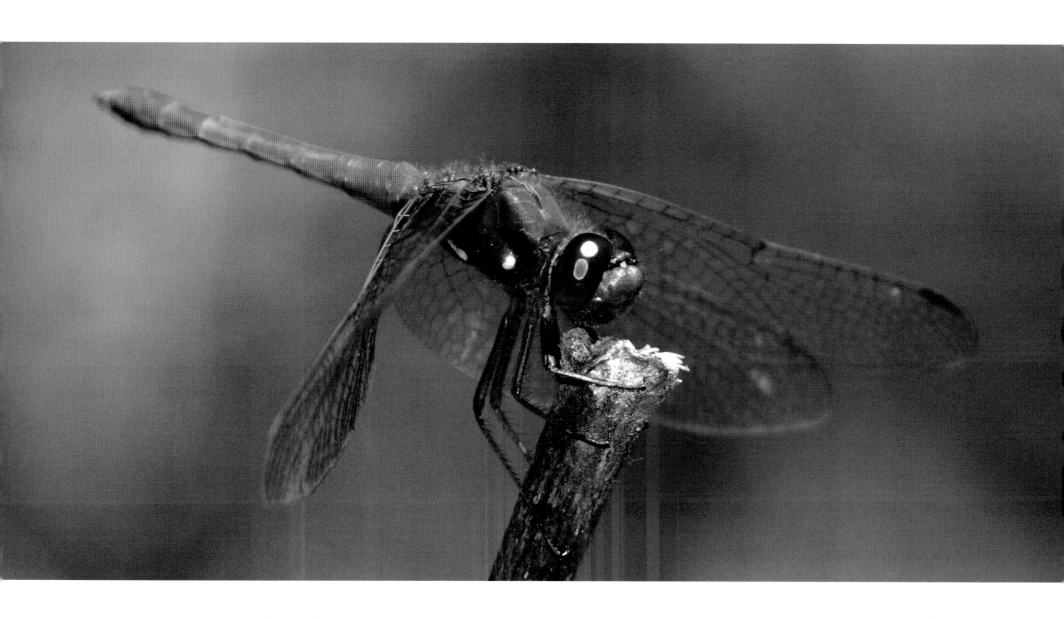

LIBÉLULA · DRAGONFLY · [*Sympetrum illotum*]

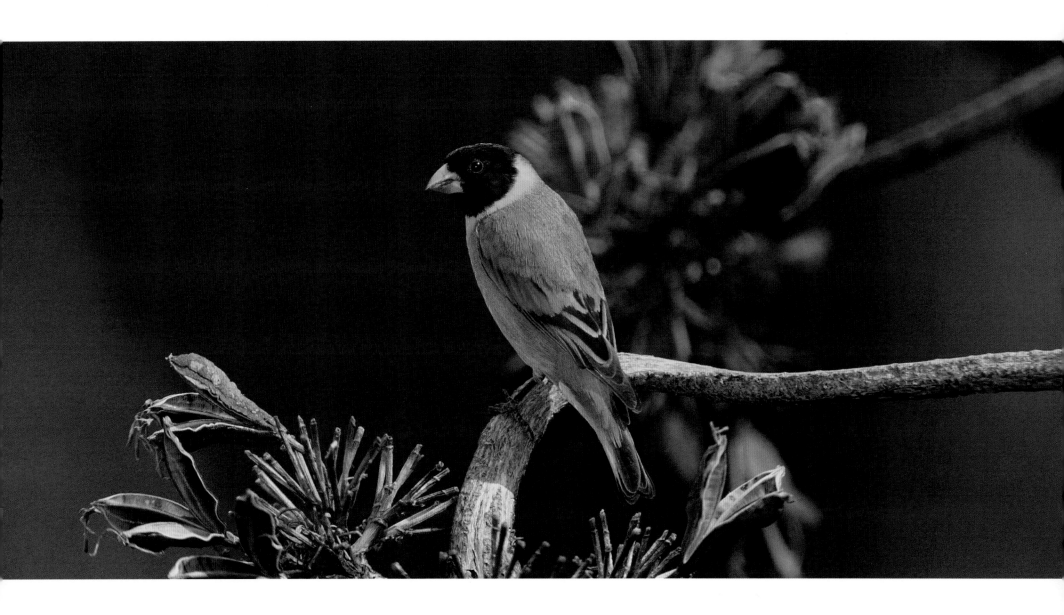

CANARIO • ANTILLEAN SISKIN • [*Carduelis dominicensis*]

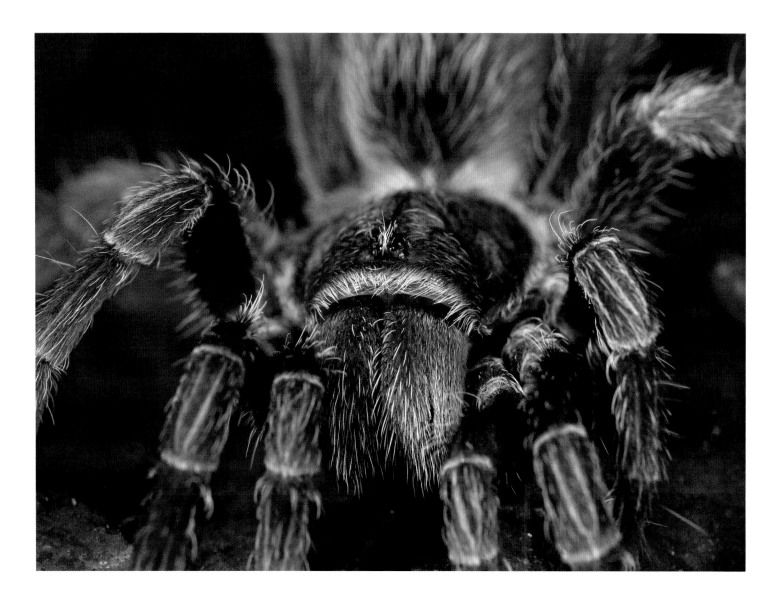

CACATA · TARANTULA · *[family Theraphosidae]* · LA NEVERA

HISPANIOLAN STRIPED GALLIWASP • *[Celestus darlingtoni]* • VALLE NUEVO

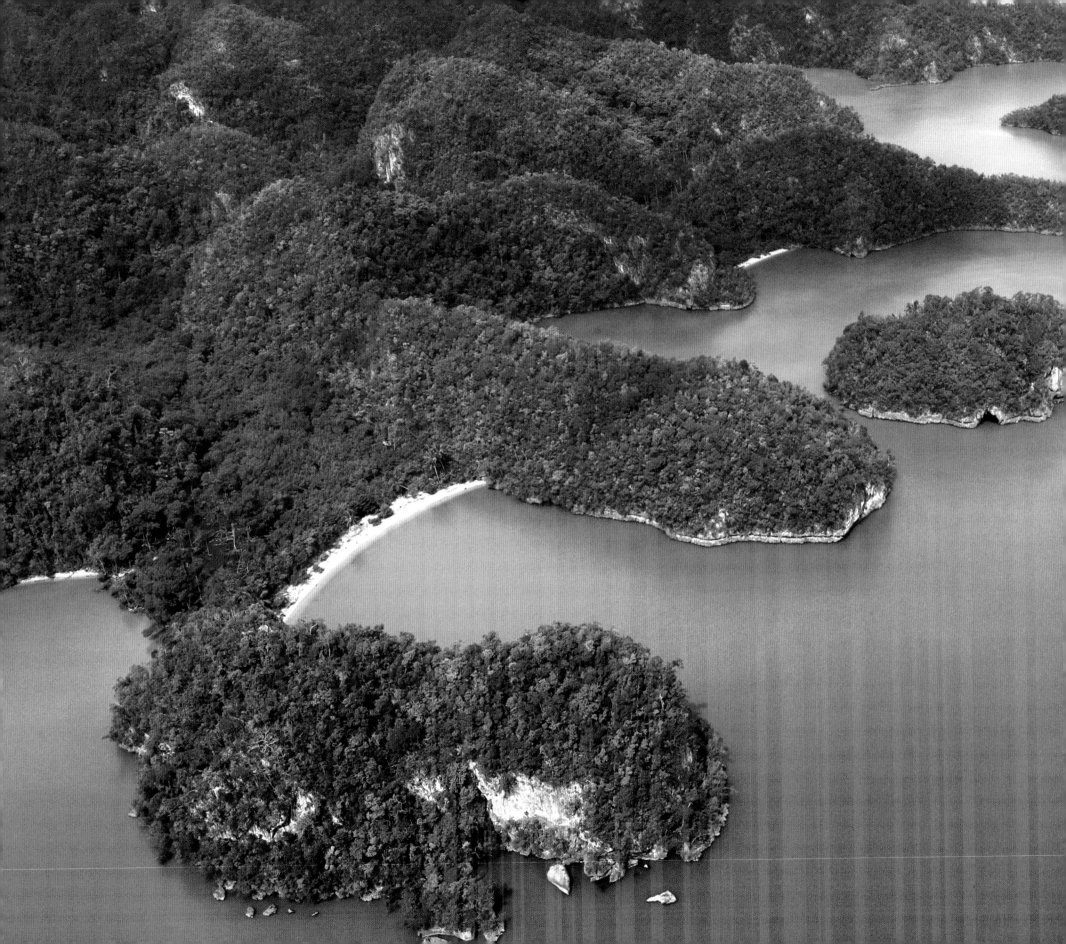

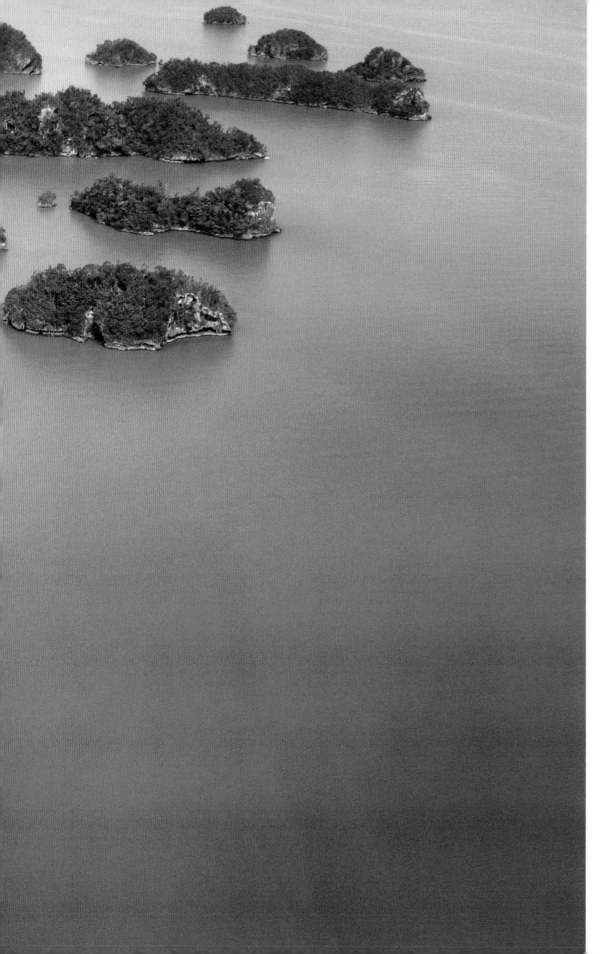

PARQUE NACIONAL
LOS HAITISES

EL SINGULAR PAISAJE DEL PARQUE NACIONAL LOS HAITISES está formado por múltiples colinas de formación cársica o mogotes, como se les conoce localmente—cubiertas por un exuberante bosque latifoliado húmedo con más de 700 especies de plantas vasculares. Los 826 kilómetros cuadrados del parque albergan un número de especies en peligro (Lista Roja de la Unión Internacional para la Conservación de la Naturaleza), como es la Cotorra (*Amazona ventralis*), el Cuervo (*Corvus leucognaphalus*), el Solenodonte de La Española (*Solenodon paradoxus*) y el Guaraguaito o Gavilán (*Buteo ridgwayi*). Se estima que la población en peligro crítico de ese gavilán es de unos 200 individuos, la cual está restringida prácticamente al parque y sus áreas amortiguadoras. El parque recibe un promedio anual de 2,700 mm de lluvia, que se filtra por las rocas calizas y suple la mayor parte del agua al sistema de la ciudad de Santo Domingo.

Antiguos propietarios continúan tratando de usar las tierras dentro de los límites del parque. El desmonte y la quema como prácticas agrícolas amenazan su integridad, flora y fauna. Los gavilanes son cazados por los campesinos, que erróneamente piensan que son capaces de comerse sus aves domésticas.

THE UNIQUE LANDSCAPE OF LOS HAITISES NATIONAL PARK IS formed by multiple karstic hill formations. These hills—or *mogotes*, as they are known locally—are covered with an exuberant wet broadleaf forest that holds more than 700 vascular plants. The 826 square kilometers of the park shelter a number of threatened species (International Union of Conservation of Nature Red List), such as the Hispaniolan Parrot (*Amazona ventralis*), White-necked Crow (*Corvus leucognaphalus*), Hispaniolan Solenodon (*Solenodon paradoxus*), and Ridgway's Hawk (*Buteo ridgwayi*). The population of the critically endangered Ridgway's Hawk is estimated at 200 individuals; all are practically restricted to the park and its buffer zones. The park receives an annual average rainfall of 2,700 cubic millimeters, which leach through the limestone and supply most of the water system for the city of Santo Domingo.

Previous property owners continue to seek use of the land within park boundaries. Slash-and-burn agricultural practices threaten the integrity of the park and its flora and fauna. Ridgway's Hawks are regularly killed by *campesinos*, who mistakenly think this small raptor is capable of eating their domestic fowl.

VISTA AÉREA DE LOS HAITISES · AERIAL VIEW OF LOS HAITISES

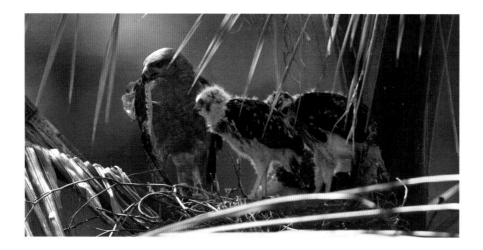

GAVILÁN · RIDGWAY'S HAWK · [*Buteo ridgwayi*] · LOS LIMONES

El gavilán (*Buteo ridgwayi*) es un ave de rapiña endémica, que se encuentra en algunos bosques de la isla de La Española. En el pasado estuvo distribuido en toda la isla pero en el último siglo su población ha sido reducida y ahora sólo consta de 80 a 120 parejas. Estas están limitadas a una extensión de menos de 208 km² de bosque tropical nativo en el Parque Nacional Los Haitises.

Ridgway's Hawk (*Buteo ridgwayi*) is a forest raptor endemic to the island of Hispaniola. Once commonly distributed throughout the island, the hawk has been reduced in the last century to a single declining population of 80 to 120 pairs, confined to less than 208 km² of native rainforest in Los Haitises National Park.

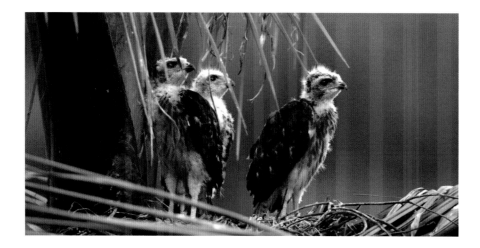

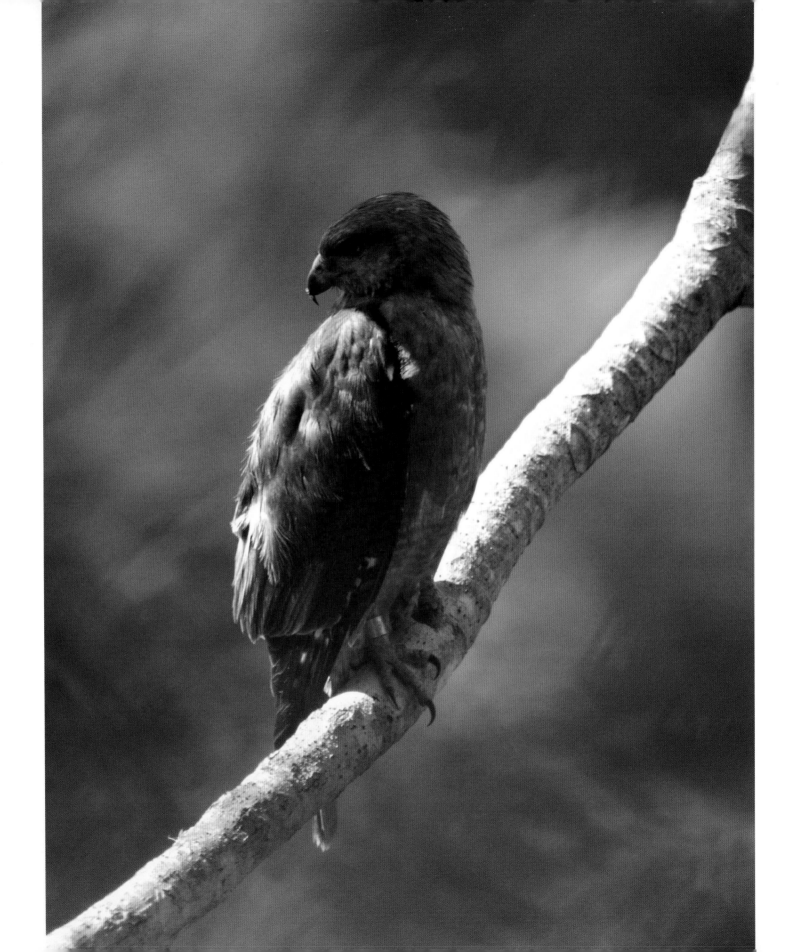

304

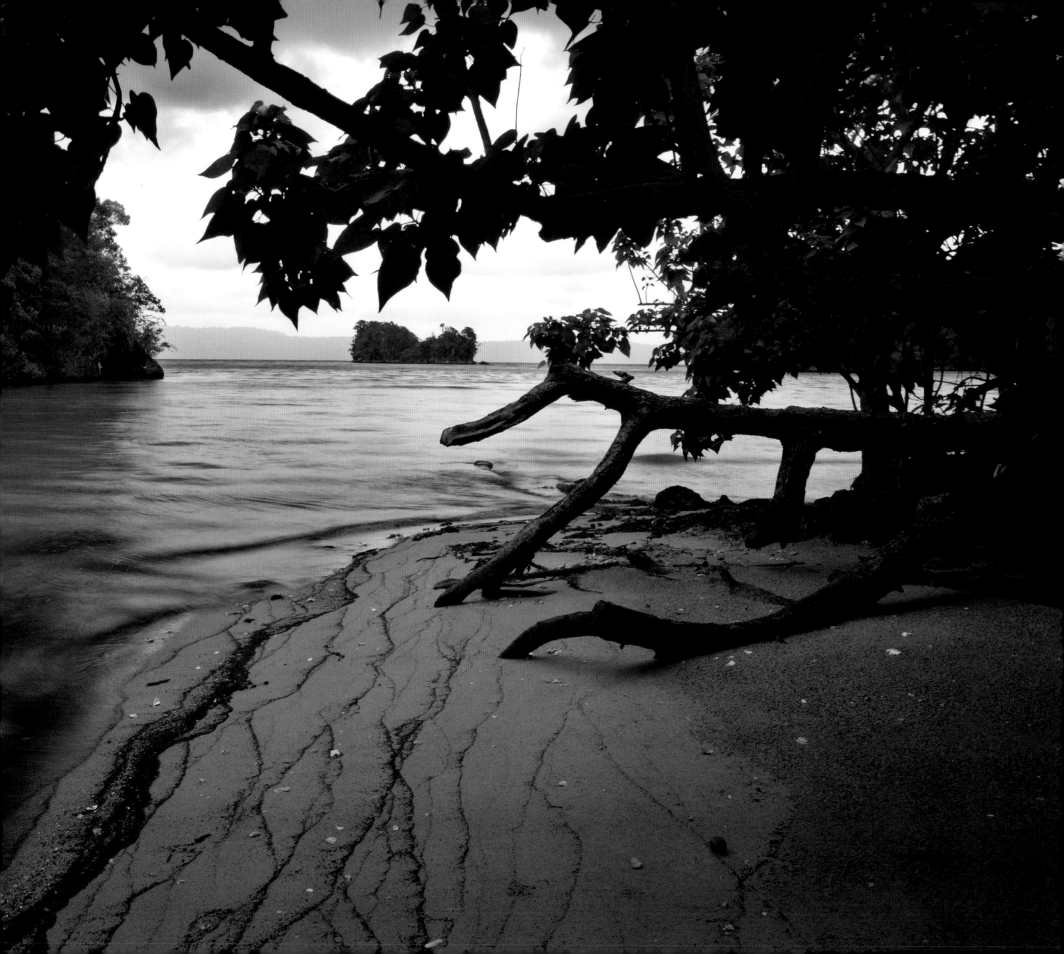

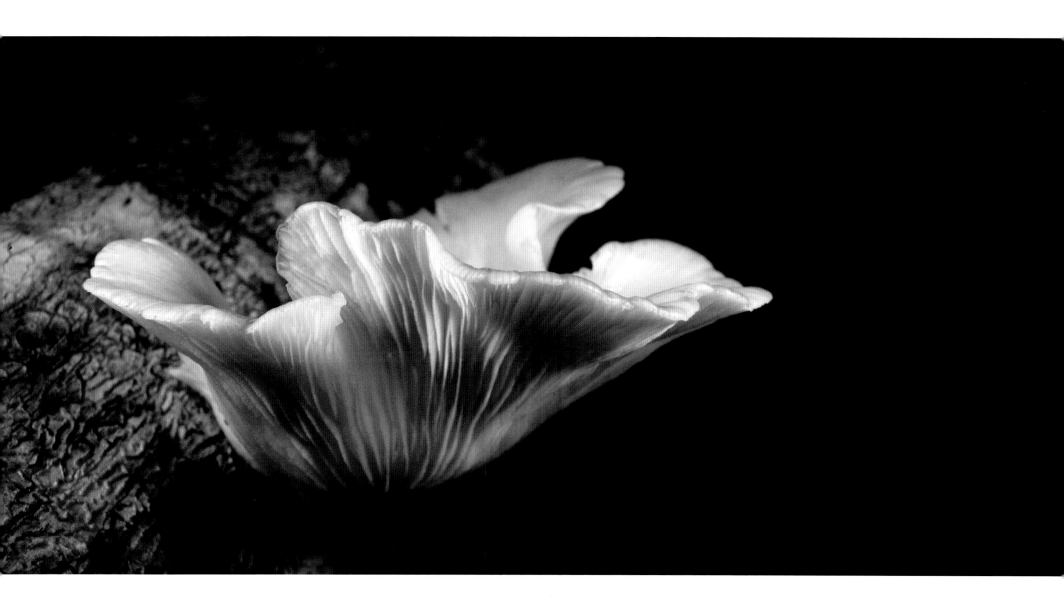

OYSTER MUSHROOM · *[Pleurotus sp.]* · CAÑO HONDO

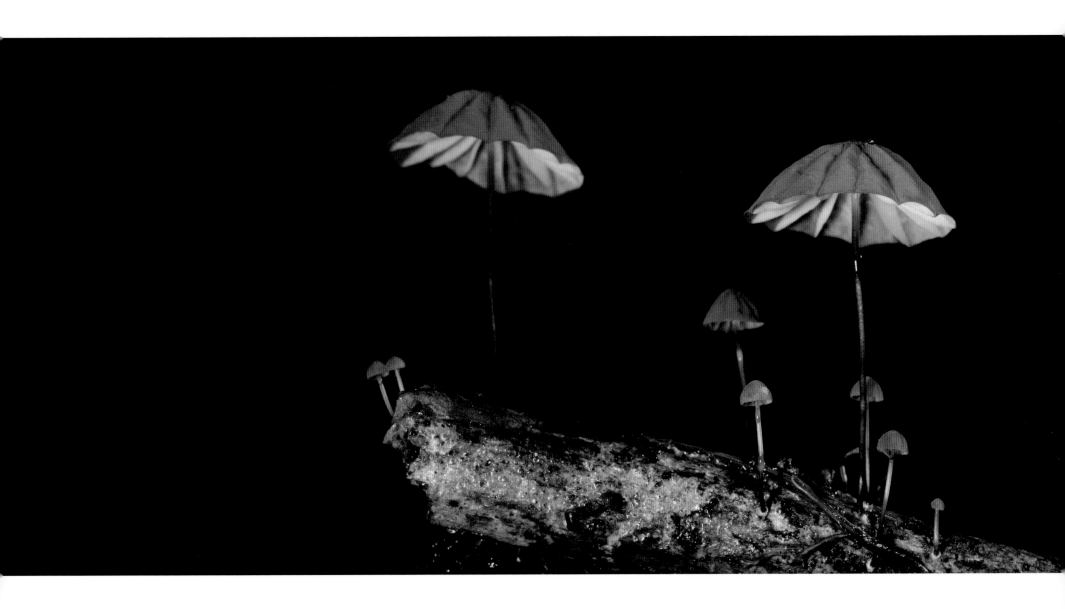

[*Marasmius sp.*] • CAÑO HONDO

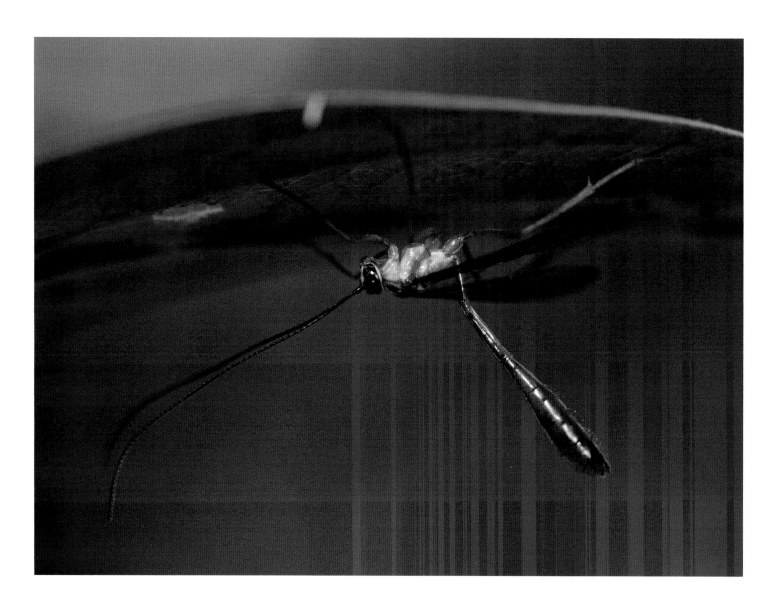

308

ICHNEUMONIDAE PARASITIC WASP · [*Ichneumonidae ophion sp.*] · LOS LIMONES

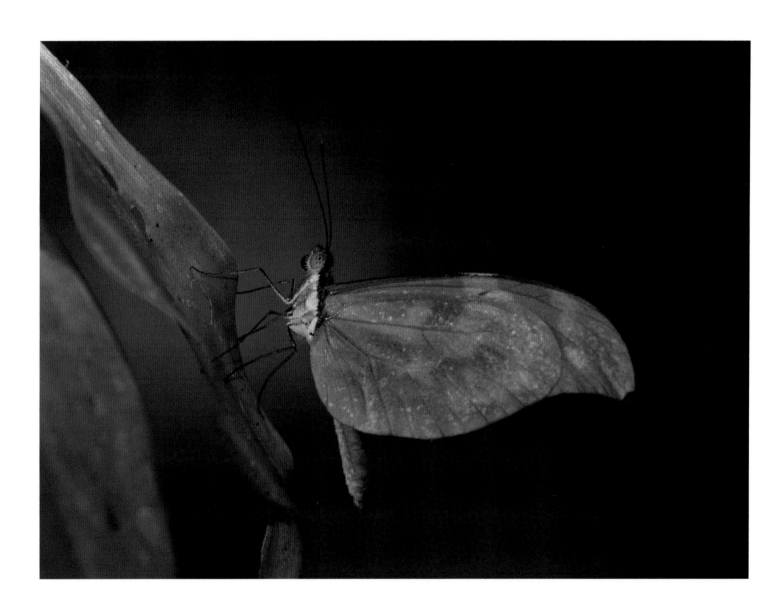

HAITIAN MIMIC · [*Dismorphia spio*] · TREPADA ALTA

[*Anastrus sempiternus*] · TREPADA ALTA

[*Eueides melphis*] • **TREPADA ALTA**

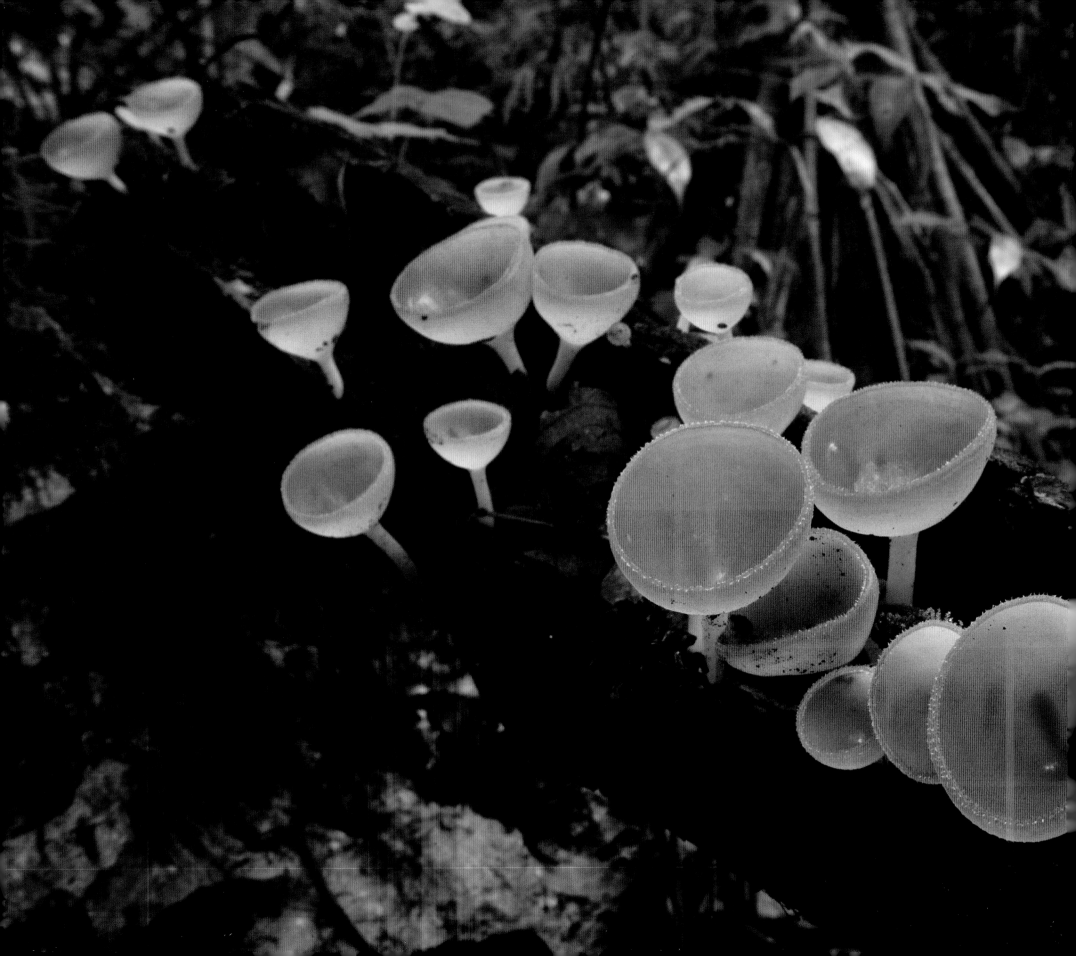

313

[Cookenia speciosa] · **EL NARANJO**

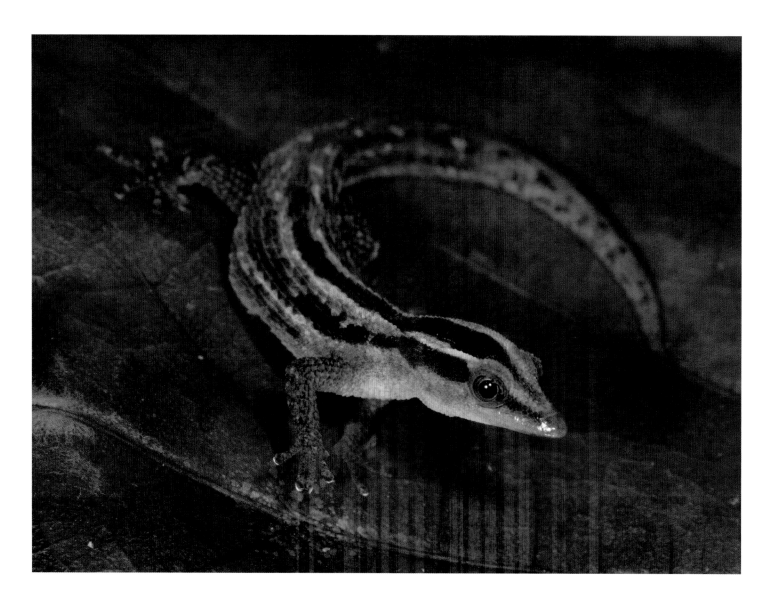

314

HAITISES STRIPED GECKO · [*Sphaerodactylus cochranae*] · LOS NARANJOS

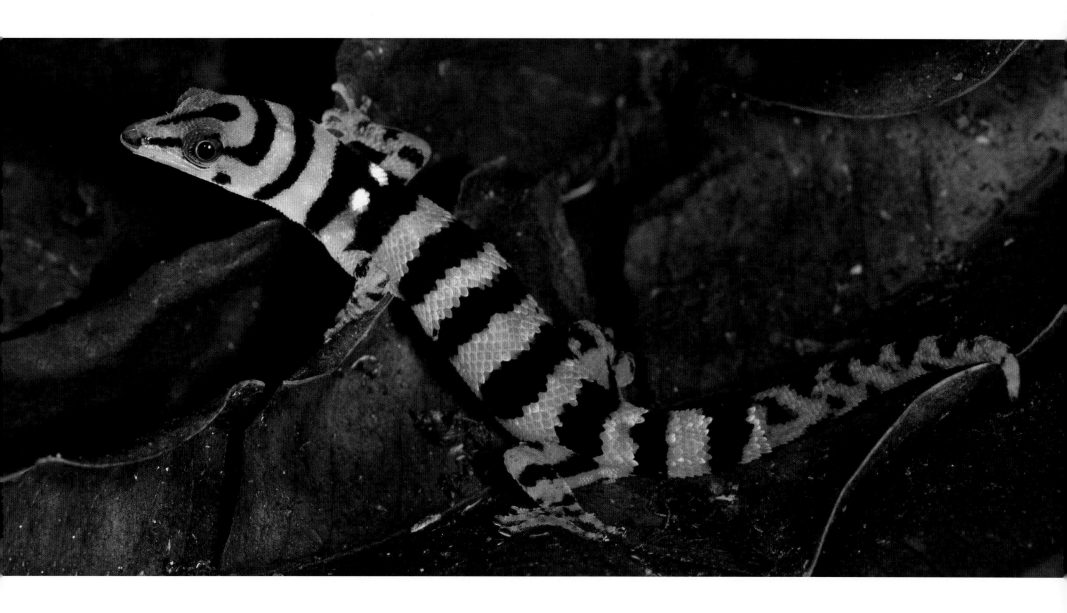

HAITISES BANDED GECKO • [*Sphaerodactylus samanensis*] • LOS NARANJOS

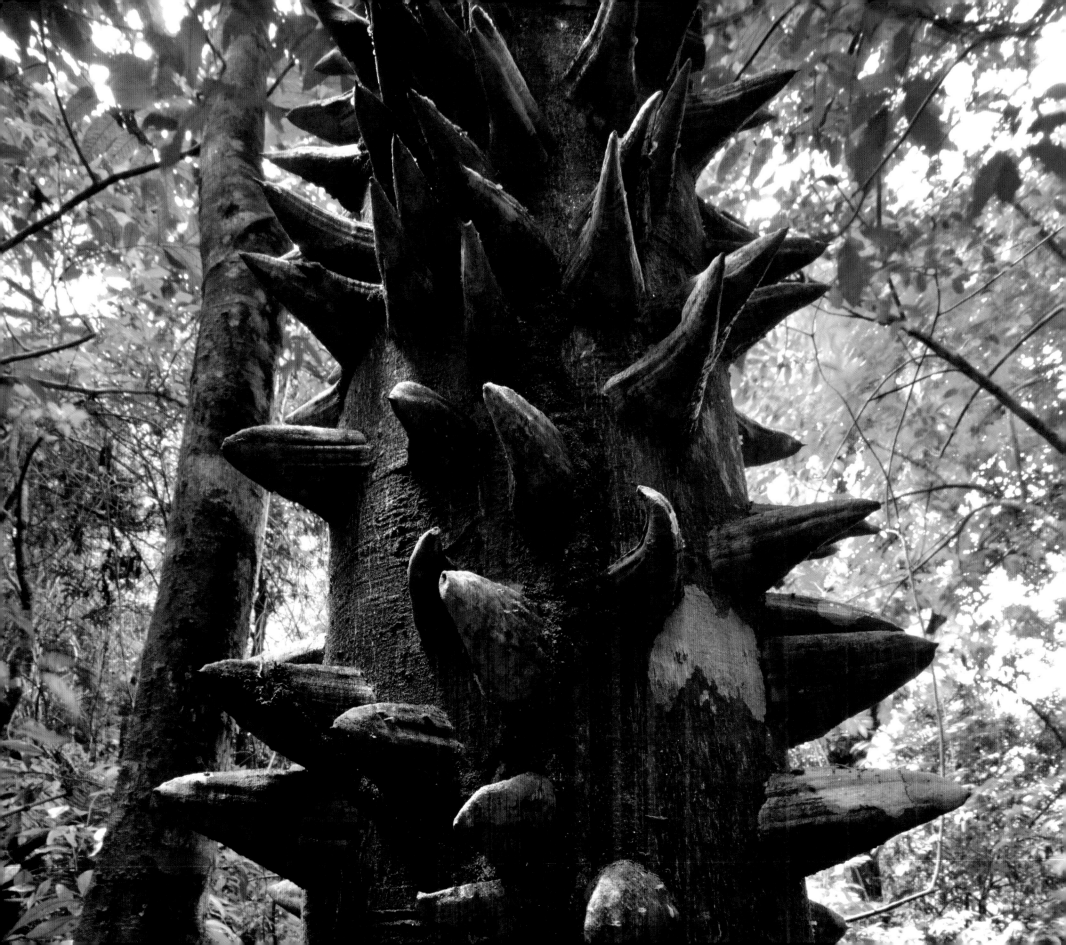

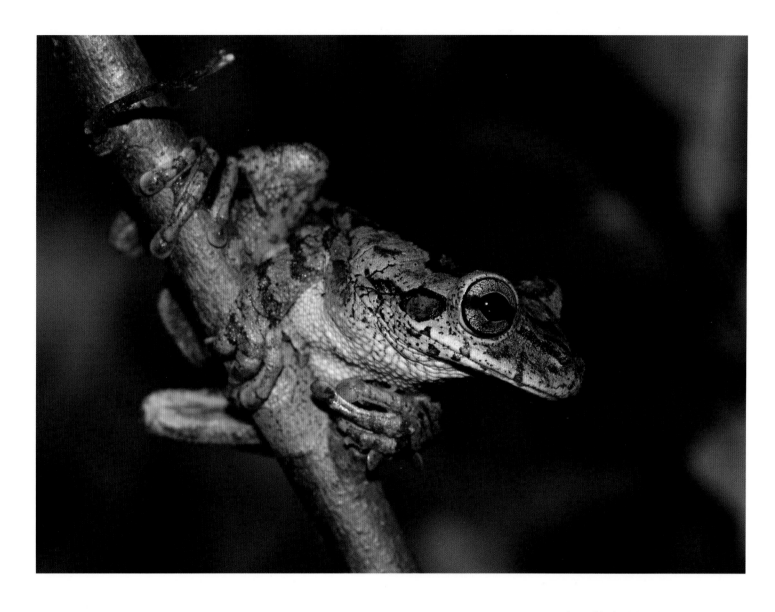

HISPANIOLAN LAUGHING TREEFROG · [*Osteopilus dominicensis*] · LOS LIMONES

PINO DE TETA · YELLOW PRICKLE · [*Zanthoxylum martinicense*] · EL NARANJO

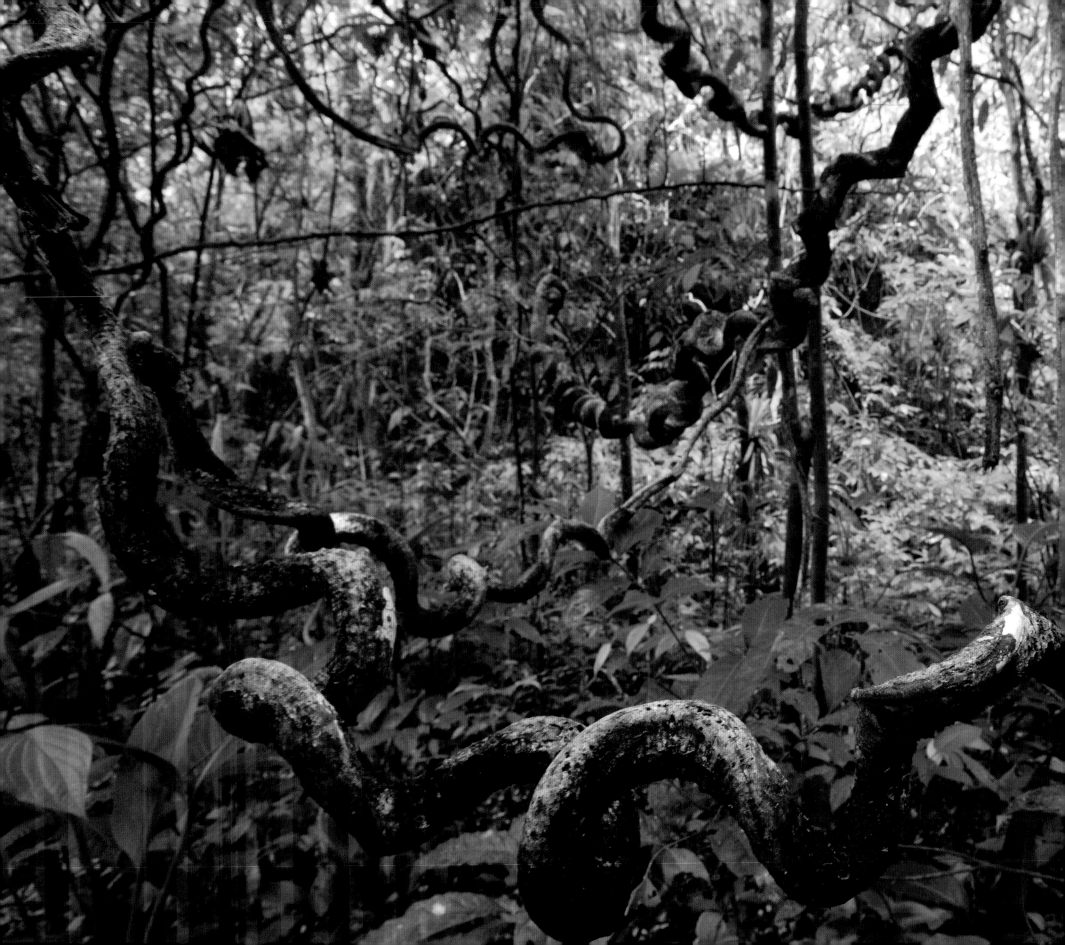

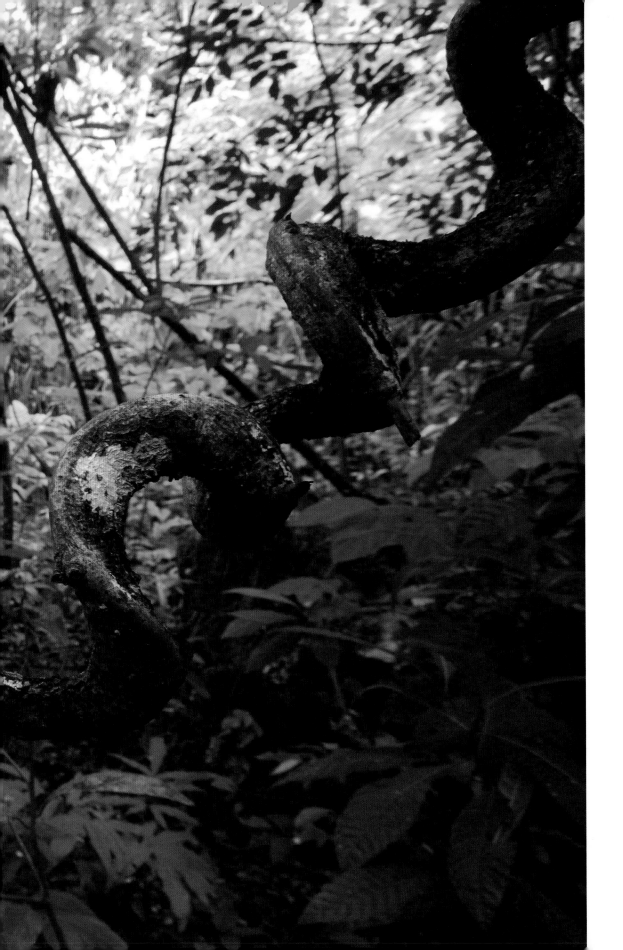

319

CARACOL, CHOCHO O SAMO · SEAHEART OR
MONKEY LADDER VINE · [*Entada gigas*] · EL NARANJO

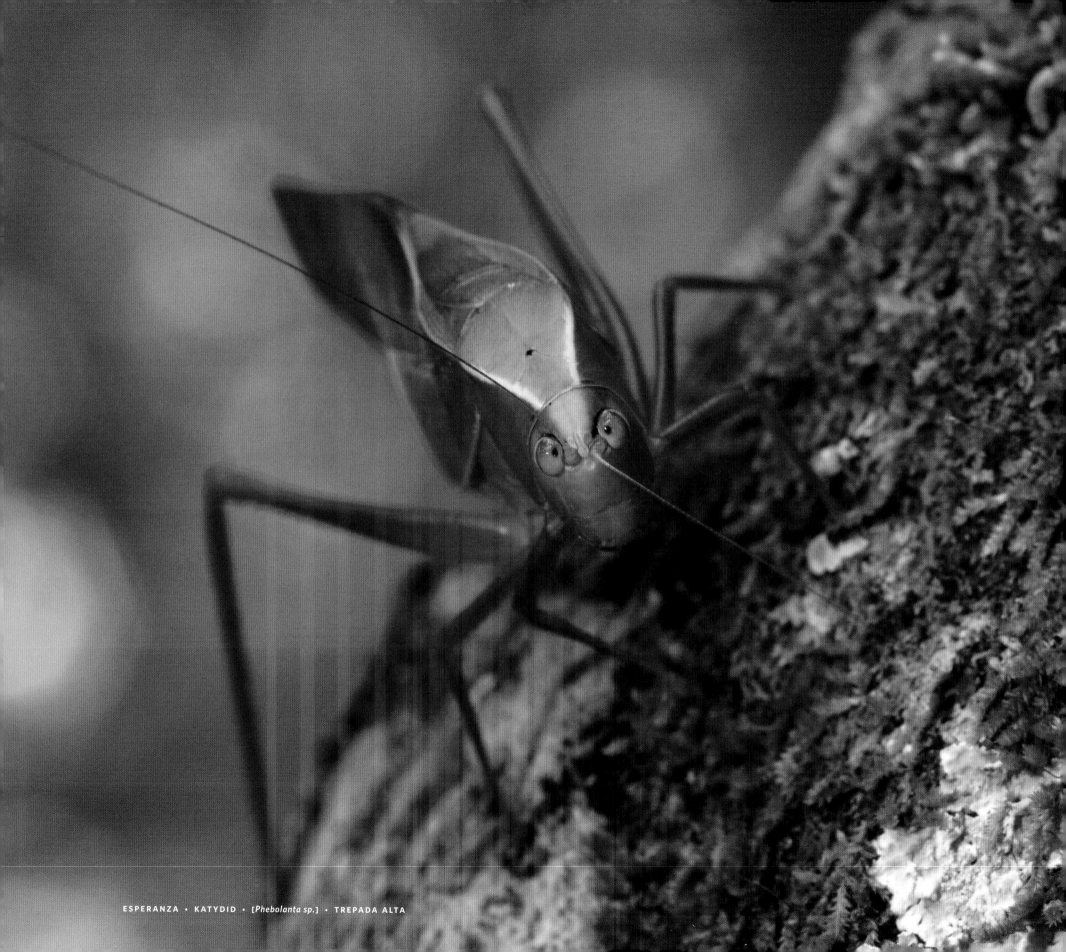

ESPERANZA · KATYDID · [*Phebolanta sp.*] · TREPADA ALTA

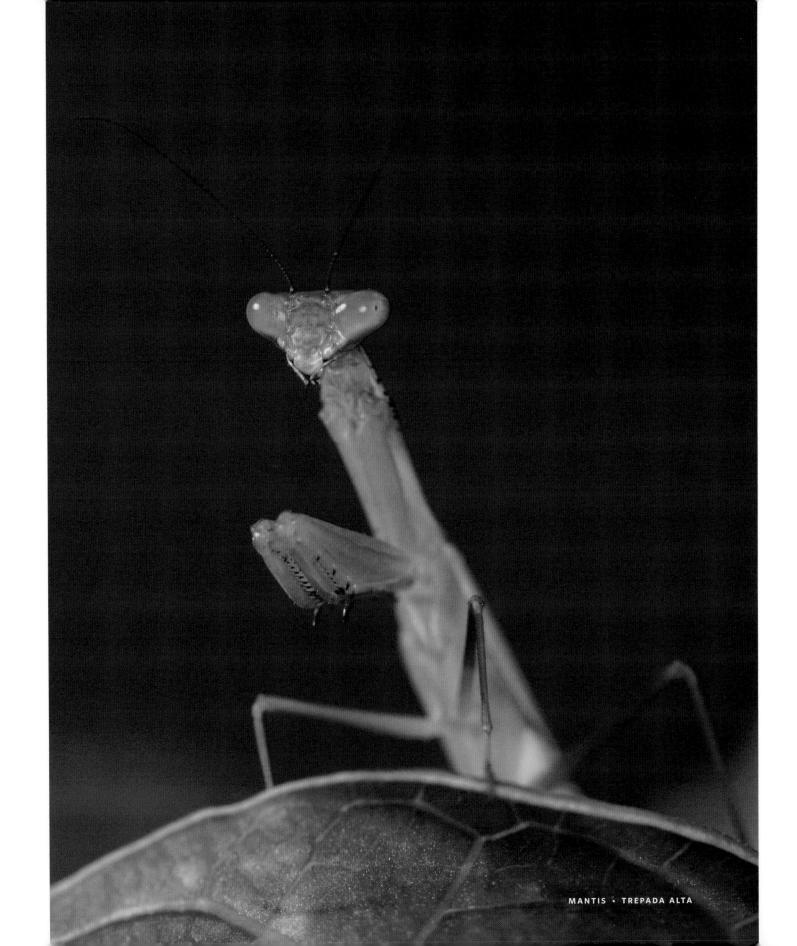

MANTIS · TREPADA ALTA

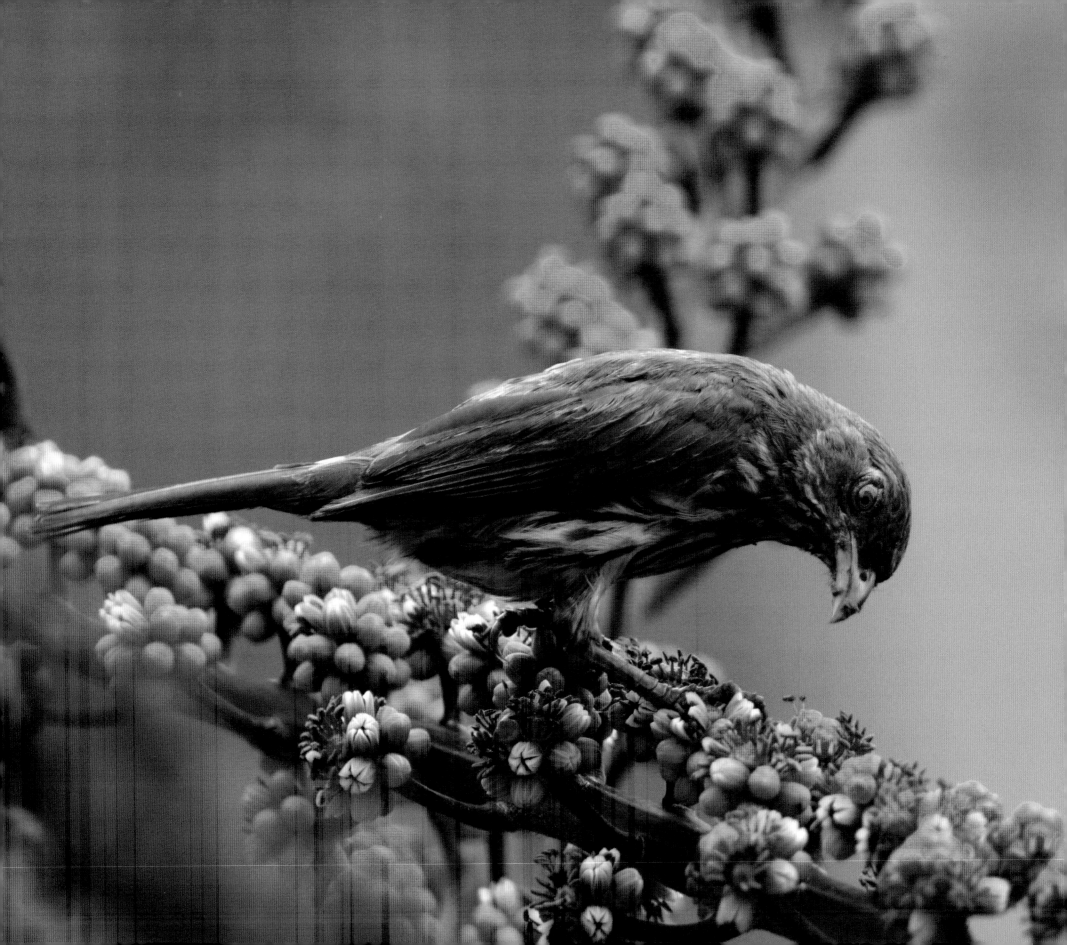

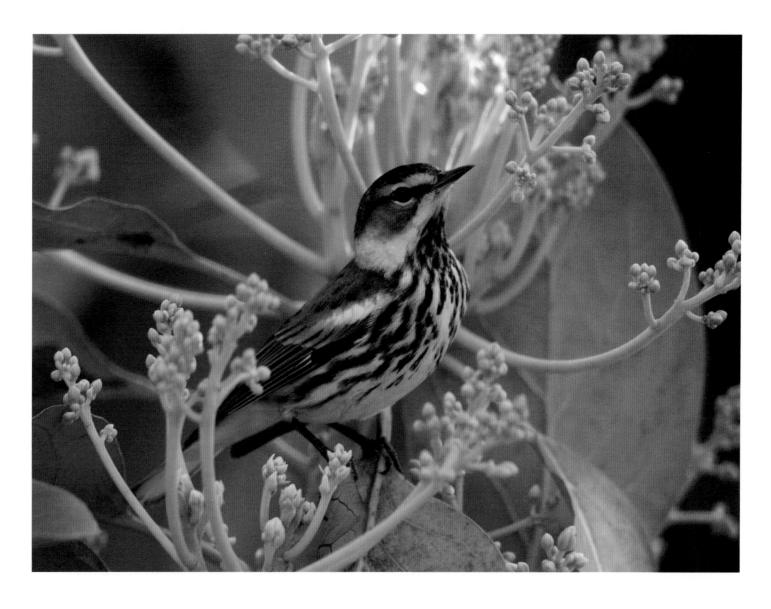

CIGUA TIGRINA · CAPE MAY WARBLER · [*Dendroica tigrina*] · LOS LIMONES

CIGUA PALMERA · PALM CHAT · [*Dulus dominicus*] · LOS LIMONES

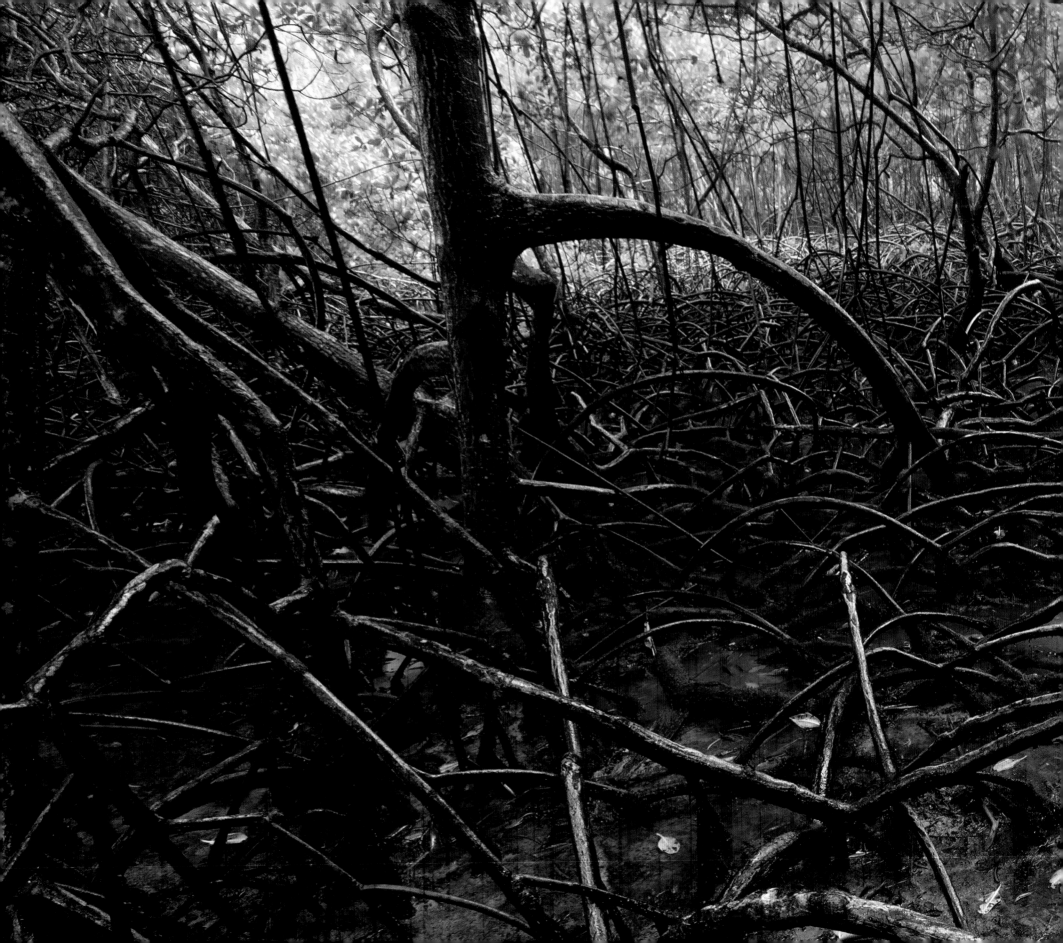

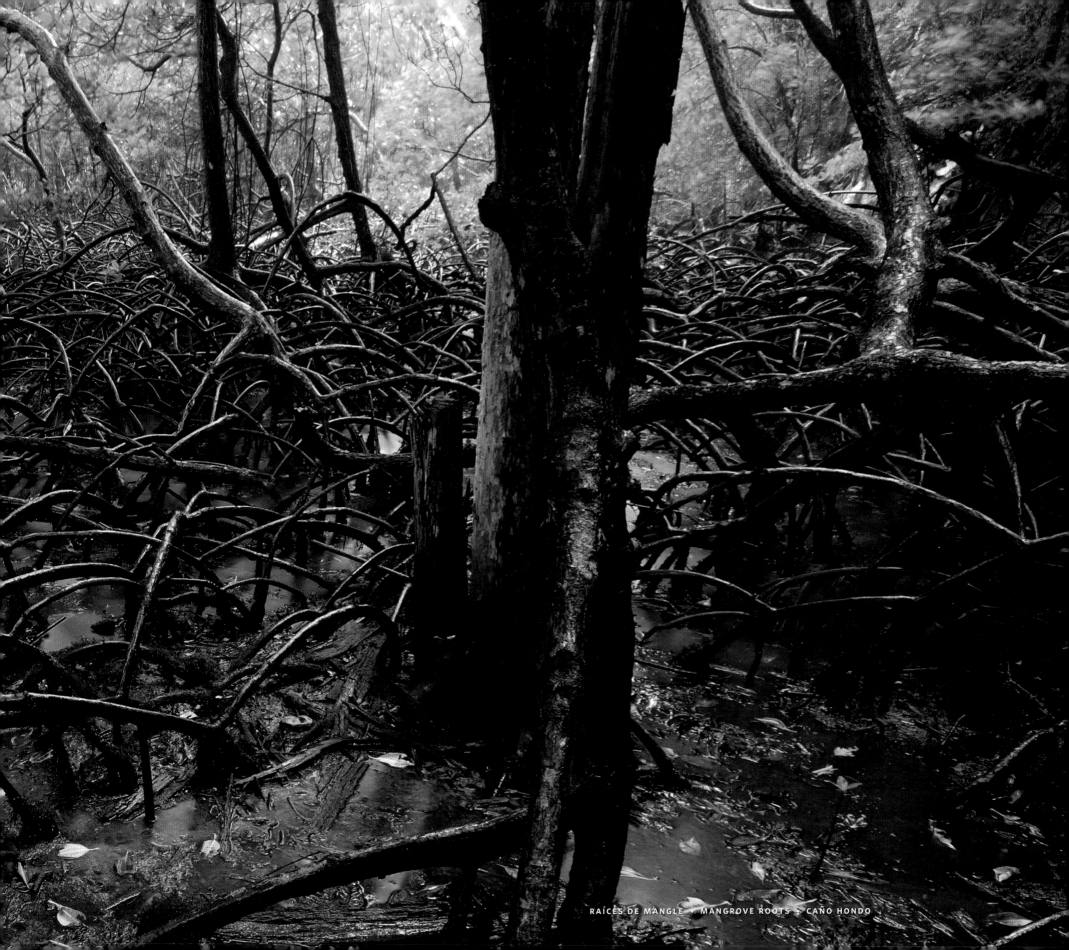

RAÍCES DE MANGLE · MANGROVE ROOTS · CAÑO HONDO

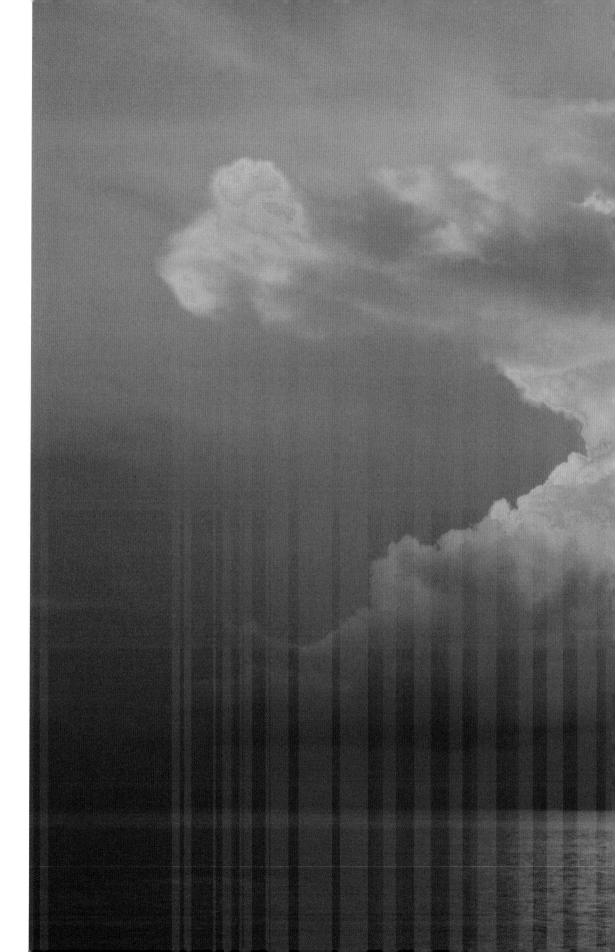

PARQUE NACIONAL DEL ESTE

CUBRIENDO 420 KILÓMETROS CUADRADOS DE SUPERFICIE terrestre y 388 kilómetros cuadrados de mar, el Parque Nacional del Este es un enorme parque costero marino situado en la punta sureste de la República Dominicana. Este parque incluye las islas Saona y Catalina y los manglares de la Bahía de las Calderas. Otros ambientes incluyen bosque seco, bosque húmedo subtropical y un ecosistema especial formado dentro de la gran diversidad de cuevas que existen en la área. Ciento doce especies de aves, cuatro especies de tortugas marinas, manatíes, delfines y numerosas especies de peces han sido reportadas dentro del parque.

El Paso de Catuano, entre tierra firme y la Isla Saona, alberga unas de las colonias mas importantes de Lambí (*Strombus gigas*) en el Caribe y una impresionante colonia de Tijeretas (*Fregata magnifiscens*).

El Parque Nacional del Este—con sus hermosas playas, atracción principal del parque—es el más popular de los parques dominicanos. Las amenazas mas grandes para el parque provienen de los políticos corruptos y los empresarios sin ética que atentan con el cierre de porciones de la costa para reclamar las playas.

COVERING 420 SQUARE KILOMETERS OF LAND AND 388 square kilometers of sea, Del Este National Park is an enormous coastal marine park in the southeastern tip of the Dominican Republic. The park includes both Saona and Catalinita islands and the mangroves of the Bahía de las Calderas. Other habitats include dry forests, humid subtropical forests, and the special ecosystems formed within a large diversity of caves that exist in the area. One hundred twelve species of birds, four species of marine turtles, manatees, dolphins, and numerous species of fish have been reported within the park.

El Paso de Catuano, between the mainland and Saona Island, holds one of the most important conch (*Strombus gigas*) colonies of the Caribbean and an impressive Magnificent Frigatebird (*Fregata magnifiscens*) colony.

Del Este National Park—with its beautiful beaches, the park's primary attraction—is the most popular of Dominican parks. A major threat to the park comes from corrupt politicians and unethical entrepreneurs who attempt to close off portions of the coast in order to claim prime beach real estate.

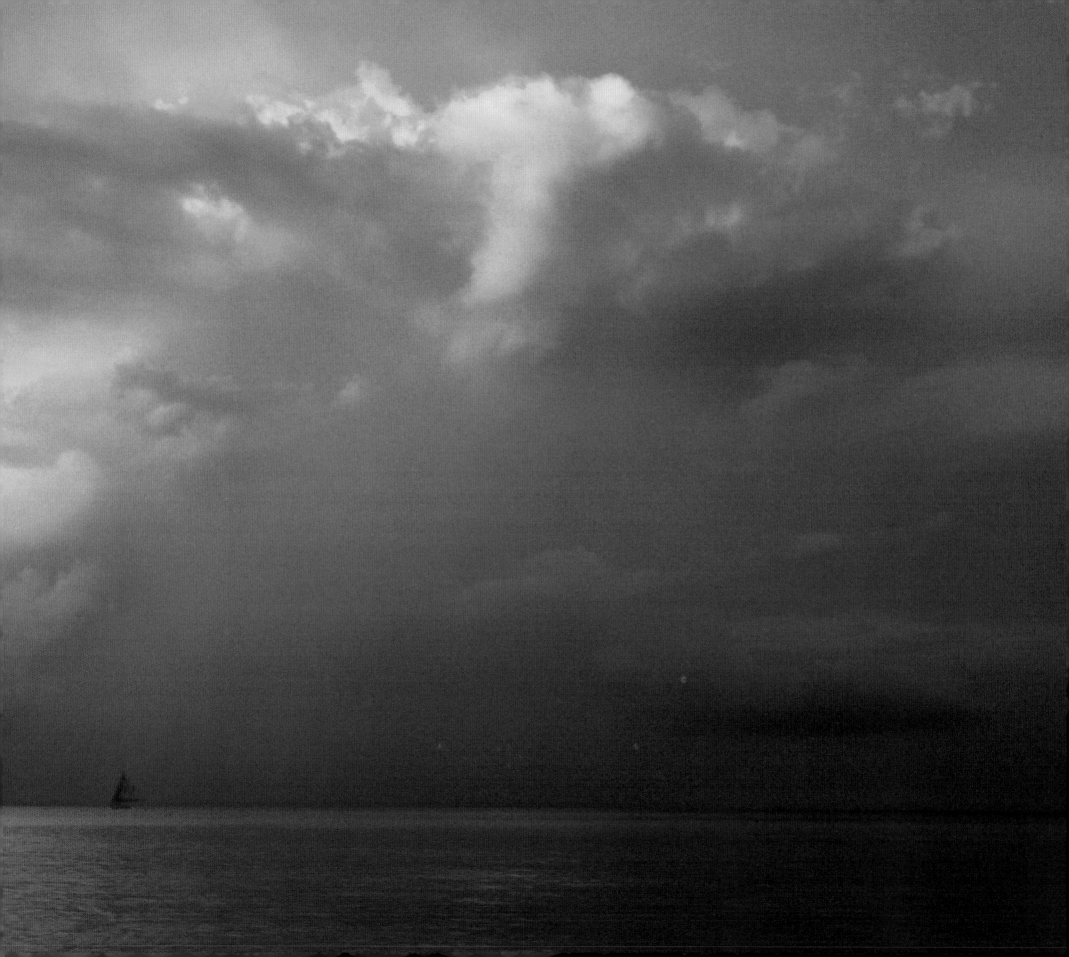

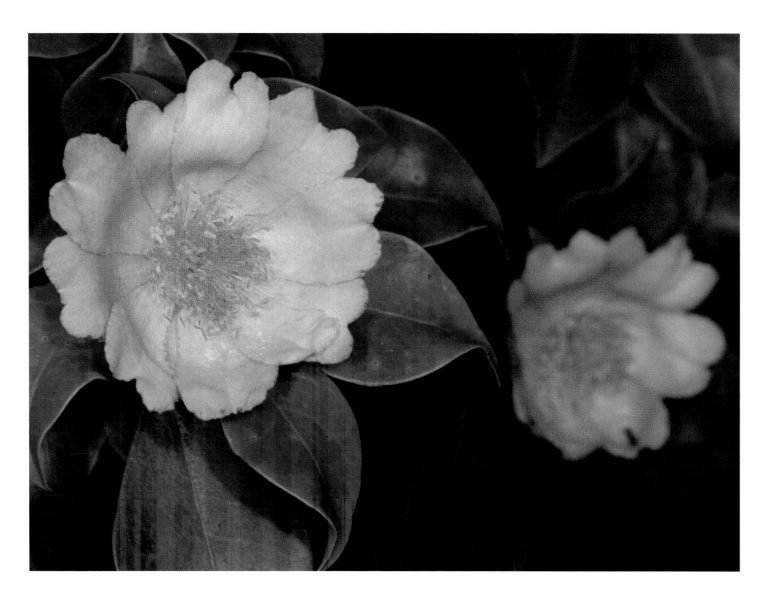

ROSA DE BAYAHIBE · [*Pereskia quisqueyana*] · BAYAHIBE

CUBANOLA · [*Cubanola dominguensis*] · GUARAGUAO

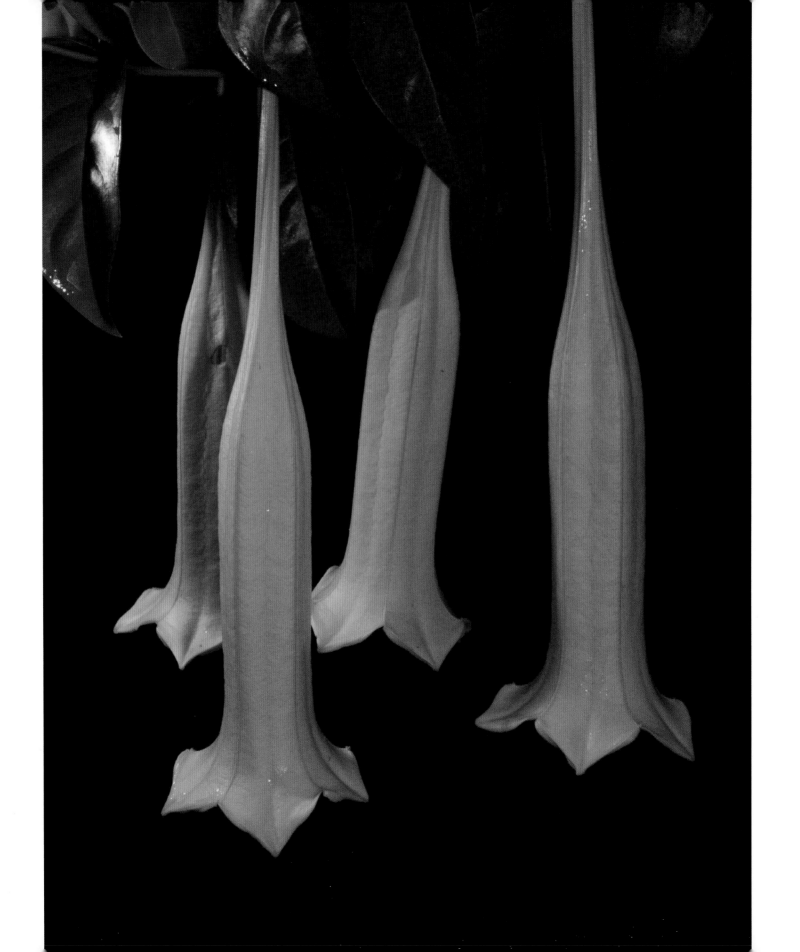

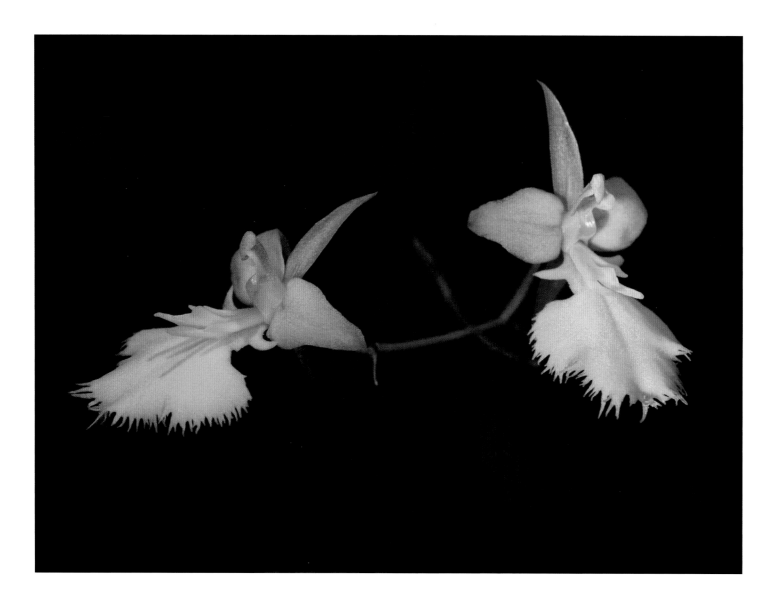

ORCHID · [*Tolumnia calochyla*] · GUARAGUAO

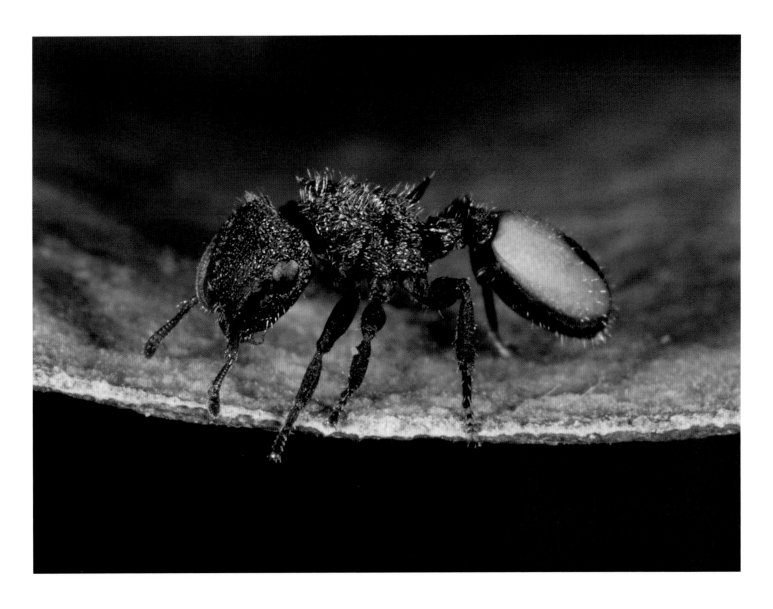

HORMIGA · ANT · [*Cephalotes unimaculatus*] · GUARAGUAO

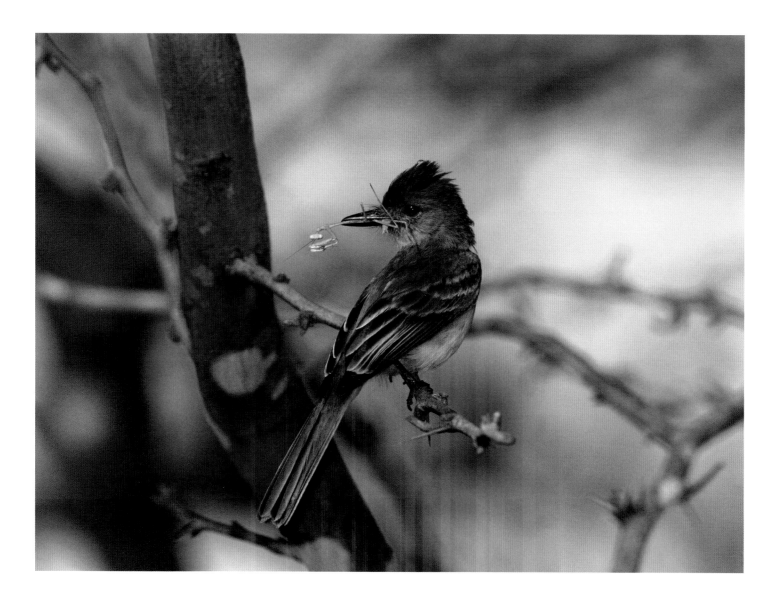

MANUELITO COMIENDO UNA MANTIS · MYIARCHUS EATING A MANTIS · [*Myiarchus stolidus*] · GUARAGUAO

CRA-CRA · GREEN HERON · [*Butorides virescens*] · GUARAGUAO

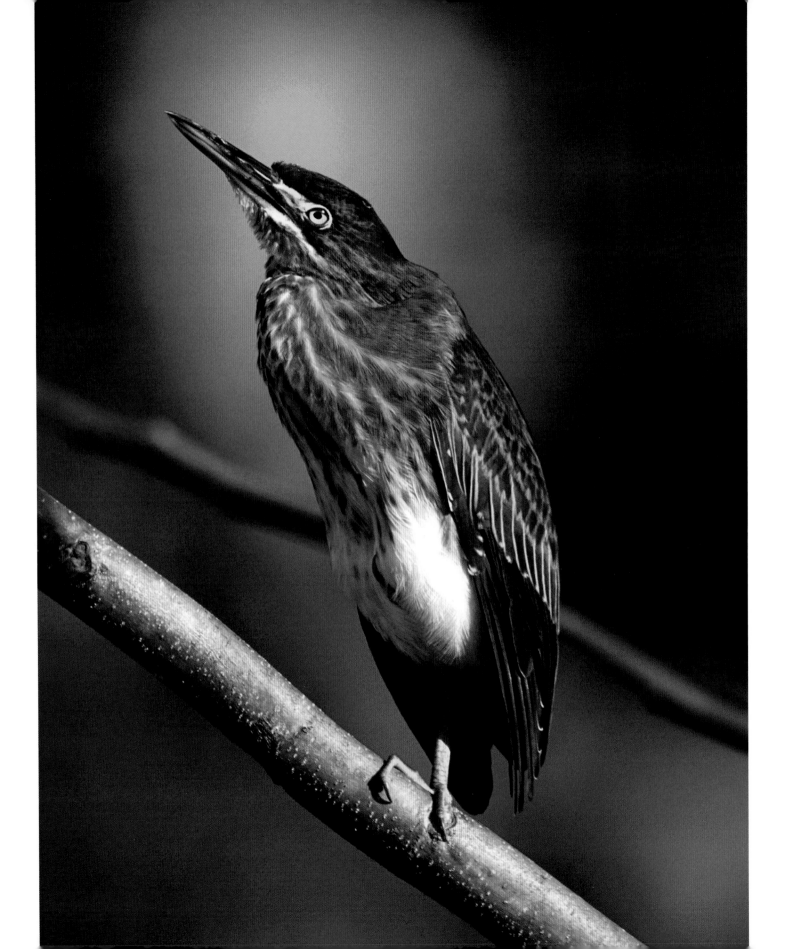

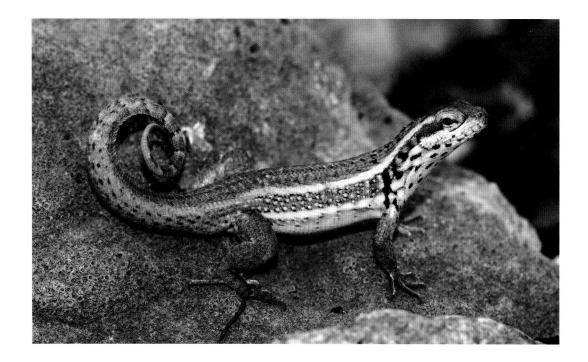

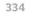

MARIJUANITA · SANTO DOMINGO CURLYTAIL · [*Leiocephalus lunatus*] · BAYAHIBE

BOA · [*Tropidophis haetianus*] · GUARAGUAO

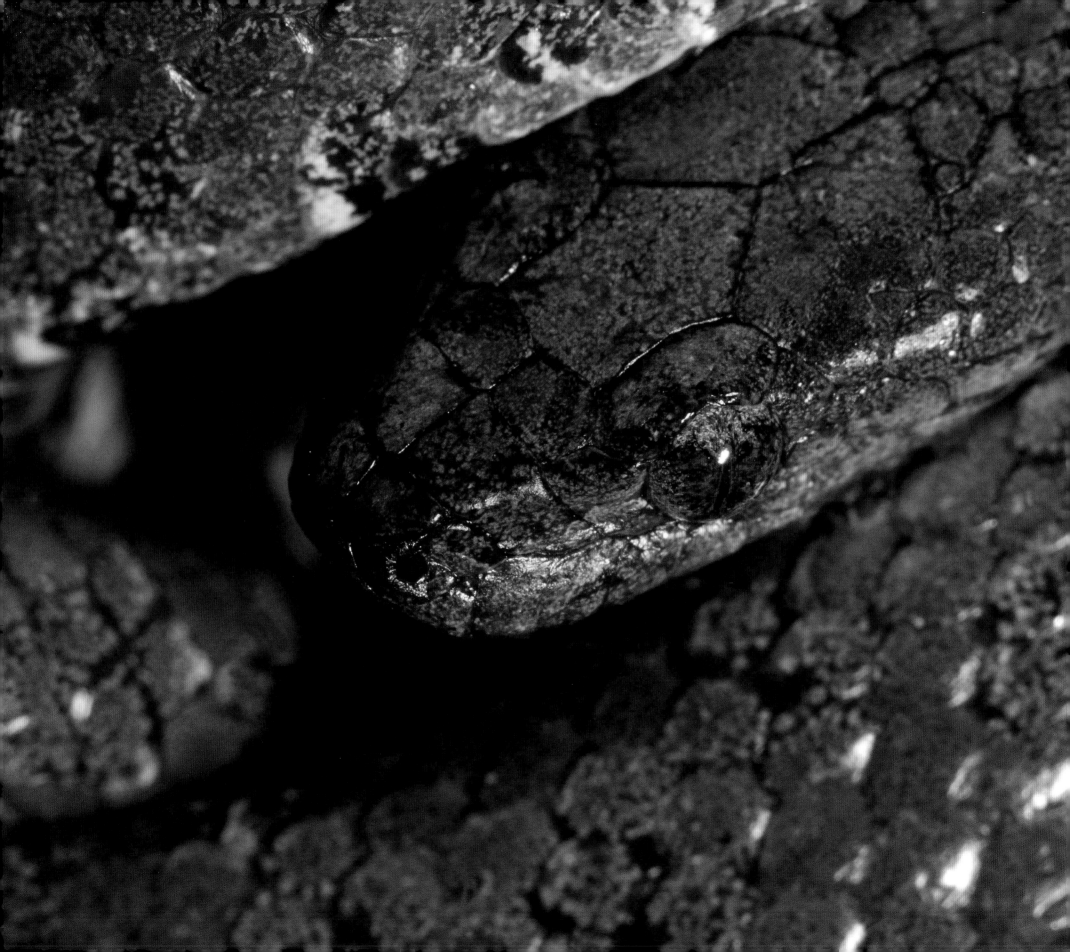

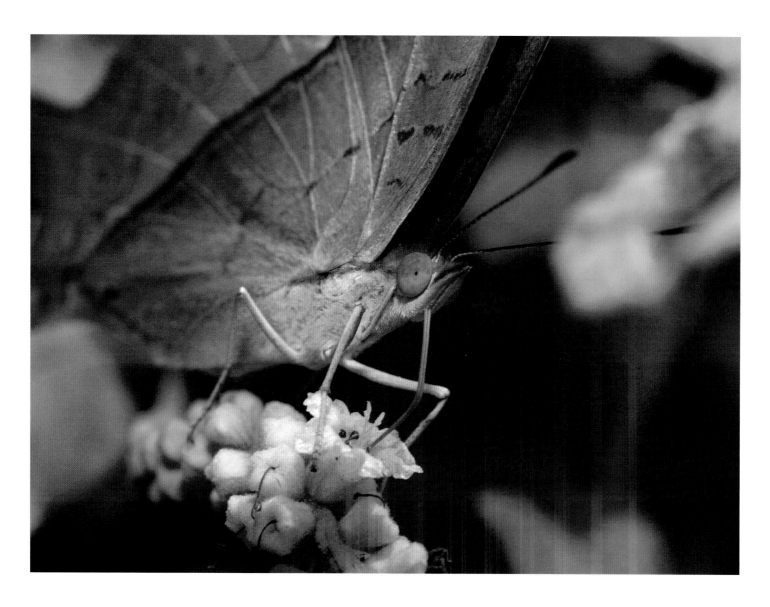

SOUTHERN DAGGER TAIL · [*Marpesia petreus*] · GUARAGUAO

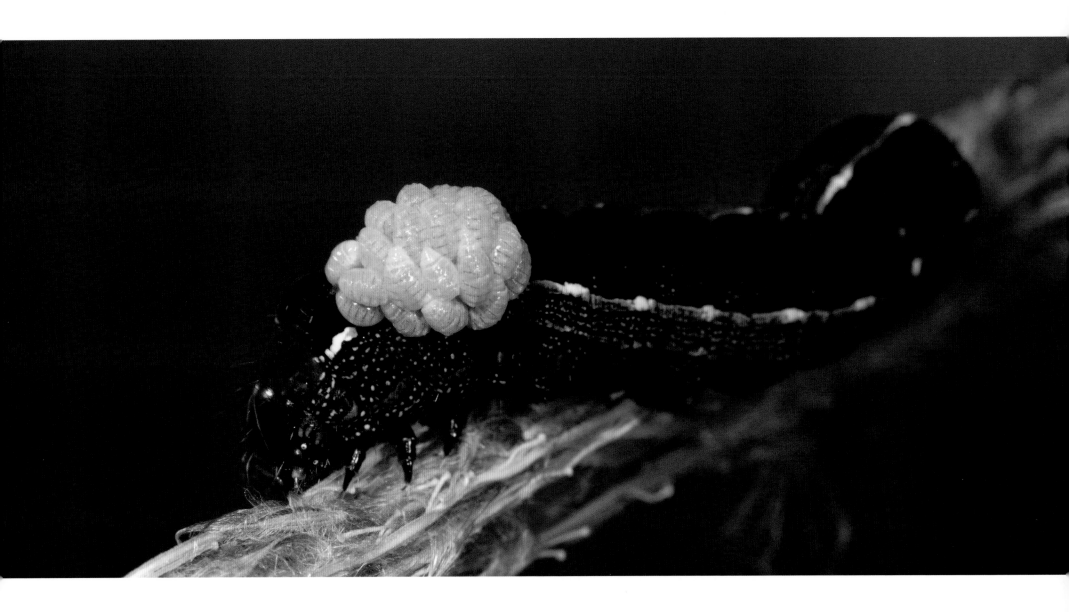

LARVAS DE AVISPAS PARASITARIAS SOBRE ORUGA · PARASITIC WASP LARVAE ON CATERPILLAR · BOCA DE YUMA

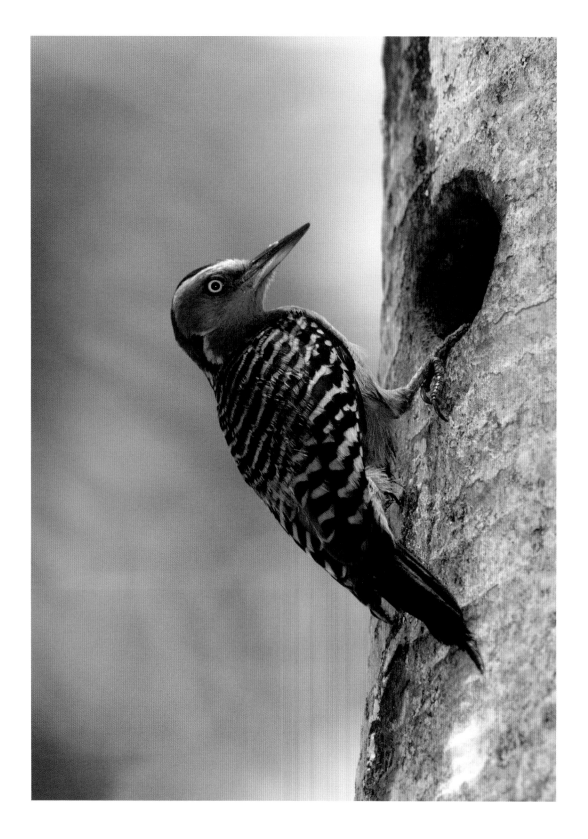

338

CARPINTERO · HISPANIOLAN WOODPECKER · [*Melanerpes striatus*] · GUARAGUAO

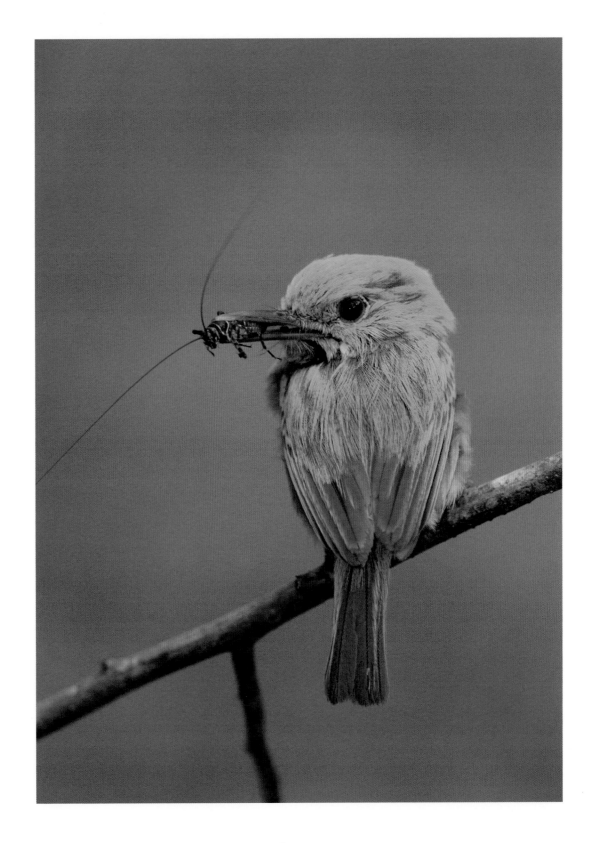

BARRANCOLÍ • BROAD-BILLED TODY • [*Todus subulatus*] • GUARAGUAO

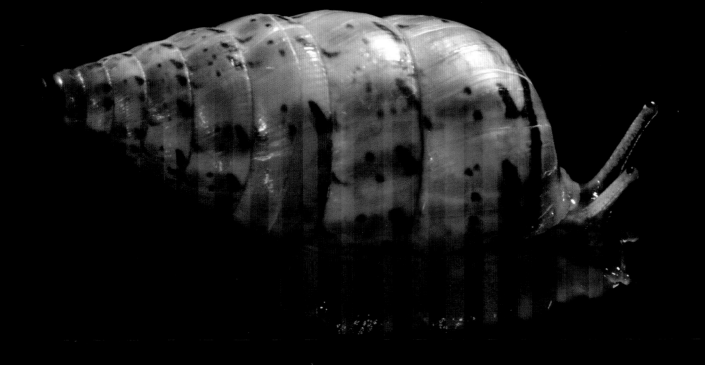

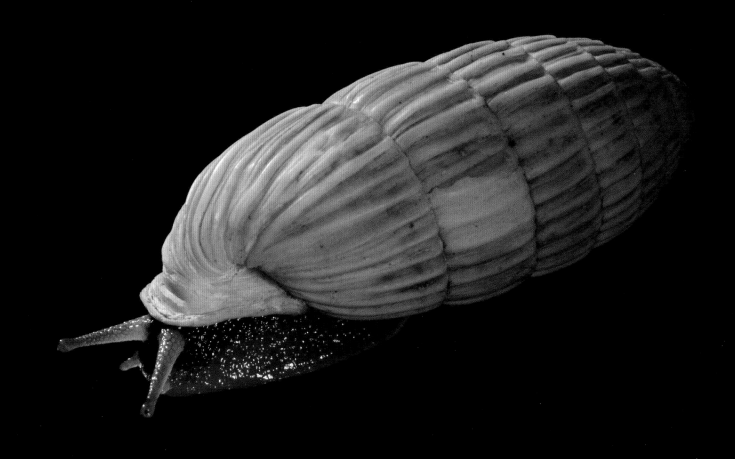

[*Cerion yumaense*] • BOCA DE YUMA

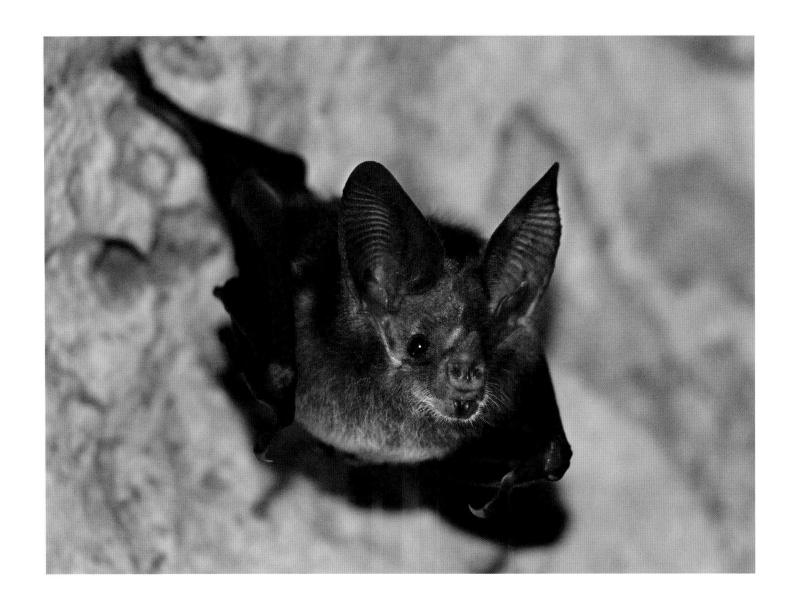

MURCIÉLAGO INSECTIVORO · INSECT-EATING BAT · [*Macrotus waterhousii*] · CUEVA DEL PUENTE

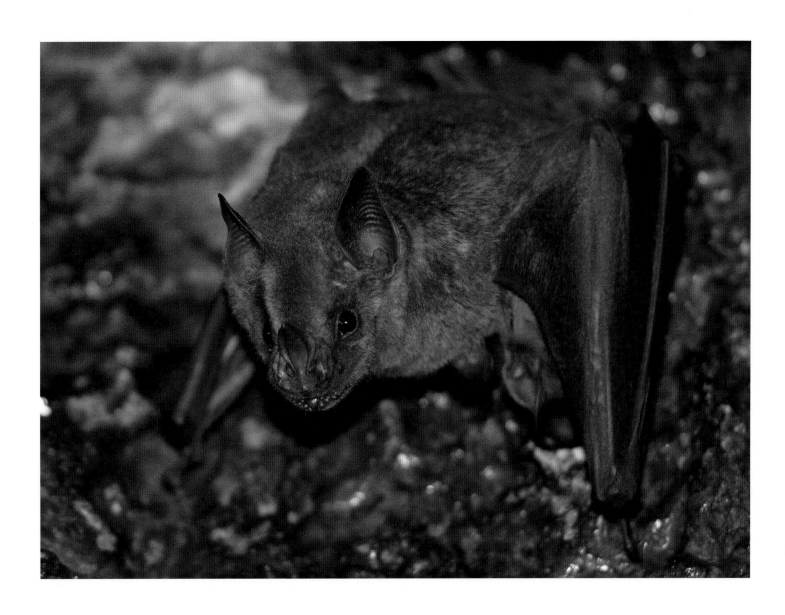

MURCIÉLAGO FRUGÍVORO JAMAIQUINO · JAMAICAN FRUIT BAT · [*Artibeus jamaicensis*] · CUEVA DEL PUENTE

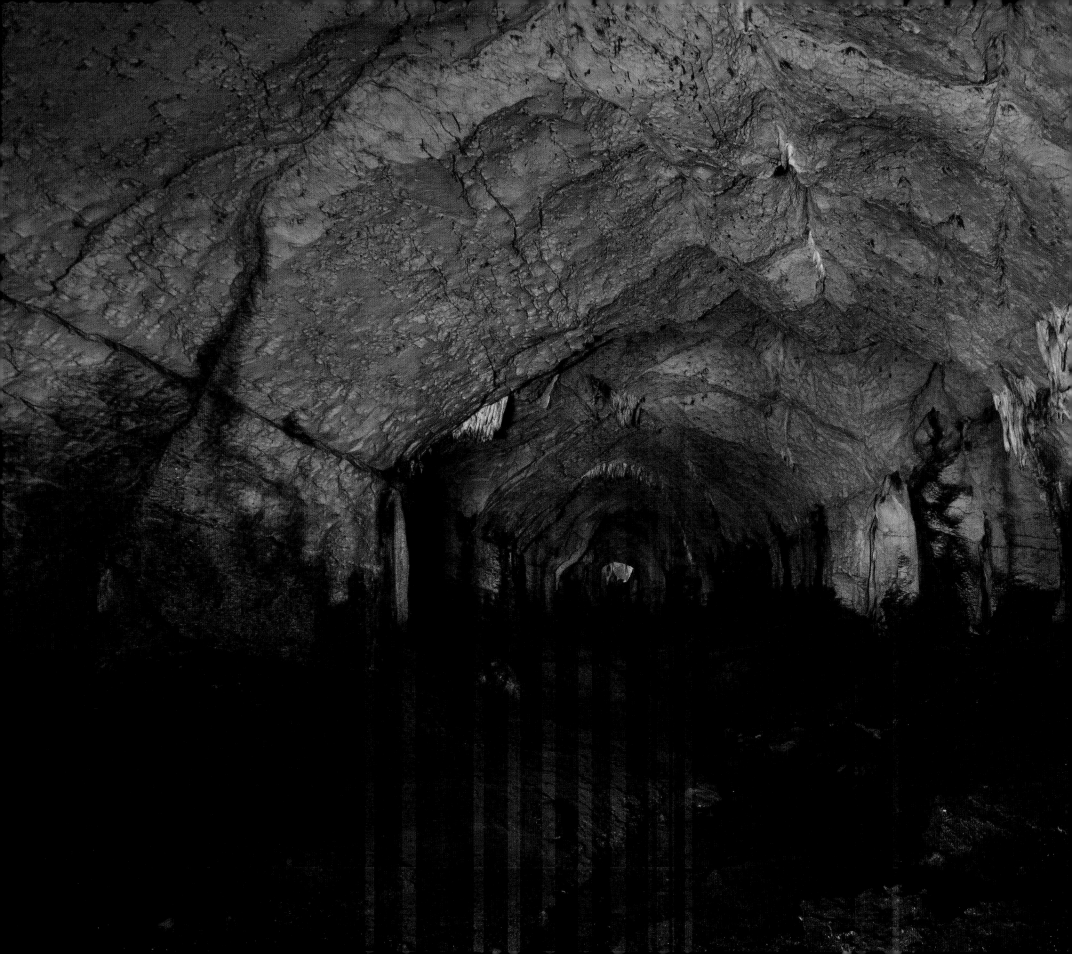

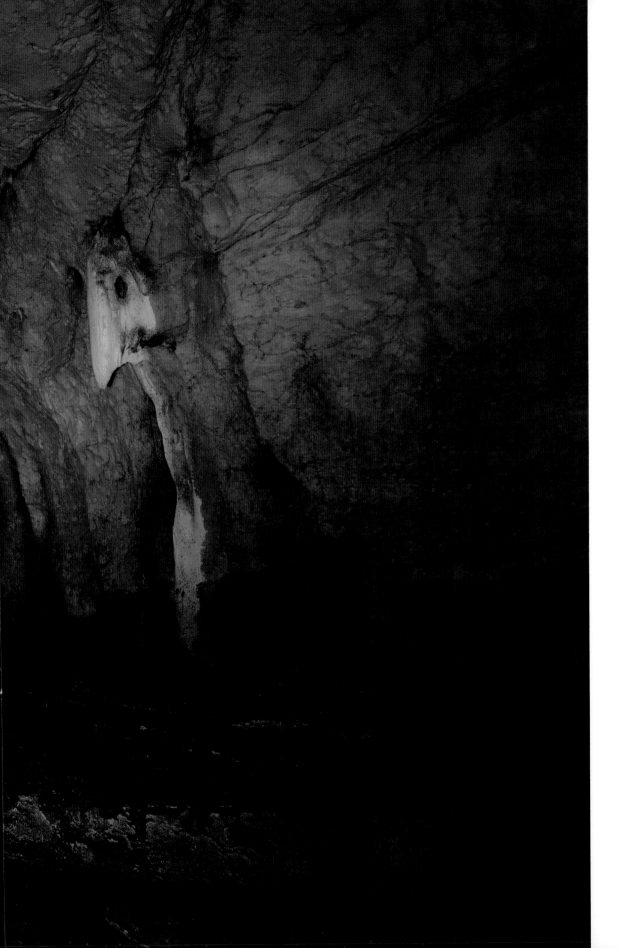

CUEVA DEL PUENTE

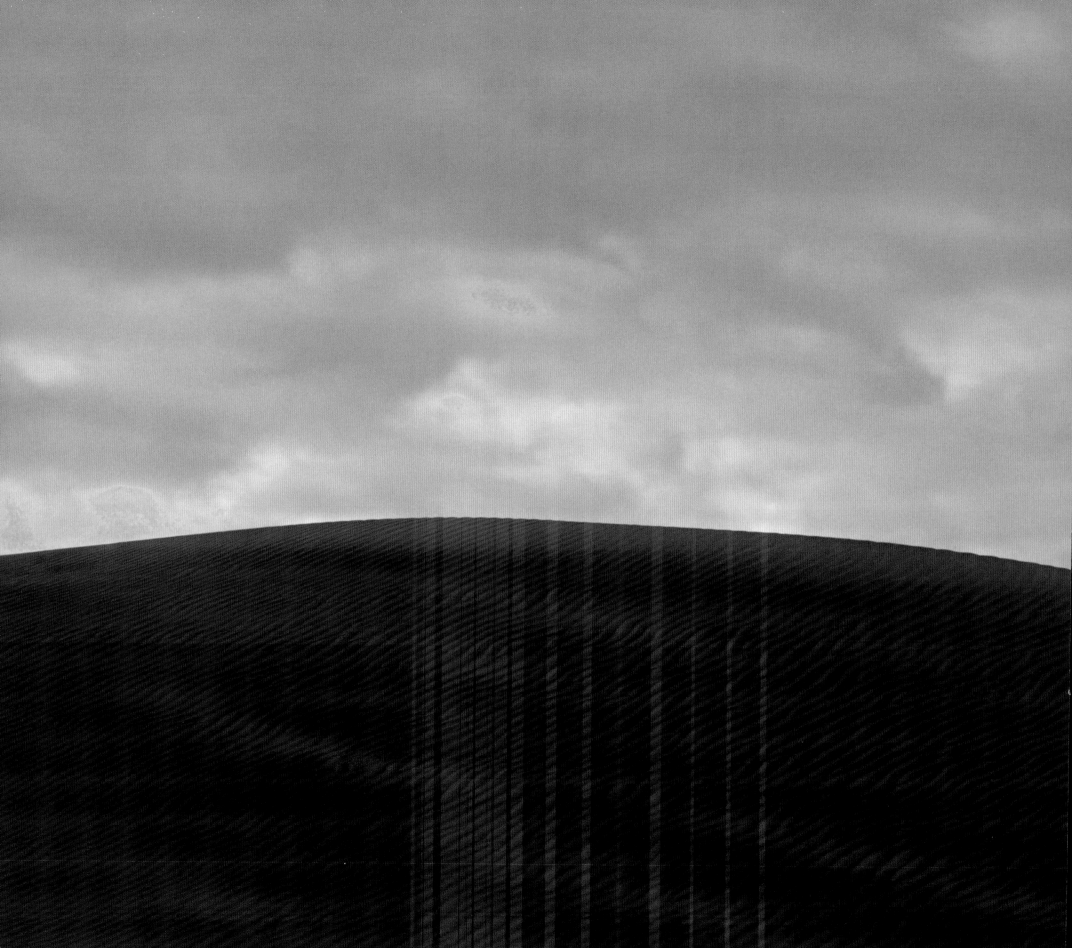

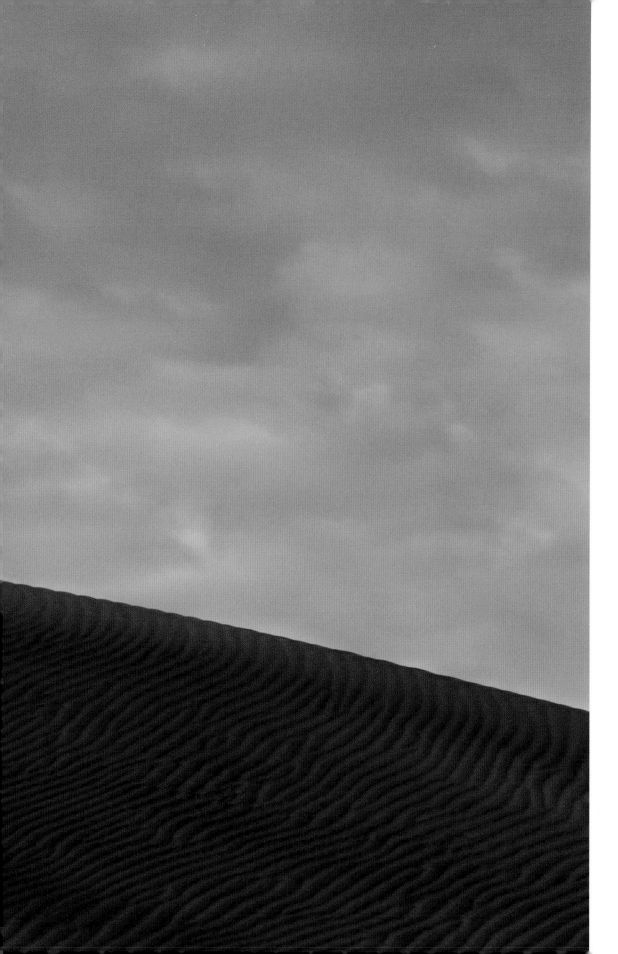

MONUMENTO NATURAL LAS DUNAS DE BANÍ

CON UNOS 20 KILÓMETROS DE LARGO, EL MONUMENTO Natural Las Dunas de Baní ocupa la Península de Las Calderas. Considerado como un ecosistema único en el Caribe, las dunas pueden alcanzar una altura de 30 metros. Se estima que unos 120 millones de metros cúbicos de arena fina están almacenados dentro de esta área protegida. Además de las dunas, manglares, bosques secos espinosos y la mina de sal proveen de refugio a aves migratorias y a especies de aves nativas. Las últimas usan el área como lugar para anidar durante los meses de primavera y verano.

ABOUT 20 KM LONG, LAS DUNAS DE BANÍ NATURAL MONUMENT occupies Las Calderas Peninsula. Considered a unique ecosystem in the Caribbean, the sand dunes here may reach a height of 30 meters. An estimated 120 million cubic meters of fine sands are stored inside this protected area. In addition to the dunes, mangroves, dry thorn scrub forests, and a salt mine provide refuge for migratory birds and native bird species. The latter use the area as nesting grounds during the spring and summer months.

DUNAS · DUNES · LAS SALINAS

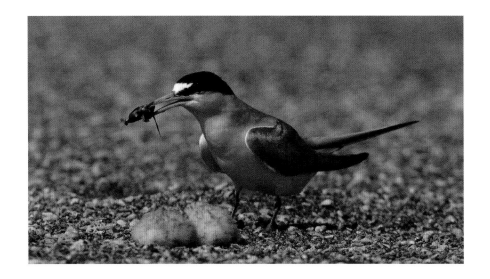

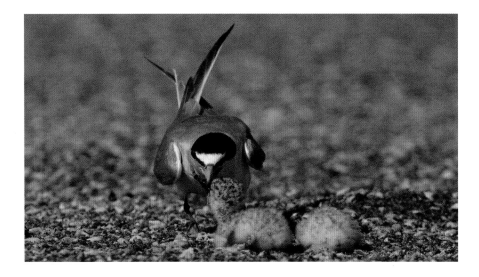

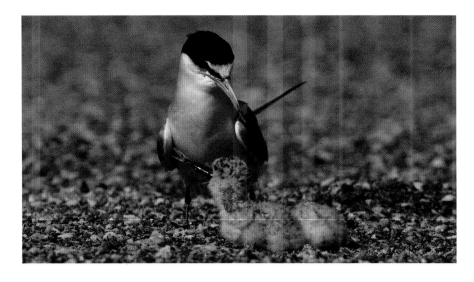

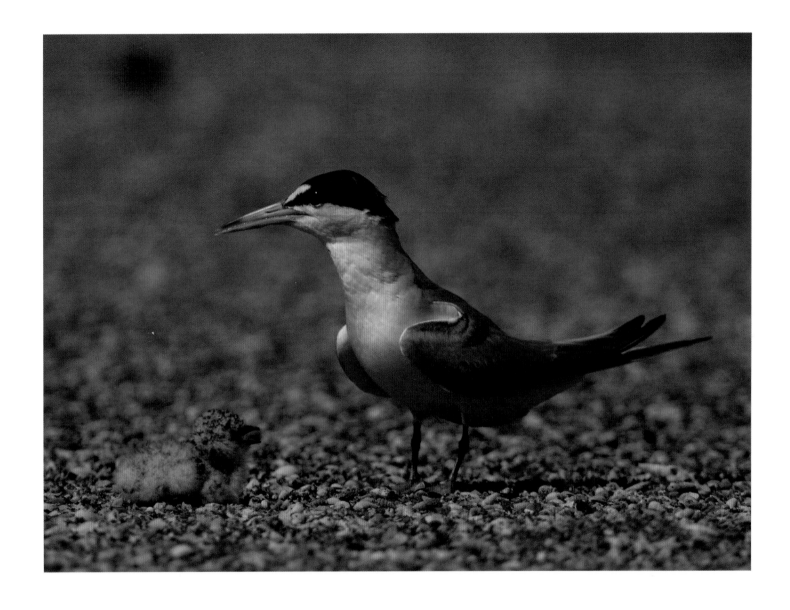

CHARRÁN MENOR · **LEAST TERN** · [*Sterna antillarum*] · EL PLAYAZO

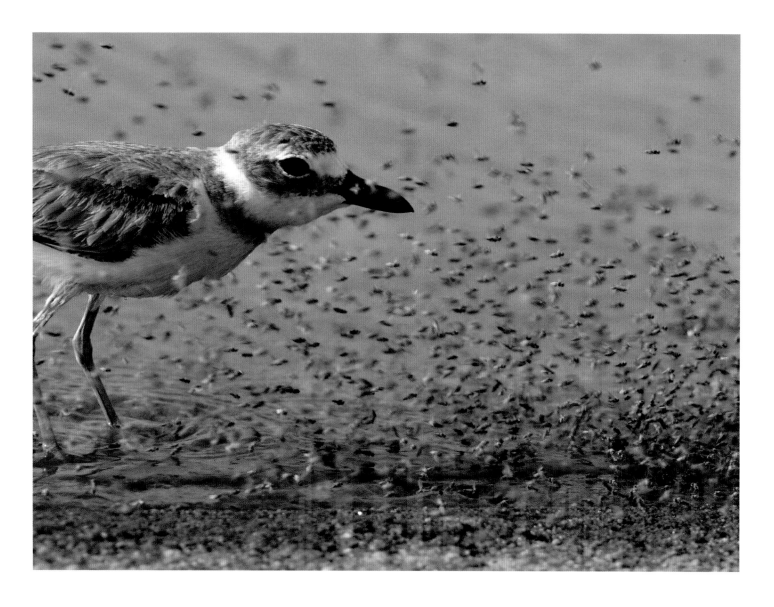

CHORLITO CABEZÓN · WILSON PLOVER · [*Charadrius wilsoni*] · LAS SALINAS

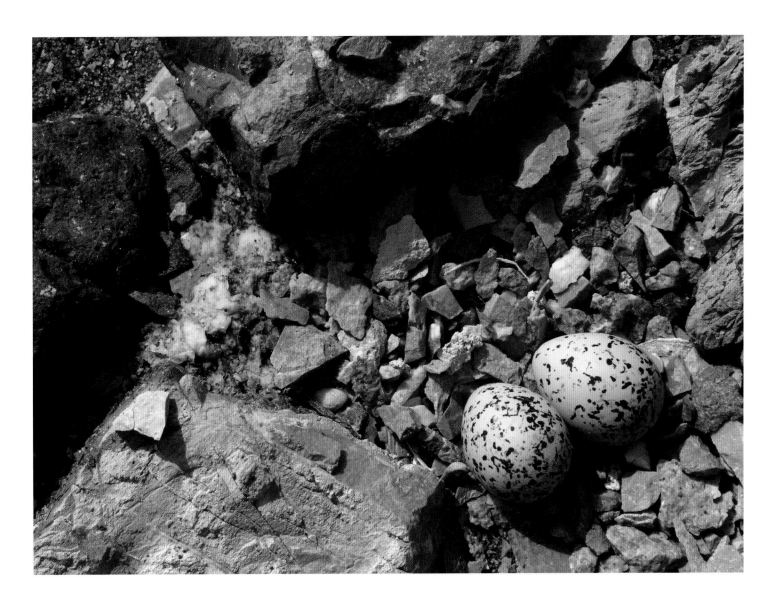

HUEVOS DE CHORLITO CABEZÓN · WILSON PLOVER EGGS

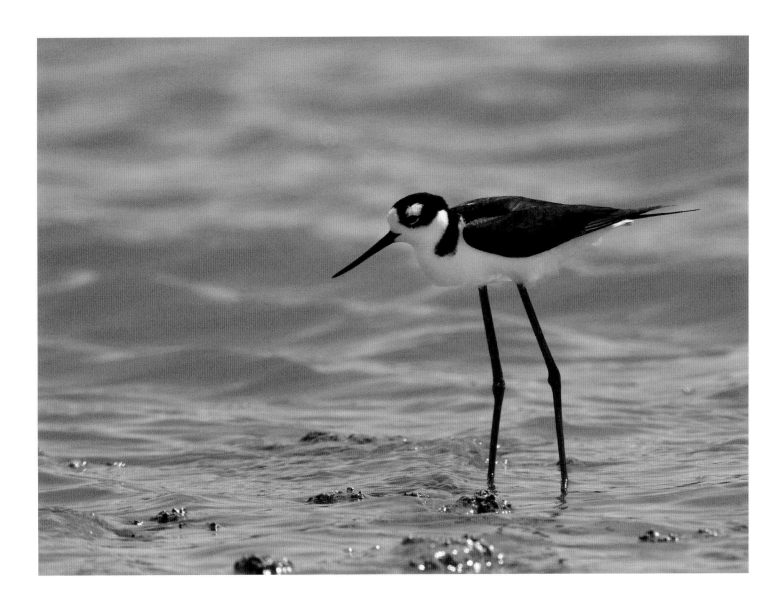

VIUDA · BLACK-NECKED STILT · [*Himantopus mexicanus*] · LAS SALINAS

HUEVO DE VIUDA RODEADO DE RIZOMAS DE MANGLE · BLACK-NECKED STILT EGG SURROUNDED BY MANGROVE ROOTS · LAS SALINAS

354

MARIJUANITA · PALE-BELLIED CURLYTAIL · [*Leiocephalus semilineatus*] · LAS SALINAS

CUYAYA COMIENDO AMEIVA · AMERICAN KESTREL EATING AMEIVA · [*Falco sparverius*] · LAS SALINAS

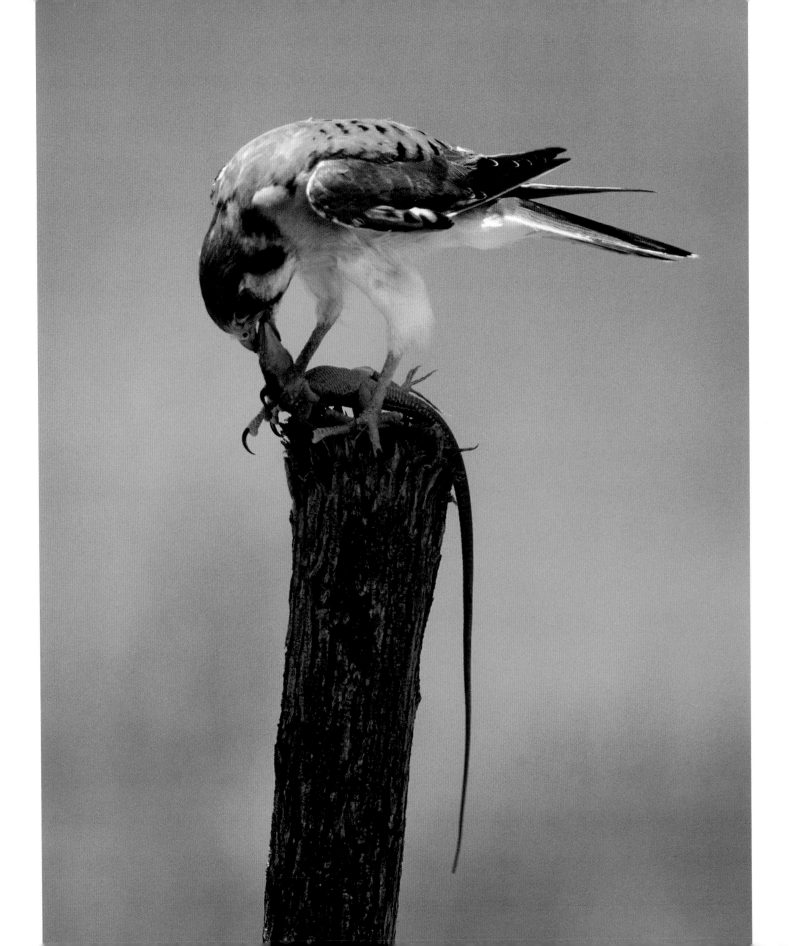

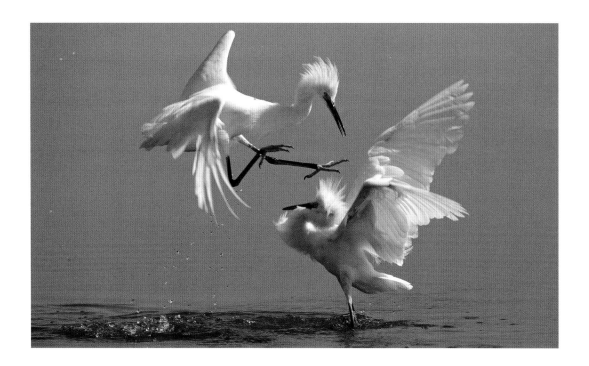

358

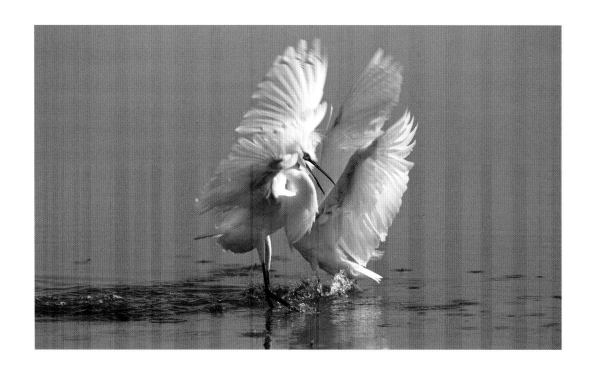

GARZAS DE RIZO PELEANDO · SNOWY EGRETS FIGHTING · [*Egretta thula*] · LAS SALINAS

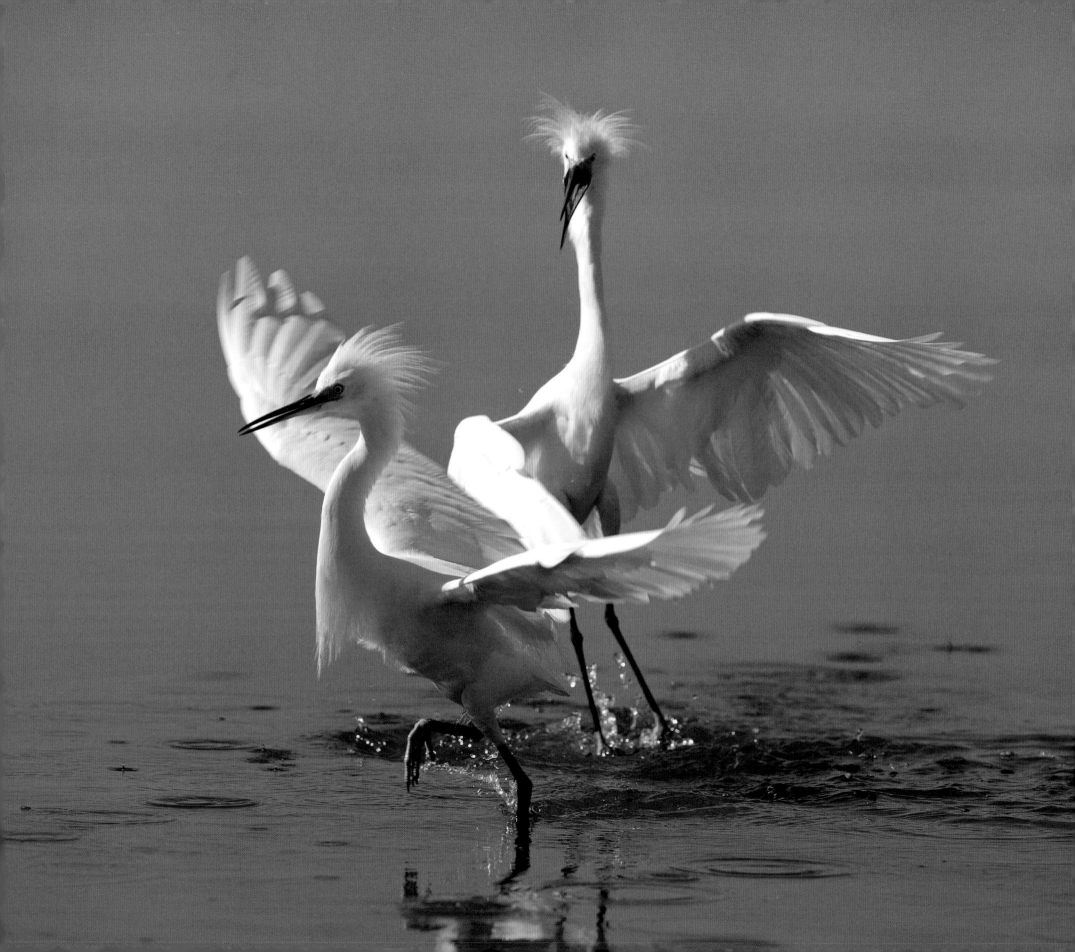

360

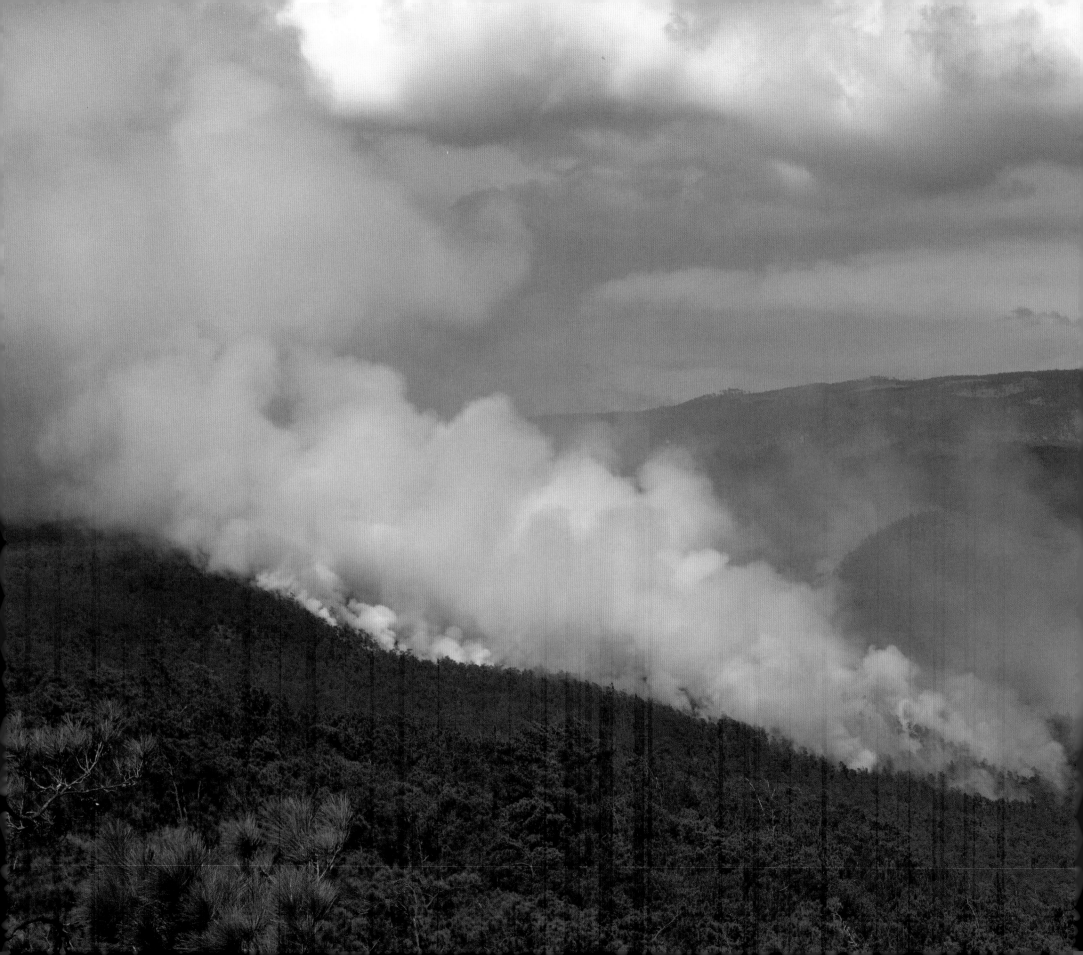

AMENAZAS A LOS RECURSOS NATURALES EN LA ESPAÑOLA

UN CONVERSACIÓN CON ANDRÉS FERRER BENZO, DIRECTOR
REGIONAL, THE NATURE CONSERVANCY

THREATS TO THE NATURAL RESOURCES OF HISPANIOLA

A CONVERSATION WITH ANDRES FERRER BENZO, REGIONAL
DIRECTOR, NATURE CONSERVANCY CENTRAL CARIBBEAN PROGRAM

HAITÍ Y LA REPÚBLICA DOMINICANA COMPARTEN NO SÓLO
la isla de La Española, sino también cuatro eco-regiones: bosque de pinos, bosque húmedo, bosque seco y humedales. En aislamiento geográfico, nuevas especies evolucionaron para llenar nichos en la tierra y en el agua, difundiéndose y llenando estos numerosos ambientes con una riqueza en especies no encontrada en ningún otro lugar del planeta.

Debido a esta alta concentración de especies nativas únicas y a una biodiversidad frágil amenazada por el desarrollo, estas eco-regiones se han declarado una prioridad en la conservación de toda la isla.

Andrés Ferrer Benzo es el Director Regional del Programa del Caribe Central de "The Nature Conservancy", sirviendo a Cuba, la República Dominicana y Puerto Rico. El explica como la flora y fauna única de esta región son vulnerables a las presiones ejercidas por la población humana, la agricultura, el turismo y otros tipos de desarrollo.

"Pero las mismas fuerzas biogeográficas que modelaron esta extraordinaria biodiversidad insular también generaron su vulnerabilidad a la extinción pues como las especies evolucionaron sin competencia en ausencia de depredadores, son frágiles frente a las amenazas causadas por el hombre. La amenaza de extinción es aumentada por la complejidad política de la isla, integrada por dos países con historias y culturas únicas, lo que resulta en una mezcla de problemas sociales, económicos y ambientales."

"En Haití, la cobertura de bosques representa menos del 3% del territorio nacional mientras que existen 7 áreas protegidas que equivalen al 0.3% del mismo. Estos recursos, por demás disminuidos, están sometidos a elevadas presiones y amenazas crecientes en el país más pobre del hemisferio occidental."

"En la República Dominicana se creó el Sistema Nacional de Áreas Protegidas (SINAP) integrado por unas 85 unidades de conservación que representan cerca del 24% del territorio nacional, el cual según estimados recientes cuenta con una cobertura de vegetación

cercana al 30% del mismo, pero aunque existen representaciones en buen estado de las cuatro eco regiones terrestres presentes en la isla, el desarrollo no planificado y el incumplimiento de políticas ambientales—o bien la falta de ellas—ponen en peligro la viabilidad de los recursos remanentes."

"Pero la isla contiene una creciente población que ronda los 18 millones de personas. Esta elevada densidad poblacional crea presiones sobre sus limitados recursos. La expansión agrícola, la contaminación, el desarrollo turístico no regulado, las especies invasoras, la construcción de infraestructuras, las alteraciones del régimen hidrológico y del régimen natural del fuego representan serias y crecientes amenazas para sus recursos naturales."

"Su reducido territorio y su aislamiento aceleran la velocidad con que ocurren estos procesos de degradación, limitando la capacidad de los recursos naturales para recuperarse de los daños inflingidos. Si el avance de estas amenazas y el crecimiento de la población no son controlados racionalmente, es posible predecir que a mediano plazo el suministro de agua potable será cada vez más escaso mientras la contaminación representará un problema creciente para la salud pública."

"La eliminación de cobertura boscosa, principalmente en áreas montañosas frágiles dentro de las cuencas hidrográficas, ocasiona erosión y degradación de suelos y alteración de los flujos de los sistemas acuáticos lo que ya ha generado inundaciones catastróficas con grandes pérdidas de vidas y bienes como en Fond Verrettes, Haití, reduciendo además la cantidad y calidad del agua. Los suelos erosionados e infértiles aumentan la pobreza generando un mayor grado de expansión de la agricultura en desmedro de los bosques remanentes, en un círculo vicioso como ocurre en el Parque Nacional Valle Nuevo donde nacen los principales ríos de la República Dominicana."

"Las descargas de petroquímicos usados en la agricultura, la industria y la minería también contribuyen a contaminar aguas, suelos y zonas costeras y marinas reduciendo la productividad de las pesquerías, degradando recursos bajo explotación turística, perjudicando tanto a los habitantes de las ciudades como a aquellos que viven en las zonas rurales."

"La introducción de especies foráneas es una grave amenaza que afecta sensiblemente las poblaciones de especies nativas, por su incapacidad para competir con aquellas. Tal es el caso de la Mangosta de la India (Herpestes javanicus) mejor conocida en estas latitudes como Hurón que se considera responsable por la disminución de las poblaciones de varias especies de reptiles y anfibios a partir de su introducción el siglo pasado. La evidencia también señala a gatos, perros, cerdos y chivos como animales que dañan significativamente la flora y la fauna de la isla como ocurre en la isla Beata dentro de la Reserva de Biosfera Enriquillo en la República Dominicana."

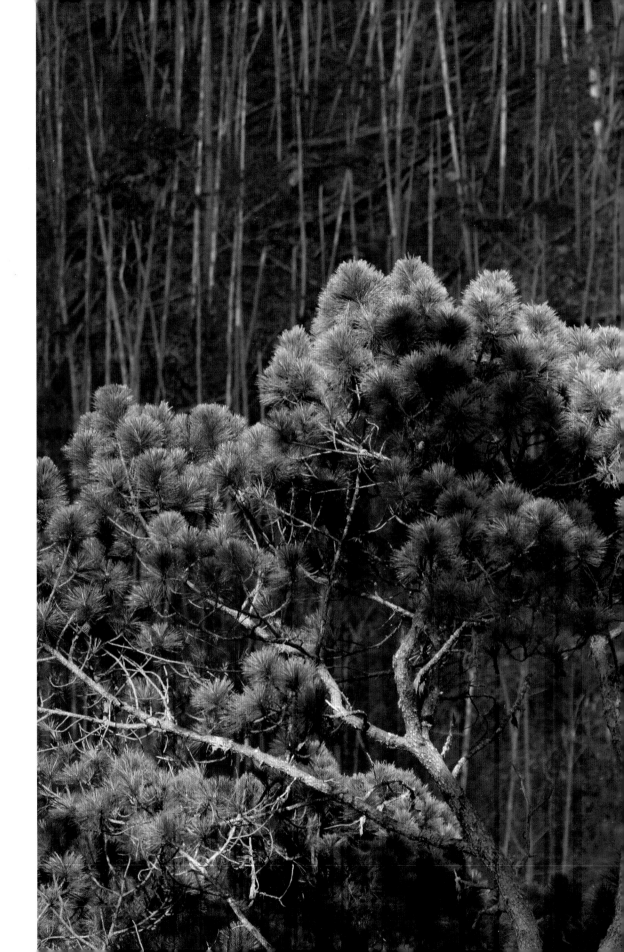

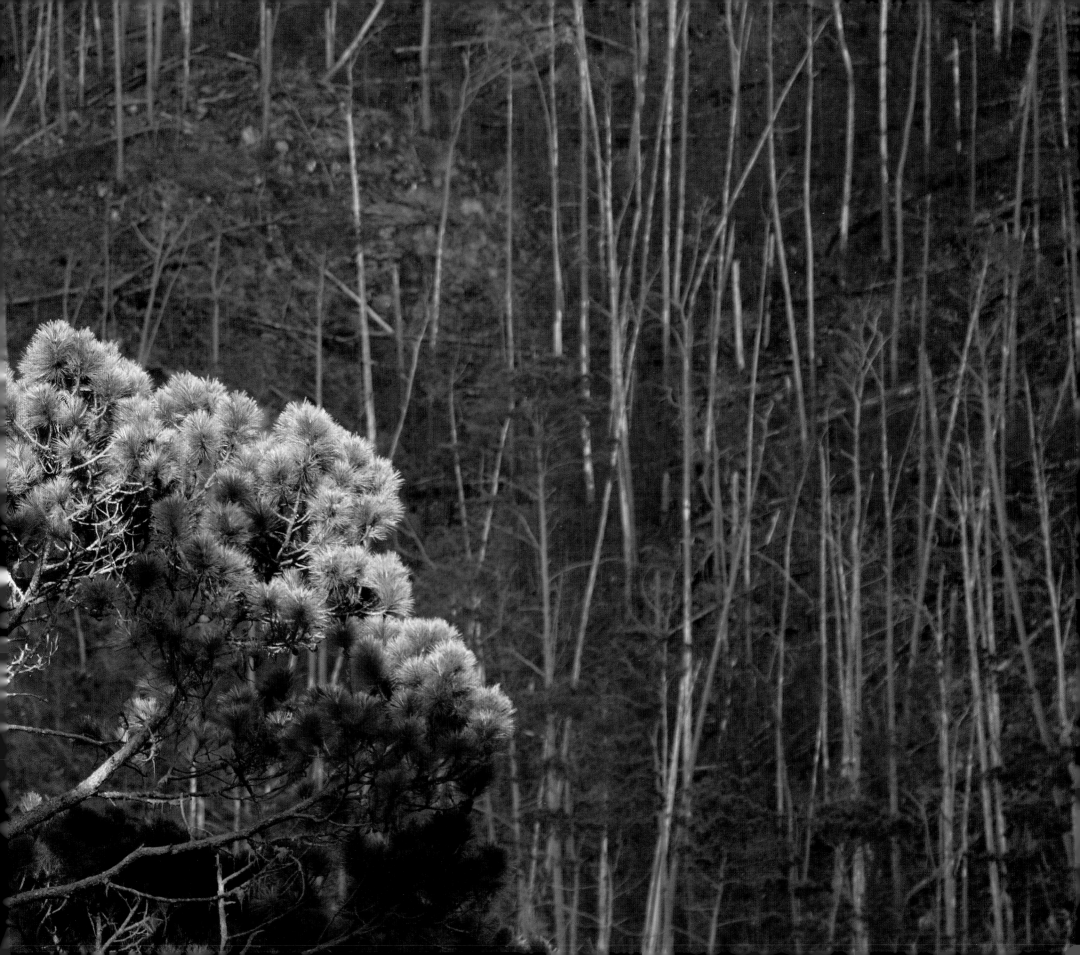

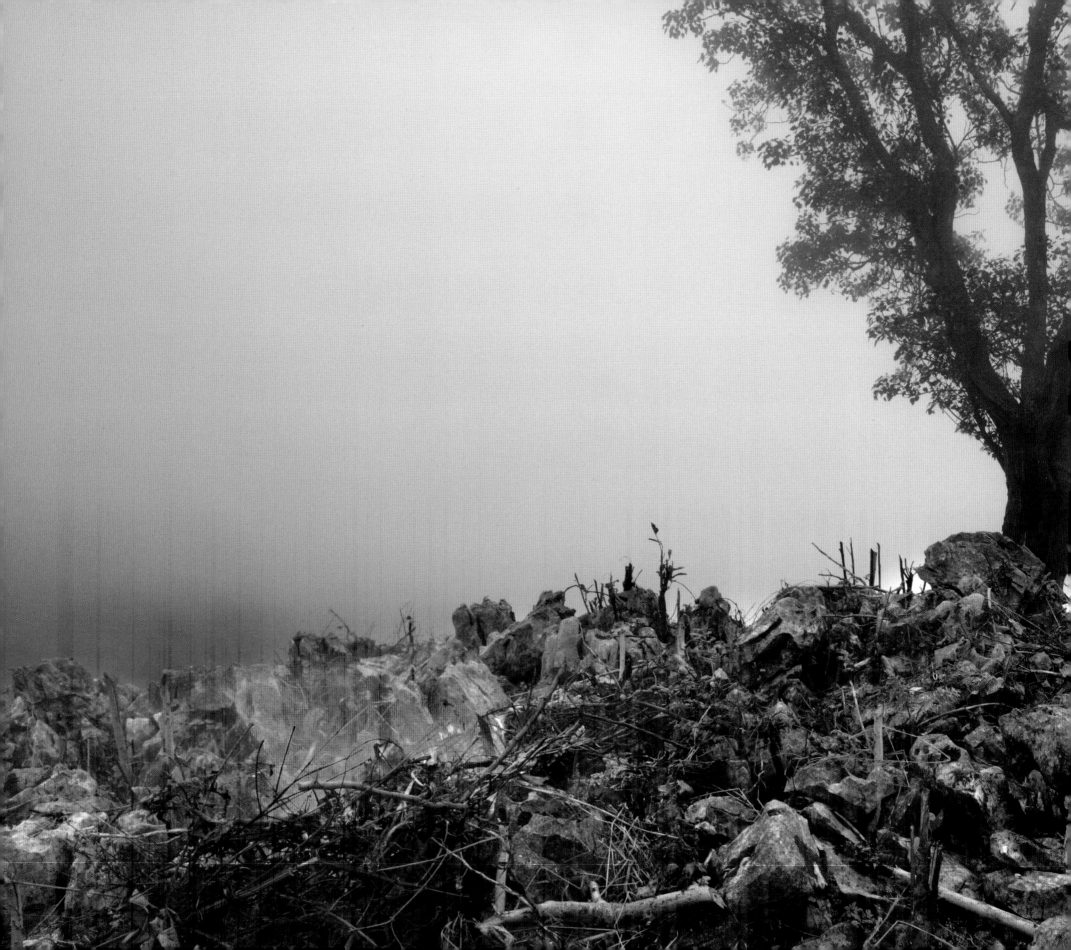

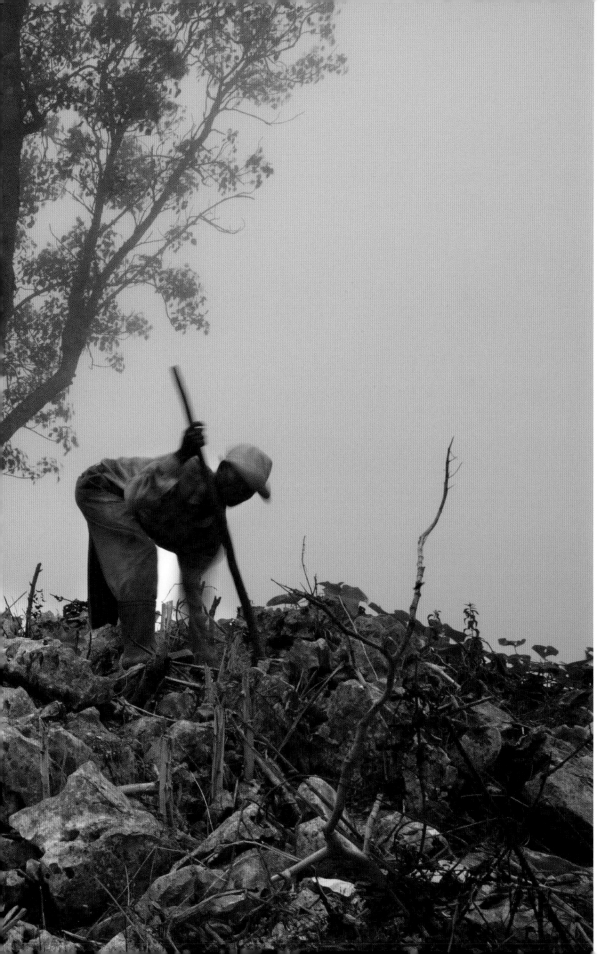

"La alteración del régimen natural del fuego en los bosques de pinos pone en grave riesgo la permanencia de los mismos. En áreas como el Parque Nacional José del Carmen Ramírez, la recurrencia del fuego causada por intervenciones ilegales promovidas en esa área protegida ya han modificado la composición de la vegetación con la consecuente disminución de los caudales de los ríos que nacen en la zona y el empobrecimiento de su biodiversidad. Es evidente que el hombre y la naturaleza constituyen dos elementos inseparables, por lo que el bienestar de aquel depende de la conservación de ésta."

Pero Ferrer Benzo todavía tiene la esperanza de que las tendencias actuales que amenazan la biodivesidad de la isla no son todavía irreversibles: "... pues existen en la porción de la Española ocupada por la República Dominicana y dentro del Sistema Nacional de Áreas Protegidas (SINAP), muestras viables de bosque de pinos, bosque húmedo, bosque seco y humedales. Estas estrategias y acciones pueden ser capaces de mitigar o abatir las amenazas y presiones que afectan la biodiversidad de la isla."

Pero él advierte "... que es necesario asumir como prioridad e implementar las acciones de planificación necesarias para cumplir con las obligaciones asumidas por ambos estados frente a la Convención sobre Diversidad Biológica, y lograr entonces un acuerdo a largo plazo entre gobiernos, fuerzas políticas y sociedades civiles para consignar en las cuentas nacionales los costos de conservación y manejo de la biodiversidad".

De esta forma, el tamaño de la isla podría ser ventajoso ya que políticas y estrategias destinadas a lograr un desarrollo racional y aliviar la pobreza a largo plazo podrían ser implementadas y mejoradas mas fácilmente por razones de escala, y los resultados iniciales se obtendrían en plazos relativamente cortos. Mas aún, es la esperanza del Sr. Ferrer Benzo que organizaciones como la Sociedad Audobon de Haití y la Sociedad Ornitológica de la Hispaniola puedan servir para difundir el mensaje de conservación y crear soluciones a nivel local y a la vez proporcionar un modelo para esfuerzos similares a una escala mayor en otros países. Quizás entonces el deterioro ambiental en espiral pueda ser detenido y estos ambientes únicos con su rica herencia biológica puedan ser preservados.

367

HAITI AND THE DOMINICAN REPUBLIC SHARE HISPANIOLA, the site of four officially designated Ecoregions: Hispaniolan Pine Forests (Bosque de Piños de la Española), Hispaniolan Moist Forests (Bosque Húmedo de la Española), Hispaniolan Dry Forests (Bosque Seco de la Española), and Enriquillo Wetlands (Humedales de la Española). These four are considered to be the highest conservation priorities for the Caribbean region because of their great species richness, endemism, and ecological vulnerability.

Andrés Ferrer Benzo, Regional Director of the Nature Conservancy's Central Caribbean Program (Cuba, Dominican Republic, Haiti, and Puerto Rico), explains the origins and importance of the region's flora and fauna—and why they are so fragile and vulnerable to threats from humans. Further, Ferrer Benzo cautions, "the threat of extinction on Hispaniola is increased by the political complexity of the island, where two countries of distinct history and culture have created a unique mix of social, economic, and environmental conditions."

On the island of Hispaniola, says Ferrer, "terrestrial and freshwater species have evolved in isolation; through adaptive radiation, new species have moved into a variety of habitats. However, the same biogeographic processes that produced this extraordinary biodiversity and high levels of endemism (species unique to the area) also left these species extremely vulnerable to extinction. Species that evolved in the absence of competitors or predators are especially sensitive to environmental changes, including those changes caused by humans."

Because Hispaniolan flora and fauna evolved in an isolated island environment, a significant ecological threat is the introduction of exotic species, Ferrer points out. "The introduction of exotic species poses a grave threat to the native species that do not have the capacity to compete with the exotics. For example, the Indian Mongoose (*Herpestes javanicus*), known locally as Hurón, is considered to be responsible for the decrease in populations of many species of reptiles and amphibians since its introduction a century ago. According to evidence, cats, dogs, pigs, and goats have also caused significant damage to the flora and fauna of Hispaniola, such as has occurred on Beata Island in the Enriquillo Biosphere Reserve in the Dominican Republic."

Growing population and economic development have resulted in ecological threats to Hispaniola's Ecoregions, continues Ferrer. "The island has a growing population of around 18 million. This high population density creates pressures on limited resources. Serious and growing threats to natural resources include agricultural expansion, contamination, unregulated development of tourism, exotic (introduced) species, road construction, and disruption of the natural hydrology and fire ecology. The small size and the isolation of Hispaniola both accelerate the pace of environmental degradation and limit the capacity of the ecosystems to recuperate from damage.

"If the increase in threats and population growth are not controlled in a rational way, it is possible to predict that in the not too distant future the water supply will decline and contamination will be an increasing problem for public health. The discharge of petrochemicals used in agriculture, industry, and mining contributes to the contamination of freshwater and soil, as well as of coastal and marine areas, where it reduces the productivity of fisheries. These sources of contamination, along with the pressure of unregulated tourism, have harmed the citizens of our cities and rural areas.

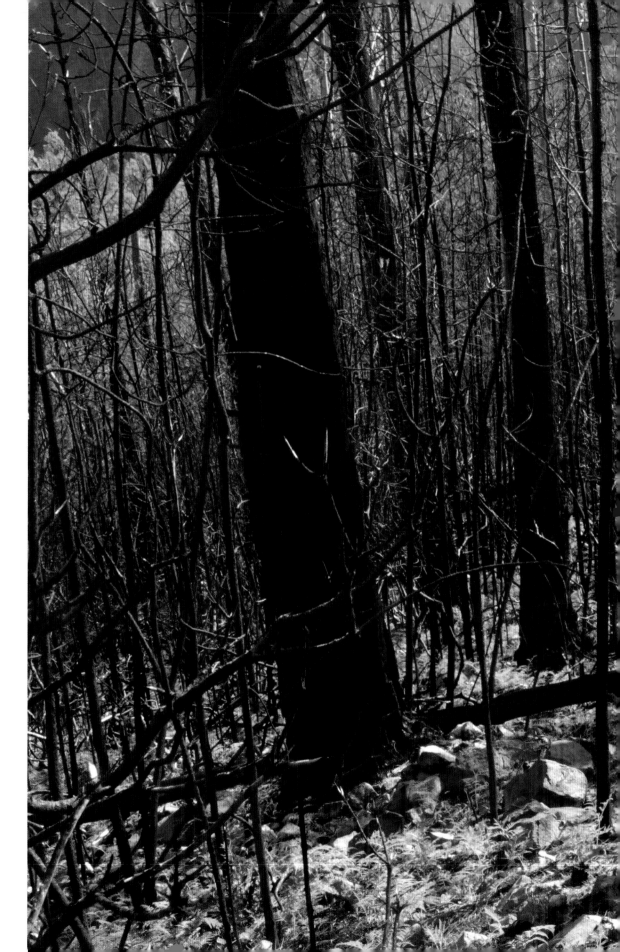

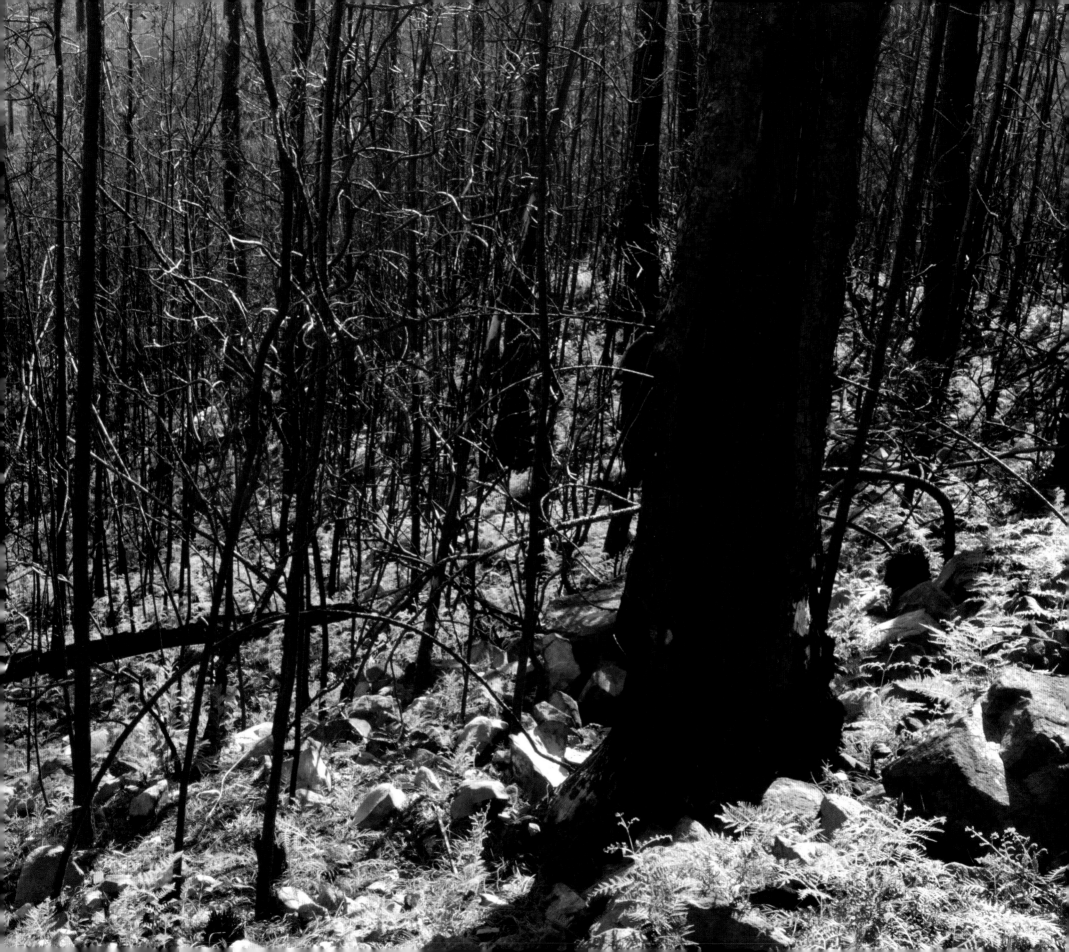

"The elimination of forest cover, especially in the fragile mountain habitats that give rise to vast watersheds, causes erosion and degradation of soils and alters the flow of aquatic systems. Soils that are eroded and infertile increase poverty and cause further incursions of subsistence agriculture into the remaining forest. This sort of vicious cycle occurs in the National Park Valle Nuevo, where the most important rivers of the Dominican Republic originate. Elimination of forest cover reduces the quantity and quality of water available, and also causes catastrophic flooding, with great losses of human life and dwellings, such as occurred in Fond Verrettes, Haiti.

"The alteration of the natural regimen of fire in pine forests puts the forest's long-term security at great risk. In protected areas such as the José del Carmen Ramírez National Park, fire caused by illegal burning has modified the composition of the vegetation. As a result, the headwaters that arise in this area have been diminished, and biological diversity in the area has been impoverished.

"It is obvious that humans and nature are inseparable, and each depends on the other for its well-being; conservation is imperative. The current situation includes many ecological threats, but all is not lost. Strategies and actions can mitigate or reduce the threats and ecological pressures that affect the island's biodiversity. This is demonstrated by the areas of the Dominican Republic within the National System of Protected Areas (SINAP is the Spanish acronym), which include viable sections of each of Hispaniola's four designated Ecoregions. SINAP protected areas include 85 conservation units, covering almost 24% of the Dominican Republic's territory.

"According to recent estimates, 30% of the Dominican Republic's protected areas are forest cover, and all four Ecoregion types are represented. However, unplanned development and the absence of (or noncompliance with) environmental policies puts these remaining resources in danger. In Haiti, forest cover is less than 3%, and the seven protected areas cover about 0.3% of the nation's territory. These resources, already depleted, are subject to elevated pressures and increasing threats in the poorest country in the Western Hemisphere."

Immediate action is necessary, warns Ferrer, but there is also reason for hope. "It must be a high priority to implement the action plans that are required to comply with the obligations accepted by both countries under the Convention on Biological Diversity. There must be a long-term agreement to assume as a national responsibility the costs of conservation and biodiversity management, involving governments, political forces, and civil society.

"The small size of the island, shared by only two nations, should be considered an advantage. For reasons of scale, policies and strategies designed to achieve sustainable development and alleviate poverty for the long term can be implemented more easily. Initial results can be obtained in relatively short periods. Moreover, Hispaniola can serve as a model for larger countries. It can be an example of active leadership which changes the course of history for the common good, or an example in which the absence of leadership could not halt the downward spiral of environmental degradation, permitting shared habitats to become an inhospitable desert."

It is the hope of Ferrer that organizations such as the Société Audubon Haïti and the Sociedad Ornitológica de la Hispaniola can serve both to spread the conservation message and to devise grassroots solutions at the local level. These efforts might provide a model for similar efforts on a larger scale in other countries. Perhaps environmental deterioration can be stopped, and these unique habitats with their rich biological heritage can be preserved.

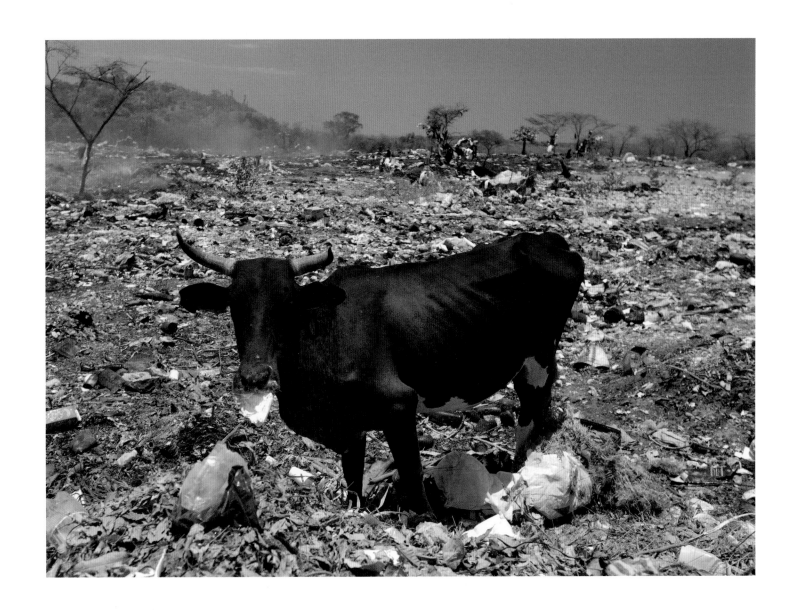

AGRADECIMIENTOS

LES DEDICO LA PRODUCCIÓN DE ESTE LIBRO A Rocío, Sara, y Eladio José, especialmente por las muchas horas que me mantuvo alejado de mi hogar. Gracias por su amor y apoyo a través de este proceso.

A mi madre Olga, le estoy eternamente agradecido por su apoyo incondicional a través de los años y a mi padre Eladin, con quien hubiese querido compartir esta etapa en mi vida.

A Maite le agradezco haberme apoyado en mi decisión de tomar el camino de una linda profesión.

Le estoy profundamente agradecido a todos en el Grupo SID—especialmente a Roberto Bonetti, José Miguel Bonetti, Lil Esteva, José Miguel Bonetti Dubreil, Ana Bonetti Dubreil, y Ligia Bonetti Dubreil—por apoyar este proyecto y por confiar tan plenamente en nuestra visión. Sin su ayuda esta publicación no seria una realidad.

Completar un proyecto tan ambicioso como este no es la labor de una sola persona, sino que requiere del esfuerzo conjunto de muchos. Me gustaría agradecer a:

E. O. Wilson, Philippe Bayard, Steve Latta, Chris Rimmer, José Ottenwalder, Blair Hedges, Milciades Mejía, y Ricardo García, y a Timothy Baroni por enriquecer este libro con sus palabras.

Brian Farrell e Irina Ferreras, quienes hicieron posible que este proyecto llegara mas alla de nuestro pais.

Nicolás Corona, por ser un incansable conservacionista. Su tenacidad y coraje no tienen comparación.

Ruth Bastardo, Jim Ackerman, Jean Vilmond Hilaire, Rich Glor, Russell Thorstrom, Mónica Vega, Paula Vega, Enrique Pugibet, Brigido Peguero, Teodoro Clase, Sharon Cantrell, Andreas Shubert, Adolfo Gottschalk, Jozef

I DEDICATE THIS BOOK TO ROCÍO, SARA LUCIA, and Eladio José. The production of this book required many hours away from home. Thank you for your love and support throughout the process.

To my mother, Olga, I'm eternally grateful for your unconditional support throughout the years and to my father, Eladio, with whom I would have liked to share this stage of my life.

I would like to thank Maite for supporting my decision to pursue a beautiful profession.

I'm extremely grateful to everyone at Grupo SID—especially Roberto Bonetti, José Miguel Bonetti, Lil Esteva, José Miguel Bonetti Dubreil, Ana Bonetti Dubreil, and Ligia Bonetti Dubreil—for supporting this project and for trusting our vision. Without their help this book would not have become a reality.

Completing an ambitious project such as this one requires the work of many. I would like to thank:

E. O. Wilson, Steve Latta, Chris Rimmer, José Ottenwalder, Blair Hedges, Timothy Baroni, Charles Woods, Milcíades Mejía, and Ricardo García for enriching this book with their words.

Brian Farrell and Irina Ferreras, who made it possible for this project to reach beyond our country.

Nicolás Corona, by far the most adventurous tracker on the island and a truly committed conservationist.

Ruth Bastardo, Jim Ackerman, Jean Vilmond Hilaire, Rich Glor, Russell Thorstrom, Mónica Vega, Enrique Pugibert, Brigido Peguero, Teodoro Clase, Andreas Shubert, Kassia Gracela, Adolfo Gottschalk, Jozef Grego, and Jozef Steffek for sharing information in their respective

372

Grego, Jozef Steffek por compartir datos en sus respectivas áreas de especialidad, por ayudar con la identificación y por proveer asistencia en apoyo de este proyecto.

Danilo Mejía, Maria Isabel Paulino, Yeyo, Tulio Mejía, Vinicio Mejía, Limbano Sánchez, Blanco Turbi, Esteban Garrido, Jean Denis Chery, Leonel Mera, Francisco, Hermógenes, Robert Ortiz, Juanito, Román, Maritza Sánchez, Juan Céspedes, Timo, Nohimi, Samuel, Bao, y Antenor, todos valiosos compañeros y asistentes de investigación, guías y oficiales de parques.

Ricardo Briones y Jesús Rodríguez por enseñarme tanto sobre fotografía paisajista y por su compañía en aquellos arduos viajes a La Descubierta.

Erwing Monsanto, Florence Sergile, y Daniel Kedar por mostrarme un Haití que pocos antes han visto y por su infinita hospitalidad.

Hjalmar Gómez, José Aris, Carlos Borrell, Pedro Rodríguez, Limbazo Sánchez, Miguel Ángel Landestoy, Ulises Borrell, y Beatriz Fernández por su compañía en tantos viajes.

Andrés Ferrer Benzo, Néstor Sánchez y Francisco Núñez del Nature Conservancy por su apoyo y consejos a través de los años.

Irina Miolán, quién fue esencial en elevar la calidad de mi trabajo a través de su diseño.

areas of expertise, helping with identification, and providing assistance in support of this project.

Danilo Mejía, María Isabel Paulino, Yeyo, Tulio Mejía, Vinicio Mejía, Limbano Sanchez, Blanco Turi, Esteban Garrido, Jean Denis Chery, Leonel Mera, Francisco, Hermógenes, Robert Ortiz, Juanito, Román, Maritza Sánchez, Juan Céspedes, Timo, Nohimi, Samuel, Bao, and Antenor, all key research assistants, guides, and park officials.

Ricardo Briones and Jesús Rodríguez, for teaching me so much about landscape photography and for their companionship on painful trips to La Descubierta.

Erwing Monsanto, Florence Sergile, and Daniel Kedar, for showing me a side of Haiti that very few people had seen before and for their hospitality.

Hjalmar Gómez, José Aris, Carlos Borrell, Pedro Rodríguez, Miguel Ángel Landestoy, Ulises Borrell, and Beatriz Fernández, for their companionship on many trips.

To Andrés Ferrer Benzo, Nestor Sánchez and Francisco Núñez from the Nature Conservancy, for their support and advice throughout the years.

Irina Miolán, who was key in taking my work to another level through her beautiful design.

CONTRIBUIDORES | CONTRIBUTORS

PHILIPPE BAYARD
Société Audubon Haïti
Pétitionville, Haïti

TIMOTHY J. BARONI
SUNY Cortland
Cortland, New York

SHARON A. CANTRELL
Sabana Field Research Station
Luquillo, Puerto Rico

BRIAN D. FARRELL
Harvard University
Cambridge, Massachusetts

ELADIO FERNÁNDEZ
Photographer and Conservationist
Santo Domingo, Dominican Republic

RICARDO GARCÍA
Jardín Botánico Nacional
Santo Domingo, Dominican Republic

S. BLAIR HEDGES
Penn State University
University Park, Pennsylvania

STEVEN C. LATTA
National Aviary
Pittsburgh, PA

MILCÍADES MEJÍA
Jardín Botánico Nacional
Santo Domingo, Dominican Republic

JOSÉ ALBERTO OTTENWALDER
National Aviary
Pittsburgh, Pennsylvania

CHRISTOPHER C. RIMMER
Vermont Institute of Natural Sciences
Quechee, Vermont

EDWARD O. WILSON
Harvard University, emeritus
Cambridge, Massachusetts

CHARLES A. WOODS
Florida Museum of Natural History, retired
Gainesville, Florida